THE PINK GLASS SWAN

95 96 97 98 9 8 7 6 5 4 3 2 1

Library of Congress Cataloging-in-Publication Data

Lippard, Lucy R.
 The pink glass swan: essays on feminist art / Lucy R. Lippard.
 p. cm.
A collection of essays previously published 1970–1993.
ISBN 1-56584-213-8
1. Feminism and art. 2. Feminist art criticism. I. Title.
N72.F45L56 1995
7013.03—dc20 94-23406
 CIP

Published in the United States by The New Press, New York
Distributed by W. W. Norton & Company, Inc., New York, NY 10110

Established in 1990 as a major alternative to the large, commercial publishing
houses, The New Press is the first full-scale nonprofit American book publisher
outside of the university presses. The press is operated editorially in the public
interest, rather than for private gain; it is committed to publishing in innovative
ways works of educational, cultural, and community value that, despite their
intellectual merits, might not normally be "commercially" viable. The New Press's
editorial offices are located at the City University of New York.

Book design by Charles Nix

Production management by Kim Waymer

Printed in the United States of America

THE PINK GLASS SWAN

SELECTED ESSAYS ON FEMINIST ART

LUCY R. LIPPARD

THE NEW PRESS · NEW YORK

TO FRIENDSHIP, AND TO ALL THE WILD WOMEN
who have made feminist art what it is.

In memory of Florence Isham Cross, Lucy Balcom Lippard,
Margaret Isham Cross Lippard, Eva Hesse, Elaine Johnson, Ree Morton,
Ana Mendieta, Lyn Blumenthal, and Vivian Browne.

And to my goddaughter, Lia Sofia Simonds.

AUTHOR'S NOTE

I have not included here any of the many monographs I have written on individual women artists since the late 1960s, partly because they would have tripled the size of the book, partly because it would have been too hard to choose which ones to use, and partly because they are now all out of date in the context of individual developments. For similar reasons I have updated most of the reproductions to reflect newer work.

I have not revised any of these essays, despite the occasional temptation to rewrite from the vantage point of lessons learned since they were written. A copy editor has demanded a few textual changes; any additions are indicated by brackets. Those pieces written more "journalistically," without endnotes, remain without sources since these have been lost in the mists of time and clutter.

All the essays in Part I were published in *From the Center: Feminist Essays on Women's Art* (New York: E. P. Dutton, 1976); those in Part II (except for the last one) were published in *Get the Message? A Decade of Art for Social Change* (New York: E. P. Dutton, 1984); those in Part III are from *Heresies,* the *Village Voice,* and elsewhere.

With thanks to all the past and present members of the Heresies Collective, PADD, Outside Agitators, and Damage Control; and to my editor, Dawn Davis.

CONTENTS

THE PINK GLASS SWAN

Moving Targets/Concentric Circles:
Notes from the Radical Whirlwind*

"Changing Since *Changing*" was what I called the introduction to *From the Center* (the 1976 collection of my essays from which the first section of this book was taken), a reference to *Changing* (1971), my first book of essays, which was inspired mostly by male Minimalism and Conceptualism. This current introduction is about changing since *From the Center*. If the contradictions inherent in the feminist enterprise have not been resolved, they too have changed—in ways we could not have predicted during that early bloom of optimism, when we thought, or hoped, that in ten years feminism would have changed society itself.

Living out those contradictions, I've been accused of being a moving target. But what target in its right mind wouldn't move? And what good art is not a moving target? Mobility (and flexibility) has become a strategy as well as a temperamental and intellectual preference. I thought of calling this introduction "From the Center to the Margins," a double entendre that describes my own personal development: I have spent the last decade and a half on the "margins" of activism and cross-culturalism, and I have moved from New York City to rural New Mexico and Maine.

But, in fact, the women's art I was writing about in the early seventies has since, in many cases, become downright central to the art world, even as inequities continue to reign for the majority. (See the Guerrilla Girls posters and the Women's Action Coalition's *WAC Stats* [New York: New Press, 1993] for the nasty details. I am just as ambivalent as I was in 1970, when our energies were concentrated on getting the art-world gates to open and admit

*This introduction incorporates excerpts from "In the Flesh...," a text published in 1993 for the exhibition "Backtalk," at the Santa Barbara Contemporary Art Forum, and some passages from the prefatory notes to *Get the Message: A Decade of Social Change?* (New York: E. P. Dutton, 1984).

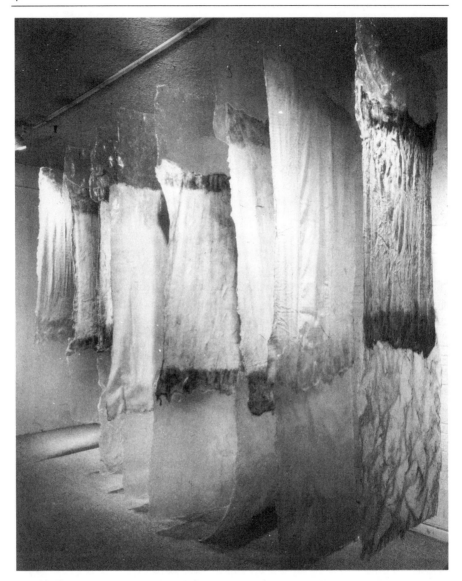

EVA HESSE
Contingent, 1 9 6 9
FIBERGLASS AND RUBBERIZED CHEESECLOTH, 14′ × 3′ (8 UNITS)
Collection the National Gallery of Australia, Canberra.

This major work of Hesse's is central to her great influence on young artists
(especially but not exclusively women) through the seventies to the nineties. Made
when she was already suffering from the brain tumor that would kill her, the
translucent sheets are remarkable for a fusion of fleshlike vulnerability and tran-
scendent abstraction.

women artists. I am still convinced that this society has yet to find a healthy context for art, and that the commercial art world is a lousy place for artists and a lousy place for art. Nevertheless, I feel strongly and have worked hard to ensure that women artists (including artists of color) have the same chance to choose to profit from that system as anyone else, even as I hope that some-day a revolution will overturn it and offer something far better.

So that's one thing that hasn't changed. What has changed in the almost twenty years since I wrote the introduction to *From the Center* is that I have deviated from the feminist center (as some see it) or the center has expanded into concentric circles (as I see it). Early in the eighties, I was told by a midwestern feminist that I hadn't been invited to a conference because rumor had it that I was "no longer a feminist"; I was "too interested in the Third World." Bemused by the notion that the Third World was perceived as all male, I was also annoyed and alarmed at such a narrow definition of feminism. The undertones of classism in such comments by feminists have not escaped working-class women. As far as I am concerned, everything in which a feminist is involved becomes feminist in some sense. (Almost like "it's art if an artist says it is.") Feminism changed my entire outlook on the world and its impact on my life has never diminished. Nor could I have gone back, even if I'd wanted to: it's like jumping off a roof—too late to change your mind halfway there.

Things have changed, but they haven't changed enough. It has been both gratifying and horrifying to hear from younger women in the last few years that *From the Center* still reflects women artists' experiences. Gratifying because all writers love to hear that what they have written means some-thing to their audiences, horrifying because that collection of feminist essays on women's art, published in 1976, but written between 1970 and 1975 in the heat of early feminist passion and rage, should be obsolete by now. Perhaps its endurance can be attributed not so much to the exposure of ongoing inequities (which many young women have not yet experienced) as to the meaningful overlapping of women's art and women's lives, which is what feminist art is all about.

When *From the Center* went out of print in 1992, it joined in oblivion another collection of my essays, *Get the Message? A Decade of Art for Social Change* (1984), many of which were originally published in *Heresies: A Femi-nist Publication on Art and Politics* (and included here in Part 2). *Heresies* provided me and many other New York women with an intellectual and political home, which was often cross-cultural and interdisciplinary as well. It offered both artists and writers new models for approaching art writing. By the mid-seventies the number of artists willing to call themselves femi-nists had swelled to a vast network of accomplishment. Direct political

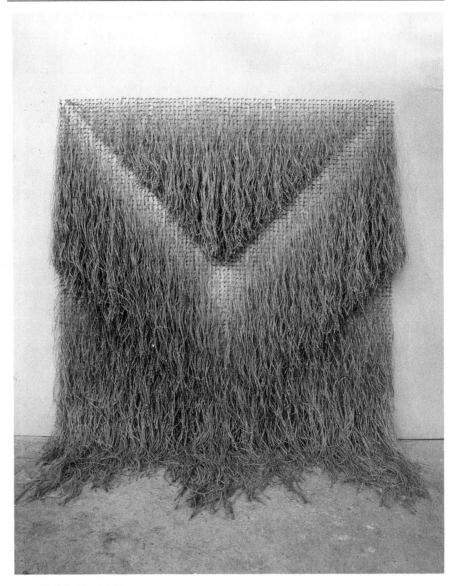

BRENDA MILLER
Diandrous, 1973
SISAL, NAILS, BLUE PENCIL, 80″ × 80″ × 1″

Miller was, with Poppy Johnson, Faith Ringgold, and me, a cofounder of the
Ad Hoc Women Artists' Committee that took on the Whitney Annual in 1970.
Her work exemplifies the female/feminist alterations of the minimal grid, its
transformation into a sensuous, organic form.

action had run its course for the time being, giving way to a new interest in theory that clarified the divisions between socialist feminists, radical feminists, and cultural feminists. The Heresies Collective—which was conceived in 1975 and founded in 1976 after a number of open meetings of the feminist community, in which membership fluctuated weekly—was the result of this mid-decade self-examination. We decided to create "a space and a voice." The space—a school—got stalled but was later set into motion by Miriam Schapiro, Nancy Azara, and others in the Feminist Art Institute; the voice was the publication.

Both the collective and the magazine, as I have often said since, allowed me the freedom I didn't realize I didn't have—the freedom to write from the heart, to write from a female space, supported (although not necessarily agreed with) by my peers in the cultural-feminist and socialist-feminist arenas. If my conversion to feminism in 1970 (and I use the word advisedly; feminism for me is a belief system, a value system, within a political movement) changed my life, six years later the Heresies Collective changed my writing. The dialogue, feedback, and support I received from the collective for my own and collaborative work was crucial. It increased my intellectual security, which in turn allowed me to write more openly, less self-protectively, about art and politics. In *Heresies,* for the first time, I was writing as part of a familiar and sympathetic fabric rather than as an isolated individual or dissident voice in the art world.

Such nurturance in turn opened up new subject matter that I had previously felt unqualified to explore, such as class, and broader cultural and media theory. The components of that still much-longed-for integration between cultural feminism and socialist feminism became clearer, even if no solutions presented themselves. In the search for bridges, I found myself scrutinizing the imposed dichotomies between "high" (or "fine") art and "low" (or "mass" or "popular") culture, in essays like "The Pink Glass Swan" (page 117) and "Making Something from Nothing" (page 128) and in later work on so-called outsider art.

Around the same time, many of us felt it was important to bring feminist ideas and cultural value systems more forcefully into the mainstream of the left and into the left of the art world. Some of us were involved in a dissident artists' group called Artists Meeting for Cultural Change. (I helped start it, with Rudolph Baranik and Hans Haacke, in response to the skewed responses of American art institutions to the U.S. bicentennial.) The left-leaning male membership paid a good deal of lip service to feminism but was unable to change even its own usage of personal pronouns (so much for "cultural change"). It was hardly an encouraging experience.

But by 1979 it was clear that the time really had come for a stronger

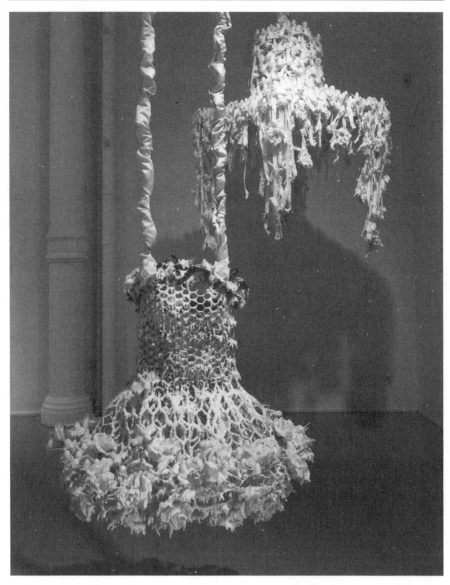

PETAH COYNE
Untitled #779, 1994
MIXED MEDIA (MELTED WAX), 38″ × 43″ × 33″
The Bailey Insurance Collection, Toronto. Photo: courtesy Jack Shainman Gallery, New York

Coyne's earlier black sculptures looked like brutally uprooted trees, burned or abandoned. The new lacy white wax works are also suspended from above. Pristine, magical, still distantly evocative of plant life, they represent the lifting of a period of mourning.

alliance between feminist artists and the activist left. I had lived in England from 1977 to 1978. There I had spent some time with British socialist feminists, whose theories on women and class and whose participation in general left politics seemed far in advance of theory and praxis in the American art world. I had also become obsessed with the great prehistoric stone and earth monuments on the Dartmoor, at Avebury, and elsewhere, as well as

NANCY HOLT
Underscan, 1974
8-MINUTE VHS VIDEOTAPE, PRODUCED BY CARLOTA SCHOOLMAN,
FIFI CORDAY PRODUCTIONS

Holt videotaped photographs of her Aunt Ethel's New England house and then reshot them with a video underscanning process. Each image was seen progressively as normal, elongated, and contracted. On the sound track Holt read excerpts from her aunt's letters, and the cycle of recurring events in her aunt's life was counterpointed by the cyclical rhythm of the transforming images.

with the landscape in which I had walked every day. I was willing to give up neither nature nor culture. However, cultural feminists (with their connective concept of women and nature) tend to perceive socialist feminists as male-identified, unfeeling intellectuals bound to an impersonal and finally antifemale economic overview; while socialist feminists tend to perceive cultural feminists as a woozy crowd of women in sheets taking refuge in a matriarchal "herstory" that was reactionary, escapist, and possibly fascist in

its suggestions of biological superiority. I spent a lot of time in one camp making excuses for my commitment to the other, and vice versa.

Aspects of these debates were reproduced during the eighties as the binary division between deconstructionists and essentialists, postmodernists and ecofeminists, and so forth. Actually, it is all a good deal messier than such artificial dichotomies suggest. In 1979, at Artemesia, the Chicago women's co-op gallery, I curated an exhibition called "Both Sides Now," which was an attempt to heal this rift by bringing together women from both groups. (I reused the title for a 1988 essay [page 266] that was another attempt at integration.) In the mid-eighties I curated a show at Ohio State University called "All's Fair in Love and War: New Feminist Art," which acknowledged ongoing struggles. Today I am more interested in the nature of the differences than in their comparative virtues, and I am resigned to living in the gaps between many different positions.

Personally, I try to stay out of categorical captivity. I don't qualify as a deconstructionist because, among other deficiencies, I have never read much of nor fully understood Derrida, Lacan, et al. The essentialists don't claim me either, but I probably lean more that way, perhaps from sheer perversity. Since the mid-seventies my politics has had a spiritual component, which I now take for granted. It was initially sparked by the deaths of a number of friends in their thirties and forties, and developed through studies of "prehistoric" religions. I listen to my dreams and my intuitions more than ever. Politics, art, and the spiritual all have in common the power to envision, move, and change. I like blurred boundaries.

For these and other reasons, my writing is often called "reductive"—not as a compliment. Yet reduction, or distillation, of complex ideas to forthright and accessible sentences is my deliberate intention as a writer. I like to tell it like I see it, get to the bottom of things as directly as possible, and leave the finer points to others. I confess that I find much postmodern scholarship impossible to read, and when I do unpack it, I often find old laundry—quite simple and familiar ideas that were common in early-seventies feminism. When ideas are reinvented in obscure language, their burden is lost to many, and they are rendered powerless. However, the full range of cultural criticism goes way beyond academic convolution, especially when an increasingly layered feminist theory is informed by the experiences of important scholars like bell hooks, Michele Wallace, Gloria Anzaludúa, and Trinh T. Minh-ha, all of whom are writers as well as theorists.

In the early eighties (not coincidentally the time I first traveled to China and Cuba) I fell in love with the word *propaganda*. Disavowing its institutional meaning (as in the Catholic Church or the U.S. government), I recalled its original sense of propagation, or spreading the word, which has

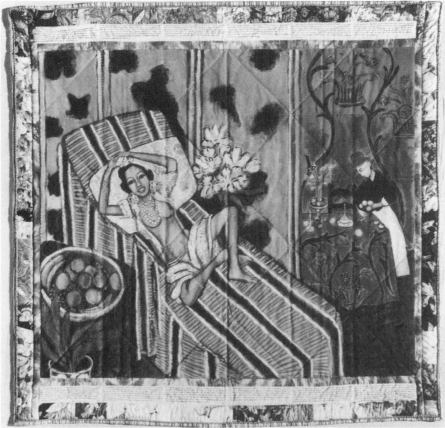

FAITH RINGGOLD
Jo Baker's Birthday, 1993
ACRYLIC ON CANVAS, TIE-DIED, PRINTED AND PIECED FABRICS, 72″ X 72″
Collection Saint Louis Art Museum, Minority Artists Purchase Fund and funds given in honor
of Cuesta Benberry.

In this exuberant odalisque, Ringgold takes off both Manet's Olympia and Matisse's
exotic North Africans; the artist is black, the maid hovering in the background is
white.

always been my goal. I wrote "Propaganda Fictions" (delivered as a diatribe,
or performance piece), curated a "propaganda" show at Franklin Furnace,
and wrote "Some Propaganda for Propaganda" (page 139). I was immensely
pleased when, in 1982, Hilton Kramer wrote in the conservative journal
The New Criterion:

> One of the saddest cases is that of the critic Lucy Lippard....There was
> every reason to believe that a writer of this quality would one day become
> one of our leading historians of the modern movement. Yet in the Seven-

ties Miss [sic] Lippard fell victim to the radical whirlwind....This, to be
sure, is an extreme case. The descent into straightout political propaganda
is not usually so crude.

I've never thought of myself as a historian (although I have a master's
degree in art history, which I got for purely practical reasons in 1962; it
enabled me to earn a whopping three dollars an hour instead of two dollars
as a freelance researcher). And I don't like the term *critic* because I don't
see myself as an adversary or teacher to artists, from whom I've learned
most of what I know. I still describe myself not as an art critic but as a
writer and activist, much to the annoyance of the universities where I
lecture. In the late sixties and the seventies I was interested in reinventing
criticism to reflect more closely the art it rode on; Conceptual art provided
a model for weird texts that resembled experimental fiction (which I was
also writing) and got me accused of being an artist, although I saw these
pieces merely as different—and feminist—ways of approaching art criti-
cism. (See "New York Times IV," page 192). In the eighties I saw my writing
as an organizing tool and myself as an advocate—someone who "works from
a communal base to identify and criticize the existing social structures as a
means to locate and evaluate the social and esthetic effect of the art," who
"tries to innovate the notion of 'quality' to include the unheard voices, the
unseen images of the unconsidered people" (as I wrote in "Headlines, Heart-
lines, Hardlines," D. Kahn and D. Neumaier, eds., *Cultures in Contention*
[Seattle: Real Comet Press, 1985]).

I spent most of the eighties doing cultural organizing around political
issues, especially within the frameworks of Heresies, PADD—Political Art
Documentation/Distribution (which I started as an international archive
of socially concerned art in 1979, after returning from England)—and
the nationwide Artists Call Against U.S. Intervention in Central America.
In the eighties I also did some personal/didactic performances with my
working partner, Jerry Kearns, got very involved in the possibilities of
demonstration art, perpetrated a few "Polly Tickle" comics, and did some
street theater in New York and in Boulder, Colorado, with Outside Agita-
tors, Pink Medicine Show, and Damage Control (the latter consisted of
"five women over forty" protesting the Gulf War). In the early nineties my
activist energies went into a national campaign to reevaluate Columbus's
"discovery" (with the Alliance for Cultural Democracy) and the Women's
Action Coalition (WAC), which commemorated Anita Hill's courage with
a new wave of pan-feminist activism that began in the art world.

The earth was and often still is seen as a woman's body. This has, on one
hand, provided a psychic history of female strength that remains, vestigially,
even in urban societies. It is also the source of much debate among feminists

on issues of female stereotyping, submissiveness, [social construction] and biological destiny. There is no question that the identification of woman with nature and man with culture has played a damaging role in the relegation of women to inferiority in male-dominated societies. Many theorists have pointed out that the essence of a culture can be found in the degree of its domination of, or independence from, nature. (New York: Pantheon Books, 1983)

Although the binary simplicity of "women are nature; men are culture" has been laid to rest (at least in feminist theory), the nature/culture opposition remains a highly visual social force and continues to fascinate me, especially as it is reflected in photography. The photographic image's role in representation and history was the subject of *Partial Recall: Photographs of Native North Americans* (New York: New Press, 1993) which I edited and wrote part of, along with a group of Native writers. As is clear from the last essay in this book, also written in 1993, I am still absorbed by the apparent differences between the way women and men look around them and affect what they see. Of course, social construction is paramount, but I still feel there may be more to it than unconditional worship of The Text would imply.

When I finished *Mixed Blessings* in 1989, I found my interest reviving in the nature and culture of culture and nature. A chapter of that book called "Landing" got me started, along with rural living, time spent in the West, and acquaintance with a growing number of Native people in whose arts of connection and pantheistic politics I found affinities.

For the last five years, most of my energies have gone into intercultural work on land, history, and place for a book I am writing called *The Lure of the Local*. Land rights, especially those of the Native American nations and Mexican Americans in the Southwest and displaced white "natives" of the northeast coast and midwestern farms, are central to this work. Environmental racism (aka environmental justice) is a crucial component. Since this is turf that has, so far, been covered by few artists, I'm invading the fields of environmental politics and cultural geography.

Displacement—voluntary and involuntary—may seem far from the center I began at. But like culturally/racially/sexually hybrid models of change, it is a feminist issue. For instance, I am still struck by the psychological displacement of women who are alienated by and in language. In my first book of essays, I constantly referred to "the critic, he," as though my own identity and actions had been subsumed by patriarchal nomenclature. Last week, when I heard a much respected elderly woman artist speak constantly of "the artist, he," it brought tears to my eyes. As I work on issues of land, history, culture, and place, the layers of women's lives and the crucial act of naming-as-possessing arise again and again, and I take for granted that I bring a feminist, cross-cultural, and interdisciplinary state of mind to these, as to any other subjects.

> As I type this, I have hanging over my desk two pictures of typewriters.
> In one the paper is replaced by a sheet of flames; in the other by a
> green-leafed plant. And as I write this I'm still trying to resolve all these
> contradictions…(1983)

Eleven years later the flames have subsided to some extent, but the leaves are still growing. I'm still trying to resolve the contradictions inherent in the trialectic. All of this activity represents for me the concentric circles, the broader ripples of feminism; none of it would have been possible without the understanding of the world that feminism has brought or the support of my women friends, whose diverse interests constantly inspire me to see new connections, to see how everything relates to everything else. In the sixties we used to say: "Sexism and racism—same game, different name." And although that is not strictly true, the fact remains that as I have spent more and more time since the early eighties on intercultural issues, my feminist training has been invaluable. Being a white middle-class woman is not the same as being a woman of color or a woman from a working-class background, but there are enough crossbeams to build some bridges. I regret not having made the last chapter of *Mixed Blessings* about the development of white consciousness—the source not only of racism but of identity among those who feel that only "others" have a "culture." Sometimes when I talk about white consciousness I get yelled at for paying too much attention to an already dominant culture, but at the same time I've been criticized for being white and writing *Mixed Blessings* at all. While all this interrogation can be painful, it is also illuminating, forcing me to scrutinize all choices of focus and personal motivation. It has often been helpful (and humbling) to compare my position in regard to artists of color with that of well-meaning men in regard to women's art.

If the Heresies Collective was the greatest influence on my work from 1975 to the early eighties, "Mixing It Up"—an annual two-day symposium on crossing cultures that I organized at the University of Colorado in Boulder for seven years—became the major influence from its inception in 1988. "Mixing It Up" allowed me to invite four women artists of color each year to discuss issues of identity, feminism, community, art, and politics. (In the last two years' symposia I included men; in 1993 the focus was on lesbian and gay issues, thanks to Colorado's infamous Amendment 2; in 1994 it was on mixed-blood issues, the hybrid state, which is surely the next major issue of multiculturalism.)

Spending time over the years with the twenty-nine participants/friends in "Mixing It Up," twenty-six of whom are women, was an education in itself. I'm still processing it. Some obvious but hitherto uninternalized "revelations" have emerged: The Other is simply Another (I don't agree with Craig Owens that this notion simply flattens everyone out); the feminist use of

white heterosexual woman as the generic woman and everyone else as some separate group (as in "women and women of color," or "women and lesbians") is racist and sexist; and white people have to give up the privilege of representing everyone "else." (Obviously I haven't gotten to that point yet, and I'm not sure that this means white people can no longer step over the fake borders at all; it's more about negotiation and respect—and learning to take no for an answer.)

YONG SOON MIN AND ALLAN DE SOUZA
Untitled, 1992
BLACK-AND-WHITE PHOTOGRAPH REPRODUCED IN VARIABLE FORMS INCLUDING
COLOR COVER FOR CONDOM PACKETS
Photo: Karen Bell.

Min (Korean American) and de Souza (Portuguese East Indian/British) collaborate on an ongoing series of phototext works about the politics of identity and sexuality. Min's work often superimposes the "heartland" or "homeland" on the female body and draws parallels between the division of Korea and social divisions in the lives of women and Asian Americans.

The vilest misogynist can't deny that a whole new crop of very diverse "bad girls" (a phrase that tends to appeal to seventies rebels but is less popular among the young) has emerged to warm the hearts of feminists of all stripes. Emerging artists are making some lively, aggressive, intelligent, and provocative art. But the work is not always developed, and sometimes it feels as though the wheel is being reinvented by those who don't know the feminist art history of "transgression." The bad girls' front line was held by Judy Chicago, Carolee Schneemann, Nancy Spero, and Anita Steckel, among others.

It's not just nostalgia that keeps calling me back to the pioneering feminist art of the seventies but the ever-more-obvious affinities with what's going on in the nineties. It seems politically and aesthetically crucial that the work

RONA PONDICK
Mouth, 1992–93
RUBBER TEETH, FLAX, PLASTIC. 600 PARTS, VARYING DIMENSIONS
Photo: Jennifer Kotter, courtesy Jose Freire Fine Art, New York.

These hairy pink-and-black "mouths" are oral and pubic, funny and scary, erotic and repellent, a postmodernist take on the vagina dentata.

done then not be forgotten now, and that its connections to the succeeding decades be clarified. Elizabeth Hess and I have proposed an exhibition—"The Changing Body Is Always the Same: How Feminist Art from the Seventies Is Reborn in the Nineties"—that has not yet been snapped up by major institutions, but it is a subject that is on more minds than our own.

The themes of body, gender, and sexuality that have driven and defined women's art since the late sixties incorporate (so to speak) all the other major feminist issues, including identity, autobiography, and the most compelling economic and political concerns: the feminization of poverty, equal wages, child and health care, rape and sexual harassment, reproductive rights, domestic violence, and hate crimes. Sometimes expressive of self, sometimes utterly remote from self, the concepts of body, pain, pleasure, and desire remain the vehicle of much major feminist art, as they were in the seventies (see "The Pains and Pleasures of Rebirth," page 99)—from Lynda Benglis's *Artforum* ads and Hannah Wilke's willful narcissism to the Cyberpunkettes and the Riot Grrrls.

Feminists were well aware from the start that "a woman artist's approach to herself is necessarily complicated by social stereotypes" (see "Sweeping Exchanges," page 171). The early media-critical and body-exploratory art was based on primary revelations; even the simple things hadn't been said yet. In the seventies, Judy Chicago said: "What has prevented women from being really great artists is the fact that we have been unable to transform our circumstances into our subject matter...to use them to reveal the whole nature of the human condition." I added to that: "If our only contribution is to be the incorporation on a broader scale of women's traditions of crafts, autobiography, narrative, overall collage or any other technical or stylistic innovation—then we shall have failed."

It's still too early to tell, because, somewhat to my surprise, young women artists are still mining these rich veins in fresh ways. There is a new surge of body-related identity/sexuality imagery that is reminiscent of the mid-seventies. Hess and I have formed cross-generational clusters of works that share theme, concern, or style. The visual parallels between work from the seventies and work from the nineties is telling. Ida Applebroog's deadpan commentaries on the dysfunctional family precede Sue Williams's darkly humorous canvases on domestic violence. Nancy Spero's delicate, scattered forms, which belie their harsh content, can be seen in Nicole Eisenman's scatological watercolors and the work of a number of other young artists. Jana Sterbak's meat dresses echo Mimi Smith's steel-wool peignoir (and former model and feminist activist Ann Simonton's political protests). Louise Bourgeois's alarming comments on sexuality and nature reappear not only in her own art but in Rona Pondick's Freudian bedroom nightmares and in Kiki Smith's

hanging/crawling women. Twenty-four years after her death, the influence of Eva Hesse is rampant in younger women's sculpture, a point made abundantly clear in the 1994 exhibition "In the Lineage of Eva Hesse," at the Larry Aldrich Museum. Harmony Hammond's use of hair and fabric, ethnological references, and hanging or wrapped abstract "bodies" (as opposed to "figures"), like Hesse's embodiment of materials, is ubiquitous among such artists as Petah Coyne, Ava Gerber, Lisa Hoke, and Marcia Lyons. And we could go on and on with different lists.

Stuart Hall has made the point that cultural identity is as much a matter of "becoming" as "being." The word *transformation* was common in seventies feminist writing, implying the power to change self and society; but it is used less often today, perhaps because it has been co-opted by the "New Age." In a 1975 essay on role-playing and transformation (page 89), I wrote about those earlier works that have since invisibly informed the gender-unspecific work of the early nineties and deserve to be resurrected along with the then-popular reference to Marcel Duchamp's revisions of the identities of self and objects.

For instance, Adrian Piper's, Eleanor Antin's, and Martha Wilson's early works with "drag" and gender and racial identity and stereotypes are the precursors of much current photographic work. The use of clothing as mask

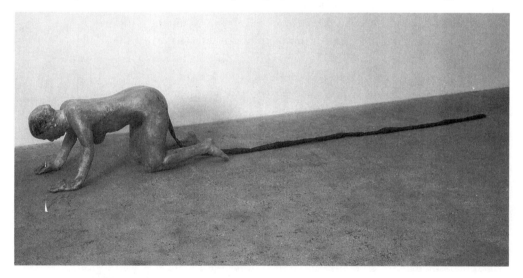

KIKI SMITH
Tale, 1992
WAX, PAPIER-MÂCHÉ, LIFE-SIZE
Private collection, New York. Photo: courtesy Pace Gallery, New York.

In this alarming work, a woman crawling like an animal trails her "tale" behind her, a narrative umbilical cord that evokes pain and humiliation, but also natural connections such as birth and possibility.

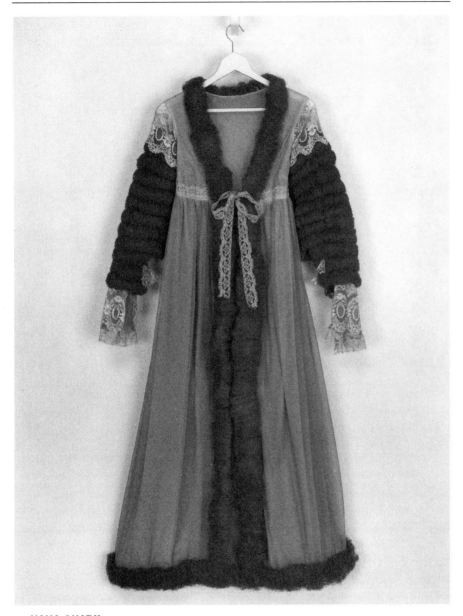

MIMI SMITH
Steel Wool Peignoir, 1966
STEEL WOOL, NYLON, LACE, 59″ × 26″ × 8″
Photo: Oren Slor.

This protofeminist sculpture is a witty commentary on women's work on a double level—sexual and domestic. Smith predicted the feminist artist's fascination with clothing as an extension of the body and the life—a device that flourished throughout the seventies, was revived in the late eighties, and is still going strong.

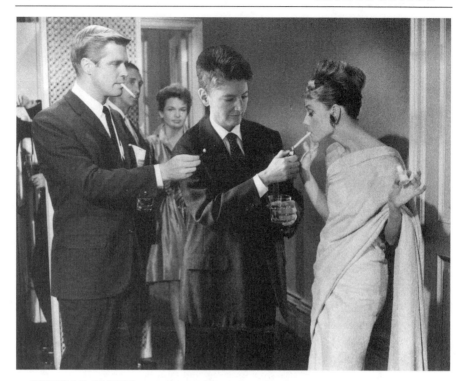

DEBORAH BRIGHT
UNTITLED STILL FROM *Dream Girls* series, 1990
PHOTOMONTAGE

The movie still is from *Breakfast at Tiffany's,* and the artist has suavely interceded to light
Audrey Hepburn's cigarette.

or as weapon was common in the seventies as a means of exploring guise and
disguise within imposed gender identities. That strategy was continued into
the eighties by photographers Cindy Sherman and Lorna Simpson, among
others. Carrie Mae Weems's witty gridded overview of an African American
woman in stereotypical personae mocked social assumptions. An example in
the nineties would be Deborah Bright's *Dream Girls,* a hilarious series on
lesbian sexuality in which she montages her own image into classic movie
stills; lighting Audrey Hepburn's cigarette or insinuating herself between
Katharine Hepburn and her leading man, the dyke always gets the girl.

There was a point in the mid-eighties where everyone seemed to agree
that feminist art was the hottest, most radical, "cutting edge" (I hate that
term) item around. This enthusiasm was provoked by postmodern interest
in gender, and it happened at a time when in fact the most politically effec-
tive and lively work was coming from gay activist groups like ACT UP and
Gran Fury that had overwhelmingly urgent political causes (AIDS and

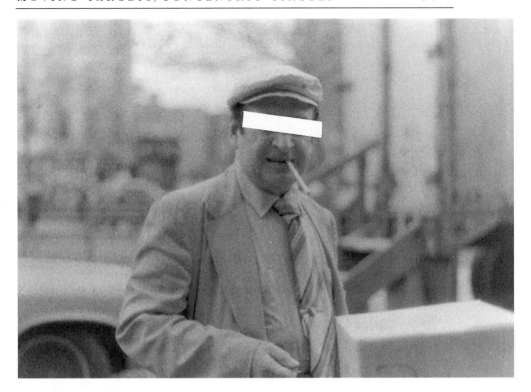

LAURIE ANDERSON
Object, Objection, Objectivity, JULY 1972
PHOTOGRAPH WITH ACCOMPANYING TEXT: "When I passed this man, he was
unloading a cardboard box into the trunk of his Chevrolet. 'Hey Cutie,' he said. When I asked
to take his picture, he began to question me: Who was I? What did I think I was doing? Was I
a cop? etc. While he was talking, an unlit cigarette, stuck to his lower lip, kept bobbing up
and down."

homophobia) to fuel their aesthetic statements. In addition to (often feeble)
efforts toward cultural diversity, the coming out of a powerful and often
activist in-your-face queer theory in the mid-eighties repositioned feminist
art, opening up new spaces to operate in, expanding the middleground, and
perhaps diminishing the polarization between genders. At the same time,
lesbians have had to reestablish their particular place within the queer art
community and within the feminist art community, as they did in the seven-
ties. All this good news is countered by suggestions that feminist and queer
art are only given art-world space when the art market is in lousy shape.

It seems to me that the overlapping experiences of feminists, queer activists,
and artists of color have come closer in the last decade. The politics of identity
that has concerned so many artists and scholars holds the possibility of still
firmer alliances, even as it shakes the ground on which previous alliances were

built by asking more difficult questions. As Trinh T. Minh-ha has pointed out, "Subjectivity does not merely consist of talking about oneself."

In the sixties and early seventies, New York feminists tended to be messy, antiformalist, and justifiably "self"-centered. The Los Angeles feminists were formally neater and cleaner, also autobiographically inclined, and much more communally oriented. Those scattered geographically between the coasts took what suited them from these two major models and often made something entirely new of it. Both groups were considered outrageous in their focus on taboos such as rape, menstruation, abortion, motherhood, and domesticity. In the meantime, other women artists were more subtly rearranging the Minimalist mainstream to fit female experience. The obstacles to the representation of a female subject were just being defined. "It is no accident," I wrote in the early seventies, "that so much of the dialogue about whether there is and what is a female imagery has centered upon sexual concepts. If women have been more obsessed by sexuality than men, it is because we have been raised and conditioned to think of ourselves and our futures in sexual terms." (See "Fragments," page 66).

The prime taboo in the early seventies was lived female experience and "feminine" materials used in unexpectedly perverse ways and contexts; by the end of the decade, the pattern-and-decoration artists had brought some of these elements into the mainstream, and the taboo by then was that chimera called political art. In many ways, the early feminist art issues were very similar to those of the nineties, although the vocabulary was more straightforward and the underlying theory less complex. Issues of representation in advertising, film, and fiction, for instance, were perceived and analyzed from a base in social anger and sudden recognition (*Ms. Magazine*'s famous "*click!*") that engendered another decade (the eighties) of media-based feminist art that became more and more intricate, following Martha Rosler's lead.

In the early days of what was then unashamedly called feminist art, the task was to separate the women from the men so we could see who the hell *we* were. By the end of the decade, we had at least some idea. Identity politics was reintroduced during the eighties and has become marvelously confused in the nineties, with much crossing of cultures and coutures. Judith Butler has called this "gender insurbordination," and remarks that "'all gender is drag,' where men and women impersonate an ideal that no one inhabits." The gender bending and blending of the last few years has added another level to the ongoing battle against stereotypes, a battle that can be seen as a crisis not so much of identity as of reciprocity—difference seen from many sides. It couldn't have happened without the exuberant, extremist, gutsy, layered first stage of feminist art, which was also didactic in the best sense: a lot of the lessons sank in.

The mirror has always been a standard prop in feminist art, from the early "Who am I? How can I recreate myself?" days (epitomized by Rachel Youdelman's and Nancy Angelo's eternally repeated make-up piece based on a Colette story, at Womanhouse in 1971) to works informed by Lacan's influential theory of the "mirror stage," which lends itself to emblems of female independence from the way women are seen by society, while also touching on conflicts between presence and absence. For instance, Lorraine O'Grady has reconsidered Manet in "Olympia's Maid," citing the absence and/or only tentative presence of the African American female nude in art. And in this era of shifting identities and unauthorized autobiographies, lesbian feminists often outdo their straight sisters in asserting their right to be whatever they decide to be, looking for the multiple truths beneath the illusion of Truth—some of which is deemed downright politically incorrect.

Despite its deliberate denial of biological and social dualisms and its insistence on overlapping identities, much recent feminist art deals with the same kind of formal contradictions (male/female, outside/inside, hard/soft, solid/vulnerable, armored/wounded, repulsive/attractive) consistently found in the work of the seventies. Among the significant, if often hermetic, body themes in women's art all along have been abuse, incest, and rape (with eating disorders and breast cancer just beginning to be confronted). I suspect such subjects are reflected in the fact that furniture and empty clothing are so often surrogates for the female body in contemporary women's work. The objects are often padded or garbed in sleek fabrics, but they display uneasiness, discomfort, even menace.

Although the words *sexuality* and *desire* are on everyone's lips, I don't hear much talk about erotic art anymore, despite the fact that younger artists are sexually overt, past the shock (and schlock) points of the seventies. The erotic seems to have been absorbed by the more neutral concept of gender and the less neutral concept of sex, even when eroticism remains the focus. If externally this situation has fueled reactionary indignation and censorship, internally it has also taken the prurient edge off the art world's attention to sexuality. In a forthcoming article provocatively titled "A Space of Infinite and Pleasurable Possibilities," the pioneering lesbian feminist artist Harmony Hammond has remarked on the "desexualization" of lesbian feminism in the seventies and early eighties, which was followed in the late eighties and early nineties by a more explicit exploration of lesbian fantasy and desire "which reasserts sexuality as central to lesbian identity." She quotes Monique Wittig: "It is not as 'women' that lesbians are oppressed, but rather in that they are 'not women.'"

Some recent work appropriates the male position, or "male gaze," and hands it over to the female viewer, forcing us to come to terms with mixed

fear and desire from both homosexual and heterosexual viewpoints. (Compare, for instance, Mel Ramos's and Lutz Bacher's calendar girls.) In the late seventies and early eighties, I and a lot of other feminists had a sharply ambivalent political relationship to punk art/new wave (Cindy Sherman's early work, for example). Ambiguity was the key word of the day. The punk-rock group Devo announced: "The position of any artist is, in pop entertainment, really self-contempt. Hate what you like, like what you hate." Even as I loved punk's energy, I often hated its forms and was wary of its content, which flaunted ambiguity and irony, inverting feminist pieties and presaging the irreverent nineties and some of the controversy over misogyny and politics in rap music. "We're offended or titillated or outraged," I wrote in 1979:

> Now we have to figure out whether it's satire, protest, or bigotry....
> When a woman artist satirizes pornography but uses the same grim
> images, is it still pornography? Is the split beaver just as prurient in a satir-
> ical context as it is in its original guise? What about an Aunt Jemima
> image, or a white artist imitating a Black's violent slurs against honkies?

Rhetorically puritanical, maybe, but I think I was onto something when I wondered about artists "shrewdly wallowing in 'politically incorrect' images while claiming to be 'politically correct' in some subtle (read *incomprehensible*) way." A case in point that I both admired and abhorred was Diane Torr's five-minute piece in Co-Lab's 1980 "Times Square Show": two feminists with dildos performed brutalities on a life-sized inflated female doll (a sex toy sold in the area), yelling things like, "She likes it. She loves it, don't you, dearie," and, over and over, "Does this turn you on?" Finally a man yelled, "No, it's disgusting!" And a woman replied, "You got it, baby," and the point of the performance was made. How would this be taken now? How does it relate to the new feminist appropriations?

In 1979 I publicly refused to go see an exhibition called "Talking Legs" because the announcement displayed a pair of high-heel-booted, garter-belted female legs, cut just above the crotch and standing over a toilet seat. Nowadays I'd probably go to the show, and I might see some tough new feminist art. "Retrochic," as we called it then, is still with us, however, and still feeds right-wing fury and plays *agent provocateur* to the working people with whom some artists claim to identify. At the same time, such belligerent rejection of anything "correct" is a potent ingredient of much radical art when the underlying politics is understood rather than ignored. These contradictions have yet to be resolved and have been exacerbated by the ongoing political battles over art during the eighties.

In the seventies self-conscious distance was considered in some quarters to be male-identified; by the eighties, seventies women's art had begun to

seem too earnest to a younger, cooler, and sometimes more cynical genera-
tion, and was condemned somewhat unfairly as biologistic, reductionist,
simplistic, or essentialist by those unfamiliar with its origins and diversity.
But with the acknowledgment of instability that has become the norm, the
boundaries are successfully being blurred again, and such false dichotomies
are being contested. At this point it seems far more productive to acknowl-
edge the common ground and common goals, given the affinities between
some feminist work of the seventies and nineties.

Younger women sometimes thank us older feminists "for all we have
done," implying that we *did it,* that they are grateful for not having to carry
on the work. Nothing could be further from the truth. Backlash and back-
sliding, ever new (mis)interpretations of feminism make it painfully obvious
that a woman's work is never done. bell hooks always writes about "femi-
nist movement"; by omitting *the,* she endows our political noun with the
forward momentum of a verb. The renewed struggle for reproductive
rights—a battle we once considered won—provides the obvious lesson.
And feminist art wasn't a movement—or rather it was a movement, and
still is, but not an art movement, with the implied aesthetic breakthroughs
and exhaustion. As Hesse has pointed out, conservative critics argue that
nothing happened during the 1970s, by which they mean nothing happened
except feminist art, which has yet to receive full art-historical recognition.
One reason for this is that the feminist art "movement" was not based on
style but on content. Another reason is that it is still going on. That same
content, put on simmer in the eighties, has now resurfaced in the work of
younger and emerging artists, with a vengeance.

The search goes on for a theoretical framework in which to set the
"female imagery" that exploded in the seventies. Younger feminist artists
continue to think, debate, image, and imagine what "woman" is, what she
wants, what her experience is, and how that experience varies across class,
culture, age; how it forms, is formed by, and can change society itself.
Much of their "backtalk" is about affirmation, about talking back to the
culture that tries to define women as the "other."

I've always claimed that the collage aesthetic—also the core image of
postmodernity—is particularly feminist. Collage is about gluing and unglu-
ing. It is an aesthetic that willfully takes apart what is or is supposed to be
and rearranges it in ways that suggest what it could be. The much-touted
dismantling of modernism might be said to have begun with the birth of
feminist art around 1970. "Feminism's greatest contribution to the future
of art has probably been precisely its lack of contribution to modernism," I
announced rather sententiously in 1980. "The goal of feminism is *to change
the character of art.*" I would still like to think that is where we are headed,

LORRAINE O'GRADY
Gaze I: Senga Nengudi
PHOTOGRAPH FROM *The Gaze Quadriptych,* 1991

This series consists of four double portraits, two women, two men, their expressions
responding to cues from the artist. The gaze of the title is not an objectifying gaze
but a direct look that reveals and connects the subject's inner and outer self-image.

because the need for change has been nothing but exacerbated in the
interim. Such pronouncements reflect my own lack of interest in a strictly
delimited modernism (or postmodernism, for that matter) and a dislike of
"movementism"—the way feminist art was, by 1980, being made into yet
another trend—a waning one, of course. (The question of "survivors" of all
art movements is also complicated by gender.) But throughout the seven-
ties, the way away from modernism was being paved by feminist mistrust of
modernism's misogynist and authoritarian history and its alienation from

audience. The destruction of derogatory myths was one of the tasks of the seventies; in the early eighties some of these myths crept back into fashion, inspiring a whole new array of conciliatory and media-friendly feminisms and, on the other side, a whole new array of angry feminist art emphasizing process over product and offering altered and contested views of female identity. For many women artists, the truly transgressive point was to subvert modernism by inserting feminist content. Without waiting for permission, these artists simply walked in and took what they wanted from previously male dominions, refusing to be defined as outsiders for doing so.

In the seventies, I wrote hopefully about a "trialectic" in which women artists would simultaneously address the feminist world, the art world, and the "real world." However, I was wrong in 1980 about the vernacular direction feminist art might take. Some fifteen years ago I hoped that the historically male modernist rejection of audience and communication would be reversed by feminist artists. A number of the most important artists were working collectively or collaboratively or in communities. This impulse retracted quite drastically during the eighties with the resounding commercial triumph of Neo-expressionism, but among those who have kept that impulse alive through the eighties into the present are Judy Baca, Mierle Laderman Ukeles, Jerri Allyn, at times Jenny Holzer and Barbara Kruger, and particularly Suzanne Lacy, with her brilliant forays into the public psyche. In the nineties an outer-directed vernacular art seems to be reemerging as an option. As feminist artists try to find new and more relevant ways of working in social contexts, however, they also seem more distanced from their subject matter than their seventies counterparts were. Some might say this represents progress, replacing the overheated political and spiritual passions that often fueled earlier women's art; women have always been accused of taking everything too personally. The current engagement with the dialectic between acceptable surfaces and unacceptable content further destabilizes the female subject. At least we're rocking our own boat.

So what is a radical feminist artist today? Is it Louise Bourgeois, with her disturbing, outrageous sexual/infantile forms? Is it Judy Chicago, with her wholly female approach to universal issues? Is it Adrian Piper, with her acid commentaries on color lines? Or May Stevens, with her combinations of mystery and politics, ordinary and extraordinary? Is it Jenny Holzer, who has mastered technology to raise outspoken, often embarrassing concerns in popular narrative form? Is it Harmony Hammond, who has angrily but subtly introduced lesbian sexual identity into abstraction? Is it Mary Beth Edelson, who fuses primeval and activist imagery? Or is it Joyce Kozloff and Miriam Schapiro, who have reclaimed traditional decorative modes? Is it Joan Snyder and her unabated passion for paint and visceral experience? Or

Barbara Kruger, whose postmodern co-optation of dominant advertising techniques is used to ask blunt feminist questions of society as a whole? Is it Suzanne Lacy, who creates visually beautiful participatory frameworks in which women gather to name themselves and strategies for change? Is it Sue Williams or Nicole Eisenman, with their fearless appropriation of pornographic and scatological image-language?

The answer, of course, must be given in the spirit of classic feminist inclusion and generosity: all of the above, and more. The concentric circles might represent open arms, a wider and wider embrace. Mobility within representation, especially when it is controlled from within, is a subtle form of resistance. Art, especially avant-garde art, is expected to be unexpected. All radical feminist artists are moving targets.

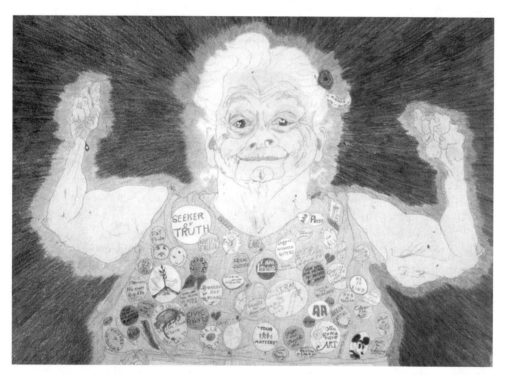

ELIZABETH LAYTON
Buttons, 1982
COLORED PENCIL ON PAPER, 22″ × 30″
Photo: courtesy Don Lambert.

Layton, who began making art as therapy in her seventies in a small Kansas town, humbly called herself "Grandma Layton." But she was one of the most outspoken and powerful political artists in the United States during the decade in which she produced her unflinching self-portraits of ageing in a society that doesn't like to think about it.

PART I: FROM THE CENTER
1970–1975

Changing Since *Changing*

It's strange to stop and go back when I feel I've only started. While the essays in this book represent five years' work—the greater part of my energies since *Changing* was published in 1971[1]—they are in fact only the early stages of an ongoing process, a small percentage of what I hope to write about women's art. Looking back, I get impatient with the slow and laborious development of my feminism and its application to aesthetics and politics. What was I doing all that time? (Well, I was being mother, lover, homemaker, part-time political activist, writing fiction, and earning a living.) The first two years of the movement wailed by in a haze of polemic, picketing, paperwork, and exhilaration. Now, instead of hashing over the past, I wish I could leap into the future and bring back the essays that come next—those on the twenty-odd artists who have particularly interested me, and those on ideas, and those on artists whose work I haven't even seen yet. It's all very frustrating. Similarly, the five-year attempt, represented by these essays, to generalize about a feminist art would be much easier to communicate if I could reproduce the three hundred and fifty slides I show when I'm lecturing—or, for that matter, if I could reproduce the whole New York Women's Art Registry, or all the WEB (West-East Bag) registries, or slides of what every woman everywhere is doing—because it is exposure to such an immense variety of art by women that has formed the ideas in this book. Without the visual experience, the more specific one gets, the more absurd the generalizations sound.

The women's movement changed my life in many ways, not the least being my approach to criticism. It may not show too clearly from outside; I'm still working on that. But from inside, from where I live, there is a new

Reprinted from *From the Center* (New York: E. P. Dutton, 1976).

freedom to say how I feel, and to respond to all art on a far more personal level. I'm more willing to be confessional, vulnerable, autobiographical, even embarrassing, if that seems called for. I just reread *Changing,* looking for contradictions, however, and found fewer than I expected. In 1966 and 1967 I was proselytizing for a public art, a broader art audience, looking for sexual content, declaring that it was "time that the word *intuitive* regained its dignity and rejoined the word *conceptual* as a necessary aesthetic ingredient." I got in a word against Salvador Dalí's rip-off of Meret Oppenheim, and the first three artists discussed in one essay were women. On the other hand, the monographs were all on men.[2] I knew women artists whose work I respected immensely, but somehow I hadn't gotten around to writing about them yet. (I was still working on a piece on Eva Hesse when she died, and the fact that I have since written a book on her, a book that was a great influence on my own development, doesn't make me feel much better about that.) All through *Changing,* I say "the artist, *he,*" "the reader and viewer, *he,*" and worse still—a real case of confused identity— "the critic, *he.*"

Throughout *Changing,* I can also see that I was drawing back from certain taboos, among them "sentiment," "emotionalism," "permissive lyricism," and "literary generalization"—all of which I am now frequently guilty of. I disapproved of Oscar Wilde's description of criticism as "the highest form of autobiography," and preferred it to be not "self-expression, but autodidacticism." The major point of disagreement with my then self was my denial of the need for integrating art with "other experience," for personal interpretation. "Is there any reason," I demanded, "why the rarefied atmosphere of aesthetic pleasure should be obscured by everyday emotional and associative obsessions, by definite pasts, presents, and futures, by 'human' experience? Overt human content and the need for overt human content in the visual arts in this century is rapidly diminishing....Thus the issue of introducing 'other experience' into art is, in the context of rejective [Minimal] styles, and for better or worse, irrelevant."[3] Reading this over, I shudder at its narrowness, taking consolation only in the fact that I ignored this rule in other essays, since I never could resist puns, associative and psychological readings, and sneaked them in when I could.

I recognize now the seeds of feminism in my revolt against Clement Greenberg's patronization of artists, against the notion that if you don't like so-and-so's work for the "right" reasons, you can't like it at all, as well as against the "masterpiece" syndrome, the "three great artists" syndrome, and so forth. I was opposed to all these male authority figures not because they were male, however, but because they were authorities. I considered myself one of the boys—the Bowery Boys[4] rather than the Green Mountain Boys.

While this choice of an opposing position came from aesthetic and social identification, it was not finally so different from its opposite. The same pie was being consumed by all. Eventually I came to realize this only through the combined influences of Ad Reinhardt's witty ambivalence toward the art world, of a group of artists in Rosario, Argentina, who felt they could not merely make art in a world so miserable and corrupt, and of the Art Workers' Coalition "alternatives," "action," and "decentralization" committees. One of the first feminist artists' groups—WAR—came out of the Coalition, too, but I resisted them for over a year. I was decidedly not accustomed to identifying with female underdogs—with oppressed people and unknown artists, yes, but *women*—that was too close for comfort. "I made it as a person, not as a woman," I kept saying. Androgyny was only attractive because it was too hard to be a woman.

It is no accident that I finally accepted feminism during a period spent alone with my five-year-old son in a fishing village in a foreign country, good and far away from the art world. I had retreated to write fiction—something I had been doing in fits and starts all my life and have always intended to make my "real" career. First, I realized that the book I planned to write didn't come from me but from the artists I lived with and wrote about. They were, of course, mostly men. And second, I realized that I was ashamed of being a woman. Trite as this may sound in retrospect, it came as an earthshaking revelation. (I was ashamed of being ashamed.) It changed entirely what I wanted to do. I began to write for myself rather than for some imaginary male audience and, by extension, I began to write for women. When I got back to New York, Brenda Miller and Poppy Johnson suggested I join them, with Faith Ringgold, and protest the Whitney Museum's lousy coverage of women artists in their Annual exhibitions. As the process of consciousness continued, I realized with relief that I no longer had to walk a tightrope and pretend to be what I wasn't. Working with women I could be—for better *and* worse—what I was. Looking back, I find it ironic that it took fiction to make me recognize fact.

Five years after the birth of my feminist consciousness, I still have to question every assumption, every reaction I have, in order to examine them for signs of preconditioning. Some changes came across fast. In the winter of 1970, I went to a great many women's studios and my preconceptions were jolted daily. I thought serious artists had to have big, professional-looking spaces. I found women in corners of men's studios, in bedrooms and children's rooms, even in kitchens, working away. I thought important American art was large. I found women working small, both out of inclination and necessity. I thought important art had to show a formal "advance" over the art preceding

it. I found that I could be moved more by content than by context. I was accustomed to male artists coming on with a veneer of self-confidence, jargon, articulation of formal problems—in other words, "knowing what they were doing." I found some women were confused, unsure of themselves, much more vulnerable, but at the same time far more willing to open themselves and their work to personal and associative readings on the part of the viewer, willing to participate in the sharing of their art, their experience, their lives. It is no coincidence that the advent of a behaviorist, autobiographical art coincided with the rise of the women's movement.

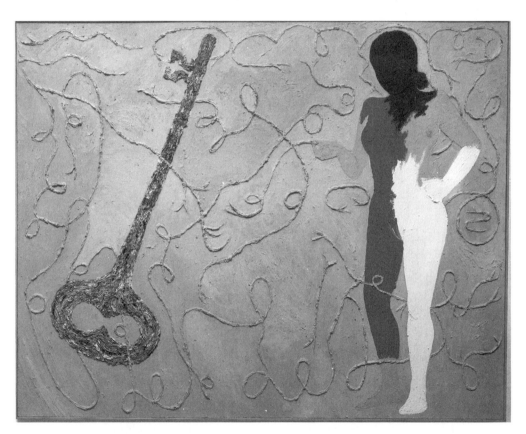

KAY MILLER
Gateway, 1988
OIL ON CANVAS, 78″ × 90″
Collection Harry Mellconian.

Miller considers this painting "a generational gift to young women artists." The curvilinear background represents nature and eternal change, derived from an ancient Taoist charm. The confident multicolored woman, embodying a full interracial spectrum, reaches for the sequinned key to change, for new openings to a global feminist spiritual politics.

One thing I find about my more recent criticism is that along with a denial of historical determinism comes a resistance to relating art by women to that of the men still dominating the art world. If I write about Mary Miss, for instance, I don't compare her achievements in time to those of Bill Bollinger or Alan Saret, not only because I don't think they are trying to do the same things, but also because her innovative early work never entered the general consciousness; making a belated case for unseen innovations, hidden developments, tends to sound rather pathetic. My reluctance to compare can be attributed to several other things: one, my preference for a dialogue with the work itself, in the *present;* two, my desire to help forge a separate feminist aesthetic consciousness; three, the "inauthenticity" of some of my favorite women's art when compared to the male mainstream, and conversely the "inauthenticity" of the male mainstream when compared to some of my favorite women artists' work (these streams diverge, or run parallel, or perhaps they are oil and water); and thus a protective impulse, a resistance to bringing this art in all its newborn sensitivity into a history that has rejected its sources. Much women's art, forged in isolation, is deprived not only of a historical context, but also of that dialogue with other recent art that makes it possible to categorize or discuss in regard to public interrelationships, aesthetic or professional. It is not that the women weren't aware all that time of the art-world art, so much as those men were not aware of *their* art. The notoriously late starts of many women artists, late aesthetic developments, and belated success or even attention—these can be attributed to that isolation as well as to more mundane domestic factors and public discrimination. For instance, when *Artforum* began a couple of years ago to do a series of short articles on "younger artists" (they called them "featurettes"), many of these turned out to be women well into their thirties. Similarly, when I did my first women's show, I selected only artists who had never had a show in New York. Several of them were in their thirties and forties. I could never have arrived at such a strong show of men on that basis; by that point of maturity in this day and age, they would nearly all have been shown already. Due to this long-term bottleneck, more good work by women than by men is appearing today. I have been accused of discrimination against men, but it really boils down to good old "quality," which is nothing *but* my personal preference. And this situation makes me feel good, although the reasons behind it don't; I can't help wondering how many women artists have fallen by the wayside.

Feminism, or at least the self-consciousness of femaleness, has opened the way for a new context within which to think about art by women. So far, such thinking (and feminist criticism itself) is only tentative. Within the old,

"progressive," or "evolutionary" contexts, much women's art is "not innova-
tive," or "retrograde" (or so I have been told repeatedly by men since I
started writing about women; apparently I no longer qualify for the "avant-
garde"). Some women artists are consciously reacting against avant-gardism
and retrenching in aesthetic areas neglected or ignored in the past; others
are unaffected by such rebellious motivations but continue to work in
personal modes that outwardly resemble varied art styles of the recent past.
One of the major questions facing feminist criticism has to be whether styl-
istic innovation is indeed the only innovation, or whether other aspects of
originality have yet to be investigated: "Maybe the existing forms of art for
the ideas men have had are inadequate for the ideas women have."[5] Susana
Torre suggests that perhaps women, unable to identify with historical styles,
are really more interested in *art itself,* in self-expression and its collective
history and communication, differing from the traditional notion of the
avant-garde by opposing not styles and forms, but ideologies.[6]

To run counter to the so-called mainstreams is one way of developing a
feminist context, although therein lies the danger of being controlled by
what one opposes. Also, the perception of art-world viewers, trained to see
within the other context, may not be able to distinguish the genuine
attempts to forge a new mode or a new image for new, and thereby unrec-
ognizable, content. Old habits die hard. Some feminist artists have chosen a
fundamentally sexual or erotic imagery that is inescapably seen "through the
object's eye" (to use the title of a painting by Joan Semmel). Others have
opted for a realist or conceptual celebration of female experience in which
birth, motherhood, rape, maintenance, household imagery, windows,
menstruation, autobiography, family background, and portraits of friends
figure prominently. Others feel the only feminist art is that with a "right-on"
political poster-like content. Others are involved in materials and colors
formerly denigrated as "feminine," or in a more symbolic or abstract parallel
to their experiences; for example, images of veiling, confinement, enclo-
sure, pressures, barriers, constrictions, as well as of growth, unwinding,
unfolding, and sensuous surfaces, are common. Others are dealing with
organic "life" images and others are starting with the self as subject, moving
from the inside outward. All of this work, at its best, exchanges stylistic
derivation for a convincing insight into a potential female culture. Every
artist trying to extricate her personal expressions and a universal feminism
from the styles and prejudices of a male culture is undertaking a risky and
courageous enterprise.

But feminist art does not consist simply of imagery or of "pictures,"
although these must inevitably be a vehicle for its affect. Judith Stein has
pointed out that "perhaps the only things a truly feminist artist would

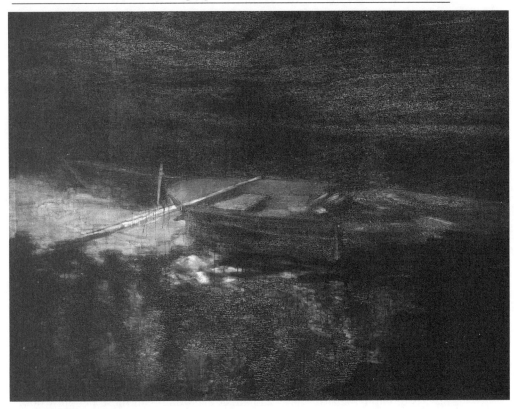

MAY STEVENS
Missing Persons, 1993
ACRYLIC ON UNSTRETCHED CANVAS, 83″ × 108″
Photo: David Heinlein.

A boat adrift in a silver-and-gold sea of words, this painting relates to Stevens's well-
known "Ordinary/Extraordinary" series about the lives of her mother (associated
with the Fore River in Quincy, Massachusetts) and Rosa Luxemburg (associated with
the Berlin Canal where her body was found). But it also has a mythical quality and
functions as a profoundly touching memorial to the missing persons in and beyond
the artist's life.

concern herself with are the feminist movement and building a feminist art
system inside a feminist society."[7] Until that society is clarified, feminist
art must struggle to define itself within the art system as it stands—a capi-
talist system already appropriated by, and probably more appropriate to,
male art. The formal anti-content tradition that has been prevalent in the
last fifteen years of aesthetics and criticism of abstract art militates against
comprehension of a feminist art with different values. For as Shulamith
Firestone has pointed out: "In those cases where individual women have
participated in male culture they have had to do so in male terms. And it

shows....It is not just a question of being as competent, it is also a question of being *authentic*."[8]

The earliest feminist artists (I'm thinking particularly of Judy Chicago in 1970 and 1971) found that no matter how much they talked about their intentions, public perception was unable to grasp the meaning of the work as they had intended it. Because Chicago's form language had painfully evolved out of years in the male culture, it was still superficially recognizable within that culture and could be read back into it even by relatively sympathetic viewers. Only when her imagery grew increasingly sexual and overt, and only when this process coincided with a higher level of consciousness in the general art world as well as in her primary audience— the Los Angeles women's community—did it begin to make sense as feminist art.

Psychological interpretations of art have not been popular since the late 1950s, and an artist insisting on content, when faced by an audience trained not to peer past the surface or to look behind the object, will complain that "no one understands what I'm doing," just as the artist who persists in a neutral, intellectual, or formal reading will be distressed by an "ignorant" audience that approaches art from its own life experience and associations. An exclusively female audience might alter this perceptual distortion or prejudice to some extent, but sooner or later the goal of feminist art, bolstered by the confidence and understanding received in a female community, is to enter the real world and affect everyone—all those people whom contemporary art has failed to reach or to move. The question of authenticity is one of the greatest barriers to the comprehensibility of a feminist art, and it is one that feminist criticism must confront so that the larger public may also deal with it.

Clearly everyone looks forward to the time when the distinctions between male and female are minimized and equalized. This will not happen until we understand the elements and conditions that underlie the experience of each sex. A lot of women artists have joined together, successfully, to bring more women into the system as it now stands. But if the art itself, whatever its "quality," is indistinguishable from the art made by men that is already in the galleries, nothing will change. Arguments against distinction between men's and women's expressions inevitably contain elements of fear or competition, or maintain an isolationist insistence on the distinction of every artist's work from that of every other artist's. (Nobody's art is an immaculate conception, but in aesthetics parthenogenesis is possible; women can now begin to work from the embryonic history of other women's art.) The most valid objection to the notion of a "woman's art" is the basic fear that an individual's art will not be seen with a free eye, or

seen with equal concentration, or seen as one intended it, or seen at all, if preconceptions and categorizations overwhelm it. But it would be naive not to realize the extent to which this is already true in today's art world. I wince when I hear all the lovely variety of women's art lumped together as a single entity. Nor do I think all art by women or all feminist art is good art. At the moment that's not even the point, because I'm questioning what good art is anyway. While I hope that the mere presence of more women in the art establishment is changing its values slightly, simply because women are different from men, I worry that we will be absorbed and misled before we can fully develop a solid value structure of our own.

The gap between object and intelligent perception of the object is, of course, one of the prevailing problems of making art at any time in an alienated society. It is a time and space gap filled only when the work is finally shown, discussed, written about, deciphered by an audience—in short, when the moment of communication is at hand. But the feminist gap is a more fundamental one. It cannot be closed by mere absorption into the current system. In the bad old days, women artists often worked in isolation, worked from and for themselves, and were, paradoxically, freer from the pressures and influences felt within the art world. For, once there, the temptation is to work for the art audience. That temptation may prove a more effective barrier to the evolution of a feminist art than discrimination is. I should know. I am still entrenched in this same art world I so often protest. In fact, feminism is my sole remaining excuse for being there. There are so few of us writing primarily on women's art, and so few feminists in the establishment, that I feel needed. I *am* needed. At the same time, maybe it's a cop-out. The goal of radical feminism is to change the world. I would like to revolutionize, but I am stuck with reform because of the context I work in. Right now art feminism is trapped within the system.

While I feel strongly that women should have a chance at everything that men have, even the bad things, I am all too aware of the traps set by the art world for the ambitious artist. And women are, of course, as ambitious as men, although one of the feminist goals is to get rid of hierarchies. The older women, who are just having their first exhibitions after years of lonely struggle, are discovering they *can* be ambitious. The younger women, just finding their ways free of total male domination, are more wary of ambition but they are also surer of themselves and well able to compete. As a critic, it's none of my business to tell artists not to grab whatever chances for fame and fortune that present themselves, especially when I'm making a living off the same system. The entrance of more art by women into the establishment is certainly good for the establishment. But it is, perhaps, less of a good thing for feminist art. One of the questions we have yet to answer is

whether women do want the same things that men have wanted; whether
"greatness" in its present form is in fact desirable.[9]

Perhaps the greatest challenge to the feminist movement in the visual
arts, then, is the establishment of new criteria by which to evaluate not only
the aesthetic effect, but the communicative effectiveness of art attempting
to avoid becoming a new establishment in itself, or, god forbid, a new styl-
istic "movement," to be rapidly superseded by some other one. Women's
conditioning and propensity to please can lead to pleasing a broad audience
as well as to pleasing the art hierarchy—but the ideally broad audience,
unlike the art audience, would be, of course, half female. Finding that audi-
ence, making contact, is a political as much as an artistic act, but it is as
creative as anything an artist can do. It takes immense amounts of energy,
courage, originality. The art-world route is easier. Nevertheless, there are
women emerging, all over the world now, who have realized through expe-
rience how unsatisfying success can be in an alien framework. They are the
ones who will make a feminist art reflecting a different set of values.
Precisely which values these will be can be worked out only in relationship
to a new community, not to the present art world, which can be called a
community only at times of severe stress or crisis, when the competition at
its core is temporarily submerged. Perhaps the art will not change until the
community changes it, or until it changes in response to the community.
We have not wholly realized how deep a transformation is necessary.

To begin with, we have to think about why it is so difficult to go past a
certain point in discussing the ways in which a woman's art can answer the
needs of a greater female (and, potentially, a liberated male) audience. The
fact that most women artists are not very interested in these needs damp-
ens, but hopefully will not extinguish, the spark. Why are we all still so
afraid of being *other* than men? Women are still in hiding. We still find it
difficult, even the young ones, to express ourselves freely in large groups of
men. Since the art world is still dominated by men, this attitude pervades
the art that is being made. In the process, feelings and forms are neutral-
ized. For this reason, I am all in favor of a separatist art world for the time
being—separate women's schools, galleries, museums—until we reach the
point when women are as at home in the world as men are. The danger of
separatism, however, is that it can become not a training ground but a
protective womb. The only effective strategies are those effective inside and
outside a separatist society. Exchange, for instance, is a feminist strategy;
out of dialogue between peers comes a focus to be shared by others. There
is no reason why strong women artists cannot emerge from a feminist
community to operate in both spheres, why they cannot, in fact, form a

*tri*alectic between the female world, the art world, and the real world. That's where I'd like to be. How to get there is the question.

I know now that I have not only to analyze my own (acculturated) taste but also to translate it into a value system that can universalize the task. (Male experience is already universal.) I have not only to reexamine the psychological and social motivations of myself and of the artists I write about, but also to find out what the prevalent metaphors refer to beyond themselves. I have to develop a temperamental consciousness into a cultural consciousness. So while I wish I could claim that this book [*From the Center*] established a new feminist criticism, all I can say is that it extends the basic knowledge of art by women, that it provides the raw material for such a development. The ongoing process that forms my own criticism will produce neither conclusions nor solutions but will, I hope, engender more questions, more dialogue, more discussion, more investigation on the part of women artists and critics, as well as myself. The art written about here contains the seeds of such change, more or less invisible now—but growing, growing.

Sexual Politics: Art Style

For the last three New York seasons [1969–1971], and particularly
during the past winter, women artists have begun to protest discrimination
against their sex in the art world. Active protest began in 1969 with WAR
(Women Artists in Revolution)—the women's group affiliated with the Art
Workers' Coalition—whose pioneering efforts received virtually no support
from better-known artists of either sex. From October 1970 to February
1971, another group, also emerging from the AWC, called itself the Ad
Hoc Women Artists' Committee and addressed itself solely to the issue of
the Whitney Museum's Annual Exhibition of American Art. That group
now exists on a broader basis and focuses on (1) weekly discussion groups,
(2) political action in the streets, and (3) legal action in concert with WAR.
A third group is restricted to figurative artists, and a fourth general organi-
zation of women in the arts was formed in the spring. There are also
numerous smaller consciousness-raising groups of women artists.

On the West Coast, Judy Chicago and Miriam Schapiro are setting up the
first feminist art program, at the California Institute of the Arts in Valencia,
based on Judy's work at Fresno, and Marcia Tucker will direct a women's
course at the School of Visual Arts here [New York] this coming winter.[1] In
June the newly formed Los Angeles Council of Women Artists threatened a
civil rights suit against the Los Angeles County Museum of Art with statis-
tics that reflect the national situation: only twenty-nine out of 713 artists
whose works appeared in group shows at the museum in the past ten years
were women. Of fifty-three one-artist shows, only one was devoted to a

This is the original, longer, version of "Sexual Politics: Art Style," which appeared in
Art in America 59, no. 5 (Sept. 1971).

woman (the same record as New York's Museum of Modern Art; both women were photographers—Dorothea Lange and Berenice Abbott). On June 1, 1971, less than one percent of all work displayed at the Los Angeles museum was by women. A spokesman from the museum, according to the *Los Angeles Times,* "declined to comment," though he held up as hopeful the fact that the two *assistants* to the male curator of modern art were women. (Assistants to curators, like editorial assistants in publishing, are rarely allowed any independent responsibility and are usually underpaid, overtitled slaves.) In April, 1971, WEB (West-East Bag) was created as a liaison network to inform women artists' groups internationally of each other's actions, legal maneuvers, methodology, discussion topics, and techniques; so far it has representatives in twelve states and five countries.

The history of these actions is complex, infuriating, exhilarating—especially that at the Whitney, which was sustained over an active four-month period of picketing, public interviewing, and harassment (such as an anonymously forged press release announcing that the Annual would be fifty percent female; five hundred fake tickets to the opening, for women; guerrilla actions within the museum; and so on). As a result, the Whitney suddenly raised the number of women in the Annual from the past year's 4.5 percent (painting) to 22 percent, even though it was a sculpture year and, according to the "Did a Little Girl Like You Make That Great Big Sculpture?" syndrome, there aren't supposed to be many women sculptors.

Yet in spite of all this activity, and a number of symposia addressed to the subject, the art world was and still is late in coming to grips with sexism. It is a male-dominated world despite the few women dealers, critics, and curators whose names always crop up as tokens and, more curiously, despite the notion that most collectors are advised by their wives. The reasons for this domination in a field considered conventionally a kind of "sissy" occupation, not serious in itself, are inherent in the society we live in. Real change won't come until woman–man relationships are fundamentally altered. In the meantime, however, discrimination against women in the art world consists of: (1) disregarding women or stripping them of self-confidence from art school on; (2) refusing to consider a married woman or mother a serious artist no matter how hard she works or what she produces; (3) labeling women unfeminine and abnormally assertive if they persist in maintaining the value of their art or protest their treatment; (4) treating women artists as sex objects and using this as an excuse not to visit their studios or not to show their work ("Sure, her work looked terrific, but she's such a good-looking chick, if I went to her studio I wouldn't know if I liked the work or her," one male dealer told me earnestly; "so I never went"); (5) using fear of social or professional rejection to turn successful

women against unsuccessful women, and vice versa; (6) ripping off women
if they participate in the unfortunately influential social life of the art world
(if she comes to the bar with a man, she's a sexual appendage and is ignored
as such; if she comes with a woman, she's gay; if she comes alone, she's
on the make); (7) identifying women artists with their men ("That's so-and-

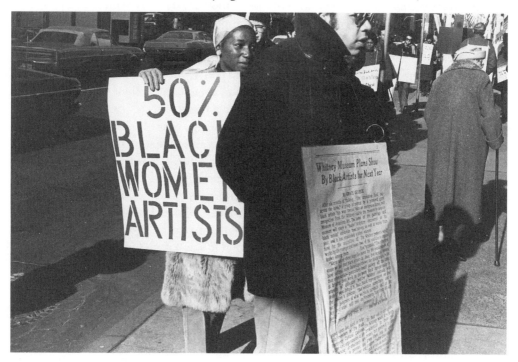

50% Black Women Artists, 1969
Michele Wallace at a protest against a white-curated black exhibition at
Whitney Museum of American Art.
Photo: Ann Arlen.

Wallace (see p. 288, "Out of Turn") and her mother, the artist Faith Ringgold, as
members of WASBAL (Women Artists and Students for Black Art Liberation)
demonstrated for the strong presence of women artists in any exhibition of African
American art; they also collaborated with members of Ad Hoc Women Artists in
protests against the Whitney Annual in 1970, demanding 50-percent representation
of women of color.

so's wife; I think she paints too"); (8) exploiting a woman's inherent sensi-
tivity and upbringing as a nonviolent creature by resorting to personal
insults, shouting down, arrogance, and art-world clout to avoid confronta-
tion or to subdue and discourage women who may be more intelligent and
articulate or better artists than their male company; and (9) galleries turning
an artist away without seeing her slides ("Sorry, we already have a woman,"

or "Women are too difficult"—direct quotes from dealers, although since the women's movement, people are more careful to whom they say these things).

The roots of this discrimination can probably be traced to the fact that making art is considered a primary function, like running a business, or a government, and women are conventionally relegated to the secondary, housekeeping activities, such as writing about, exhibiting, caring for the art made by men. Artmaking in America has had a particularly virile tradition over the last twenty-five years, the ideal of large-scale, "tough," uncompromising work being implicitly a masculine prerogative. Men are somehow "professional" artists even if they must teach a twenty-hour week, work forty hours as a carpenter, museum guard, designer, or any of the other temporary tasks with which most artists are forced to support themselves in an unsympathetic society. Women, on the other hand, especially if they are married and have children, are supposed to be wholly consumed by menial labors. If a single-woman artist supports herself teaching, waitressing, working as a "gallery girl," she is often called a dilettante. If she is a mother, she may work full-time in her studio and she will not be taken seriously by other artists until she has become so thoroughly paranoid about her position that she can be called "an aggressive bitch" or an opportunist. It doesn't seem to occur to people that women who can manage all this and still be serious artists may be *more* serious than their male counterparts.

The rare woman who has made it into the public eye tends to reject younger or lesser women artists for fear of competition, for fear of being forced into a "woman's ghetto," and thereby having her work taken less seriously. She is likely to say, "*I* made it on my own, as a person, why can't they?"; at the same time she will occasionally acknowledge how rough it was to make it as a woman, how hard it was to remain "ultrafeminine" (which may be a major issue, since by this time she has so often been accused of being the opposite by men and by other women jealous of her talent and drive). Saddest of all is when a woman's identity becomes so absorbed by the male world that she believes herself one of an extraordinary elite who are strong enough and good enough to make it, not realizing that she denigrates and isolates herself and her work by being ashamed of her own sex. If her art is good, it cannot be changed by pride in being a woman.

The worst sources, not only of discrimination, but of the tragic feelings of inferiority so common among women artists, are the art schools and college art departments (especially at women's colleges), most of which have few or no female faculty despite a plethora of unknown male names. Women comprise a majority of art students, at least for the early years; after that they begin to drop out as a result of having no women teachers

after whom to model themselves, seeing few women shown in museums and galleries, lack of encouragement from male professors who tell them that they'll just get married anyway, or that the only women artists who make it are dykes, or that they'll get along fine if they screw their instructors, or that pale colors, weak design, cunt images, fine line are "feminine"

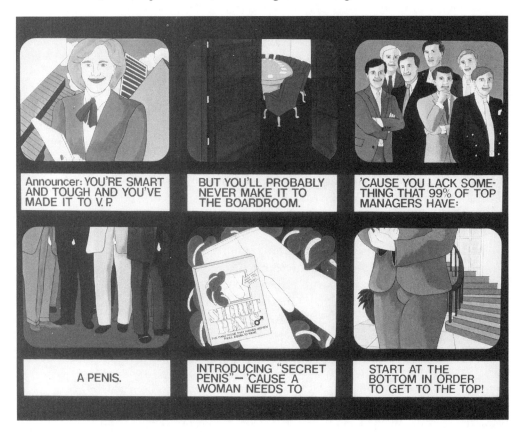

ERIKA ROTHENBERG
Secret Penis, 1987
ACRYLIC ON CANVAS, 50" × 66"
Private collection. Photo: Rossi.

Rothenberg's hilarious storyboards for TV commercials bare the dominant culture's burdens. The dildo is an instrument of power rather than pleasure.

(i.e., bad), but less so when perpetrated by men. Small wonder that there are far fewer women in the graduate schools, that survivors of this system are afraid to take their slides to galleries or invite criticism, that they find it difficult to work in isolation if their husbands move them to the suburbs, that they marry an artist instead of continuing to be one, or become the

despised "lady painter" in between children, without studio space or materials money....

When a woman does have a show, the same attitudes prevail in regard to journalistic coverage. And last spring [April 1971], an all-woman show, the first of its kind in the New York area since the current feminist movement, was ignored by the art press and rather pathetically mocked in a *Times* news story by a woman who was basically sympathetic and enthusiastic, but presumably had to keep her contacts intact. Cindy Nemser's collection of statements by critics on women's art is not being published as planned, perhaps because some of the critics made such asses of themselves on the subject. The one art magazine that has had any feature coverage of the "woman problem" (running two articles on the topic in the entire magazine, which enabled it to be called "the woman's issue") now feels it need never mention the subject again.[2]

Survey shows are the most obvious examples of discrimination, which is why the Whitney Annual was chosen for a sustained public protest. If such shows are indeed focused on no particular taste, but on what is "being done" in such and such an area this year, why are so few women's studios visited? The Ad Hoc Women Artists' Committee demanded equal opportunity— that as many women's works be viewed as men's, and submitted a long list in case the museum didn't know any women artists. It was still up to the "judges" to decide whether this would result in equal representation, but the museums continue to refuse to make public any of their obviously incriminating figures on the process of selecting such shows.

Connections in the art world are, for better or worse, made through friends and galleries. Aside from, or because of the problem of competition with men, women rarely seem to be recommended by their male friends and are lucky to be given a corner, or a third, of their husband's or friend's studio where they can even show work. Few are represented by the big galleries to which the curators refer when doing a show. Only recently have some women critics begun to turn their attention to women's work. Many women in the art world (and men, too) are afraid to alienate the men who run it for fear of being ostracized. If they have no position, they are afraid to antagonize those who might help them; if they have a position, they don't want to endanger it by being associated with anyone not equally "important." (This goes, unfortunately, for all artists considering any political involvement of any kind.) The situation is changing, but not fast enough. The rule still overwhelms the exceptions.

What applies to group shows applies equally to foundation grants, which again claim to concentrate on no single style, gallery affiliation, or institutional support. The statistics here are even worse. The usual defense is that

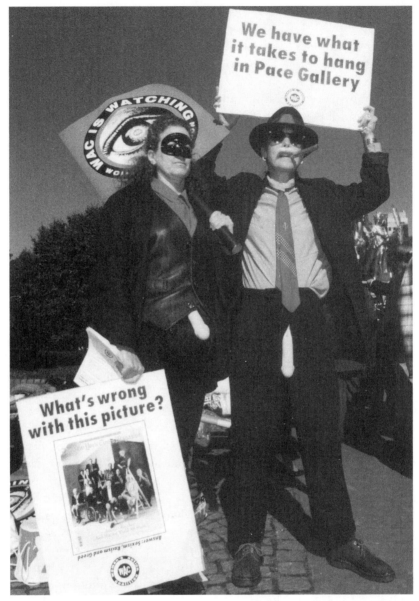

WAC (Women's Action Coalition) protest at Pace Gallery, New York, October 1993. Photo: Mary Beth Edelson.

The picture on the placard (lower left corner) was featured in a *New York Times Magazine* cover story on the Pace Gallery, showing its all-white-male stable of artists. (Agnes Martin is represented by the gallery but wasn't acknowledged in any way; nor was the late Louise Nevelson; Kiki Smith has since been added to the roster.) WAC staged a protest featuring well-hung women artists in drag: "We have what it takes to hang in Pace Gallery."

not many women applied, or that they weren't "good enough." It is important to remember that the so-called quality of the work of, say, twenty-five younger artists given grants or shown in a museum will not be agreed upon by any five "experts." If "quality" is admittedly elusive, why is it that foundations ignore women with *qualifications*—one-artist shows, prestigious group exhibitions, specialized press coverage, even maturity and length of career—far exceeding those of male colleagues who do receive grants? A Women's Art Registry, now including slides by several hundred women, makes it clear that a large number of female artists are working on a par with men. Last spring it was possible for me to put together, in good conscience, an exhibition of twenty-six women who had never had one-artist shows in New York. I could not have organized an exhibition of that strength (*all* this being regulated by my own taste, of course) of unshown male artists; by the time they are that mature, most men have had a show somewhere. All grant lists, all art school faculties, and all group shows include a certain percentage of names that are totally inexplicable to anybody. Why aren't those artists, *at least*, replaced with women whose work is as good as the best men accepted? The John Simon Guggenheim Foundation and the National Endowment for the Arts, among others, have lousy records.[3] In fact, there isn't any art-world institution so far that hasn't.

Prefaces to Catalogs
of Three Women's Exhibitions

I . 1 9 7 1 : "T W E N T Y - S I X C O N T E M P O R A R Y
W O M E N A R T I S T S "

I took on this show because I knew there were many women artists whose
work was as good or better than that currently being shown, but who,
because of the prevailingly discriminatory policies of most galleries and
museums, can rarely get anyone to visit their studios or take them as seri-
ously as their male counterparts. The show itself, of course, is about art.
The restriction to women's art has its obviously polemic source, but as a
framework within which to exhibit good art it is no more restrictive than,
say, exhibitions of German, Cubist, black and white, soft, young, or new
art. I chose what I chose because of my personal tastes, accumulated over
six years of writing about and twelve years of looking at contemporary art.
These tastes are for the most part based on a broad acceptance of the double
mainstream of modern art, the so-called avant-garde, which for better or
worse has been largely white and male-dominated.

Within the next few years, I expect a body of art history and criticism
will emerge that is more suited to women's sensibilities. In the meantime,
I have no clear picture of what, if anything, constitutes "women's art,"

Reprinted from the catalog of *Twenty-Six Contemporary Women Artists*, Aldrich Museum,
Ridgefield, Connecticut, April 1971. The artists in the show were: Cecile Abish, Alice
Aycock, Cynthia Carlson, Sue Ann Childress, Glorianna Davenport, Susan Hall, Mary
Heilmann, Audrey Hemenway, Laurace James, Mablen Jones, Carol Kinne, Christine
Kozlov, Sylvia Mangold, Brenda Miller, Mary Miss, Dona Nelson, Louise Parks,
Shirley Pettibone, Howardena Pindell, Adrian Piper, Reeva Potoff, Paula Tavins,
Merrill Wagner, Grace Bakst Wapner, Jacqueline Winsor, Barbara Zucker.

although I am convinced that there is a latent difference in sensibility; and *vive la différence.* After selecting this show from hundreds of possibilities, I was aware of a strong personal identification with work by women, but as yet I hesitate to draw any conclusions from it; I sensed a similar undercurrent in 1966 and 1968 when organizing two shows called "Eccentric Abstraction" and "Soft Sculpture," which included more women than was my habit or anyone else's at that time. I have heard suggestions that the common factor is a vague "earthiness," "organic images," "curved lines," and, most convincingly, "a centralized focus" (Judy Chicago's idea). But until a great many women artists surface who have been taught by women, turned on by women's art as much as all artists have been turned on by the widely exposed art of men, until women artists have become aware and unashamed of the particularities of their own sensibilities—until then, I don't think anything definitive can be said on the subject.

It is, however, fully possible, and necessary, to reject the inane clichés of

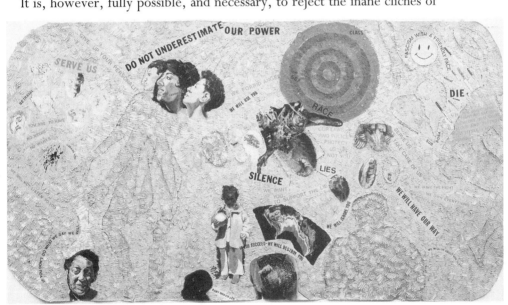

HOWARDENA PINDELL
Autobiography: Scapegoat, 1990
ACRYLIC, TEMPERA, OIL STICK, POLYMER, PHOTO TRANSFER
ON CANVAS, 41″ × 72″
Collection The Studio Museum in Harlem. Photo: courtesy D. James Dee.

Pindell's "Autobiography" is a series of outraged self-portraits that take her through the experiences of African American history. Combining a painterly surface and polemic photocollage, *Scapegoat* details the injustices of "fascism with a friendly face" and announces its agenda: "Serve Us, Take Care of Us...You Are to Have No Needs...Give Up Your Personality...." (Pindell was in the "26 Contemporary Women Artists" at the Larry Aldrich Museum in 1971.)

"feminine" art based on superficial characteristics such as delicacy, pretti-
ness, paleness, sweetness, and lack of structure. Miriam Brumer has pointed
out that from Renoir to Lyrical Abstraction, these qualities are consistently
found in art made by men. As the search for more profound biological,
psychological, and political sources advances, far more interesting common
factors will be exposed. Organizations like the pioneering WAR (Women
Artists in Revolution), the more recent Ad Hoc Women Artists' Commit-
tee, and the West Coast groups, as well as art historians like Linda Nochlin
and critics like Cindy Nemser, are among those who have begun to raise
and propose answers to these questions in the art world. My own answer,
for the time being, is this show, the work of all the other women who
could have been included in it, the work of those few who have already
"made it," and of those who have the guts to keep up the struggle and make
it easier for their sisters.

 I also took on this show as a form of personal retribution to women
artists I'd slighted, unintentionally, in the past. I have recently become
aware of my own previous reluctance to take women's work as seriously as
men's, the result of a common conditioning from which we all suffer.
(When I was an art historian, the problem rarely arose; most women artists
have already been "evaluated" out of the picture by male-oriented histori-
ans.[1]) The woman artist has tended to be seen either as another artist's
wife, or mistress, or as a dilettante. Now I know that, contrary to popular
opinion, women are not "part-time artists" any more than anyone else.
Very few artists of any sex in America do not work at something other than
their art to earn a living, though it's true that women often have three jobs
instead of two: their art, work for pay, and the traditional unpaid "work
that's never done." The infamous Queens housewife who tries to crack the
gallery circuit is working against odds that no Queens housepainter (Frank
Stella was one) has had to contend with. I admire tremendously the courage
of those who stick with it. Women's art often has an obsessive element to
it; it *has* to, given the obstacles laid in its path. It is far easier to be success-
ful as a woman critic, curator, or historian than as a woman artist, since
these are secondary, or housekeeping activities, considered more natural for
women than the primary activity of making art.

 For these and endless other reasons, choosing this show has been an
exhilarating and a depressing experience; exhilarating because I saw so much
personal and aesthetic strength, so much more good work than even I had
suspected; depressing because of the spectacle of so many women torn
between so-called femininity and their work (a choice that will, hopefully,
soon be outdated), and because I didn't see enough, because I had to make
judgments and choices and narrow down several hundred artists to twenty-

six. In order to facilitate the task of going to some one hundred studios in the New York area in six weeks, I made one wholly arbitrary limitation. I hope it was at least no more unfair than any other. No one in this exhibition had had a one-woman show in New York prior to March 1, when I made my final decisions. For the injustices incorporated in this limitation, I apologize, specifically to the three women whom I asked to participate and had to withdraw because they had shown: Agnes Denes, Pat Johanson, and Anne Wilson; and generally to all those whose work I liked very much and didn't include for illogical reasons of space, compatibility, in short, my manner of putting together a show as a whole....

II. 1973: "WHY SEPARATE WOMEN'S ART?"*

A large-scale exhibition of women's art in New York ["Women Choose Women"] is necessary at this time for a variety of reasons: because so few women have up until now been taken seriously enough to be considered for, still less included in, museum group shows; because there are so few women in the major commercial galleries; because young women artists are lucky if they can find ten successful older women artists to whom to look as role models; because although 75 percent of the undergraduate art students are female, only two percent of their teachers are female; and above all, because the New York museums have been particularly discriminatory, usually under the guise of being discriminating.

A couple of years ago even a sympathetic observer could dredge up the names of no more than twenty women artists who were well known at all. Even other women artists had trouble remembering colleagues. This, I suspect, was as much a psychological block on their part as a statistical fact, having to do with not wanting to be identified as a woman artist. A simultaneous pride in uniqueness and an underlying fear of inferiority seemed then to affect the ranks of women artists themselves. Yet once the protests and meetings and shows began in New York, women's own memories loosened up to the point where endless friends from art school who had been working away in silence suddenly began to surface, and groups began to get together for consciousness raising, for aesthetic discussion, for political actions, to remedy the years of suppression.

* A revised amalgam of prefaces to the catalogs for: "Ten Artists (Who Also Happen to be Women)," the Kenan Art Center, Lockport, New York, and the Michael C. Rockefeller Arts Center, Fredonia, New York, January 1973; "Women Choose Women," organized and selected by Women in the Arts, the New York Cultural Center, New York City, October 1973; and to the "Women's Issue" of *Art and Artists* 8, no. 7 (Oct. 1973).

Grisly tales of maltreatment and inhumanity emerged from these sessions, including those from art school students whose professors classically discouraged them by historical and sexual denigration. This treatment was even handed out by well-meaning men so conditioned to sexist attitudes that it never occurred to them that they were making it impossible for many women to continue working. The survivors became understandably reluctant to identify with other women's art, thus encouraging the isolation that, until recently, made so many women artists accomplices to their own professional murders. Others simply retired from the art-world competition and worked in total isolation. The single most moving aspect of the early days of the women's art movement was the reemergence of and communication among these "invisible" people; included were women already in the art world by marriage or friendship who had rarely profited from the studio visits, bar talk, and discussions of their work that the men had limited primarily to their "peers" (other men). Slowly women artists came out of the woodwork, and slowly a real community was formed.

One meeting I attended early in 1971 seems in retrospect to be particularly significant. Some thirty-five women artists sat in a large circle and described their work, with no visual aids. Time after time, objects of an acceptably ambitious art-world nature and scale would be described; then there would be a curious pause and the artist would add hesitantly something to the effect of "and...in my private time (or in the summer, or at night), I make these little collages (or journals, or work with dolls, or paint on pebbles)." One woman made large, hard-edge, color canvases, but in her spare time she was photographing friends in the nude against Mylar hangings, creating a strange, intimate but fugitive world that seemed in direct conflict with her "public" style. When it was my turn, I "confessed" to writing fiction. This "closet art," too vulnerable and private (and by implication "minor") for public display, often seemed to touch the core of women's experience, women's art, but most of us were afraid at that time to send these tender sprouts into the dog-eat-dog world of "high" art. Only the subsequent establishment of women's galleries, women's shows, women's magazines, women's courses paved the way for eventual exposure.

Whenever there is a women's show, or a black artists' show, or any similarly "segregated" event, objections are raised on the basis that art is art and has no sex, no color. That's all very well, but artists do, and there has been considerable discrimination against artists of a certain sex and certain colors. A woman's show is no more arbitrary a manner of bringing together a group of artworks than a show of Czechoslovakian Art Since 1945 or Artists Under Thirty-five. When you open a magazine or enter an exhibition space,

you have to look at what is there individually, no matter how vague or arbitrary the label under which it is hanging. If you can't enjoy good art because it is hanging with art by one political group or another, but you can enjoy art if it is grouped under the imposition of a movement or a theme or some curatorial whim, then you probably should think about why you are looking at art in the first place.

Women's shows function, hopefully, as educational devices for the institutions exhibiting them.[2] A similar function is served by independent shows, by the establishment of women's co-op galleries like A.I.R., SoHo 20, and the Women's Interarts Center in New York; Hera in Rhode Island, Artemesia and ARC in Chicago, those in the Los Angeles Woman's Building; and by organizations like the Women's Art Registry, a slide collection founded in response to the constant comment that "there are no women working in kinetics, or light, or Conceptual or...even sculpture";[3] or WEB (West-East Bag), an international network of women artists' groups.[4] These and others like them are beginning to indicate the tip of the iceberg, or the volcano, that is women's art; they are providing ways for women outside the major art centers to keep in touch with each other and with their new female audience.

I became involved in the women's movement for endless reasons, but the most public one is the fact that, as a working critic for five years, I had been guilty of the same lack of seriousness toward women's work as the museums and galleries. Although I had once been an artist's wife, serving tea and smoothing the way for visitors, and had had my own infuriating experiences in that anonymous role, I continued to go to men's studios and either disregard or matronize the women artists who worked in corners of their husband's spaces, or in the bedroom—even in the kitchen. I was, I think now, unconsciously responding to her sense of inferiority and insecurity as well as to my own (my "reputation" supposedly depended on male support and respect...).

Now, three years later, a lot has changed, but there is still an immense amount of changing yet to be done. One no longer hears as a matter of course comments from dealers like, "I can't have a woman in the gallery; they're too difficult," or "Collectors won't buy women's work." Nor does the art press dare use the term "feminine" in a value-judgmental context, something that once caused many women literally to be afraid of using delicate line, sewn materials, household imagery, or pastel colors—especially pink. One well-known stain painter was accused in a review of "painting her monthlies." This won't happen anymore, or if it does, such a statement might come from an artist who, exploring her own experience, is doing just that!

ANA MENDIETA
Silueta, 1976
Photograph by the artist of site-specific work in Mexico.

In the seventies, Mendieta used natural materials in various ways to superimpose silhouettes of her own body (or that of Everywoman or the goddess) onto the earth, representing her longing for return to her motherland, Cuba. Birth, orgasm, and death are all suggested by such a total surrender to, or merging with, nature.

. . .

Totally aside from the political necessities fulfilled by women's shows, they also provide a fascinating field of speculation for the question asked so often over the last two or three years: Is there a women's art? And if so, what is it like? One of the difficulties in drawing any conclusions so early in the game is the fact that art is inevitably influenced by other art publicly made visible, which now means primarily art by men. However, the overwhelming fact remains that a woman's experience in this society—social and biological—is simply not like that of a man. If art comes from inside, as it must, then the art of men and women must be different too. And if this factor does not show up in women's work, only repression can be to blame.

For every time I can be specific about this differentiation, there are endless times in which it remains just out of reach. Perhaps it is impossible to pin it down until women's place in society is indeed equalized and women's work can be studied outside of the confines of oppressive conditioning. Nevertheless, generalizations are made in every field, especially art, and often profitably. It seems most important that our eyes and spirits be attuned to the glimpses we are afforded of women's sensibility and imagery. There are some things I've noticed that I can't seem to deny. For example, in 1966 I was organizing a show around the work of Eva Hesse and Frank Viner—a kind of offbeat, not quite Minimal, not quite funky style I called "Eccentric Abstraction" that later developed into so-called anti-form. I found a lot of women doing this kind of sensuous geometric work—far more than I'd encountered on similar searches for other styles, and in addition, I, a woman, was doing the show because this kind of work appealed to me personally. I wondered briefly about that at the time, and did still more so four years later when I became involved in the women's movement. When I went to a great many women's studios in the winter of 1970–71, I noticed that these and other elements often recurred. It might have been attributable to my own taste, or to something more universal. When I first heard Judy Chicago's and Miriam Schapiro's theories about the high incidence of central-core imagery, of boxes, ovals, spheres, and "empty" centers in women's art, I vehemently resisted them. I was still resisting them when we visited the women's show I organized for the Aldrich Museum, and they ran from work to work shouting "There it is!" There it was. I was astounded, because I'd had no intention of focusing on that idea, no knowledge that I had been doing so.

Here, in any case, for your own consideration, are some of these elements that recur: a uniform density, or overall texture, often sensuously tactile and repetitive or detailed to the point of obsession; the preponderance of circular forms, central focus, inner space (sometimes contradicting

the first aspect); a ubiquitous linear "bag" or parabolic form that turns in on itself; layers, or strata, or veils; an indefinable looseness or flexibility of handling; windows; autobiographical content; animals; flowers; a certain kind of fragmentation; a new fondness for the pinks and pastels and ephemeral cloud colors that used to be taboo unless a woman wanted to be accused of making "feminine" art. Theories and refutations and new theories and new refutations will continue to surround this issue, but it is a rewarding debate that can only help women artists and critics to develop a sense of our individual aesthetic directions, and perhaps in the process to define more clearly the web formed by the multiple threads of these individual developments.

Once the fact that there are women working, and working well, in all media and in all styles gets through to those in the art establishment, and once those in charge of that establishment begin to implement their newfound knowledge by selecting women the same way men have been selected all along, the process of segregation may be obsolete. Or there is the chance that women artists will not want to be used the same way men have been all along.

III. 1975: EXCERPTS FROM THE CATALOGS OF THREE WOMEN'S EXHIBITIONS*

Mothers of Perception

I am struck by the fact that a show like this, in which delicate touch, pale colors, and gynosensuous imagery are frankly associated with femaleness (by the artists themselves rather than by a patronizing reviewer deigning to cover "minor" art), could not have taken place five years ago, when so many women artists still feared the adjective *feminine*. And for good reason. Such subject matter, such admission of sexual consciousness has traditionally been taken as a synonym for inferiority. It is no longer true that the greatest compliment a woman artist can receive is the classic: "You paint like a man." In Gail Crimmins's quietly precise rendition of old photographs, the figures are wistful and distant, seen through a veil of nostalgia. Judith Szarama's bulbous oral fish swimming in an unfamiliar medium, Winona Taylor's pastel flowers, hands, ballet slippers, ribbons, woven into a nostalgic memento, Marjorie Pickard's tactile, crotched leaves, and Debora Hunter's misty

*Reprinted from *Mothers of Perception,* Rebecca Cooper Gallery, Newport, Rhode Island, spring 1975.

photographs of young women peering into their futures are all unashamedly feminine. The vulnerability of women's lives is poignantly exposed, but the very fact of this exposure, and the pride of the statements accompanying the work, lend to these fragile images a new strength that recalls the survival over the ages of this same morphology. An extremely sensual, and by extension sexual, impact is found in this work by no coincidence....A female audience will be able to identify with the soft skin of natural surfaces, with little girls' ambitions to be ballerinas, with the layered and obsessively detailed techniques, with the hidden/expansive anatomical forms veiled in poetic subject matter. Other women will reject these elements as panderings to a stereotype better forgotten. There is some truth in both approaches, though the power of the feminist movement lies in the fact that everything is open and possible now, that no one art can be imposed. At the same time, equality does not necessarily lie in androgyny alone. If we as women do not return to the sources of our art and our experience before we attempt to transcend gender, the results will be far less fertile.

*Women Artists Series: Year Five**

Five years of women artists at the Douglass Library, forty-four one-woman shows by the end of this season, plus group shows of New Jersey women and of the Rip-Off File:[5] landmarks for an alternative exhibition space within a (usually sexist) institution. Until recently no fiscal support except from women's groups. Until this year a bastion amid an all-male faculty at this women's college. In previous catalogs the artists' statements often referred to their alienation from the art world, to the warmth and solidarity of feminist groups, to the new community of women artists. They talked about their struggles, about art-world hustling, about mirrors, and self-portraits, breaking boundaries, the nature of art, the sky, the edge, and the surface. They offered "circuits, events, signals, waves," "a feeling of movement," an "ironic, perverse, creative order, transcribed from the domestic arena," "bands of light...bands of 'song' or 'talk,'" "a symbolic interpretation of life forms," a "picked-up image, its space activated by incidents and events," the "possession of a surface." They were "being tactile, geometric, organic, subtle, sensuous, serene, mystical," "thinking about how we can feminize our society, how we can make images which reflect a new set of values," and thinking about "the fleeting gestures, moments...caught in motion, the rhythm of the whole, seemingly discordant and incomplete,"

*Reprinted from *Women Artists Series: Year Five,* Mabel Smith Douglass Library, New Brunswick, New Jersey, 1975.

and how it "relates to fractured time." They tried "to turn woman from an object into an active subject."

Women's shows are still very important. In the past five years, thanks in great measure to such "separatism," there has been an increase in the numbers of women artists shown in commercial galleries and in large museum shows. But even now the figures are nowhere near equal representation, and the teaching situation remains virtually unimproved in many schools, where the student body remains mostly female and the faculty remains mostly male.[6] At this point, when the women artists movement is just entering maturity, nothing could be more dangerous than a loss of energy, loss of identification, which means, inevitably, a loss of ground. But aside from the strictly professional aspects, and farther reaching, is the psychological factor. It would be still sadder to lose the strength transmitted from artist to artist, generation to generation, when women support other women in alternate situations such as women's co-op galleries, workshops, art centers, local shows, open shows, *"salons des refusés"* like this one, and hopefully, in the future, more connections between feminist artists and broader, extra-art-world audiences. An increasing amount of vital work by feminist artists is being shown in more or less isolated places. This fact bodes well for an expanded consciousness, a rejection of the social and aesthetic pressures that constrict art-world conventions, customs, fads. The Douglass series is unique, and also exemplary in that it has included well-known and unknown artists, a broad range of style, age, and intent. Its organizers have had the courage to be honest with themselves and with their audience, which has responded in kind by strong reactions—for and against—to each individual show.[7]

*Works on Paper: Women Artists**

This exhibition marks another triumph for persistence, hard work, and a good cause. But its worst result would be a false sense of victory. Much has been accomplished since 1969, when Women Artists in Revolution pioneered the women's visual-arts movement in New York. But much has

*Reprinted from catalog *Works on Paper: Women Artists,* the Brooklyn Museum and Women in the Arts Foundation, Brooklyn, New York, October 1975. Like the "Women Choose Women" show at the New York Cultural Center in 1973, also sponsored by Women in the Arts and chosen by and/or from its own membership, this show and catalog were paid for by the exhibiting artists with grants they raised themselves and with entry fees. It is regrettable that although far less important shows are supported by the institutions, women must continue to make their own ways. This somewhat mitigates the gratitude we must feel to the two museums who at least opened their doors where others feared even to open their eyes.

yet to be done. Established institutions seem to have set a 20 percent quota for female representation in group shows. While commercial galleries have done more for women (for obvious reasons), other organizations have resisted all but the most minute changes.

The major question is whether or not women are falling into the same traps, the same commercialism, the same success-oriented egotism sustained by the male art world. Other questions follow: Is "making it" into a "good" gallery or museum show the only goal? Who is the feminist artist's audience? Shouldn't women's groups and galleries be attempting to revive the relationship between art and people? How can women's art and imagery most strongly translate the goals of feminism into effective and communicable visual metaphors? The struggle has not ended just because a few more women show and sell more work in a sterile art world. We haven't any real laurels to rest on yet.

Household Images in Art

Probably more than most artists, women make art to escape,
overwhelm, or transform daily realities. So it makes sense that those
women artists who do focus on domestic imagery often seem to be taking
off from, rather than getting off on, the implications of floors and brooms
and dirty laundry. They work from such imagery because it's there, because
it's what they know best, because they can't escape it.

Of course, men have dealt with domestic imagery, too. In the early
1960s, the male artists moved into woman's domain and pillaged with
impunity. The result was Pop Art, the most popular American art move-
ment ever. (Popular with men and women alike, or just those women who
had maids to deal with the absurdity of that sort of imagery?)

If the first major Pop artists had been women, the movement might never
have gotten out of the kitchen. Then it would have struck those same critics
who welcomed and eulogized Pop Art as just women making more genre
art. But since it was primarily men who were painting and sculpting the
ironing boards, dishwashers, appliances, food and soap ads, or soup cans,
the choice of imagery was considered a breakthrough. The same is true of
the more recent "movement" known as Lyrical Abstraction, based on wishy-
washy color and nuance, which would have been called "merely" feminine if
it hadn't been taken up by a lot of men as well. The art world works this
way, which may explain why there are fewer women artists working with
"household imagery" than one would expect.

After all, the few women artists making it in the 1950s and 1960s were
rarely housewives, and anybody who was took care to hide it when showing

Reprinted from *Ms.* 1, no. 9 (Mar. 1973).

MIERLE LADERMAN UKELES
Washing/Tracks/Maintenance, 1973
A "Maintenance Art Event" at the Wadsworth Atheneum, Hartford, Connecticut, July 1973, as part of "c. 2,500," a traveling exhibition of women's conceptual art I curated, one of an international series of conceptual art shows with index card catalogs.

Over the years, Ukeles's Maintenance Art evolved from caring for her house and children to scrubbing museum floors to her artist-in-residence position as an honorary Deputy Sanitation Commissioner of New York City (see page 168).

her work in the serious art world. (Because women were considered "part-time artists" if they worked for a living outside of art, or were married, or had a child, they didn't have to be taken seriously.) Another version of the same taboo was made unmistakably clear in art schools. "Female techniques" like sewing, weaving, knitting, ceramics, even the use of pastel colors (pink!) and delicate lines—all natural elements of artmaking—were avoided by women. They knew they could not afford to be called "feminine artists," the implications of inferiority having been all too precisely learned from experience.

Some of this has been changed, or at least modified, by the women's movement. Many women artists have organized, are shedding their shackles, proudly untying the apron strings—and, in some cases, keeping the apron on, flaunting it, turning it into art. For example, there is *Womanhouse,* made in 1971 by students at the California Institute of the Arts with their teachers, feminists Judy Chicago and Miriam Schapiro. This immense and immensely successful project was an attempt to concretize the fantasies and oppressions of women's experience. It included a dollhouse room, a menstruation bathroom, a bridal staircase, a nude womannequin emerging from a (linen) closet, a pink kitchen with fried-egg–breast decor, and an elaborate bedroom in which a seated woman perpetually made herself up and brushed her hair.

Most of the work I've seen that deals with household imagery does so either by means of a cool, detached realism, or funky fantasy. Examples are Los Angeles artist Wanda Westcoast's lumpy curtain sculptures, or Brooklynite Sandra de Sando's plaster birthday cakes decorated with cookies and animal crackers. Also in New York, Rosalind Hodgkins's holocaustically erotic, angry, funny paintings rigorously organize a pictorial vocabulary that rivals a mail-order catalog. In Chicago, Ellen Lanyon takes off from old magic manuals and bewitches her way out of *Housekeeper's Terror* (one of her titles) with paintings of mysteriously balanced dishes and silverware, often invaded by bird and animal life. Irene Siegel, another Chicagoan, used to make beautifully detailed drawings of unmade beds.

The two most frequent images are fundamentally televisionary. The first is food. Why? Perhaps for compensation; stuffing yourself until there's no room inside for anything else. New York painter Janet Fish depicts produce, bottled or super-wrapped, lined up neatly on the shelf. Judy Ott, in Lawrence, Kansas, paints steaks and pies sailing out across the galaxies, as if to say, "Out of my house." The second prevalent image is a "down" one—floors, tools for cleaning floors. Marjorie Strider's freestanding brooms and dustpans (wielded by an invisible Somebody Else) have a Disney-like quality

of "singing while we work." Susan Crile does paintings of decorative rugs that become both pictures of floors and abstract canvases. Sylvia Mangold's paintings of bare wooden floors (though sometimes defiled by a pile of dirty laundry) have the clarity and innocence of hope. Isn't cleaning up all about hope? And doesn't the futile repetition of endless housework mean losing hope?

When Mangold paints a laundryless floor, it exudes the peace and quiet of being left alone in the morning light. The same feeling is evoked by the crisply real interiors of Yvonne Jacquette or Cecile Gray Bazelon. But the intimacy of familiar things can give way to suffocation by things that are too familiar. Grace Samburg's linoleum floor with a bottle of Rose-Ex cleaner and a stove strikes me as less about sunlight on the surfaces of homelife than about pollution and the relentless New York soot filtering in through the windows. And Muriel Castanis's dishrag, clothes, laundry, tablecloths, and whole furnished domestic environments (made from cloth stiffened with epoxy) are ghostly reminders of the isolation in which so many women, even those who are artists, frequently find themselves trapped.

Finally, a stylistic exception in the treatment of domestic imagery: Mierle Laderman Ukeles's Conceptual artwork and/or exhibition called "Mainte-nance Art," or "Care," a written project for a museum show in which she would, among other things, perform all her housework and domestic duties in public. She sees women's role ("unification...the perpetuation and main-tenance of the species, survival systems, equilibrium") as representing the life instinct in art. This opposes the death instinct, or the reigning principle of the avant-garde ("to follow one's own path to the death—do your own thing, dynamic change"). She thereby airs the real problem; what she calls "the sour ball of every revolution: after the revolution, who's going to pick up the garbage on Monday morning?"

Fragments

I. FROM *The New York Element**

Saturday, 3:00 P.M. The Whitney is picketed by the Ad Hoc Women Artists'
Committee, a group loosely associated with the AWC; the hoc ad which it
addresses itself is 50 percent women's art in the Whitney's surveys of Ameri-
can art (sculpture this year). Despite a great increase in female representa-
tion—from about 4.5 percent at last year's painting show to 22 percent this
year[1]—the group has picketed every Saturday, armed with police whistles.
The basic issues are the current lack of equal attention to women's work, the
Ford Foundation and New York State Arts Council funds laid on museums
now practicing discrimination. The main activity is consciousness raising in
public—discussions, sometimes confrontations, with Madison Avenue
passersby and museum visitors. The drawbridge entrance seems expressly
designed for effective picketing. Some funny things happen: An art student
asks when we are going to get the schools for having so few women faculty
(*Soon*). An older woman, beminked, shouts over her shoulder that we're
ridiculous. We look down and see she is leading a rat-sized dog in ruffled
pantaloons and tiny boots. Two short-haired young working men jeer that we
want alimony and won't go into the army; we say we'd lay down the guns
faster than they, given the chance, and several of us have supported our
husbands, don't believe in alimony; they stop, talk a long time, and go away
friendly. A well-dressed man around fifty-five refuses to walk around us and
crashes through our big sign instead; the woman on the end holds her
ground; he hauls off and gives her another shove that spills the next person's

*Excerpt from "Charitable Visits by the A.W.C. to Whitney, MOMA, Met," reprinted
from *The New York Element* 2, no. 4 (Mar.–Apr. 1971).

coffee; she turns and throws the remains in his face; coffee is still seeping down into his cashmere scarf when the police arrive, but nothing is done to us. The white-haired lady who has been at the Whitney desk for years tells us, "I was a suffragette." A gray-flanneled suburban woman interviewed in the Georgia O'Keeffe show says she is a sculptor but has experienced no discrimination as a woman artist; an odd look comes over her face when she adds, "But of course…I use a man's name," and she walks off looking dazed. A Yale coed writes us and says, "What confidence you inspired in me concerning the future of women artists! Your protest at the Whitney Museum represents a noble breakthrough."

LOUISE BOURGEOIS
Untitled (With Foot), 1989
PINK MARBLE, 3 0″ × 2 6″ × 2 1″
Collection of the artist. Photo: Peter Bellamy, courtesy the Robert Miller Gallery, New York.

Burgeois's unique combination of representation and abstraction has become a style in itself. Her sculptures emerge from deep in the psyche, often as vehicles for bitter and sweet memories of her childhood or acid commentaries on modern sexuality. "Do you love me? Do you love me?" is inscribed in the rough stone base below the perfect, invulnerable sphere rolling indomitably over a child, who is signified only by a doll-like leg.

II. LETTER, DECEMBER 21, 1970*

I "evaluate" women's work on the same basis as men's, though evaluation is a term I prefer to avoid. I write about and show work that I like, no matter who did it. The problem rarely if ever came up in art-historical work since most women artists tended to have been "evaluated" out of the picture by previous (male?) historians. However, over the five years I've been writing criticism and organizing exhibitions of contemporary art, I became slowly aware of and eventually appalled by my own (and others') reluctance to take women's work as seriously as men's. While there have been outstanding exceptions, I tended to approach, as so many still do, women artists as the wives or girls of male artists instead of as serious painters or sculptors in their own rights—a result of previous conditioning from which we all suffer. If my record wasn't quite as bad as some others during this period, it was because I was lucky enough to be exposed to the work of several extremely serious and innovatory women artists who to some extent reversed such a bias. In the last six months, for extra-aesthetic reasons, I have become particularly interested in seeing and making visible women's art in the hope that the situation of neglect that has existed for so long in the past can be remedied in the future. At the same time, I continue to approach all art across my own formal, psychological, etc., prejudices. Some of these prejudices result from the fact that I am a woman and just learning to be proud of it.

III. THE GREAT GRID IRONY†

A) Perhaps by coincidence, perhaps not, many of the artists who have drawn from the grid's precise strains a particularly unique interpretation are women. Agnes Martin's channels of nuance stretched on a rack of linear tensions which "destroy the rectangle" are the legendary examples of an

*In response to Cindy Nemser's request for "a statement as to how you, as an art critic or historian, evaluate women's art"; replies were published in *Women in Art* 1, no. 1 (winter 1971).

† A. Excerpt from "Top to Bottom, Left to Right," in *Grids,* Institute of Contemporary Art, University of Pennsylvania, Philadelphia, 1972.
 B. Reprinted from Lawrence Alloway, "Agnes Martin," *Artforum* 11, no. 8 (Apr. 1973), p. 36.
 C. Letter from Lucy R. Lippard to *Artforum,* May 17, 1973; not published. Although this letter was not published, those of several women artists similarly protesting were published in *Artforum* (Sept. 1973), and Alloway also included them when the article was reprinted in his collection of essays, *Topics in American Art* (New York: W. W. Norton, 1975).

unrepetitive use of a repetitive medium. Dona Nelson's variations on the theme push color weights against the grid's heavy boundaries. For Eva Hesse the grid provided a long-sought-after discipline within which her own obsessions could finally be expressed. Knowing that a relatively rigid framework could control her inclinations to chaos, she said in 1970: "I was always aware that I should take order versus chaos, stringy versus mass, huge versus small, and I would try to find the most absurd opposites or extreme opposites.... Repetition exaggerates. If something is meaningful, maybe it's more meaningful said ten times. It's not just an aesthetic choice. If something is absurd, it's much more exaggerated, much more absurd if it's repeated...."

Merrill Wagner's prints were made by masking off a grid, then drawing rapidly over the whole surface; when the tape is stripped, the result is a negative-positive, handmade-mechanical contrast. Mary Heilmann distorts the grid to conform to the almost crude, almost naive character of her tactile surfaces and an imagery often derived from open nature. Pat Lasch's threaded lines fan out from points originating in autobiographical data. Joan Snyder's rhythmic signs and wounds are all the more moving for their balancing on the verge of freedom from dependence upon the underlying grid: "If you're going to dissect something, you can't just do it from the front, you have to go *into* the surface."

B) "Lucy Lippard points out that 'perhaps by coincidence, perhaps not, many of the artists who have drawn a particularly unique interpretation from the grid's precise strains are women.' To the extent that women artists use grids Martin is a probable influence on their practice. That is to say, rather than taking grids as an inherent tendency of women's art, I consider their use to be learned and, in fact, the aura surrounding Martin and the influence of Lippard herself may be precisely the predisposing factors. It is notable that a number of the women artists who use grids, or synonymous forms, are associated with the Women's Ad Hoc Committee, of which Lippard was a cofounder. There may be a factor special to women and that is their recent willingness to use domestic techniques such as sewing and pleating in the construction of searching works of art. Martin implies this kind of repetitive technique by forms that resemble stitching and by occasional reminiscences of the motifs on American Indian textiles...."

C) Lawrence Alloway's statement that a few members of the Ad Hoc Women Artists' Committee use the grid because I was a cofounder of that politically activist (not aesthetic) organization is absurd. And, perhaps not coincidentally, divisive. I resent it on my own part as well as on that of the

artists. The grid has been a predictable element in the New York art vocabulary since the early 1960s, via Reinhardt, Ryman, Poons, Kelly, LeWitt, and endless others, as well as Martin, whose cult three years ago was not what it is now. Ad Hoc was founded in late 1970. I resent the implication that women artists are so retrograde that this technique didn't occur to them until then. When I visited over one hundred women's studios in 1970 to choose a show, I found many using grids—by that time in very personal ways relating little to previous uses. Most of the women who ended up in the show had never been to an Ad Hoc meeting. I suspect more Ad Hoc members paint in styles related to so-called Lyrical Abstraction and Photo-Realism modes than use grids. *That* can hardly be blamed on me!

IV: LETTER TO A YOUNG WOMAN ARTIST, MARCH 6, 1974*

I'm sorry this has to be so short, because I have a lot I'd like to talk about with you, but try to read between the lines. I hope you're angry but get it over with fast and *use* it while you've got it. I hope you don't stop being angry now and then until things are better for all women, not just artists; I hope you're working from yourself and know how to fuck the art-world pressures when you get out there; and I hope you're working for everybody else too; I hope you'll be the one to figure out a way to keep art from being used the wrong way and for the wrong things in this society; I hope you make your art accessible to more people, to all women and to everybody; I hope you think about that *now* and aren't waiting till you make it, because that's likely to be too late. I hope you remember that being a feminist carries with it a real responsibility to be a *human*. I hope and I hope and I hope....

V. FROM NOTES FOR TWO UNPUBLISHED ESSAYS†

The images most frequently appearing in women's art have biological and sexual sources, to the horror of those who use these configurations neutrally, or those who fear biological determinism. The central focus or aperture (*not* necessarily a "void"), domes, spheres, cylinders, eggs, ovals,

*Reprinted from *Anonymous Was a Woman,* Feminist Art Program, California Institute of the Arts, Valencia, California, 1974.

†"Sensuous, Sensual, Sexual and/or Erotic Abstraction" was written for *The New Eros,* an anthology edited by Joan Semmel, which was never published. "Centers and Fragments: Women's Spaces" was published in Susana Torre (ed.), *Women in American Architecture and Design* (New York: Watson-Guptill, 1977, p. 186–197).

containers, phalluses tend to occur most often in early, or immature, or naive, not yet acculturated work. Unless consciously deepened as part of a mature individual aesthetic, they tend to disappear or go underground with the rise of sophistication, exposure to the art world, and success. Needless to say, some men also use these images; there is no technique, form, or approach used exclusively by women. Yet those listed above are ubiquitous in large groups of work by women in and out of the New York or Los Angeles art worlds—far more so than in any body of work by men. Whether this fact is due solely to conditioning, or whether other elements are in question, cannot be decided yet, but must surely be investigated.

Artistic motivation and imagery have rarely been studied by people who understand the aesthetic and art-historical sources as well as the psychological ones. And on the other hand, much has been written in recent years about the perception of contemporary art from the retinal and philosophical points of view, and from that of Gestalt psychology, but a most significant element in seeing art has been neglected—how a viewer innocent of "art appreciation" looks at art, and the influence of the individual's experience, fantasies, and associations as they merge, or not, with those of the artist. Because women's erotic experience is not the same as men's, and because a great deal less is known about it than about male sexuality in art, this area of identification may be harder to perceive. Because of the dangers of exposure, sexual imagery in women's art has been externalized so unconsciously that it remains personally threatening for many artists to confront their own content. There are endless degrees of acceptance, neutralization, and outright denial involved in any study of women's imagery, especially sexual imagery. Conditioning, however, now works both ways. In contrast to those women artists who have suffered too long and lean over backward to avoid association and identification with other women, there are those who lean over forward to cultivate their feminist identities through self-conscious choice of "female" images and techniques and content. Among the former is Georgia O'Keeffe, who said, "Eroticism! That's something people themselves put in the paintings. They've found things that never entered my mind. That doesn't mean they weren't there, but the things they said astonished me."[2] Among the latter are those Los Angeles feminists who are "not indiscriminately interested in just any art made by women, for a lot of women have emotionally and psychically internalized the male world.... We are interested in a level of sensation and sensitivity directly related to cunt sensation. I'm not talking about sex or orgasm as much as I am about the experience of cunt as a living, seeking, pulsating organism."[3]

Needless to say, there is a broad middle ground between these two attitudes. Louise Bourgeois was able to overcome those years in which female

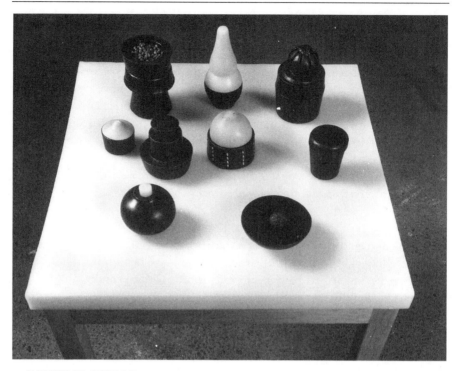

MICHELLE STUART
Seed Containers #3, 1993
VARIOUS SEEDS, BEESWAX, PINE, 3 8 ½ " × 2 5 ¾ "
Photo: Karen Bell, courtesy Fawbush Gallery, New York.

These extremely sensuous (even aromatic) black and honey-colored wax vessels are
the three-dimensional heirs to Stuart's monumental scrolls from the seventies,
formed of earth and obsessive repetitive touch, or caress.

sexual imagery was acceptable only if subliminal and the artist was seen as a
feeble medium whose "natural" acts were left to be "culturally" interpreted
by others. "For a long time," she recalls, "the sexual aspect in my art was
not openly acknowledged. People talked about the erotic aspects, about my
obsessions, but they didn't discuss the phallic aspects. If they had, I would
have ceased to do it....Now I admit the imagery. I am not embarrassed
about it."[4]

It is no accident that so much of the dialogue about whether there is and
what is a female imagery has centered upon sexual concepts. If women are
more obsessed by sexuality than men, it is because we have been raised and
conditioned to think of ourselves and our futures in sexual terms. Sex is a
way of obtaining our desires and it is also the key to the love and affection
we are supposed to be so dependent on. Lynda Benglis, for instance,
believes that a female sensibility is based on the fact that "women want to

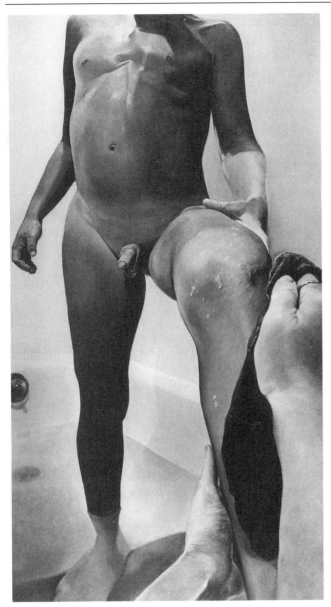

JOAN SEMMEL
Bathing Andy, 1975
OIL ON CANVAS, 108″ × 60″
Photo: Bevan Davies.

This moving and potentially disturbing image about the mother/son relationship
was part of a body of work in which Semmel explored sexuality "through the
object's eyes," looking for a new woman-centered eroticism that combined intimacy
and autonomy.

please…women make pleasing art."[5] And for better or worse, our interpretations are also conditioned by the pervasive influence of Freud, who listed as symbolic representations of the female genitalia "all such objects as share with them the property of enclosing a space or are capable of acting as receptacles such as pits, hollows, and caves." Many women artists, whether or not they choose to acknowledge the role of interior space and central-core imagery, are consciously preoccupied with formal relationships between inside and outside—among them Louise Bourgeois, Mary Miss, Ree Morton, and Jackie Winsor.

Traditionally, inside represents female, outside, male. We have broadly accepted the male concern with facade and monument, the female concern with function and environment; the male concern with performance and structural imposition, the female concern with adaptability and psychological needs; the male concern with public image, the female resistance to specialization; the male concern with abstract theory, the female concern with biography and autobiography. These stereotypes are more often proved right than wrong. Interiors are seen in women's literature as prisons and sanctuaries. In the visual arts, women's images of enclosed space convey either confinement (inside looking out, as in the graphic works depicting windows from the inside, windows as barriers or protectors) or else freedom within confinement (inside looking in, turning to the self in isolation) or combinations of the two.

Sometimes nature is "out there," on the other side of the window, representing life and opposed to compartmentalized death. The editor of a 1945 kitchen-improvement contest for farm women noted, "I don't believe there was an entry that didn't mention plans for enlarging at least one window," and the first criterion for a house was one which "fits the land." As the earth is identified with the female body, the garden may provide a transition to the world seen through the window. Christine Oatman's environmental sculpture, *A Child's Garden of Verses,* is a fantasy in praise of fiction, poetry, the imagination as escape. Shoes and socks belonging to an invisible little girl are left outside the gate in a picket fence that encloses a grassy plot. Barefoot, her senses tuned, she belies her confinement by creating other worlds within, marked by piles of books and tiny constructions that seem to have emerged from their pages—a Greek temple of sugar cubes occupied by a Monarch butterfly; a glass train going through a tunnel hollowed out of a loaf of bread; a sky-painted egg.

On another level, that of the universal mythologies of Mother Nature, the Devouring Mother as part of the ouroboric "Great Round" of nature, birth and death, there are Eunice Golden's series of abstracted sexual landscapes, one of which shows woman crucified on the land, paralleling Paul Shepard's notion that the sexual anthropomorphism of the world is the "last

defense against the naive reductionism and pseudo materialism of the [male] technological society which confers death and uniformity on the landscape."[6] An untitled painting by Cynthia Carlson of a padded or furrowed landscape, or cave, with the earth's skin peeled away in layers by three inhuman instruments to admit light from a distance, is an extraordinary combination of several of these themes—an image at once cruel and hopeful, which might evoke the pain of either violation or rebirth.

At the core of experiencing any sensuous to sexual art is body identification. I have used, out of context, the psychological term "body ego," and Gaston Bachelard's "muscular consciousness" to refer to that sensation of physical identification between a work of art (especially sculpture in its three-dimensionality) and the body of the maker and/or viewer. As Barbara Hepworth has said, people who find her work difficult to understand are "the ones who've decided that women artists are no damned good anyway and they stiffen up as soon as they see a work. So they won't go round; they can't touch....You can't make sculpture without involving your body....The spectator is the same....In sculpture the main thing to do is to stand on your toes and become aware of the fingertips."[7]

When private expression is exposed to public interpretation, a certain amount of dislocation inevitably results. This is all the truer of art based on women's sensuality, which has traditionally been forbidden and devaluated subject matter. Since artists learn from communicating with their audiences, and the broader based the audience, the more they learn, the damage done to women unable to exhibit, teach, find role models in history, participate and communicate in the art world becomes particularly devastating. If it is generally assumed that there is opposition between nature and culture, if "woman creates naturally from within her own being, while men are free to, or forced to, create artificially...through cultural means,"[8] then it helps to explain why women choosing to depict their own sexual experience would have been considered in dangerous opposition to "high art." Like the education of children, contemporary art "evolves" from the defiling environment of women to the more exalted and abstract world of men. Sexual art made by women, recalling in its yawning and often ominous pits and mountains the origin of man, is distasteful and threatening to the "maturity" of the male-dominated establishment. Even Hepworth has been accused of making "menacing forms." As Barbara Rose has remarked, erotic art focused on vaginal images "is profoundly radical in that it attacks the basis of male supremacy from the point of view of depth psychology," attacks "the most fundamental area of male supremacy—that a penis, because it is visible, is superior....Women's erotic art is in effect propaganda for sexual equality based on discrediting... the idea of women as unclean Pandoras with evil boxes."[9]

The stereotypes of "female imagery" have not been imposed by men. Women are not so weak. They have arisen from the work of those few women who dared to make such subject matter visible and to accept the potential scorn of a society unfamiliar with it. A notable example is Lee Bontecou, whose sculpture from the early 1960s, with its dark central cavities forced into high relief and the occasional *vagina dentata* form, was received with apprehension, although eventually accepted on the basis of its formal power. At the end of that decade, however, Bontecou's art changed drastically—not in style, or even imagery, but in strategy—from the "tough" threatening canvas and metal constructions to tender, transparent plastic fishes and flowers whose insides are totally exposed rather than remaining dark secrets. Seeing these, one realized just how much the earlier work, which had seemed so bold in its "femaleness," had in fact been confined by the rules of the art society in which it was understood. Perhaps the most overwhelming problem facing the development of a truly feminist art is the state of aesthetic perception in the culture as a whole.

Six

Is there a women's art?

What do you mean—an art by women?

A lot of women do art, but is there an art made only by women?

All women?

No, just an art, no matter how little of it—not a style and not a technique, but something broader—that's done only by women.

I don't know. Is there?

Well, there should be. Women's experience—social and biological—in this and every other society, is different from men's.

And every *person's* experience is different from every other person's. Art is individual.

It's still possible to generalize about it. Black experience is different from white. Poor is different from rich. Child's art is different from adult's. And women's is different from men's.

But art is a mixture. Art is androgynous.

Sure, artists are probably more androgynous than "normal" people. Like male artists, no matter how macho they are (or because of it), have more of the woman in them than some other men in other professions. God knows women artists have traditionally had to have some "male" in them to get the hell up and create something on the primary level—or rather to have it seen as such. It takes imagination to transcend your sex. But it's dangerous, like building a house on sand. If you don't know your own identity, the real meaning of your own experience, you can't just jump up and "transcend." Eva Hesse once described the female part of her art as its sensitivity and the male part as its strength. Hopefully a year later she would have realized it could all be unified, that strength is female too.

One of a series of columns, reprinted from *Studio International* 187, no. 963 (Feb. 1974), slightly revised.

Why will so few women admit to using their own bodies or biological experience even as *unconscious* subject matter?

Because it has been common knowledge that "women are inferior" and women artists trying to transcend that in their work sensibly don't want to identify with inferiority. So why not aspire to "maleness"?

But now that everybody knows women aren't inferior?

Ha! Everybody hasn't gotten the message yet. Anyway, it still holds in our generations, through conditioning. It's in the back of our minds, as fear or as rage, even when the rhetoric's on our lips.

Not in the back of *mine*, it isn't.

You're lucky, then. Another reason women don't like their art to be seen through their bodies is that women have been sex objects all along and to let your art be seen that way is just falling right back into the same old rut.

Not once attitudes are changed. Not once you can be proud of being a woman.

Nobody whose consciousness has been raised wants to be seen as just a vagina, an interior space, a cunt. You're hardly doing women a favor by laying that kind of restriction on them.

It's not a restriction. It's a basic element to our own identities we have to come to terms with. Did you hear yourself say "*just* a vagina"? Anyway, I didn't say that sexual or biological identity was the only factor in women's art. But to make art that is together, unified with the maker, that too has to be acknowledged instead of apologized for. And it's *there*. I looked at the New York Women's Art Registry—something like twenty-five hundred slides of women's work; I saw them with a man and he kept saying, "A man couldn't have made this work." It wasn't necessarily a compliment, but it was a fact we could both see. A huge amount of the work, especially the more naive or funky (and therefore often more directly inside art, less affected by bandwagon art-world numbers), did have blatant sexual subject matter, and so did a lot of the work made by women who deny that subject matter even when it's visible, by saying, "Oh, I wasn't thinking about that so it isn't there." Sex is bound to be a factor in women's work precisely because women have been sex objects and are much more aware of their bodies than men. Men are aware of their pricks. Women are aware that every movement they make in public is supposed to have sexual content for the opposite sex. *Some* of that *has* to come out in the work. When it's absolutely absent, when it isn't even suggested, I wonder.

But that's like the cliché "Women are irrational and men are rational"; "Women are illogical, men are logical." You're taking women down to the level of mere bodies, while men can repress that and are allowed to make art with their minds.

No. No, not at all. Just that good art by either sex, no matter how

"objective" or "nonobjective," has to have both elements or it's dead. But I must say that I think a lot of what we call logic and rationality is a male-focused, male-invented code. So-called logic is often insanely illogical, but it's still called logic because it works within its own system. Like formalist or Minimal art is popularly supposed to be logical because it looks like it should be, while work with a more obviously psychological basis is called illogical. I'd like to see those terms forgotten and have people look at everything according to a new set of criteria, criteria that don't imply value judgments through the use of certain code words or phrases. When I write that something is illogical in art, and I like it, I have to add "marvelously illogical" or it will be seen as a put-down. Not so with logic, which I often think is "merely logical." R. D. Laing pointed out the same thing about subjective and objective; he said it was always "merely subjective." I'm constantly called illogical, and I don't care, because for me it's logical, according to my own system.

Crazy lady.

Maybe, but I know that a certain kind of fragmentation, certain rhythms, are wholly sensible to me even if I can't analyze them. I find that fragmentation more and more often in the art—written and visual—of women who are willing to risk something, willing to let more of themselves out, let more of themselves be subject to ridicule according to the prevailing systems. Part of the energy that emerges from that impetus is sexual. Part is intellectual in a new way. Of course there's still an endless stream of art by women who are copying the old way, who are scared to alter the mathematics or geometry or logic or whatever it is they're interested in toward a new and perhaps more vulnerable model. I'm certainly not saying that any of those things should be taboo for women's art. But I'm convinced that women *feel* them differently and *that* either does not come out or should come out in the art. Like the way so many women artists are using geometry or the grid primarily to blur its neat edges, to alter its meaning, to subtly screw up the kind of order that runs the world. The most convincing women's art I see, of any style, is very personal, and by being very personal finds a system of its own.

But you're so vague.

I know. On one hand I don't want to draw any conclusions. I mistrust conclusions because they get taken for granted and stop the flow of things. On the other hand, even if I wanted to, I couldn't draw conclusions on this subject now because I don't know enough. And because society hasn't radically changed yet for women, so what we're seeing is a mixture of what women really want to do and what they think they should do....

The Women Artists' Movement
—What Next?

This year's Paris Biennale includes approximately twenty-five female participants out of one hundred and forty-six artists. This dubious triumph is cause for at least some celebration, since previous ratios have presumably been far lower. It is interesting that the percentage of women in this show is a little lower than, but close to what seems to have been made the gender quota by the Whitney Museum of American Art's Biennials and by a few other American organizations. The Whitney, which was struck by and responded to demands by women artists in 1970, raised its percentage by four hundred percent and then stopped dead in its tracks. No figures are available on the international artists' population, so it is anybody's guess whether only twenty percent of the artists in the world are women. However, I suspect that this figure marks a barrier rather than a fact, a barrier that will have to be a target of the next wave of the women artists' movement—should there be such a wave.

I say "should there be," because it appears that for many women artists this figure is satisfactory. Attitudes range from successful elation to modest pleasure to uneasiness to bitterness, depending on the effect the women's movement has had (1) on their lives, and (2) on their careers. The great danger of the current situation in America (presumably less so in Europe, where the women artists' movement is just beginning) is that this barrier will be accepted, that women artists will be content with a "piece of the pie" so long dominated by men, satisfied with the newfound luxury of greater representation in museums and galleries (though not yet in teaching jobs, not yet in the history books) rather than continuing to explore alternatives. These alternatives will, hopefully, change more than mere percentages,

Reprinted from the catalog of the 9th Biennale de Paris, 1975.

more than the superficial aspect of the way art is seen, bought, sold, and used in our culture. The pie so eagerly sought after is, after all, neither big nor tasty enough to satisfy all appetites. The pie, in fact, can be seen to be poisonous. Women artists entering the system for the first time after many years of painful struggle can hardly be blamed for not noticing this. Pie is pie for the starving. Nevertheless, it is crucial that art by women not be sucked into the establishment and absorbed by it. If this happens, we shall find ourselves back where we started within another decade, with a few more women known in the art world, with the same old system clouding the issues, and with those women not included beginning to wonder why. The worst thing that could happen at this time would be a false sense of victory. Some things have changed a little, most have not.[1] For this reason I have mixed feelings about the increased number of women in the Paris Biennale this year, and, hopefully, following years.

It is no coincidence that the women artists' movement emerged in a time of political travail and political consciousness, nor that the art-world tendency toward behaviorism and content and autobiography coincided with the women's movement and its emphasis on self-searching and on the social structures that have oppressed women. Ideally, the women artists' movement could provide a model for the rest of the world, could indicate ways to move back toward a more basic contact between artists and real life. One of the major obstacles to consolidating the gains made since 1969 has been a lack of real consciousness raising within the middle class, which makes up the bulk of the women's movement. Subsequently there has been a lack of identity with and support for other women artists, except in such special advanced situations as the Los Angeles Woman's Building. It is certainly important that there be role models for younger women artists, that they be able to see women in the classrooms, the museums, the history books, so that their own progress does not seem utterly impossible. But it is still more important that the community forged in the early days of struggle not be diminished when a few are successful. Each woman artist who "makes it" into the establishment must feel responsible on some level for those who have not been so fortunate. But still more so, it is important that we do not adopt the criteria set by the existing structures, but insist upon the individuality of what women have to offer as women, that we revise and revolutionize criticism and exhibition and market procedures in our own image.

This is perhaps the most controversial question in the women artists' movement today: Is there an art unique to women? Another way of putting it, which alters the ramifications, is: Is there a feminist art? The two intersect interestingly. On the first question, I, for one, am convinced that there are aspects of art by women that are inaccessible to men and that these

aspects arise from the fact that a woman's political, biological, and social experience in this society is different from that of a man. Art that is unrelated to the person who made it and to the culture that produced it is no more than decorative. It would be ridiculous to assert that the characteristics of the female sensibility that arise from this situation are not shared to some degree by some male artists, and denied by numerous women artists. The fact remains that certain elements—a central focus (often "empty," often circular or oval), parabolic baglike forms, obsessive line and detail, veiled strata, tactile or sensuous surfaces and forms, associative fragmentation, autobiographical emphasis, and so forth—are found far *more often* in the work of women than of men. There are also, of course, characteristics far more subtle and more interesting that cannot be pinned down in one sentence, and any such simple-minded listing should raise opposition. Yet anyone who has studied the work of thousands of women artists must acknowledge its veracity.

What is more provocative than the mere fact that a female sensibility exists is the question it raises. For example, is this common imagery the result of social conditioning or of something deeper? Is it more likely to result from conscious awareness of one's experience as a woman, or from the unconscious experience of isolation? It has been noted that the work of women artists was more blatantly "female" when barred from the art community, hidden away in the closet—probably because of immunity to art-world fashions and pressures; as a woman's work matures and gains a broader public, it seems to refine these unconscious images into more subtle variations and sometimes discards them completely. On the other hand, the opposite process is also at work. Women who have become feminists under the influence of consciousness raising have moved from a neutralized to a formidably overt contact with their own experience (and frequently to a focus on sexual experience). Which provokes the question: Is feminist art necessarily concerned with female experience and/or sexual experience? There are many women artists who consider themselves feminists but who work from other sources. Art by women is not necessarily feminist art. The problems that interest many of us most at the moment are how *do* we define a feminist art; how *do* we make the distinctions?

Part of the resistance on the part of some women artists to identification with other women artists is the product of years of rebellion against the derogatory connotations of the word "feminine" applied to art or any other facet of life. Until very recently, most of the women over the age of thirty in the art world have been survivors. Sufficiently early in our lives we learned to identify with men rather than with women, to be "one of the boys," to be accepted. With the advent of the women's movement it was

suddenly possible to stop being ashamed of being a woman, but "inferior" has not changed to "superior" overnight, and many artists are still understandably reluctant to be identified with other women. It has been argued that by emphasizing our femaleness, women artists are just playing into the hands of the men who have stereotyped and downgraded us for years. "My art has no gender" is a common statement. Of course art has no gender, but artists do. We are only now recognizing that those "stereotypes," those emphases on female experience, are positive, not negative, characteristics. It is not the quality of our femaleness that is inferior, but the quality of a society that has produced such a viewpoint. To deny one's sex is to deny a large part of where art comes from. I do not think it is possible to make important or even communicable art without some strong sense of source and self on one hand and some strong sense of audience and communication on the other. I do not agree, obviously, with Agnes Martin's statement that "the concept of a female sensibility is our greatest burden as women artists." Only when we have understood that concept will we be released from the real burden—the strictures that make possible in the first place qualitative distinctions between men's and women's art.

Women's art has not yet been seen in its own context. In 1966, I wrote for the "Eccentric Abstraction" catalog that metaphor should be freed from subjective bonds, that "ideally a bag remains a bag and does not become a uterus, a tube is a tube and not a phallic symbol, a semisphere is just that and not a breast." At that time I neither cared nor dared to break with that attitude, which was part of a Minimally and intellectually oriented culture in which I was deeply involved (though I was seeking in that exhibition a way back to a more sensuous experience for abstract art). I can no longer support the statement quoted above. I am still emotionally and contradictorily torn between the strictly experiential or formal and the interpretative aspects of looking at art. But the time has come to call a semisphere a breast if we know damn well that's what it suggests, instead of repressing the association and negating an area of experience that has been dormant except in the work of a small number of artists, many of them women. To see a semisphere as a breast does not mean it cannot be seen as a semisphere and as endless other things as well, although the image of the breast used by a woman artist can now be subject as well as object. By confronting such other levels of seeing again, we may be able to come to terms more quickly with that volcanic layer of suppressed imagery so rarely acknowledged today. And such a confrontation can only produce a deeper understanding of what makes women's art different from men's art, thereby providing new and broader criteria by which to evaluate the concerns of half the world's population.

The L.A. Woman's Building

At night, the Woman's Building at 743 Grandview, Los Angeles, in an "ethnic" neighborhood near MacArthur Park, is bathed in pink floodlights.[1] In its closets, the tools are painted pink. It opened last fall in the former Chouinard Art Institute building, exactly eight decades after the inauguration of its namesake, the Woman's Building of the World's Columbian Exposition in Chicago in 1893, which was designed by a woman and included murals by Mary Cassatt, and whose catalog declared:

> The great work of the world is carried on by those inseparable yoke-mates man and woman, but there are certain feminine touches in the spiritual architecture which each generation raises as a temple to its own genius, and it is as a record of this essentially feminine side of human effort that the Woman's Building is dedicated.

Today this might be stated in different terms; eighty years have turned those "gentle touches" into blows for justice. The new Woman's Building (managed by Edie Gross) shelters an impressive group of feminist organizations:

Womanspace, a community art gallery and center, directed by Marge Goldwater, that was the prototype for the whole project when it opened at another location last year;

The Feminist Studio Workshop, a small, far from conventional art school, founded by art historian Arlene Raven, designer Sheila de Bretteville, and painter Judy Chicago, that will receive accreditation next year from the International Community College;

The Center for Art-Historical Studies, an affiliate of the Feminist Studio

Reprinted in *Art in America* 62, no. 3 (May–June 1974).

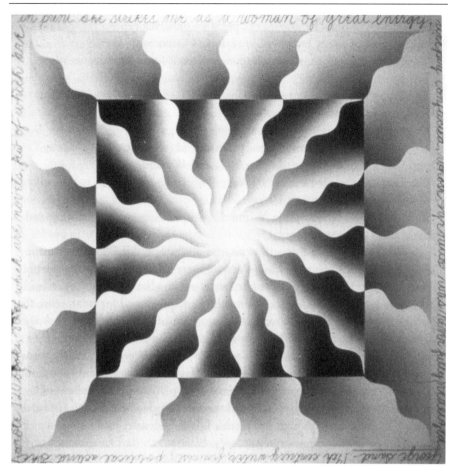

JUDY CHICAGO
George Sand FROM *The Reincarnation Triptych,* 1973
OIL ON CANVAS, 60″ × 60″
Photo: courtesy Through the Flower Archives, Albuquerque.

The triptych was dedicated to women whose work Chicago strongly identified with; the other paintings were *Madame de Staël* and *Virginia Woolf.* The borders are handwritten texts about each woman. "The change in the nature of the image," said Chicago, reflects "the change of consciousness through the last two hundred years of women's history." In *George Sand,* the central panel, "the inside and outside are more at odds [than in *Madame de Staël*], like the inside wants to come out and outside is stopping it. A strong orange glow in the center represents her/my repressed energy."

Workshop run by Raven and art historian Ruth Iskin that includes the Los Angeles West-East Bag slide registry;

Gallery 707, a private gallery owned by Anait Stevens that is also a fore-runner of the Woman's Building;

What is perhaps most interesting is that *art* is the focus of such a place as the Woman's Building. Though in part due to the intensely committed and energetic women who started it and who happened to be involved in art, this may also indicate some of art's potential for effecting real change. The less an alternate structure is in competition with the commodity art world, the better. I sadly doubt if New York, whose art world is too large, too powerful, too competitive, will ever succeed in having a single-focused center like the Woman's Building; New York lends itself to many separate institutions, often overlapping ones. (At the moment there are the Women's Interart Center, the closest we have to the Woman's Building; A.I.R. and SoHo 20, nonprofit women's galleries; the Women's Art Registry—the slide file; and various political and consciousness-raising groups, both organized and informal.) I suspect we'll need such rooms of our own for some time. The difference between talking to a mixed art-school class and one made up solely of women has to be experienced to be believed, but there sure as hell *is* a difference in the way women open up, become smart and imaginative and assertive—and better artists. Those who denounce such situations as "separatist" should just get a glimpse of the sense of purpose and the relaxed exhilaration at the Woman's Building. There, everything seems possible—including a nonseparatist future.

Making Up: Role-Playing and Transformation in Women's Art

A New Life, or the Unnecessary Betrothal of Frau Holle with the Shaman, *a series of photographs by Christiane Möbus in which the artist, dressed in giant feathered wings, dances across a landscape, perches in a tree.*

*

A series of booklets by Athena Tacha dealing with aspects of her self and life, including an illustrated one detailing her physical features according to heredity, and one on the emerging effects of age on her body.

*

The Haube, *video tape by Ulrike Rosenbach of herself in her kitchen wearing the obsolete headdress worn by European women in the Middle Ages "originally designed to denote possession by the husband, and developing through usage to be the symbol of her self-confidence and equality."*

*

A series of photographs by Renee Nahum showing people first in working uniforms, then in their "own" clothes.

*

Shocking, bloody "rape tableaux" performed by Ana Mendieta with herself as victim.

*

First published as "Transformation Art," *Ms.* 4, no. 4 (Oct. 1975).

An exhibition by "Judy and Adrienne" of memorabilia from their own pasts, from baby pictures to prom corsages to divorce papers.

*

Judith Stein proposes a name change, solicits suggestions, then publishes them, but reasserts her own identity by not changing her name.

*

Susan Mogul's very funny video stories, in one of which she proceeds from disrobed to robed, reminiscing about the history of each item of clothing.

*

MARTHA WILSON
I Make Up the Image of My Deformity; I Make Up the Image of My Perfection, 1974
COLOR SLIDES

Wilson explores the roller coaster of self-imagery in a society that dictates how women should look. As founder/director of Franklin Furnace and a target of censorship since the eighties, Wilson has continued her persona works, appearing in public as Nancy Reagan, and then as Tipper Gore.

Laurie Anderson's series of photographs of men in her neighborhood, taken by her as they accosted her or commented on her appearance, with captions describing each situation. [See page 2 1.]

*

A "father-daughter piece" by Joanne Seltzer—a montage of herself as a ballerina over a grid of checks paid by her father for ballet lessons and supplies.

*

Handwritten cards detailing the life of one Anne Chapman Scales. I receive them almost weekly and come to know her quite well; later I am informed they are sent by a Joseph Gabe. I am disappointed because I could have sworn they were by a woman; next I am informed that J. G. is only a name used "at certain times when I am not making art, but thinking about it," by Mary Jean Kenton. (I think she's real.)

*

The pieces listed above are among a growing number of artworks by women with the self as subject matter. The turn of Conceptual Art toward behaviorism and narrative about 1970 coincided with the entrance of more women into its ranks, and with the turn of women's minds toward questions of identity raised by the feminist movement: What Am I? What Do I Want to Be? I Can Be Anything I Like But First I Have to Know What I Have Been and What I Am.

Conceptual Art—inexpensively written and/or photographed or taped pieces in which the idea is usually more important than the visual object— provided a direct outlet for private journals and relics, undared performances, self-revelations that had until then been mostly "closet art." Many of these artists chose themselves as their subject matter, a natural outcome of the previous isolation of women artists and of the general process of consciousness raising. Some chose an autobiographical method; many chose to concentrate on a self that was not outwardly apparent, a self that challenged or exposed the roles they had been playing. By means of costumes, disguises, and fantasies, they detailed the self-transformation that now seemed possible.

The first manifestation of such transformation was not intended as art; it was an announcement of painter Judy Chicago's show at California State College at Fullerton in 1970, and of her simultaneous name change (she had to procure legal permission from her husband, whose name she had never used). Chicago appeared as a prizefighter, leaning arrogantly in her corner; there were those, of course, who instantly misread her statement as a lesbian, rather than an across-the-board feminist, challenge.

Four years later, Lynda Benglis, also living in California (where an honored macho tradition is the exhibition announcement showing a photograph of the artist—usually featuring a cigar, cowboy boots, a truck, and/or a dog— rather than his work), deliberately took her image as a serious sculptor in vain, with four consecutive published photographs: the first (an exhibition notice and ad) showed her as a child dressed in a skirted Greek soldier's costume; the second (an ad) showed her leaning against a car, short hair plastered back, looking mean; the third (a long color postcard announcing an exhibition) showed her in a cutie pinup pose, coyly peering over her shoulder, nude except for her jeans around her calves over platform boots; and the fourth, which must be the climax, was a full-color advertisement in *Artforum* magazine showing the artist in shades but nothing else, belligerently and flirtatiously sporting a gigantic latex dildo.

The series has, needless to say, been wildly controversial. A group of *Artforum*'s editors played into Benglis's hands by writing a pompously irate letter in which they condemned her ad as "an object of extreme vulgar- ity...brutalizing ourselves and...our readers," making at the same time a mealymouthed claim that the magazine had "made conscious efforts to support Women's Liberation." Readers' responses to the letter were largely in favor of Benglis: art historian Robert Rosenblum voted "three dildos and a Pandora's box" to the artist and bemoaned the fact that the editors hadn't been "around to protest when Dada and Surrealism let those arty people run amok and do unspeakably vulgar things." Another reader was shocked that the editors were shocked. On the other side, one man pettishly noted, "I don't care what she is doing with that dildo, and furthermore I don't even like her artwork," while another tried to vandalize an abstract sculpture by Benglis in the Philadelphia Museum of Art.

Benglis herself intended the series as a "mockery" of role-playing, and the dildo ad as a "media statement...to end all statements, the ultimate mock- ery of the pinup and the macho." Certainly it was a successful display of the various ways in which woman is used and therefore can use herself as a political sex object in the art world, and it was thus that the series was generally understood by the audience to whom it was directed in the first place—younger women artists.

Of the virtually hundreds of women here and abroad working with self-trans- formation as art, five who have been doing so with particular effectiveness are Eleanor Antin in San Diego, Adrian Piper in New York (now Boston), Martha Wilson in Nova Scotia (now New York), and Nancy Kitchel and Jacki Apple in New York. They speak about their work in terms of expanding identity, of an "awareness of the boundaries of my personality" (Piper),

"moving out to, into, up to, and down to the frontiers of myself" (Antin).

Antin had made biographies of women from objects and words before turning primarily to photography. In *Domestic Peace,* she documented with texts and graphs the transformation of herself into the "good daughter" while staying a few weeks with her mother, "so she would leave me alone to pursue my real interests." In *Carving: A Traditional Sculpture,* she peeled away the flesh in search of her own Michelangelesque core, documenting a ten-pound weight loss over thirty-six days with 144 nude photographs.

In video pieces, Antin has projected four selves: The Ballerina (every little girl's dream?), The King, The Black Movie Star, and The Nurse, discovering in the process that "a human life is constructed much like a literary one," and that her characters—hybrids of autobiography and fiction—began to lead their own lives. "Autobiography in its fundamental sense,"

ELEANOR ANTIN
AS *The King of Solana Beach,* 1975
Photo: courtesy Ronald Feldman Fine Art, New York.

This was the first of Antin's ongoing personae. Over the years she has been a nurse on the Florence Nightingale model, a black ballerina, and the ballerina Eleanora Antinova. The ballerina figure carried her into other characters, indoor installations, performance art, and finally film, the vehicle for her "historical" narratives in the nineties.

says Antin, "is the self getting a grip on itself....[It] can be considered a particular type of transformation in which the subject chooses a specific, as yet unarticulated image and proceeds to progressively define [herself]....The usual aids to self-definition—sex, age, talent, time, and space—are merely tyrannical limitations upon my freedom of choice."

The "drag syndrome," which goes back to Duchamp's female avatar, "Rrose Selavy," is inherent in any exploration of sexual role-playing. Antin thought herself "in drag" when she wore a skirt for the first time in two years. Martha Wilson's photographic *Posturing: Drag* was a double transformation in which she became first a man, then a man dressed as a woman. Perhaps such trying on or trying out of different roles is the opposite of disguise. A woman who assumes a primary or "male" role is not (as is presumed) "in drag." Wilson began in 1971 to concretize her fantasies through makeup, clothes, and facial expression. She dyed her hair, became a glamour queen, recorded the emotional grimaces made before a mirror and a camera, comparing these two images of self-consciousness. (How often have we all "practiced" for some scene or confrontation to see how we'd look when? Or dressed up or changed our hair with only ourselves as appreciative audience?)

Wilson discovered during this period that "artmaking is an identity-making process....I could generate a new self out of the absence that was left when my boyfriends' ideas, my teachers', and my parents' ideas were subtracted." When she and Jacki Apple met, they found they had been working in a similar direction and they began to collaborate, creating "Claudia: a composite person who exists in the space between ourselves, a fantasy self—powerful, gorgeous, mobile—who is the result of the merging of the realized and the idealized self."

One Saturday, six New York women who shared this "fantasy of omnipotence" dressed up fit to kill and lunched at the Plaza as Claudia; then they took a limousine to the SoHo galleries, engendering admiration and hostility along the way. "By manipulating elements from the culture to our own ends," they discovered an expansion of the self, "power over destiny, choice of and responsibility for one's own actions."

"How others see me" and "how I see myself" are two of the basic themes that lend themselves to Conceptual media. Makeup (pretend) is in turn one of the basic tools. In 1972, *Léa's Room* at the Cal Arts Feminist Art Program's *Womanhouse* was occupied by a lovely young woman sitting before a mirror, day after day, putting on makeup, wiping it off in discontent, beginning again, dissatisfied again. When Apple had herself "redone" as an artwork at a department store in a free cosmetic advice session, she came out looking just as she makes *herself* up. A fashion designer already equipped

with a strong sense of identity, she works mainly with the effects of disguise on other people, or in relationship to herself. She has concentrated on three themes: "Transfer/Exchanges (exploring [Freud's idea of] the four people in every relationship between two)"; "Identity Exchange (changing roles with another person)"; and "Identity Redefinition (many views of myself as defined by others' perceptions)." Wilson and Apple solicited opinions about themselves and their appearances from acquaintances and documented them, evolving a new form of the self-portrait.

The effect of events or the personality of others (especially relatives) on oneself is a major aspect of this concern. Nancy Kitchel, who has worked frequently with secrets and disguises, has made two pieces involving her complex interaction with her mother—one documenting changes in the artist's physiognomy during a visit home, and the other an eerie telephone tape "seen" by earphones. She also made a series of photographs—*Identity Piece* I—showing the gestures and mannerisms she had inherited from her "rebel grandmother." These pieces led Kitchel "to think that the mental processes of one person are available to another through physical clues and can be at least partially understood through the reenactment or re-creation of...physical attributes."

Since then Kitchel has continued the *Identity Piece* series and has worked on *The Intruders*—"pieces which refer to penetration anxieties, jealousy, rejection fears, and territorial concerns." Two of the most poignant of the *Intruders* pieces deal with the exorcism—first literal, then figurative—of the women who were with her husband after she was, and with her lover before she was.

Exorcism—of an imposed sex role, of authority figures, of social expectations, or of childhood hang-ups—might in fact be said to be the subject of much of these artists' work. For instance, a much more drastic example of disguise was offered by Adrian Piper in the *Catalysis* series, which involved her appearance in public looking "mutilated" in some way: riding the subway in clothes that had been soaked for a week in a mixture of wine, cod liver oil, eggs, and milk, or with her clothes stuffed with Mickey Mouse balloons; in the Metropolitan Museum blowing gum bubbles and leaving the remains on her face; in a library with tape-recorded burps going off every few minutes. At the time of the action she neither talked nor provided any explanation to passersby for her bizarre conduct, though later she substituted conversation for costume as her instrument. No immediate distinction was thus made between art and madness except in her writings, published in art contexts.

Among other things, Piper was protesting that art was imprisoned within its own world and did not reach into the real world: "I needn't live my art-

object life in the presence of an art audience in order to make it aestheti-
cally valid, although I did when I went to art school and presented and
discussed my work with teachers." She realizes that being a woman (and of
mixed racial background, though seemingly white) has a great deal to do
with this aggressive use of her own face and body to disorient society. "At
times I was 'violating my body'; I was making it public. I was exposing it. I
was turning me into an object," but an object that was rebelliously more

ADRIAN PIPER
Cornered, 1988
VIDEO, TABLE, LIGHTING, BIRTH CERTIFICATES
Photo: Fred Scruton, courtesy John Weber Gallery, New York

Piper's performance work is always painful, but she also gives herself the pleasure of
fighting back, which is the focus of the partially autobiographical polemic of *Cornered.*
In earlier works, she crossed lines of gender, race, and sanity, appearing in the
streets as a Hispanic male, or grotesquely transformed, or acting out. Later, in
dramatic performance monologues, she danced sensuously with long, flowing hair
and a mustache.

CINDY SHERMAN
Untitled, 1985
COLOR PHOTOGRAPH, 72½″ × 49⅜″
Photo: courtesy Metro Pictures, New York.

Sherman began in the late 1970s to simultaneously interrupt and reproduce the master narrative on gender and representation. From the early black-and-white film stills, into the life-size color self-portraits, Sherman's entire physiognomy seems to change according to expression, disguise, and lighting. Behind and before her own camera, she is threatened and threatening, battered and satisfied, a challenger, a victim, a tease, a harridan. This haunting, timelessly garbed or turbaned series of witchlike archetypes, commissioned by *Vanity Fair* to illustrate children's fairy tales, was, understandably, rejected.

repellent than attractive. Also relevant is the fact that Piper was once a model—the epitome of professional role-playing, of the transformation of a woman into whatever someone else thinks she (and everyone) should look like, with the resulting loss of identity. Still in her twenties, Piper is now on scholarship at Harvard, getting her doctorate in philosophy, a field she has found "siphons off all my abstractions," and makes her "feel much more concrete" about her art.

All of this work may be seen as the visual counterpart of the "confessional" and "diaristic" literature that many women writers so unjustifiably disavow. The artists claim it in defiance of what is expected of art and of them. Although clearly related to conventional self-portraiture and straight photography (Diane Arbus's work, for instance), as well as to literature, the examples here belong in the flow of an expression at one less remove from real life, real time, real experience than the traditional fine arts. If narcissism is not always redeemed by aesthetics, these artists have, nevertheless, brought a flood of psychological insights to the nature of all art as a transformational process, to the relationship between artwork and artist. Art is, after all, a fantasy, for all its imagined "new realisms," and the artist is a fantasy figure made up by herself/himself in collaboration with society and legend.

The Pains and Pleasures of Rebirth: European and American Women's Body Art

When women began to use their own faces and bodies in photoworks, performance, film, and video, rather than being used as props in pieces by men, it was inevitable that body art would acquire a different tone. Since 1970, when the women's movement hit the art world, it has; and the questions it raises concern not only form and content, but context and political climate. Although the Western world is habitually considered a cultural whole, varying points of view on women's body art have emerged on both sides of the Atlantic, on the two American coasts, and particularly from the two sexes.

I have no strict definition of "body art" to offer, since I am less interested in categorizing it than in the issues it raises and in its relationship to feminism. Early on, the term body art was used too loosely, like all art labels, and it has since been applied to all performance art and autobiographical art rather than just to that art that focuses upon the body or body parts— usually the artist's own body, but at times, especially in men's work, other bodies, envisioned as extensions of the artist him/herself. The differences between men's and women's body art are differences of attitude, which will probably be neither seen nor sensed by those who resist or are simply unaware of the possibility, and ramifications, of such an approach. I am not setting out, therefore, to draw any conclusions, but to provoke thought and discussion about sexual and gender-oriented uses of the body in Conceptual art by women.

As Lea Vergine has pointed out in her book *Il Corpo come Linguaggio* (Milan: Prearo, 1974), body art originated in Europe, although not with the expres-

Reprinted from *Art in America* 64, no. 3 (May–June 1976).

sionist happenings of the sadomasochistic Viennese school in 1962, as she states, but with Yves Klein's use of nude women as "living brushes."[1] In the U.S., something like body art was an aspect of many happenings from the late 1950s on, but bodyworks as entities in themselves only emerged in the late 1960s as an offshoot of Minimalism, Conceptualism, film, video, and performance art. Virtually no women made body art in New York during the late 1960s although it was an important element in the overall oeuvres of Carolee Schneemann, Yayoi Kusama, Charlotte Moorman, Yvonne Rainer, Joan Jonas, and others. In the early days of the new feminism, the first art by women to be taken seriously and accepted into the gallery and museum structure rarely differed from the prevailing, primarily abstract styles initiated by men. If it did reflect a different sensibility beneath an acceptable facade, this was hardly noticed by either men or women.

Bodyworks by women, and art dealing with specifically female and feminist issues, materials, images, and experience, no matter what style they were couched in, became publicly visible with more difficulty than mainstream art and have therefore acquired a "radical" image in some circles. Although such "women's work" eventually suffered a brief vogue, it was initially considered clever, or pretty, but not important, and was often relegated to the categories of naive art, or craft. This, despite the fact that the autobiographical and narrative modes now fashionable were in part inspired by women's activities, especially consciousness raising. Indeed, since much of this women's work came out of isolation and feminist enclaves, rather than from the general "scene," and since it attempted to establish a new iconography, it was justifiably perceived as coming from an "other" point of view, and was frequently labeled retrograde for its lack of compliance with the evolutionary mainstream.

In a parallel development, the concept of "female imagery" arose on the West Coast through the ideas and programs of Judy Chicago and Miriam Schapiro. The initial notion (central-core abstraction, boxes, spheres, ovals) emphasized body identification and biologically derived forms, primarily in painting and sculpture. It met strong resistance when it reached the East Coast, and in New York—the Minimal/Conceptual stronghold—these images were diffused into more deadpan styles and "avant-garde" media. Nevertheless, all kinds of possibilities were opened up to women artists here who had recently espoused feminism, wanted change in their art as well as in their lives, and were mustering the courage to deal publicly with intimate and specifically female experience. If the results on the East and West Coasts were somewhat different, the motivations were the same. Now, six years later, body art combined with a feminist consciousness is still considered more subversive than neutralized art by women that ignores the sexual identity of its maker and its audience.

In Europe, on the other hand, the opposite situation seems to have developed. "Neutral" art made by women still has little chance of making it into the market mainstream, while the male establishment, unsympathetic to women's participation in the art world as equal competitors, has approved (if rather patronizingly and perhaps lasciviously) of women working with their own, preferably attractive, bodies and faces. Most of the handful of women artists who currently appear at all in the vanguard European magazines and exhibitions deal with their own faces and figures. This was borne out by last fall's Biennale des Jeunes in Paris. I have been told that both the male editor of an Italian art tabloid and a male French neo-Duchampian artist have discouraged women from working in any other area by publicly and powerfully applauding women's art that limits itself to these areas. Perhaps, as a result, female critics like Catherine Francblin have had negative reactions to women's body art. In an interesting article in *Art Press* (Paris, Sept.–Oct. 1975), she sees it as a return to infantilism and an inability to separate one's own identity from that of the mother, or subject from object. She blames these artists for "reactivation of primitive autoerotic pleasures. For what most women expose in the field of art...is just the opposite of a denial of the woman as object insomuch as the object of desire is precisely the woman's own body."

The way I see it—obviously controversially—is that due to their legitimate and necessary desire to affirm their female experience and themselves as artists, many European women have been forced into the position of voluntarily doing what the male establishment wants them to do: stay out of the "real world" of sales and seriousness. To extricate themselves, they have the tragic choice of rejecting the only outlet for their work (the magazine and museum systems) or of rejecting their feminist consciousness and its effect on their work and, by implication, rejecting themselves. This does not affect the quality of the art being made, but it does crucially affect how it is perceived and interpreted by the general audience.

The alternative, of course, might be the foundation of art outlets based on solid political feminism, but this too is difficult in a culture where Marxism has successfully overrun or disdained feminist issues, so that the apolitical artist has no place to turn and the political artist has only one place to turn. One does not call oneself a feminist in polite art society in Europe unless one wants to be ridiculed or ignored. All of this must be partially due to the lack of an organized feminist art movement in Europe and of any alternative galleries or magazines for women artists. In the resultant void, middle-class, generally apolitical women have ironically become the sole purveyors of what, in another context and with a higher level of political awareness, might be seen as radical feminist imagery. This happens in the

U.S. as well, but here at least there is a broad-based support and interpretative faculty provided by the women's movement.

It is no wonder that women artists so often deal with sexual imagery, consciously or unconsciously, in abstract and representational and Conceptual styles. Even now, if less so than before, we are raised to be aware that our faces and figures will affect our fortunes, and to mold these parts of ourselves, however insecure we may feel about them, into forms that will please the (male) audience. When women use their own bodies in their art work, they are using their *selves;* a significant psychological factor converts these bodies or faces from object to subject. However, there are ways and ways of using one's own body, and women have not always avoided self-exploitation. A woman artist's approach to herself is necessarily complicated by social stereotypes. I must admit to a personal lack of sympathy with women who have themselves photographed in black stockings, garter belts, boots, with bare breasts, bananas, and coy, come-hither glances. Parody it may be (as in Dutch artist Marja Samsom's "humorous glamour pictures" featuring her alter ego "Miss Kerr," or in Polish artist Natalia LL's red-lipped tongue and sucking "Consumption Art"), but the artist rarely seems to get the last laugh. A woman using her own face and body has a right to do what she will with them, but it is a subtle abyss that separates men's use of women for sexual titillation from women's use of women to expose that insult.

It was not just shyness, I suspect, that kept many women from making their own body art from 1967 to 1971 when Bruce Nauman was "Thighing," Vito Acconci was masturbating, Dennis Oppenheim was sunbathing and burning, and Barry Le Va was slamming into walls. It seemed like another very male pursuit, a manipulation of the audience's voyeurist impulses, not likely to appeal to vulnerable women artists just emerging from isolation. Articles and books on body art include frequent pictures of nude females, but few are by women artists.[2] Men can use beautiful, sexy women as neutral objects or surfaces,[3] but when women use their own faces and bodies, they are immediately accused of narcissism. There is an element of exhibitionism in all body art, perhaps a legitimate result of the choice between exploiting oneself or someone else. Yet the degree to which narcissism informs and affects the work varies immensely. Because women are considered sex objects, it is taken for granted that any woman who presents her nude body in public is doing so because she thinks she is beautiful. She is a narcissist, and Acconci, with his less romantic image and pimply back, is an artist.

Yet Vergine has noted that, "generally speaking, it is the women, like

Joan Jonas, who are the least afraid to know their own body, who don't censor it. They make attempts at discovery beyond acculturation" *(Data, summer 1974)*. I must say I admire the courage of the women with less than beautiful bodies who defy convention and become particularly vulnerable to cruel criticism, although those women who *do* happen to be physically well endowed probably come in for more punishment in the long run. Hans Peter Feldmann can use a series of ridiculous porno-pinups as his art *(Extra, no. 5)*, but Hannah Wilke, a glamour girl in her own right who sees her art as "seductive," is considered a little too good to be true when she flaunts her body in parody of the role she actually plays in real life. She has been making erotic art with vaginal imagery for over a decade, and since the women's movement, has begun to do performances in conjunction with her sculpture, but her own confusion of her roles as beautiful woman and artist, as flirt and feminist, has resulted at times in politically ambiguous manifestations that have exposed her to criticism on a personal as well as on an artistic level.

Another case in point is Carolee Schneemann, known in the early 1960s as a "body beautiful" because she appeared nude in Happenings—her own as well as those of Oldenburg and others, though for years she was labeled more comfortably "dancer" than "artist"—"an image, but not an Image-Maker, creating my own self-image" (1968). Her work has always been concerned with sexual (and personal) freedom, a theme still generally unacceptable from a woman; she intends to prove that "the life of the body is more *variously* expressive than a sex-negative society can admit. I didn't stand naked in front of 300 people because I wanted to be fucked, but because my sex and work were harmoniously experienced [so] I could have the audacity, or courage, to show the body as a source of varying emotive Power (1968)....I use my nude body in *Up To and Including Her Limits* [a mixed-media performance in which Schneemann read from a long scroll removed form her vagina] as the stripped-down, undecorated human object (1975)....In some sense I made a gift of my body to other women: giving our bodies back to ourselves. The haunting images of the Cretan bull dancer—joyful, free, bare-breasted, skilled women leaping precisely from danger to ascendancy, guided my imagination" (1968).[4]

A similarly defiant narcissism or "vulgarity" resulted when Lynda Benglis confronted the double standard head-on in some advertisements for herself, which provided the liveliest controversy the art world has had for years. A respected sculptor (whose imagery is, incidentally, as abstract as it is sexual[5]) and video artist (whose imagery is autobiographical and autoerotic), she published a series of photographic ads that included: herself in a Greek boy's skirt; herself leaning Butch on a car; herself as a pinup in a famous

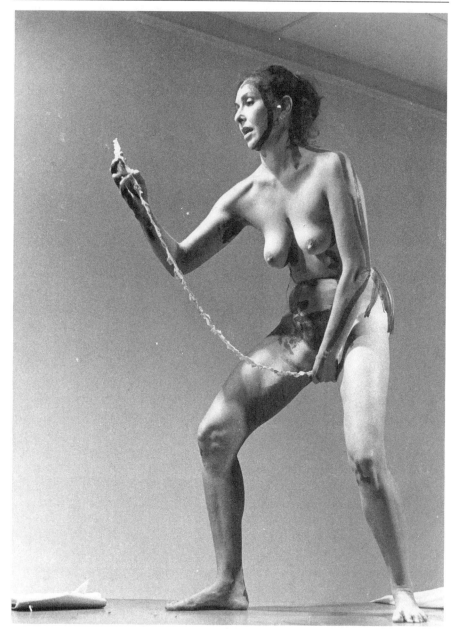

CAROLEE SCHNEEMANN
Interior Scroll, 1975
Photo: Anthony McCall.

Schneemann's work since the early sixties has been unabashedly "liberated," and this amazing image from a performance has become one of the icons of feminist art, the inside story from a woman's body.

Betty Grable pose, but with her jeans dropped around her ankles; and finally—the *coup de grâce*—herself as a greased nude in sunglasses, belligerently sporting a gigantic dildo. The uproar that this last image created proved conclusively that there are still things women may not do. The notion of sexual transformation has, after all, been around for some time. No such clamor arose in 1970 when Vito Acconci burned hair from his chest, "pulling at it, making it supple, flexible—an attempt to develop a female breast," then tucked his penis between his legs to "extend the sex change," and finally "acquired a female form" by having a woman kneel behind him with his penis "disappearing" in her mouth *(Avalanche,* fall 1972).[6] Nor was there any hullabaloo when Scott Burton promenaded Fourteenth Street in drag for a 1969 Street Work, or when he flaunted a giant black phallus in a static performance in 1973; or when William Wegman made his amusing trompe-l'oeil "breast" piece (on video, with his elbows); or when Lucas Samaras played with himself in front of his Polaroid camera.

It has often been remarked that body art reflects the "role crisis" in contemporary life. The urge to androgyny, in fact, has been frequently expressed by artists of both sexes, although more often by men than by women (odd, given the advantage of being male in this society, but not so much so when one sees it as a result of "birth envy"). Urs Lüthi, the Viennese who makes campy transvestite photodramas starring himself, says that ambivalence is the most significant aspect of his work, and that he sees himself as a stranger. Katharina Sieverding, in Düsseldorf, has made photoworks on "Aspects of Transvestism," which she sees not as a pathological phenomenon, but as "communications-material," exposing roles, repression, ambiguity, possibility, and self-extension: "The conquest of another gender takes place in oneself" *(Heute Kunst,* Apr.–May 1974). Such a positive approach has more in common with the traditional (platonic, gnostic, etc.) myth of the androgyne as two in one, "the outside as the inside and the male with the female neither male nor female,"[7] than with contemporary art's emphasis on separation over union of the two sexes. A woman working with androgyny these days would not be "accused" of being a lesbian because gay women clearly no longer want to be men, but see themselves as the last word in woman-identified women.

In 1972, in Halifax, Martha Wilson made a "drag" piece in which she transformed herself into a man, and then into a man dressed as a woman. In Montreal, Suzy Lake transforms herself into her friends, both male and female, in two stages—cosmetic and photo-retouching. In *Suzy Lake as Gary Smith,* the documentation is organized "with reference to a binary logic: The first row = female, augmentation, transformation done on the actual subject; the second row = male, diminution, transformation done at a

distance on the photo image" (Paul Heyer in *Camerart,* Montreal: Galerie Optica, 1974). In her several "Annette Messager, Collector"—albums of found photographic images from women's lives—she has created *femmes-hommes* and *hommes-femmes* where the disguise is lightly laid over the dominant characteristics; men are still men (although with long lashes and red lips) and women are still women (although with beard and mustache). Jacki Apple's *Identity Exchanges, Transfers,* and *Redefinitions* also involve impersonation of both sexes and "the relationship between the many views of a single person and the varying positions of the viewers to the object" (catalog of *c. 7500,* 1973). Eleanor Antin's several art personae include one man—the seventeenth-century king, in whose beard, boots, cape, and sword she visits her subjects on the street of Solana Beach, California. Adrian Piper too has a male ego—the "Mythic Being," with Afro, shades, and mustache, who also walks the streets—in a continuation of Piper's several years of exploration of the boundaries of her personality ("The fact that I'm a woman I'm sure has a great deal to do with it...at times I was 'violating my body'; I was making it public. I was exposing it; I was turning me into an object..." [*The Drama Review,* Mar. 1972]). Dressed as the Mythic Being, she reenacts events from her own life but experiences them as a man. One of the many things the Mythic Being means to his creator is: "a therapeutic device for freeing me of the burden of my past, which haunts me, determines all my actions..." ("Notes on the *Mythic Being, I,*" Mar. 1974).

For the most part, however, women are more concerned with female than with male roles and role models.[8] Ulrike Rosenbach (Germany) has made a series of video tapes of herself dressed in the high hat, or *haube,* worn in the fourteenth century by married women and in the Renaissance made a symbol of self-confidence and equality; she uses it "to transcend the conventional erotic context of contemporary women." In a 1974 performance called *Isolation Is Transparent,* dressed in a black net leotard, she combined erotic "coquetry with the female body" and "man's work with hammer and nails," weaving a rope skirt around herself from the corners of the space until she became "the center of the earth" *(Avalanche,* May 1974). Also in performance, Marina Abramovic (Yugoslavia) recorded her reactions after swallowing pills intended to cure schizophrenia. Two cameras, one pointed at the artist and the other at the audience, emphasized the subject/ object relationship and the perfectly natural desire to see yourself as others see you. Camera and video monitor have indeed become the mirrors into which for centuries women have peered anxiously before going out to confront the world. Cosmetics pieces were common in the early 1970s, when consciousness raising began to bring those mirrors out before public scrutiny. One of the early instances was *Léa's Room* in the Cal Arts Feminist

Art Program's *Womanhouse* (1971), where a lovely young woman made herself up, wiped off the cosmetics, made herself up again, took them off again, dissatisfied.

To make yourself up is literally to create, or re-create, yourself. In two color photographs of herself—*Perfection* and *Deformation* (1974)—Martha Wilson explored her dual self-image, and did so again (fat and thin) in a black-and-white video variation in 1975, accompanied by the passage from *Alice in Wonderland* about eating mushrooms that make Alice large and small. Mary Beth Edelson has transformed her photograph into those of two admired role models—Georgia O'Keeffe and Louise Nevelson. Nancy Kitchel has also made "disguise" pieces and studied the physiological results of psychological stress on her own face in several "exorcism" pieces involving her family and love affairs. Athena Tacha has dealt with her family, heredity, and, in an ongoing piece called *The Process of Aging,* is cataloging in detail its effects on her body. Annette Messager has drawn the ravaging lines of jealousy on a photographed face, while other women, among them Marisol, Yoko Ono, Joan Jonas, and Faith Ringgold, have used masks in the place of cosmetics.

The psychological emphasis, the need for a profound level of transformation of the self and of others, is subtly reflected in the work of two Italian women. Diana Rabito deals with "Retinal Cannibalism"—"talking with the eyes"—comparing in one piece the signs of hypertension produced in a woman's face to the *craquelure* of antique Chinese porcelains. Ketty La Rocca, unable to break into the male art world with her art or her writings, made a highly expressive book in 1971 using her hands ("They could not cut off my hands"). Until her recent death, she worked in a complex matrix of word and abstracted autobiography. Her *You, You* series shows her hands juxtaposed against X-ray images, presenting, for instance, the skull of a mask, the face as "pantomime made by language," the skull as fetal image with the hand—the language symbol—about to burst out of it, the image outlined by the handwritten word *you* repeated around its boundary.

Transformation is also the motive for cooler variations in which body is subordinated to art, exemplified by Martha Wilson's antiprurient *Breast Forms Permutated* (1975), in which nine pairs of breasts stare out of a grid, wondrous and humorous in their variety; or by Rita Myers's laconic *Body Halves* of 1971, where her nude photo is split vertically down the middle and reversed, revealing the minute discrepancies between the two halves; or by Antin's *Carving,* a series of clinically naked self-portrait photos documenting the artist's weight loss. Austrian artist Friederike Pezold's video tapes use her body abstractly, but the most "ordinary" (i.e., not erogenous) zones, such as elbows, feet, knees, shoulders, evoke extraordinary images of

HANNAH WILKE
Intra-Venus #4 (July 26, 1992/February 19, 1993), 1992–93
TWO PANELS, CHROMAGENIC SUPERGLOSS PRINTS, 71½″ × 47½″ EACH
Photo: Dennis Cowley, courtesy Ronald Feldman Fine Art, New York.

These courageous works were done when Wilke was being treated for the cancer that killed her a year later. They make a painful contrast with the rest of her oeuvre, which concentrated on the scars and triumphs accumulated by a woman as physically beautiful as society demands. Earlier, Wilke had made a moving photographic series of her mother, also dying of cancer.

sensuality—more erotic in their disguise than the parts simulated would be in reality. She manipulates video monitor and subject to create patterns of light and dark that are pure form as well as bodyscape, landscape, shifting shapes on a surface. Lauren Ewing, in a video tape, also uses ambiguously defined body parts in a suggestive manner; fingers slowly erase the words "She was forced to consider the Message after it was over" from an apparently erotic zone.

From 1971 to 1974, French artist Tania Mouraud used the object-self/sex-object relationship in objective, philosophical statements illustrated by subjective autobiographical images and nude body parts, as in *Mine Not I,*

People Call Me Tania Mouraud, Which of These Bodies Are They Referring To? Her photographic mandalas reached out from the center, which is herself, to concentric rings of family, friends, and increasingly distanced relationships or environments. Mouraud is an ardent feminist; however, in the last year or so, in response to the circumstances surrounding women's art in Europe, she has abandoned all female subject matter in favor of the same perception-word-concept form based on a wholly neutral vehicle—the wall.

Women do not often use men's bodies in their work, although Renate Weh (Germany) did a piece in which a man is dressed and undressed like a paper doll, and Verita Monselles (Italy), who is trying in her photo series to "objectify woman's existential crisis, her rebellions against a codified behavior," has reached what she calls "the negative moment in her analysis" where man is represented as "a dummy, or as a son [also a doll] petrified in his privileges as a petty speculator exploiting mother love." Her work is particularly interesting because of its overt anti-Catholicism, a burning issue for Italian feminists. Hannah Wilke has also used one of the great symbols of male domination in her *Jesus Christ Super-tart* performance, although the feminist crucifixion aspect was intended to overwhelm the religious satire. Wilke has also made a *Samson and Delilah* video tape in which she cuts the hair of a former lover.

Men, however, when not using themselves, are using women. Vergine has written about the "acute gynephobia" demonstrated in much male body art, and sees many of its manifestations as an "envy of the uterus as capacity for creation." Hermann Nitsch, in a destructive male imitation of the constructive female ability to give birth, smears blood and animal guts on himself and others, calling this a "birth...like a crucifixion and resurrection together."[9] Stanislao Pacus seems to speak for many of his colleagues when he declares: "Woman annuls creativeness. She is the dualistic model of love-hate in which the artist loses himself and from which, with intellectual effort, he escapes. To reconquer his professional conscience the artist derides the loved-hated woman's nakedness" (Vergine, *op. cit.*). Vettor Pisani chains women in his performances and archaically equates the female with "darkness." Such statements are parried by Tania Mouraud, who has written: "Women, who create, know what creation is. I started to paint after bringing my daughter into the world; the male argument which sees the maternal sensibility as an obstacle to creation seems inverse. On the contrary, the male's fixation on his sex, the fundamental fear which animates him of one day finding himself impotent, has completely falsified the very notion of art. Women do not act out of fear, but out of love and knowledge" *(Actuel,* no. 3, 1974).

European men, less conscious of feminism than Americans and less intim-
idated by women's consciousness of themselves, are particularly guilty of
exploitation of women's bodies in their art, but the United States is not far
behind. Acconci has tied up and otherwise manipulated women psychologi-
cally and physically; James Collins, as his own voyeur hero, "watches"
women as erotic objects on film; Roger Cutforth makes pallid films that use
naked women as though we still lived in the Renaissance; Chris Burden has
thrown burning matches on his wife's nude body in performance. In fact, it
is difficult to find any positive image whatsoever of women in male body art.

Much of the work discussed above clearly rises from a neurotic dissatisfac-
tion with the self. There are exceptions on both sides, but whereas female
unease is usually dealt with hopefully, in terms of gentle self-exploration,
self-criticism, or transformation, anxiety about the masculine role tends to
take a violent, even self-destructive form. Acconci and Oppenheim burned,
scarred, irritated their own bodies around 1970; Burden has taken the lead
since then by having himself shot in the arm, locking himself in a baggage
locker for five days, nearly electrocuting himself, nearly immolating himself,
nearly being run over, and so forth. Although lacking the horror-show
theatricality of the Viennese S and M school, the deadpan masochism of
American male body artists has a decidedly chilling effect.

Almost the only woman who engages in such practices is Gina Pane
(Paris), who has cut herself with razor blades, eaten until she was sick, and
subjected herself to other tortures. Her self-mutilation is no less repellent
than the men's, but it does exist within a framework that is curiously femi-
nine. Take, for instance, her *Sentimental Action,* a performance she describes
as the "projection of an 'intra' space" activated by the sentiments of "the
magic mother/child relationship, symbolized by death...a symbiotic rela-
tionship by which one discovers different emotional solutions." Using her
body as a "conductor," she takes apart "the prime image—the red rose,
mystic flower, erotic flower, transformed into a vagina by reconstitution
into its most present state: the painful one" (Pane quoted in Vergine, *op.
cit.*). Photodocumentation shows the artist dressed in white with her face
hidden in a bunch of roses and her bleeding arm, pierced by a line of tacks,
stretched out before her.

If few women artists inflict pain on their own bodies, the fear of pain, of
cruelty and violence, surfaces frequently in their work. Hannah Wilke's
S.O.S. ("Starification Object Series," and, not incidentally, "Help!") includes
a performance in which, shirtless, she flirts with the audience while they
chew bubble gum, which she then forms into tiny loops resembling vaginas
and sticks in patterns on her nude torso. She calls these "stars," in a play on

the celebrity game, but they are also scars, relating on the positive side to
African rituals through which women gain beauty and status, and on the
negative side to the anguish of the artist's real "internal scarification." In
Rebecca Horn's strange, mechanically erotic films, her body is always
protected by bizarre contraptions resembling medieval torture apparatus;
she makes contact with objects or people, but only at a remove. In her
elongated, stiff-fingered gloves, tickling feathered headdresses, cages, and
harnesses, she achieves a curiously moving combination of potential sadism
and tenderness.

Iole de Freitas (a Brazilian living in Italy) combats the archetypal female
fear of the knife by wielding it herself in cryptically beautiful photo pieces,
sometimes combined with fragments of her body seen in a framelike mirror
on the floor, as though in the process of examining and reconstructing her
own image. One recalls Maya Deren's image of the knife between the
sheets here, as well as in the film *Sentimental Journey*, by Italian artist
Valentina Berardinone, which concerns "the anthropomorphism of the
rose…transformation…intense persecutory anguish…and tunnels; its domi-
nant theme is murder." In Iowa City, Ana Mendieta has made brutal rape
pieces, where the unwarned audience enters her room (or a wooded area)
to discover her bloody, half-naked body. She has also used herself as a
symbol of regeneration in a series of slide pieces. In one she is nude in an
ancient stone grave in Mexico, covered by tiny white flowers that seem to
be growing from her body; in another she lies nude over a real skeleton, to
"give it life"; and in another she makes herself into the "white cock," a
Cuban voodoo fetish, covered with blood and feathers. She has traced her
skeleton on her nude body to become "Visible Woman," and ritually
outlined her silhouette in flowers, flames, earth, and candles.

A good deal of this current work by women, from psychological makeup
pieces to the more violent images, is not so much masochistic as it is
concerned with exorcism, with dispelling taboos, exposing and thereby
defusing the painful aspects of women's history. The prototypes may have
been several works by Judy Chicago—her *Menstruation Bathroom* at *Woman-
house,*[10] her notorious photolithograph *Red Flag*, a self-portrait from the
waist down showing the removal of a bloody Tampax (often read by male
viewers as a damaged penis), and her rejection drawings, which demand:
"How Does It Feel to Be Rejected? It's Like Having Your Flower Split
Open." In a recent two-woman exhibition at the College of St. Catherine in
Saint Paul, Betsy Damon and Carole Fisher showed *Mutilation Images: A
Garden* and *Self Images: Terrible Mother of the Blood River,* many of which took,
however, the hopeful shape of the female transformation symbol par excel-
lence—the butterfly (also introduced into feminist iconography by Judy

Chicago). Its visual resemblance to the Great Goddess's double-edged ax is not coincidental, for Chicago has made a series of china-painted plaques that deal with the "butterfly vagina" and its history as passage, portal, Venus of Willendorf, and so forth. Mary Beth Edelson, in photographs of herself as a symbol of "Woman Rising" from the earth, from the sea, her body painted with ancient ritual signs, adapts these images to a new feminist mythology. She also incorporates into her work stories written by the audience of her shows: mother stories, womankind stories, heroine stories, menstruation and birth stories, all of which are part of the search for ancient woman's natural, shameless relationship to her body.

One curious aspect of all this woman's work, pointed out to me by Joan Simon, is the fact that no women dealing with their own bodies and biographies have introduced pregnancy or childbirth as a major image. Sex itself is a focal point. Edelson has done ritual pieces with her son and daughter (as has Dennis Oppenheim); a *Womanhouse* performance included a splendid group birth scene; women photographers have dealt fairly often with pregnant nudes; but for individual Conceptual artists this mental and physical condition unique to women exists in a curious void. Is it because many of these artists are young and have yet to have children? Or because women artists have traditionally either refused to have children or have hidden them away in order to be taken seriously in a world that accuses wives and mothers of being part-time artists? Or because the biological aspect of female creation is anathema to women who want to be recognized for their art? Or is it related to narcissism and the fact that the swollen belly is considered

MARY BETH EDELSON
Up From the Earth, 1979
PHOTOGRAPHIC TRIPTYCH
Reykjavik, Iceland

"I separate myself from the awesome
unyielding landscape of hardened
lava without trees to establish my
own nature," wrote the artist
at the time she made this work. In
the nineties, Edelson returned to
photographing herself in nature,
now armed (or burdened) with the
critique of "essentialism" that she
had predicted in this earlier work.

unattractive in the male world? But if this were so, why wouldn't the more
adamant feminists have taken up the theme of pregnancy and birth along
with monthly cycles and aging? None of these explanations seems valid. The
process of the destruction of derogatory myths surrounding female experi-
ence and physiology appears to be one of the major motives for the recent
surge in body art by feminist artists. Perhaps procreativity is the next taboo
to be tackled, one that might make clearer the elusive factors that divide
body art by women from that by men.

PART II: GET THE MESSAGE?
1976–1980

The Pink Glass Swan:
Upward and Downward Mobility
in the Art World

The general alienation of contemporary avant-garde art
from any broad audience has been crystallized in the women's movement.
From the beginning, both liberal feminists concerned with changing women's
personal lives and socialist feminists concerned with overthrowing the clas-
sist/racist/sexist foundation of society have agreed that "fine" art is more
or less irrelevant, though holding out the hope that feminist art could and
should be different. The American women artists' movement has concen-
trated its efforts on gaining power within its own interest group—the art
world, in itself an incestuous network of relationships between artists and
art on the one hand and dealers, publishers, and buyers on the other. The
public, the "masses," or the audience is hardly considered.

The art world has evolved its own curious class system. Externally this is
a microcosm of capitalist society, but it maintains an internal dialectic (or
just plain contradiction) that attempts to reverse or ignore that parallel.
Fame may be a higher currency than mere money, but the two tend to go
together. Since the buying and selling of art and artists are done by the
ruling classes or by those chummy with them and their institutions, all
artists or producers, no matter what their individual economic backgrounds,
are dependent on the owners and forced into a proletarian role—just as
women, in Engels's analysis, play proletarian to the male ruler across all
class boundaries.

Looking at and "appreciating" art in this century has been understood as
an instrument (or at best a result) of upward social mobility, in which
owning art is the ultimate step. Making art is at the bottom of the scale.

Reprinted from *Heresies,* no. 1 (Jan. 1977).

This is the only legitimate reason to see artists as so many artists see them-selves—as "workers." At the same time, artists/makers tend to feel misun-derstood and, as *creators,* innately superior to the buyers/owners. The innermost circle of the art-world class system thereby replaces the rulers with the creators, and the contemporary artist in the big city (read New York) is a schizophrenic creature. S/he is persistently working "up" to be accepted, not only by other artists, but also by the hierarchy that exhibits, writes about, and buys her/his work. At the same time s/he is often ideo-logically working "down" in an attempt to identify with the workers outside of the art context and to overthrow the rulers in the name of art. This conflict is augmented by the fact that most artists are originally from the middle class, and their approach to the bourgeoisie includes a touch of adolescent rebellion against authority. Those few who have actually emerged from the working class sometimes use this—their very lack of background privilege—as privilege in itself, while playing the same schizo-phrenic foreground role as their solidly middle-class colleagues.

Artists, then, are workers or at least producers even when they don't know it. Yet artists dressed in work clothes (or expensive imitations thereof) and producing a commodity accessible only to the rich differ drasti-cally from the real working class in that artists control their production and their product—or could if they realized it and if they had the strength to maintain that control. In the studio, at least, unlike the farm, the factory, and the mine, the unorganized worker is in superficial control and can, if s/he dares, talk down to or tell off the boss—the collector, the critic, the curator. For years now, with little effect, it has been pointed out to artists that the art-world superstructure cannot run without them. Art, after all, is the product on which all the money is made and the power based.

During the 1950s and 1960s most American artists were unaware that they did *not* control their art, that their art could be used not only for aesthetic pleasure or decoration or status symbols, but as an educational weapon. In the late 1960s, between the civil rights, the student, the antiwar, and the women's movements, the facts of the exploitation of art in and out of the art world emerged. Most artists and art workers will ignore these issues because they make them feel too uncomfortable and helpless. If there were a strike against museums and galleries to allow artists control of their work, the scabs would be out immediately in full force, with reasons rang-ing from self-interest to total lack of political awareness to a genuine belief that society would crumble without art, that art is "above it all." Or is it in fact *below* it all, as most political activists seem to think?

Another aspect of this conflict surfaces in discussions around who gets a "piece of the pie"—a phrase that has become the scornful designation for

JERRI ALLYN
American Dining: A Working Woman's Moment, 1987–89
JERRI ALLYN (RIGHT) AND WAITRESS CARMEN DECENA AT GEFENS
DAIRY RESTAURANT, NEW YORK CITY, NOVEMBER 1987; 1950S METAL
JUKEBOX, COLORED PLEXIGLAS™, AUDIOTAPE PLAYER AND SPEAKERS,
SET OF FOUR PLACE MATS (OFFSET EDITION OF 5,000).
Photo: Marty Heitner.

This interactive art installation took place in six restaurants nationally, sponsored by
local art organizations in each city. The tabletop jukeboxes contained stories about
work, food, money, and, as a subtext, class. Allyn waitressed "live" in each place and
also presented live performances of the jukebox stories and music. Since the 1970s,
she has worked as a waitress and made work about waitressing. She was an original
member of the feminist performance group "The Waitresses" that emerged from the
Woman's Building in Los Angeles to publicly raise consciousness about women's work.

what is actually most people's goal. (Why shouldn't artists be able to make a living in this society like everybody else? Well, *almost* everybody else.) Those working for cultural change through political theorizing and occasional actions often appear to be opposed to *anybody* getting a piece of the pie, though politics is getting fashionable again in the art world, and may itself provide a vehicle for internal success; today one can refuse a piece of the pie and simultaneously be getting a chance at it. Still, the pie is very small, and there are a lot of hungry people circling it. Things were bad enough when only men were allowed to take a bite. Since "aggressive women" have gotten in there, too, competition, always at the heart of the art-world class system, has peaked.

Attendance at any large art school in the United States takes students from all classes and trains them for artists' schizophrenia. While being cool and chicly grubby (in the "uniform" of mass production), and knowing what's the latest in taste and what's the kind of art to make and the right names to drop, is clearly "upward mobility"—from school into teaching jobs and/or the art world—the lifestyle accompanying these habits is heavily weighted "downward." The working-class girl who has had to work for nice clothes must drop into frayed jeans to make it into the art middle class, which in turn considers itself both upper- and lower-class. Choosing poverty is a confusing experience for a child whose parents (or more likely mother) have tried desperately against great odds to keep a clean and pleasant home.[1]

The artist who feels superior to the rich because s/he is disguised as someone who is poor provides a puzzle for the truly deprived. A parallel notion, rarely admitted but pervasive, is that people can't understand "art" if their houses are full of pink glass swans or their lawns are inhabited by gnomes and flamingos, or if they even care about houses and clothes at all. This is particularly ridiculous now, when art itself uses so much of this paraphernalia (and not always satirically or condescendingly); or, from another angle, when even artists who have no visible means of professional support live in palatial lofts and sport beat-up hundred-dollar boots while looking down on the "tourists" who come to SoHo to see art on Saturdays. SoHo is, in fact, the new suburbia. One reason for such callousness is a hangover from the 1950s, when artists really were poor and proud of being poor because their art, the argument went, must be good if the bad guys—the rich *and* the masses—didn't like it.

In the 1960s the choice of poverty, often excused as anticonsumerism, even infiltrated the aesthetics of art.[2] First there was Pop Art, modeled on kitsch, advertising, and consumerism, and equally successful on its own level. (Women, incidentally, participated little in Pop Art, partly because of its blatant sexism—sometimes presented as a parody of the image of woman

in the media—and partly because the subject matter was often "women's work," ennobled and acceptable only when the artists were men.) Then came Process Art—a rebellion against the "precious object" traditionally desired and bought by the rich. Here another kind of co-optation took place, when temporary piles of dirt, oil, rags, and filthy rubber began to grace carpeted living rooms. (The Italian branch was even called *Arte Povera.*) Then came the rise of a third-stream medium called Conceptual Art, which offered "antiobjects" in the form of ideas—books or simple Xeroxed texts and photographs with no inherent physical or monetary value (until they got on the market, that is). Conceptual Art seemed politically viable because of its notion that the use of ordinary, inexpensive, unbulky media would lead to a kind of socialization (or at least democratization) of art as opposed to gigantic canvases and huge chrome sculptures costing five figures and filling the world with more consumer fetishes.

Yet the trip from oil on canvas to ideas on Xerox was, in retrospect, yet another instance of "downward mobility" or middle-class guilt. It was no accident that Conceptual Art appeared at the height of the social movements of the late 1960s nor that the artists were sympathetic to those movements (with the qualified exception of the women's movement). All the aesthetic tendencies listed above were genuinely instigated as rebellions by the artists themselves, yet the fact remains that only rich people can afford to (1) spend money on art that won't last; (2) live with "ugly art" or art that is not decorative, because the rest of their surroundings are beautiful and comfortable; and (3) like "nonobject art," which is only handy if you already have too many possessions—when it becomes a reactionary commentary: art for the overprivileged in a consumer society.

As a child, I was accused by my parents of being an "antisnob snob" and I'm only beginning to set the limitations of such a rebellion. Years later I was an early supporter of and proselytizer for Conceptual Art as an escape from the commodity orientation of the art world, a way of communicating with a broader audience via inexpensive media. Though I was bitterly disappointed (with the social, not the aesthetic, achievements) when I found that this work could be so easily absorbed into the system, it is only now that I've realized why the absorption took place. Conceptual Art's democratic efforts and physical vehicles were canceled out by its neutral, elitist content and its patronizing approach. From around 1967 to 1971, many of us involved in Conceptual Art saw that content as pretty revolutionary and thought of ourselves as rebels against the cool, hostile artifacts of the prevailing formalist and Minimal art. But we were so totally enveloped in the middle-class approach to everything we did and saw, we couldn't perceive how that pseudoacademic narrative piece or that art-world-

oriented action in the streets was deprived of any revolutionary content by the fact that it was usually incomprehensible and alienating to the people "out there," no matter how fashionably downwardly mobile it might be in the art world. The idea that if art is subversive in the art world, it will automatically appeal to a general audience now seems absurd.

The whole evolutionary basis of modernist innovation, the idea of aesthetic "progress," the "I-did-it-first" and "It's-been-done-already" syndromes that pervade contemporary avant-garde and criticism, is also blatantly classist and has more to do with technology than with art. To be "avant-garde" is inevitably to be on top, or to become upper-middle-class, because such innovations take place in a context accessible only to the educated elite. Thus socially conscious artists working in or with community groups and muralists try to disassociate themselves from the art world, even though its values ("quality") remain to haunt them personally.

The value systems are different in and out of the art world, and anyone attempting to straddle the two develops another kind of schizophrenia. For instance, in inner-city community murals, the images of woman are the traditional ones—a beautiful, noble mother and housewife or worker, and a rebellious young woman striving to change her world—both of them celebrated for their courage to be and to stay the way they are and to support their men in the face of horrendous odds. This is not the art-world or middle-class "radical" view of future feminism, nor is it one that radical feminists hoping to "reach out" across the classes can easily espouse. Here, in the realm of aspirations, is where upward and downward mobility and status quo clash, where the economic class barriers are established. As Michele Russell has noted, the Third World woman is not attracted to the "utopian experimentation" of the Left (in the art world, the would-be Marxist avant-garde) or to the "pragmatic opportunism" of the Right (in the art world, those who reform and co-opt the radicals).[3]

Many of the subjects touched on here have their roots in Taste. To many women, art, or a beautiful object, might be defined as something she cannot have. Beauty and art have been defined before as *the desirable*. In a consumer society, art, too, becomes a commodity rather than a life-enchanting experience. Yet the Van Gogh reproduction or the pink glass swan—the same beautiful objects that may be "below" a middle-class woman (because she has, in moving upward, acquired upper-class taste, or would like to think she has)—may be "above" or inaccessible to a welfare mother. The phrase "to dictate taste" has its own political connotations. A Minneapolis worker interviewed by students of artist Don Celender said he liked "old artworks because they're more classy,"[4] and class does seem to be what the traditional notion of art is all about. Yet contemporary avant-garde art, for all its

attempts to break out of that gold frame, is equally class-bound, and even
the artist aware of these contradictions in her/his own life and work is hard
put to resolve them. It's a vicious circle. If the artist-producer is upper-
middle-class, and our standards of art as taught in schools are persistently
upper-middle-class, how do we escape making art only *for* the upper-
middle-class?

The alternatives to "quality," to the "high" art shown in art-world galleries
and magazines, have been few and for the most part unsatisfying, although
well intended. Even when kitsch, politics, or housework are absorbed into
art, contact with the real world is not necessarily made. At no time has
the avant-garde, though playing in the famous "gap between art and life,"
moved far enough out of the art context to attract a broad audience. That
same broad audience has, ironically, been trained to think of art as some-
thing that has nothing to do with life and, at the same time, it tends only to
like that art that means something in terms of its own life or fantasies. The
dilemma for the leftist artist in the middle class is that her/his standards
seem to have been set irremediably. No matter how much we know about
what the broader public wants, or *needs,* it is very difficult to break social
conditioning and cultural habits. Hopefully, a truly feminist art will provide
other standards.

To understand the woman artist's position in this complex situation
between the art world and the real world, class, and gender, it is necessary
to know that in America artists are rarely respected unless they are stars or
rich or mad or dead. Being an artist is not being "somebody." Middle-class
families are happy to pay lip service to art but god forbid their own children
take it so seriously as to consider it a profession. Thus a man who becomes
an artist is asked when he is going to "go to work," and he is not so covertly
considered a child, a sissy (a woman), someone who has a hobby rather than
a vocation, or someone who can't make money and therefore cannot hold
his head up in the real world of men—at least until his work sells, at which
point he may be welcomed back. Male artists, bending over backward to
rid themselves of this stigma, tend to be particularly susceptible to insecu-
rity and machismo. So women daring to insist on their place in the primary
rank—as artmakers rather than as art housekeepers (curators, critics,
dealers, "patrons")—inherit a heavy burden of male fears in addition to the
economic and psychological discrimination still rampant in a patriarchal,
money-oriented society.

Most art being shown now has little to do with any woman's experience, in
part because women (rich ones as "patrons," others as decorators and "home-
makers") are in charge of the private sphere, while men identify more easily
with public art—art that has become public through economic validation (the

million-dollar Rembrandt). Private art is often seen as mere ornament; public art is associated with monuments and money, with "high" art and its containers, including unwelcoming white-walled galleries and museums with classical courthouse architecture. Even the graffiti artists, whose work is unsuccessfully transferred from subways to art galleries, are mostly men, concerned with facades, with having their names in spray paint, in lights, in museums.

Private art is visible only to intimates. I suspect the reason so few women "folk" artists work outdoors in large scale (like Simon Rodia's Watts Towers and other "naives and visionaries" with their cement and bottles) is not only because men aspire to erections and know how to use the necessary tools, but because women can and must assuage these same creative urges *inside* the house, with the pink glass swan as an element in their own works of art—the living room or kitchen. In the art world, the situation is doubly paralleled. Women's art until recently was rarely seen in public, and all artists are voluntarily "women" because of the social attitudes mentioned above; the art world is so small that it is "private."

Just as the living room is enclosed by the building it is in, art and artists are firmly imprisoned by the culture that supports them. Artists claiming to work for themselves alone, and not for any audience at all, are passively accepting the upper-middle-class audience of the internal art world. This situation is compounded by the fact that to be middle class is to be passive, to live with the expectation of being taken care of and entertained. But art should be a consciousness raiser; it partakes of and should fuse the private and the public spheres. It should be able to reintegrate the personal without being satisfied by the *merely* personal. One good test is whether or not it communicates, and then, of course, what and how it communicates. If it doesn't communicate, it may just not be very good art from anyone's point of view, or it may be that the artist is not even aware of the needs of others, or simply doesn't care.

For there is a need out there, a need vaguely satisfied at the moment by "schlock."[5] And it seems that one of the basic tenets of the feminist arts should be a reaching out from the private sphere to transform that "artificial art" and to more fully satisfy that need. For the art-world artist has come to consider her/his private needs paramount and has too often forgotten about those of the audience, any audience. Work that communicates to a dangerous number of people is derogatorily called a "crowd pleaser." This is a blatantly classist attitude, taking for granted that most people are by nature incapable of understanding good art (i.e., upper-class or quality art). At the same time, much ado is made about art-educational theories that claim to "teach people to see" (consider the political implications of this notion) and muffle all issues by stressing the "universality" of great art.

It may be that at the moment the possibilities are slim for a middle-class art world's understanding or criticism of the little art we see that reflects working-class cultural values. Perhaps our current responsibility lies in humanizing our own activities so that they will communicate more effectively with all women. I hope we aspire to more than women's art flooding the museum and gallery circuit. Perhaps a feminist art will emerge only when we become wholly responsible for our own work, for what becomes of it, who sees it, and who is nourished by it. For a feminist artist, whatever her style, the prime audience at this time is other women. So far, we have tended to be satisfied with communicating with those women whose social experience is close to ours. This is natural enough, since there is where we will get our greatest support, and we need support in taking this risk of trying to please *women,* knowing that we are almost certain to displease men in the process. In addition, it is embarrassing to talk openly about the class system that divides us, hard to do so without sounding more bourgeois than ever in the implications of superiority and inferiority inherent in such discussions (where the working class is as often considered superior to the middle class).

A book of essays called *Class and Feminism,* written by The Furies, a lesbian feminist collective, makes clear that from the point of view of working-class women, class is a definite problem within the women's movement. As Nancy Myron observes, middle-class women:

> can intellectualize, politicize, accuse, abuse, and contribute money in order not to deal with their own classism. Even if they admit that class exists, they are not likely to admit that their behavior is a product of it. They will go through every painful detail of their lives to prove to me or another working-class woman that they really didn't have any privilege, that their family was exceptional, that they actually did have an uncle who worked in a factory. To ease anyone's guilt is not the point of talking about class....You don't get rid of oppression just by talking about it.[6]

Women are more strenuously conditioned toward upward cultural mobility or "gentility" than men, which often results in the woman's consciously betraying her class origins as a matter of course. The hierarchies within the whole span of the middle class are most easily demarcated by lifestyle and dress. For instance, the much-scorned "Queens housewife" may have enough to eat, may have learned to consume the unnecessities, and may have made it to a desired social bracket in her community, but if she ventures to make art (not just own it), she will find herself back at the bottom in the art world, looking wistfully up to the plateau where the male, the young, the bejeaned seem so at ease.

For middle-class women in the art world not only dress "down," but dress like working-class *men.* They do so because housedresses, pedal push-

ers, polyester pantsuits, beehives, and the wrong accents are not such acceptable disguises for women as the boots-overalls-and-windbreaker syndrome is for men. Thus, young middle-class women tend to deny their female counterparts and take on "male" (unisex) attire. It may at times have been chic to dress like a Native American or a Bedouin woman, but it has never been chic to dress like a working woman, even if she was trying to look like Jackie Kennedy. Young working-class women (and men) spend a large amount of available money on clothes; it's a way to forget the rats and roaches by which even the cleanest tenement dwellers are blessed, or the mortgages by which even the hardest-working homeowners are blessed, and to present a classy facade. Artists dressing and talking "down" insult the hardhats much as rich kids in rags do; they insult people whose notion of art is something to work for—the pink glass swan.

Yet women, as evidenced by The Furies' publication and as pointed out elsewhere (most notably by August Bebel), have a unique chance to communicate with women across the boundaries of economic class because as a "vertical class" we share the majority of our most fundamental experiences—emotionally, even when economically we are divided. Thus an economic analysis does not adequately explore the psychological and aesthetic ramifications of the need for change within a sexually oppressed group. Nor does it take into consideration how women's needs differ from men's—or so it seems at this still unequal point in history. The vertical class cuts across the horizontal economic classes in a column of injustices. While heightened class consciousness can only clarify the way we see the world, and all clarification is for the better, I can't bring myself to trust hard lines and categories where fledgling feminism is concerned.

Even in the art world, the issue of feminism has barely been raised in mixed political groups. In 1970, women took our rage and our energies to our own organizations or directly to the public by means of picketing and protests. While a few men supported these, and most politically conscious male artists now claim to be feminists to some degree, the political *and* apolitical art world goes on as though feminism didn't exist—the presence of a few vociferous feminist artists and critics notwithstanding. And in the art world, as in the real world, political commitment frequently means total disregard for feminist priorities. Even the increasingly Marxist group ironically calling itself Art-Language is unwilling to stop the exclusive use of the male pronoun in its theoretical publications.[7]

Experiences like this one and dissatisfaction with Marxism's lack of interest in "the woman question" make me wary of merging Marxism and feminism. The notion of the noneconomic or "vertical" class is anathema to Marxists, and confusion is rampant around the chicken-egg question of

whether women can be equal before the establishment of a classless society or whether a classless society can be established before women are liberated. As Sheila Rowbotham says of her own Marxism and feminism:

> They are at once incompatible and in real need of one another. As a feminist and a Marxist, I carry their contradictions within me, and it is tempting to opt for one or the other in an effort to produce a tidy resolution of the commotion generated by the antagonism between them. But to do that would mean evading the social reality which gives rise to the antagonism.[8]

As women, therefore, we need to establish far more strongly our own sense of community, so that all our arts will be enjoyed by all women in all economic circumstances. This will happen only when women artists make conscious efforts to cross class barriers, to consider their audience, to see, respect, and work with the women who create outside the art world—whether in suburban crafts guilds or in offices and factories or in community workshops. The current feminist passion for women's traditional arts, which influences a great many women artists, should make this road much easier, unless it too becomes another commercialized rip-off. Despite the very real class obstacles, I feel strongly that women are in a privileged position to satisfy the goal of an art that would communicate the needs of all classes and genders to each other, and get rid of the we/they dichotomy to as great an extent as is possible in a capitalist framework. Our gender, our oppression, and our female experience—our female culture, just being explored—offer access to all of us by these common threads.

Making Something from Nothing (Toward a Definition of Women's "Hobby Art")

In 1968 Rubye Mae Griffith and Frank B. Griffith published a "hobby" book called *How to Make Something from Nothing*. On the cover (where it would sell books) his name was listed before hers, while on the title page (where it could do no harm), hers appeared before his. It is tempting to think that it was she who wrote the cryptofeminist dedication: "To the nothings—with the courage to turn into somethings." The book itself is concerned with transformation—of tin cans, beef knuckle bones, old razor blades, breadbaskets, and bottlecaps into more and less useful and decorative items. As "A Word in Parting," the authors state their modest credo:

> This book...is simply a collection of ideas intended to encourage your ideas....We want you to do things your way....Making nothings into somethings is a highly inventive sport but because it is inventive and spontaneous and original it releases tensions, unties knots of frustration, gives you a wonderful sense of pleasure and accomplishment. So experiment, dare, improvise—enjoy every minute—and maybe you'll discover, as we did, that once you start making something from nothing, you find you can't stop, and what's more you don't want to stop![1]

Despite the tone and the emphasis on enjoyment—unpopular in serious circles—this "sport" sounds very much like fine or "high" art. Why then are its products not art? "Lack of quality" will be the first answer offered, and "derivative" the second, even though both would equally apply to most of the more sophisticated works seen in galleries and museums. If art is popularly defined as a unique and provocative object of beauty and imagination,

Reprinted from *Heresies*, no. 4 (Winter 1978).

MIRIAM SCHAPIRO
Mary Cassatt and Me
FROM "COLLABORATION SERIES," 1974
ACRYLIC, FABRIC, AND COLLAGE ON PAPER, 30″ × 22″
Collection Dorothy Seiberling, New York. Photo: D. James Dee,
courtesy Steinbaum Krauss Gallery, New York.

Schapiro has devoted much of her feminist art to reclamation of women's tradi-
tional arts and of women artists from the past, with fabrics and sewing as the
connecting link. Recognizing the richness of women's (literally) material culture,
she has painted many "collaborations," sometimes with Anonymous, the creator
of beautiful domestic art who knew how to make something from nothing.

the work of many of the best contemporary "fine" artists must be disquali-
fied along with that of many "craftspeople," and in the eyes of the broad
audience, many of the talented hobbyists' work *would* qualify. Yet many of
these, in turn, would not even be called "crafts" by the purists in that field.
Although it is true that all this name calling is red herring, it makes me
wonder whether high art by another name might be less intimidating and
more appealing. On the other hand, would high art by any other name look
so impressive, be so respected and so commercially valued? I won't try to
answer these weighted queries here, but simply offer them as other ways of
thinking about some of the less obvious aspects of the art of making.

Much has been made of the need to erase false distinctions between art
and craft, "fine" art and the "minor" arts, "high" art and "low" art—distinc-
tions that particularly affect women's art. But there are also "high" crafts
and "low" ones, and although women wield more power in the crafts world
than in the fine art world, the same problems plague both. The crafts need
only one more step up the aesthetic and financial respectability ladder and
they will be headed for the craft museums rather than for people's homes.

Perhaps until the character of the museums changes, anything ending
up in one will remain a display of upper-class taste in expensive and doubt-
fully "useful" objects. For most of this century, the prevailing relationship
between art and "the masses" has been one of paternalistic noblesse oblige
along the lines of "we who are educated to *know* what's correct must pass
our knowledge and good taste *down* to those who haven't the taste, the
time, or the money to know what is Good." Artists and craftspeople, from
William Morris to de Stijl and the Russian Constructivists, have dreamed
of socialist utopias where everyone's life is improved by cheap and beautiful
objects and environments. Yet the path of the [New York] Museum of
Modern Art's design department, also paved with good intentions, indicates
the destination of such dreams in a capitalist consumer society. A pioneer
in bringing to the public the best available in commercial design, the
museum's admirable display of such ready-mades as a handsome and durable
thirty-nine-cent paring knife or a sixty-nine-cent coffee mug has mostly
given way to installations more typical of Bonnier's, DR, or some chic Ital-
ian furniture showroom.

It is, as it so often is, a question of audience, as well as a question of cate-
gorization. (One always follows the other.) Who sees these objects at
MOMA? Mostly people who buy three-dollar paring knives and eight-dollar
coffee mugs that are often merely "elevated" examples of the cheaper
versions, with unnecessary refinements or simplifications. Good Taste is
once again an economic captive of the classes who rule the culture and
govern its institutions. Bad Taste is preferred by those ingrates who are

uneducated enough to ignore or independent enough to reject the imposi-
tions from above. Their lack of enthusiasm provides an excuse for the
aesthetic philanthropists, their hands bitten, to stop feeding the masses.
Class-determined good/bad taste patterns revert to type.

Such is the process by which both "design" objects and the "high" crafts
have become precisely the consumer commodity that the rare socially
conscious "fine" artist is struggling to avoid. Historically, craftspeople,
whose work still exists in a less exalted equilibrium between function and
commerce, have been most aware of the contradictions inherent in the
distinction between art and crafts. The distinction between design and
"high" crafts is a modern one. Both have their origins in the "low" crafts of
earlier periods, sometimes elevated to the level of "folk art" because of their
usefulness as sources for "fine" art. A "designer" is simply the craftsperson of
the technological age, no longer forced to do her/his own *making*. The
Bauhaus became the cradle of industrial design, but the tapestries, furniture,
textiles, and tea sets made there were still primarily works of art. Today,
the most popular housewares all through the taste gamut of the American
lower-middle to upper-middle class owe as much stylistically to the "primi-
tive" or "low" crafts—Mexican, Asian, American Colonial—as to the
streamlining of the International Style. In fact, popular design tends to
combine the two, which meet at a point of (often spurious) "simplicity" to
become "kitsch"—diluted examples of the Good Taste that is hidden away
in museums, expensive stores, and the homes of the wealthy, inaccessible to
everyone else.

The hobby books reflect the manner in which Good Taste is still unar-
guably set forth by the class system. Different books are clearly aimed at
different tastes, aspirations, educational levels. For instance, Dot Aldrich's
Creating with Cattails, Cones and Pods is not aimed at the inner-city working-
class housewife or welfare mother (who couldn't afford the time or the
materials) or at the farmer's wife (who sees enough weeds in her daily
work) but at the suburban middle-class woman who thinks in terms of
"creating," has time on her hands and access to the materials. Aldrich is
described on the dust jacket as a garden club member, a naturalist, and an
artist; the book is illustrated by her daughter. She very thoroughly details
the construction of dollhouse furniture, corsages, and "arrangements" from
dried plants and an occasional orange peel. Her taste is firmly placed as
"good" within her class, although it might be seen as gauche "homemade art"
by the upper class and ugly and undecorative by the working class.[2]

Hazel Pearson Williams's *Feather Flowers and Arrangements,* on the other
hand, has the sleazy look of a mail-order catalog; it is one of a craft course
series and its fans, birdcages, butterflies, and candles are all made from

garishly colored, rather than natural, materials. The book is clearly aimed at a totally different audience, one that is presumed to respond to such colors and to have no aesthetic appreciation of the "intrinsic" superiority of natural materials over artificial ones, not to mention an inability to afford them.[3]

The objects illustrated in books like the Griffiths' are neither high art nor high craft nor design. Yet such books are myriad, and they are clearly aimed at women—the natural *bricoleurs,* as Deena Metzger has pointed out.[4] The books are usually written by a woman, and if a man is coauthor he always seems to be a husband, which adds a certain familial coziness and gives him an excuse for being involved in such blatantly female fripperies (as well as dignifying the frippery by his participation). Necessity is the mother, not the father, of invention. The home *maker's* sense of care and touch focuses on sewing, cooking, interior decoration, as often through conditioning as

REE MORTON
The Plant That Heals May Also Poison, 1974
WOOD, CELASTIC, LIGHTS, PAINT ON WALLPAPER WALL, 47″ × 66″ × 3″
Courtesy Linda Morton.

Morton, who died tragically in an accident at the height of her powers, often focused on domestic space, traditional wisdom, and popular imagery, sometimes delineated with natural materials, indoors defined by outdoors.

through necessity, providing a certain bond between middle-class and working-class housewives *and* career women (I am talking about the making of the home, not just the keeping of it; "good housekeeping" is not a prerogative for creativity in the home. It might even be the opposite, since the "houseproud" woman is often prouder of her house, her container, than she is of herself.) Even these days women still tend to be raised with an exaggerated sense of detail and a need to be "busy," often engendered by isolation within a particular space, and by the emphasis on cleaning and service. A visually sensitive woman who spends day after day in the same rooms develops a compulsion to change, adorn, *expand* them, an impetus encouraged by the "hobby" books.

The "overdecoration" of the home and the fondness for bric-a-brac often attributed to female fussiness or plain Bad Taste can just as well be attributed to creative restlessness. Since most homemade hobby objects are geared toward home improvement, they inspire less fear in their makers of being "selfish" or "self-indulgent." There is no confusion about pretensions to Art, and the woman is freed to make anything she can imagine. (At the same time it is true that the imagination is often stimulated by exposure to other such work, just as "real" artists are similarly dependent on the art world and exposure to the works of their colleagues.) Making "conversation pieces" like deer antler salad tongs or a madonna in an abalone shell grotto, or a mailbox from an old breadbox, or vice versa, can be a prelude to breaking with the "functional" excuse and the making of wholly "useless" objects.

Now that the homebound woman has a little more leisure, thanks to so-called labor-saving devices, her pastimes are more likely to be cultural in character. The less privileged she is, the more likely she is to keep her interests *inside* the home with the focus of her art remaining the same as that of her work. The better off and better educated she is, the more likely she is to go *outside* of the home for influence or stimulus, to spend her time reading, going to concerts, theater, dance, staying "well informed." If she is upwardly mobile, venturing from her own confirmed tastes into foreign realms where she must be cautious about opinions and actions, her insecurity is likely to lead to the classic docility of the middle-class audience, so receptive to what "experts" tell it to think about the arts. The term *culture vulture* is understood to apply mainly to upwardly mobile *women.* And culture, in the evangelical spirit of the work ethic, is often also inseparable from "good works."

Middle- and upper-class women, always stronger in their support of "culture" than any other group, seem to *need* aesthetic experience in the broadest sense more than men—perhaps because the vital business of

running the world, for which educated women have, to some extent, been prepared, has been denied them; and because they have the time and the background to think—but not the means to act. Despite the fact that middle-class women have frequently been strong (and anonymous) forces for social justice, the earnestness and amateur status of such activities have been consistently ridiculed, from the Marx Brothers' films to the cartoons of Helen Hokinson (whose captions were often written by male *New Yorker* editors).

Nevertheless, the League of Women Voters, the volunteer work for underfunded cultural organizations, the garden clubs, literary circles, and discussion groups of the comfortable classes have been valid and sometimes courageous attempts to move out into the world while remaining sufficiently on the fringes of the system as not to challenge its male core. The working-class counterparts are, for obvious reasons, aimed less at improving the lot of others than at improving their own, and, like hobby art, are more locally and domestically focused in unions, day care, paid rather than volunteer social work, Tupperware parties—and the PTA, where all classes meet. In any case, the housewife learns to take derision in her stride whether she intends to be socially effective or merely wants to escape from the home now and then (families are jealous of time spent elsewhere).

Women's liberation has at last begun to erode the notion that woman's role is that of the applauding spectator for men's creativity. Yet as makers of (rather than housekeepers for) art, we still trespass on male ground. No wonder, then, that all over the world, women privileged and/or desperate and/or daring enough to consider creation outside traditional limits are finding an outlet for these drives in an art that is not considered "art," an art that there is some excuse for making, an art that costs little or nothing and performs an ostensibly useful function in the bargain—the art of making something out of nothing.

If one's only known outlets are follow-the-number painting or the ready-made "kit art" offered by the supermarket magazines, books like the Griffiths' open up new territory. Suggestions in "ladies" and handiwork magazines should not be undervalued either. After all, quilt patterns were published and passed along in the nineteenth century (just as fashionable art styles are in today's art world). The innovative quilt maker or group of makers would come up with a new idea that broke or enriched the rules, just as the Navajo rug maker might vary brilliantly within set patterns (and modern abstractionists innovate by sticking to the rules of innovation).

The shared or published pattern forms the same kind of armature for painstaking handwork and for freedom of expression within a framework as the underlying grid does in contemporary painting. Most modern women

lack the skills, the motive, and the discipline to do the kind of handwork their foremothers did by necessity, but the stitchlike "mark" Harmony Hammond has noted in so much recent abstract art by women often emerges from a feminist adoption of the positive aspects of women's history. It relates to the ancient, sensuously repetitive, Penelopean rhythms of seeding, hoeing, gathering, weaving, and spinning, as well as to modern domestic routines.[5]

In addition, crocheting, needlework, embroidery, rug-hooking, and quilting are coming back into the middle- and upper-class fashion on the apron strings of feminism and fad. Ironically, these arts are now practiced by the well-off out of boredom and social pressure as often as out of emotional necessity to make connections with women in the past. What was once *work* has now become art or "high" craft—museum-worthy as well as commercially valid. In fact, when Navajo rugs and old quilts were first exhibited in New York fine arts museums in the early 1970s, they were eulogized as neutral, ungendered sources for big bold geometric abstractions by male artists like Frank Stella and Kenneth Noland. Had they been presented as exhibitions of women's art, they would have been seen quite differently and probably would not have been seen at all in a fine art context at that time.

When feminists pointed out that these much-admired and "strong" works were in fact women's "crafts," one might have expected traditional women's art to be taken more seriously, yet such borrowings from "below" must still be validated from "above." William C. Seitz's "Assemblage" show at the Museum of Modern Art in 1961 had acknowledged the generative role of popular objects for Cubism, Dada, and Surrealism, and predicted Pop Art, but he never considered women's work as the classic *bricolage.* It took a man, Claes Oldenburg, to make fabric sculpture acceptable, though his wife, Patty, did the actual sewing. Sometimes men even dabble in women's spheres in the lowest of low arts—hobby art made from throwaways by amateurs at home. But when a man makes, say, a macaroni figure or a hand-tooled leather *Last Supper,* it tends to raise the sphere rather than lower the man, and he is likely to be written up in the local newspaper. Women dabbling in men's spheres, on the other hand, are still either inferior or just freakishly amazing.

It is supposed to be men who are "handy around the house," men who "fix" things while women "make" the home. This is a myth, of course, and a popular one. There are certainly as many women who do domestic repairs as men, but perhaps the myth was devised by women to force men to invest *some* energy, to touch and to care about *some* aspect of the home. The fact remains that when a woman comes to make something, it more often than not has a particular character—whether this originates from role-playing,

the division of labor, or some deeper consciousness. The difference can often be defined as a kind of "positive fragmentation" or as the collage aesthetic—the mixing and matching of fragments to provide a new whole. Thus the boot cleaner made of bottlecaps suggested by one hobby book might also be a Surrealist object.

But it is not. And this is not entirely a disadvantage. Not only does the amateur status of hobby art dispel the need for costly art lessons, but it subverts the intimidation process that takes place when the male domain of "high" art is approached. As it stands, women—and especially women—can make hobby art in a relaxed manner, isolated from the "real" world of commerce and the pressures of professional aestheticism. During the actual creative process, this is an advantage, but when the creative ego's attendant need for an audience emerges, the next step is not the galleries, but "cottage industry." The gift shop, the county or crafts fair, and outdoor art show circuit are open to women where the high art world is not, or was not until it was pried open to some extent by the feminist art movement. For this reason, many professional women artists in the past made both "public art" (canvases and sculptures acceptable to galleries and museums, conforming to a combination of current art-world tastes) and "private" or "closet" art (made for "personal reasons" or "just for myself"—as if most art were not). With the advent of the new feminism, the private has either replaced or merged with the public in much women's art, and the delicate, the intimate, the obsessive, even the "cute" and the "fussy" in certain guises have become more acceptable, especially in feminist art circles. A striking amount of the newly discovered "closet" art by amateur and professional women artists resembles the *chotchkas* so universally scorned as women's playthings and especially despised in recent decades during the heyday of the neo-Bauhaus functionalism. The objects illustrated in *Feather Flowers and Arrangements* bear marked resemblance to what is now called women's art, including a certainly unconscious bias toward the forms that have been called female imagery.

Today we are resurrecting our mothers', aunts', and grandmothers' activities—not only in the well-publicized areas of quilts and textiles, but also in the more random and freer area of transformational *rehabilitation*. On an emotional as well as on a practical level, rehabilitation has always been women's work. Patching, turning collars and cuffs, remaking old clothes, changing buttons, refinishing or recovering old furniture are all the traditional private resorts of the economically deprived woman to give her family public dignity. The syndrome continues today, even though in affluent Western societies cheap clothes fall apart before they can be rehabilitated and inventive patching is more acceptable (to the point where

expensive new clothes are made to *look* rehabilitated and thrift shops are combed by the well-off). Thus "making something from nothing" is a brilliant title for a hobby book, appealing as it does both to housewifely thrift and to the American spirit of free enterprise—a potential means of making a fast buck.

JOYCE KOZLOFF
Pornament Is Crime Series #20: Lobster and Croquembouche, 1988
WATERCOLOR ON PAPER, 22″ × 22″
Photo: eeva-inkeri.

In this series (which culminated in an elegant book), Kozloff applied her eclectic use of international ornament to an equally cross-cultural selection of erotic art. Her sources in this image are a Gustav Klimt painting, Hokusai woodcuts, and a Chinese album painting. Most of her work for over a decade has been made in the public sphere and this book is a sly intervention of "privacy" into the published spectacle.

Finally, certain questions arise in regard to women's recent "traditionally oriented" fine art. Are the sources direct—from quilts and county-fair handiwork displays—or indirect—via Dada, Surrealism, West Coast funk, or from feminist art itself? Is the resemblance of women's art-world art to hobby art a result of coincidence? Of influence, conditioning, or some inherent female sensibility? Or is it simply another instance of camp, or fashionable downward mobility? The problem extends from source to audience.

Feminist artists have become far more conscious of women's traditional arts than most artists, and feminist artists are also politically aware of the need to broaden their audience, or of the need to broaden the kind of social experience fine art reflects. Yet the means by which to fill these needs have already been explored. The greatest lack in the feminist art movement may be of contact and dialogue with those "amateurs" whose work sometimes appears to be imitated by the professionals. Judy Chicago and her coworkers on *The Dinner Party* and their collaboration with china painters and needleworkers, Miriam Schapiro's handkerchief exchanges and the credit given the women who embroider for her, the Los Angeles "Mother Art" group, which performs in laundromats and similar public/domestic situations, the British "Postal Art Event," and a few other examples are exceptions rather than the rule.[6] It seems all too likely that only in a feminist art world will there be a chance for the "fine" arts, the "minor" arts, "crafts," and hobby circuits to meet and to develop an *art of making* with a new and revitalized communicative function. It won't happen if the feminist art world continues to be absorbed by the patriarchal art world.

And if it does happen, the next question will be to what extent can this work be reconciled with all the varying criteria that determine aesthetic "quality" in the different spheres, groups, and cultures? Visual consciousness-raising, concerned as it is now with female imagery and, increasingly, with female process, still has a long way to go before our visions are sufficiently cleared to see *all* the arts of making as equal products of a creative impulse that is as socially determined as it is personally necessary—before the idea is no longer to make nothings into somethings, but to transform and give meaning to all things. In this utopian realm, Good Taste will not be standardized in museums, but will vary from place to place, from home to home.

Some Propaganda for Propaganda

A picture is supposed to be worth a thousand words, but it turns out that a picture plus ten or a hundred words may be worthiest of all. With few exceptions, most effective social/political art being done today consists of a combination of words and images. I'm not just talking about Conceptual Art or paintings with words on them, but also about writing that integrates photographs (and vice versa), about comic strips, photonovels, slide shows, film, TV, and posters—even about advertisements and fashion propaganda. In the last decade or so, visual artists have had to begin to think about problems of narrative, detachment, drama, rhetoric, involvement—*styles of communication*—which hitherto seemed to belong to other aesthetic domains. And in order to deal with these issues, they have had to overcome the modernist taboo against "literary art," which encompasses virtually all art with political/social intentions.

"Literary art" either uses words or, through visual puns and other means, calls up content more specific and pointed than that promulgated by modernist doctrines. It is a short jump from *specific* to "obvious," "heavy-handed," "crowd-pleasing," "sloganeering," and other epithets most often aimed by the art-for-art's-sake establishment at Dada's and Surrealism's recent progeny: Pop Art, Conceptual Art, narrative art, performance and video art. Even the most conventional kinds of representational art come in for some sneers, as though *images* were by definition literary. God forbid, the taboo seems to be saying, that the content of art be accessible to its audience. And god forbid that content mean something in social terms. Because if it did, that audience might expand, and art itself might escape

Reprinted from *Heresies,* no. 9 (1980). This article owes a great deal to dialogues with the *Heresies* no. 9 collective and the New York Socialist Feminists, and especially to those with Joan Braderman in both groups.

JENNY HOLZER
Truisms, 1978
PHOTOSTAT, 120″ × 48″, IN WINDOW OF FRANKLIN FURNACE,
NEW YORK
Photo: Mike Glier.

In the sentence "Boredom makes you do crazy things," the word crazy was shot out,
the window where it hung was smashed, and the poster was torn. Holzer's truisms
have been seen on an election-time truck moving through the city, on billboards
internationally, on the LED sign above Times Square, on T-shirts and matchbooks,
and in any number of other public spaces. They inevitably confuse, outrage, and
provoke thought about the roles of both art and propaganda.

from the ivory tower, from the clutches of the ruling/corporate class that releases and interprets it to the rest of the world. Art might become "mere propaganda" for *us,* instead of for *them.*

Because we have to keep in the back of our minds at all times that we wouldn't have to use the denigrated word *propaganda* for what is, in fact—*education*—if it weren't consistently used against us. "Quality" in art, like

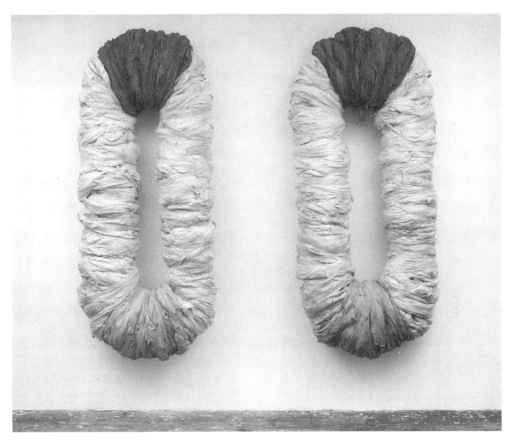

HARMONY HAMMOND
Swaddles, 1983–84
CLOTH, GESSO, ACRYLIC, RHOPLEX, LATEX, FOAM RUBBER, WOOD, 92″ × 106″
Collection the Metropolitan Museum of Art. Photo: D. James Dee.

This piece was one of the last of Hammond's wrapped sculptures, exuding, like the earlier works, a potent combination of strength, "body ego," sensuality, and comfort. Hammond was (and remains) a pioneering advocate of lesbian art activism. In some recent work, she combines rubbery, fleshlike surfaces scrawled with the insults commonly aimed at homosexuals.

"objectivity" and "neutrality," belongs to *them*. The only way to combat the "normal" taken-for-granted propaganda that surrounds us daily is to question *their* version of the truth as publicly and clearly as possible. Yet in the art world today, clarity is a taboo: "If you want to send a message, call Western Union"...but don't make art. This notion has become an implicit element of American art education and an effective barrier against artists' conscious communication, the reintegration of art into life.

After at least two decades in which the medium has been used primarily to subvert the message, the very word *message* has degenerated into a euphemism for commercial interruptions. So what's left of the avant-garde, rather naturally, rejects the notion of a didactic or "utilitarian" or "political" art, and socialist artists working in a context dominated by various empty fads and formalisms tend to agonize about the relationship between their art and their politics. "Formalism" (in the Greenbergian, not the Russian, sense) is denied them; it has been co-opted by those invested in the idea that if art communicates at all, what it communicates had better be so vague as to be virtually incommunicable, or it won't be "good art." This leaves the disen-franchised formalist (or "socialist formalist," as Rudolph Baranik has called himself in an attempt to reclaim the term) on a tightrope between accep-tance for her/his formal capacities alone and rejection for her/his need to "use" these capacities to convey social content.

Feminists, on the other hand, should be better equipped to cope with this dilemma. Women artists' historical isolation has prepared them to resist taboos. Our lives have not been separate from our arts, as they are in the dominant culture. "Utilitarian," after all, is what women's work has always been. For instance, many women artists today are rehabilitating the stitch-like mark, swaddling and wrapping, the techniques and materials of women's traditional art and work. Feminist art (and feminist propaganda) expands these sources to include what we learn from our own lived experience as women, from our sense of our bodies, from our subcultural lives as a "verti-cal class."

True, the feminist creed "the personal is the political" has been inter-preted far too widely and self-indulgently in the liberal vein of "my art is my politics," "all art is political," "everything a woman artist does is feminist art," and so forth. The "I" is not necessarily universal. The personal is only political when the individual is also seen as a member of a social whole. There is a plethora of a certain kind of "feminist art," which, like other prevailing avant-garde styles, looks into the mirror without also focusing on the meaning of the mirror itself—on the perimeter, the periphery which forms the images (form as veil; form as barrier; form as diversionary tactic). Yet despite all this, feminism has potentially changed the terms of propa-

ganda as art by being unashamed of its obsessions and political needs, and by confirming the bonds between individual and social experience.

Jacques Ellul sees propaganda as totally dangerous, as a sop, a substitute for loftier appetites, a false cure for loneliness and alienation. He reduces to propaganda all of our needs for shared belief, for a community of values.[1] Feminists may be able to see it differently. The dictionary definition of the word is "propagating, multiplying, disseminating principles by organized effort"; it acquired its negative connotation in a colonializing male culture (e.g., the Roman Catholic Church). In its positive sense the word *propaganda* can be connected to woman's classic role as synthesizer. Our culture of consumption draws women to the market, which, as Batya Weinbaum and Amy Bridges have shown, "provides the setting for the reconciliation of private production and socially determined need."[2] Similarly, women artists, few of whom have escaped traditional women's roles, might understand and clarify a viewpoint rarely if ever expressed in the arts and create new images to validate that viewpoint.

The goal of feminist propaganda is to spread the word and provide the organizational structures through which all women can resist the patriarchal propaganda that denigrates and controls us even when *we know* what we are doing. Since the role of the image has been instrumental in our exploitation (through advertising, pornography, and so on), feminist artists have a particular responsibility to create a new image vocabulary that conforms to our own interests. If, as Ellul says, "nonpropagandized" people are forced to live outside the community, then as feminists we must use our tools of consciousness raising, self-criticism, and nonhierarchical leadership to create a "good propaganda" that enables women of all races and classes to form a new, collective community. Such a "good propaganda" would be what art should be—a provocation, a new way of seeing and thinking about what goes on around us.

So far, the audience for feminist art has been, with a few exceptions, limited to the converted. The greatest political contribution of feminism to the visual arts has been a necessary first step—the introduction and expansion of the notion of autobiography and narrative, ritual and performance, women's history and women's work as ways to retrieve content without giving up form. This has involved the interweaving of photography and words and sometimes music, journal entries and imitations thereof, and the instigation of a dialogue that is particularly appropriate to video, film, or performance art. For instance, while so much "narrative art" is simply a superficial and facetious juxtaposition of words and images, it can, when informed by a politically feminist consciousness, open a dialogue between the artist and the viewer: Look at my life. Now look at yours. What do you like/hate about me/my life? What do you hate/like about you/yours? Have

you ever looked at your oppression or your accomplishments in quite this way? Is this what happened to you in a similar situation? And so forth, hopefully leading to: Why? What to do? How to organize to do it?

In a literate (but antiliterary) society, the words attached to art, even as mere titles, may have more effect on the way that art is perceived than some of the strongest images do. As a public, we (but especially the docilely educated middle class) look to be told by the experts what we are seeing/thinking/feeling. We are told, taught, or commanded mainly in words. Not just criticism, but written captions, titles, accompanying texts, soundtracks, taped dialogues, voice-overs all play major roles in clarifying the artist's intent—or in mystifying it. A title, for instance, can be the clue to the image, a hook pulling in a string of associations or providing a punch line. It can also be obfuscating, unrelated, contradictory, or even a politically offensive publicity gimmick whereby the artist so vaguely identifies with some fashionable cause that the meaning is turned back on itself. (See *Heresies,* no. 8, for the Coalition Against Racism in the Arts' position on such a situation.)

At what point, then, does the word overwhelm the image, the combination become "just a political cartoon"? Still more important, at what point does visual or verbal rhetoric take over and either authoritarianism or an insidiously persuasive vacuity overwhelm dialogue? *This* is the point at which the image/word is no longer good propaganda (socially and aesthetically aware provocation) but bad propaganda (exploitative and oppressive economic control mechanism). Authoritarian written art is basically unpopular with all except the most invested and/or specialized audiences. Feminists, too, are more likely to be swayed and moved to tears or rage by music, novels, films, and theater than by visual art, which is still popularly associated with imposed duty and elitist good taste, with gold frames and marble pedestals. Yet the feminist influence on the art of the seventies is evident in the prevalence of art open to dialogue—performance, video, film, music, poetry readings, panels, and even *meetings.* This tendency not only suggests a merger of art and entertainment (with Brechtian overtones) but also suggests that speaking is the best way we know to get the message across while offering at least the illusion of direct content and dialogue. It also implies that the combination of images and *spoken* words is often more effective than the combination of images and *written* words, especially in this day of planned obsolescence, instant recycling, and antiobject art.

Although most of the propaganda that survives is written, it tends to get diluted by time, misunderstandings, and objectification. The spoken word is realer to most people than the written word. Though more easily forgotten in its specifics, it is more easily absorbed psychologically. The spoken word

is connected with the things most people focus on almost exclusively: the stuff of daily life and the kind of personal relationships everyone longs for in an alienated society. It takes place *between* people, with eye contact, human confusion, and pictures (memory). It takes place in dialogues with friends, family, acquaintances, day after day. So one's intake of spoken propaganda is, in fact, the sum of daily communication.

This more intimate kind of propaganda seems to me to be inherently feminist. It might be seen as gossip, in the word's original sense: *godsib* meant "godparent," then "sponsor and advocate"; then it became a relative, then a woman friend, then a woman "who delights in idle talk," "groundless rumor," and "tattle." Now it means malicious and unfounded tales told by women about other people. All this happened through the increased power of patriarchal propaganda, through men gossiping about women and about each other on a grand scale (history). Thus, in the old sense, spoken propaganda, or gossip, means *relating*—a feminized style of communication either way.

Over my desk hangs a postcard showing a little black girl holding an open book and grinning broadly. The caption reads: "Forge simple words that even the children can understand." This postcard nags at me daily. As a writer who makes her living mostly through talking (one-night stands, not teaching), I am very much aware that writing and speaking are two entirely different mediums, and that they translate badly back and forth. For instance, you can imitate writing by speaking, as anyone knows who has dozed through the presentation of an academic "paper" spoken from a podium. Or you can imitate speaking by writing, as anyone knows who has read the self-conscious chitchat favored by many newspaper columnists. The best way of dealing with speaking seems to be to skip, suggest, associate, charm, and perform with passion, while referring your audience back to the written word for more complex information and analysis.

Holding people's attention while they are reading is not so easy. Like "modern art," the thoughtful essay has had a bad press. Popular magazines imitate speech by avoiding intimidating or didactic authoritarian associations with the text-filled page and by breaking the page with pictures, anecdotes, or intimate "asides." Right and Left depend equally on colloquialism to reach and convince a broad audience. Popular dislike of overtly superior or educated authority is reflected, for instance, in an antifeminist characterization of "most women's lib books" as "cumbersome university theses." The visual/word counterparts of long-running TV soap operas are the comic book and the photonovel, which, significantly, are the closest possible imitations of speaking in writing, as well as the cheapest way of combining "spoken" words with images.

As a middle-class college-educated propagandist, I rack my brain for ways to communicate with working-class women. I've had fantasies about peddling socialist feminist art comics on Lower East Side street corners, even of making it into the supermarkets (though it would be difficult to compete with the plastically slick and colorful prettiness of the propaganda already ensconced there). But this vision of "forging simple words" also has a matronizing aspect. I was taken aback at a recent meeting when a young working-class woman who did not go to college stood up for a difficult language and complex Marxist terminology. Her point was that this terminology had been forged to communicate difficult conceptions and there was no need to throw the baby out with the bathwater because of some notion that the working class wasn't capable of developing its minds. "We can look up the words we don't know," she said, "but people want to *grow*."

So are my comic book fantasies simply classist? Should I stick to the subtleties of four-syllable words? Both of us seemed to be leaning over backward to counteract our own class backgrounds. A similar conflict was expressed by the Cuban writer Nelson Herrera Ysla in a poem called "Colloquialism":

> Forgive me, defender of images and symbols.
> I forgive you, too.
> Forgive me, hermetic poets for whom I have boundless admiration,
> but we have so many things left to say
> in a way that everyone understands as clearly as possible,
> the immense majority about to discover the miracle of language.
> Forgive me, but I keep thinking that Fidel has taught us dialogue and
> that this, my dear poets,
> has been a decisive literary influence.
> Thank you.[3]

Such conflicts between high art and communication have recently been raised in the visual arts by public feminist performance art, by Judy Chicago's cooperatively executed *The Dinner Party,* and by the community mural movement—the visual counterparts of verbal colloquialism in their clear images and outreach goals. But how much conventional visual art, in fact, has been successful as propaganda? From the twentieth century we think of a few posters: "Uncle Sam Wants You"; "War Is Not Good for Children and Other Growing Things"; "And Babies?" (this last one, protesting the My Lai massacre, was actually designed collectively by a group of "fine artists" from the now defunct Art Workers' Coalition). And we think of a few modern artists—the Mexican muralists and, ironically, several Germans: the Berlin Dadas, Heartfield, Kollwitz, Staeck, Beuys, Haacke.

Compare this lackluster record with the less brutal consciousness raised by songs (those in which the musical foreground doesn't overwhelm or neutralize the lyrics). And compare it with the kind of historical consciousness raising offered through oral history, accompanied by old photographs, letters, memories of one's own grandparents' stories. We keep coming back to words. And not just to words, but to words set in visual frameworks that are emotionally as well as intellectually stimulating.

My own preference is for an art that uses words and images so integrally interwoven that even narrative elements are not seen as "captions" and even realistic images are not seen as "illustrations." Yet I have to admit I'm constantly disheartened by the content of art using the "new mediums" as vehicles not for communication or social awareness, but simply for unfocused form and fashion. Effective propaganda obviously has to be aimed at a specific audience, not just shot into the air to fall to earth we know not where. (This fact should hardly be anathema to an art already, if often unconsciously and involuntarily, aimed at a very limited audience of curators, critics, collectors, and other artists.) Targeting one's audience is very different from finding one's audience—the former having to do with marketing and the latter with strategy. If we assume that moving a large and varied audience is at the heart of the matter, perhaps we should spend our energies making art for TV, where information can be communicated in a manner that is simultaneously intimate and detached, and where there might be some hope of turning that huge, passive, consuming audience into a huge, active, critical, potentially revolutionary audience. And *if* (a monstrous if) we were ever to succeed in wresting TV time from 100 percent corporate control, would this lead to solid alliances, or to a wishy-washy pluralism? And where would artists come in?

Most "art video" (as opposed to documentary, real-time political video) is still limited to art audiences and is, or would be, rejected by people accustomed to a kind of entertainment most avant-garde artists are not skillful enough to produce, even if they did decide to stop boring their audiences to death. Most artists prefer not to move out of the competitive, incestuous, but comprehensible art context into the unwelcoming Big Time of the real world. In the late sixties, a few Conceptual artists did make newspaper pieces, but they were usually art-world "in" jokes or rhetorical arguments plunked down with no attempt to adapt to the new medium, becoming in the process another kind of ineffectual cultural colonialism. (Ellul says that ineffective propaganda is simply *not* propaganda.) Despite its idealistic beginnings, most book art is now a pale imitation of gallery art, the page becoming a miniature wall instead of something to be *read* (i.e., understood). In turn, written art hung on gallery walls is difficult to read and

arrogant in its enlargement from the book form it imitates. There have been some genuine and successful attempts to integrate art into street and community life, and others to analyze and compete with public advertising in the form of posters and rubber-stamp commentaries, but for all the theoretical acumen of some of this work, it tends to be visually indistinguishable from the mass media it parodies.

These issues open a can of worms about satires and "parodies" that aren't comprehensible if one isn't in the know. Ambiguity is chic *and* modernist, lending itself to esoteric theories that inflate the art and deflate any possible messages. A left-wing film, for instance, might be a "parody" of macho fantasy films of violence, but in fact uses parody as an excuse to wallow in just that "politically incorrect" imagery. This happens often in feminist art and performance, too. When women artists use their own nude bodies, made-up faces, "hooker costumes," and so on, it is all too often difficult to tell which direction the art is coming from. Is this bare-breasted woman mugging in black stockings and garter belt a swipe at feminist "prudery" and in agreement with right-wing propaganda that feminism denies femininity? Is it a gesture of solidarity with prostitutes? Is it a parody of the ways in which fashion and media exploit and degrade women? Is it an angry satirical commentary on pornography? Or does it approve of pornography? Much so-called punk art (politically aware at one point in Britain, although almost never in the United States) raises these questions in a framework of neutral passivity masquerading as deadpan passion. Similarly, a work might cleverly pretend to espouse the opposite of what it does, in fact, believe, as a means of emphasizing the contradictions involved. But how are we to know? Are we just to be embarrassed when the artist says, "But I didn't mean it that way. How naive, how paranoid and moralistic of you to see it that way. You must be really out of it"? Are we to back down because it is, after all, art, which isn't supposed to be comprehensible and isn't just about appearances? Or can we demand to know why the artist hasn't asked her/himself what kind of context this work needs to be seen "right" or "not taken seriously"—to be seen as the satire it really is?

Women are always assumed by the patriarchy to be suckers for propaganda—less educated, less worldly, more submissive, more emotional than men. Looking at it a different way, acknowledging the edge we have in empathy, feminist consciousness of communication, narrative, intimate scale, and outreach networks, why aren't women artists taking the lead in inventing, say, a new kind of magazine art that transforms a legitimate avant-garde direction into propaganda with an aesthetic character of its own? Why aren't many women artists making imaginative public art focused on feminist issues? Why do the Right-to-Lifers have more compelling demonstration skits,

posters, and pamphlet images than the Pro-Choice movement? (One reason, of course, is that the right wing has money and The Committee for Abortion Rights and Against Sterilization Abuse [CARASA] doesn't. But surely there are enough economically comfortable women artists to lend some time and talents and aesthetic energy to causes they believe in?) Why does *Heresies* receive so few pertinent visual pieces? Why have the few artists committed to such work often found it easier to use words than images? And how can we get more visibility for those word and word/image pieces that do tackle this problem? Some crucial factor is lacking in our strategies for making memorable images or emblems that will move, affect, and provoke a larger group of women. Some crucial breakdown in confidence or commitment, or caring energy, seems to occur when an art-world-trained artist is confronted with the possibility of making "useful" art. I could make a lot of psychological guesses why (fear of the real world, fear of being used by the powers that be, fear of being misunderstood and misperceived, fear of humiliation and lack of support) but I'm more interested in encouraging artists to move into such situations so we can see what happens then.

A lot of these questions and problems may be the result of our own misunderstanding of propaganda turning back on us. No one on the Left would deny the importance of propaganda. Yet it is a rare left-wing feminist who is interested in or even aware of the resources visual artists could bring to the struggle. The current lack of sparks between art and propaganda is due to a fundamental polarity that is in the best interests of those who decide these things for us. There are very effective pressures in the art world to keep the two separate, to make artists see political concern and aesthetic quality as mutually exclusive and basically incompatible; to make us see our commitment to social change as a result of our own human weaknesses, our own lack of talent and success. This imposed polarity keeps people (artists) unsure and bewildered amid a chaos of "information" and conflicting signals produced by the media, the marketplace, and those who manipulate them and us. It keeps us desperate to be sophisticated, cool, plugged in, and competitively ahead of the game (other artists, that is). It makes us impatient with criticism and questions. It deprives us of tools with which to understand the way we exploit ourselves as artists. It makes us forget that words and images working together can create those sparks between daily life and the political world instead of hovering in a ghostly realm of their own, which is the predicament of the visual arts right now. It keeps us from forming the alliances we need to begin to make our own lives whole.

Issue and Taboo

"Issue" is of course a pun on generation and topicality. It is about
propagation, spreading the word that it is possible to think about art as a
functioning element in society. While all art should to some extent act as
provocation, as a jolt or interruption in the way social life and sensuous
experience are conventionally perceived, the work shown here attempts to
replace the illusion of neutral aesthetic freedom with social responsibility
by focusing—to a greater or lesser degree—on specific issues. It is all
made by women because the contributions of feminist art to the full pano-
rama of social-change art and the ways in which a politicized or topical art
approaches, overlaps, and diverges from the various notions of a feminist
art are crucial to its further development. The concerns of "Issue" parallel on
an art front those of Sheila Rowbotham's, Lynne Segal's, and Hilary Wain-
right's important book *Beyond the Fragments.* While the fragments vary from
field to field and from country to country, the fact that feminism has some-
thing to offer the Left that the Left badly needs is as inarguable in art as
it is in political organization. The transformation of society, at the heart of
both feminism and socialism, will not take place until feminist strategies
are acknowledged and fully integrated into the struggle.

After the 1978 "Hayward Annual" (inaccurately called "the woman's
show" and sometimes still more inaccurately seen as a feminist show),
Griselda Pollock called for "an exhibition of feminist work which will
present and encourage debate around the issues of feminism and art practice
which have emerged within the women's movement...conceived and struc-

Reprinted from *Issue: Social Strategies by Women Artists* (London: Institute for Contempo-
rary Arts, 1980), catalog for exhibition curated by Lucy R. Lippard.

tured as a sustained political intervention."[1] I would like to think that "Issue"
starts to provide such a framework for a transatlantic and cross-cultural
dialogue. I want to make clear at the outset, however, that despite its stylis-
tic diversity, "Issue" was conceived within a relatively narrow focus. It
is concerned with what is being done in this specific activist area. It is in
no way a general show of "feminist art" dealing with the politics of being
female. Nor is it even a general "women's political art" show, since it
does not include highly effective multi-issue artists like Toni Robertson or
Annie Newmarch in Australia, nor community muralists like Judy Baca in
Los Angeles, nor the many women who concentrate on video, film, per-
formance, photography,[2] organizational slide shows, or realist painting and
sculpture with political subject matter. Certainly "Issue" does not constitute
a value judgment about what is the only effective feminist art, effective
political art, or aesthetically successful feminist art. In fact, such outreach
art is no more a style or movement than feminist art is. If I am protesting
too much about these distinctions, it is because I am sick and tired of
the divisive categorizing that supports reactionary taboos against social-
change art by stimulating the competition inherent in the present high-art
system. I hope it will also be clear that "Issue" sidesteps debates on stylistic
assumptions about women's art. I still hold the opinion that women's art
differs from that of men, but I have moved away from my earlier attempt to
analyze these differences in formal terms alone. In ten years, the needs,
contexts, and developments have changed. In the early days of the feminist
art movement we were looking for shared *images*—or rather they popped
out at us and demanded to be dealt with. For some of us this preoccupation
then led to a search for shared aesthetic and political *approaches*, for a theo-
retical framework in which to set these ubiquitous images. Now we are
in a stage where we tend to take that earlier data on image and approach for
granted; the real challenges seem to lie in analyzing structures and effects.
Thus the time seemed right to begin to break down the various kinds of
feminist political art (all truly feminist art being political one way or another).
"Issue" scrutinizes that branch which is "moving out" into the world, placing
so-called women's issues in a broader perspective and/or utilizing mass
production techniques to convey its messages about global traumas such as
racism, imperialism, nuclear war, starvation, and inflation to a broader
audience.

There is, I know, a certain danger that when women's issues are
expanded too far they will get swallowed up by an amorphous liberalism.
Yet I have opted here for an ecumenical view rather than a strictly socialist
feminist view because I am convinced that the cross-references made
between all these works—even within the limiting context of an art show—

add up to a denser, deeper statement. I hope the web of interconnections and disagreements will cross boundaries of medium, aesthetic, and ideology to facilitate a dialogue with the audience. The conference taking place in conjunction with "Issue" and her sister shows at the ICA—"Women's Images of Men" and "About Time"—will be a still more effective factor in this process.

One reason for placing a women's show outside strictly women's issues is to provide a fresh look at feminist art from a different angle. Most of the work in "Issue" is urgent and explicit about its subject matter. It is *experimental art,* throwing itself into that notorious abyss between art and life of which so much has been ready-made since Duchamp and Dada. The artists have chosen different ways to slalom between the poles of isolation, separatism, struggle, and autonomy within the male Left and assimilation that have been the choices open to feminists for the past decade or so. Yet all of them have worked collaboratively or collectively on some aspect of their art-related lives—whether in a co-op gallery, a political collective, a woman's center, a periodical, a school, artist-organized exhibitions and events, team-teaching, or in art-making itself—with other women or with politically sympathetic men. (Three of the twenty participants *are* collaboratives—Ariadne, Croiset/Yalter, and Fenix—while Leeson and Holzer work regularly with male partners, several others do so irregularly, and Sherk works with a mixed group.)

The collaborative aspect is particularly significant because artists involved with outreach have to learn to work with others before they can hope to be effective in larger contexts. The women in "Issue" share an awareness of their capacity (and *responsibility)* as artists to raise consciousness, to forge intimate bonds between their perceptions and those of their audience. Some of them may feel that feminist art's most effective tactic is intervention *into* the mainstream so as to attach from within; others see the mainstream as irrelevant and seek alternative models for artists disillusioned with the role of art as handed down from above. They have all to some degree been exhibited and discussed within the current system, but each has also kept a wary eye outside of it. Their art gains from the resulting tensions. For instance, a large number of them have chosen potentially populist, mass-produced mediums such as posters, books, magazine pieces, and video as a means by which to extend control of their own art and its distribution, in the process choosing their own audience, or at least not letting their audience be chosen for them. The dominant culture tends to see such small, inexpensive, disposable objects as by-products, a watering down of the unique artifact for mass consumption. But, in fact, the reproductive works often represent a *culmination* in compact form that intends to compete (on

however small a scale) with the mass media for cultural power. Such direct-
ness stems from the artists' desire to bring art out of its class and economic
confinement, and it is integral to their strategies to such an extent that
direct—as a verb and an adjective—seems to be a key word.

Jenny Holzer, for instance, uses direct mail and street leafleting to convey
her provocative messages about thinking for oneself in the morass of con-
flicting propaganda that surrounds us. She does this by making her own
carefully researched collections of aphorisms and essays, whose messages
sound ultrapositive and direct, but are often, on scrutiny, highly ambiguous.
Holzer operates in a curious realm between belief and disbelief, cliché and
fact, cynicism and hope. She sees her work as nonideological; it does not
so much impose a fresh view as it criticizes all existing views. One of her
recent works—a leaflet with a return-response coupon that is headlined
"Jesus Will Come to New York November 4" (U.S. election day)—exposes
right-wing and religious connections and warns its readers that three million
fundamentalists are newly registered to vote. The language is clear and
nonrhetorical and the piece is potentially effective in that it could scare
more liberals and leftists into voting.

Nancy Spero's delicate collaged scrolls are directed against brutality and
violence. In a bold, irregular, oversized print, interspersed with twisted and
attenuated figures, sharp tongues out or arms flailing, she catalogs human-
ity's current nightmares—the Vietnam war, the torture of women, the
bomb, fascist coups. She often uses poetry (by Artaud or H.D. or from
mythological sources) ironically to undermine the whole notion of poetry,
or art, as something beautiful and soothing. In *Torture in Chile,* Spero uses
fragmentation as a metaphor for the dismemberment of women and of a
revolutionary motherland. The vast horizontal scroll is drawn out, strung up
against the wall like a prolonged scream of rage. The images are less active
than usual, as though the horror of the factual text, underscored by sharp
geometric lines, has immobilized the figures.

In a very different way, Nicole Croiset and Nil Yalter also explore fragmen-
tation in their extended video/text/drawing "oblique object" installations
about the fourteen million working-class immigrants to urban centers and to
the wealthier European nations. Yalter is herself Turkish and the piece in
"Issue" focuses on Rahime, a Kurdish woman of nomadic background
making the wrenching transition between her village and an industrial shan-
tytown outside of Istanbul. Married at thirteen, a mother at fourteen, she is
undergoing a forced triple consciousness raising (as a woman, a worker, and

a rural alien), tragically heightened when her progressive daughter was murdered by a man she refused to marry. Rahime is very articulate about the injustices of her situation. She notes how the rich can't *do* anything— work in a factory or even fulfill their military service. Croiset and Yalter combine art, sympathetic anthropology, and documentary approaches. As in their previous works on the city of Paris, a women's prison, and immigrant workers in France and Germany, they bring to rhythm and life the people who make up the statistics of Europe's new, reluctant melting-pot status.

Miriam Sharon is also involved in cross-cultural awareness. An Israeli, she has worked with the Bedouins in the Negev and Sinai deserts. Her earth-covered tents and costumes pay homage to their close relationship to nature. By performing rituals in the desert and on the Tel Aviv waterfront (at Ashdod Harbor, appropriately named after an ancient goddess), Sharon uses her art as a vehicle of cultural exchange; she reminds the workers of the plight of the nomads who are being herded into cement villages and forced to abandon their traditional ways of life. She also shows her work in factories and has become a one-woman liaison organization between the "desert people" and their rulers.

Maria Karras also deals with dislocation in her phototext posters on the subject of "multicultural awareness." *Both Here and There* consists of fourteen posters in English and one of twelve different languages; each shows a relaxed portrait of a woman from a different ethnic origin and a statement excerpted from an interview about her experience as a woman and an immigrant in America. Conceived and marketed as teaching aids as well, the posters were seen by over a million people when they went up in Los Angeles public buses in 1979. They stem from Karras's earlier work on her own Greek heritage. What initially appears to be a bland, chamber-of-commerce format is ruffled by the casual poses and the controversial things some of her subjects have to say about women's roles in their communities. Each poster is a small and pointed political geography lesson. Karras offers positive images of women, new role models and new sources of confidence for women. She provides an exchange between Los Angeles's many and isolated ethnic communities, and makes connections between feminism and the anxiety, alienation, and assimilation of the bicultural experience.

Posters, of course, are probably the most direct public art medium there is. Loraine Leeson and Peter Dunn have been collaborating for several years with the trade unions and local groups to produce a series protesting hospital shutdowns and health cutbacks for the East London Health Project.

Because of their formal strength and visual interrelation, these campaigns lend themselves to art contexts as well as to the intended social function, although the artists make it clear they dislike using their audiences as "passive consumers," and don't think "gallery socialism" is enough. The series in "Issue" was made by Leeson with the Women's Health Information Centre Collective and deals with specific issues such as abortion, contraception, home care, and women's work hazards, as well as more general questions such as women being driven back into the home as the result of health cuts, the social role of women and its indirect effects on health, and why certain aspects of health care should be seen as women's issues. Like the earlier campaign, this is seen as social art for a "transitional period" between art based on the values of a consumer society and "something else" that will occur when that society is changed. Since she is acutely aware of the dangers of art colonization, Leeson's poster work is informed by a rigorous self-criticism that brings it to the edge of disappearance into social *work*, from which it is saved, paradoxically, by its visual and aesthetic force.

For most of these artists, the international Women's Liberation Movement is a source of great theoretical vitality. However, they use it in very different styles, to very different degrees, and operating from very different political assumptions. This could not be otherwise since they are also of different nationalities, different races, different class and aesthetic backgrounds and foregrounds. The difficulty of generalizing about twenty-four such diverse artists is compounded by the fact that the discourses around feminist and sociopolitical art in the United States and the United Kingdom (where the majority of these artists live) are literally in such different places. The state of British art is not the state of American art. For example, this ICA series is the first establishment-approved women's show in London, while New York has had women's shows but has never had a "political art show" on the order of London's "Art for Whom," "Art for Society," and others.[3] In mainstream America, social art is basically ignored; in England, it enjoys the attention of a small but vocal (and often divided) group with a certain amount of visibility and media access. In America, artist-organized tentatives toward a socialist art movement are marginal and temporary, waxing and waning every five years or so with only a few tenacious recidivists providing the continuity. In England, there are actually Left political *parties* that artists can join and even work with—and the more advanced level of theoretical discussion reflects this availability of practice.

In England, feminist art is thought by some to be "utterly concerned with notions of what art is and only concerned with making strong, direct statements about the position of women in our culture"[4]—which certainly helps

to explain the reluctance of some professional artists to be labeled as femi-
nists. In America, on the other hand, it is the feminist Left that is reluctant
to be associated with "bourgeois" or "radical" or "separatist" feminism, and
the popular notion of feminist art is more oriented toward images than
toward ideologies. There is also a firm resistance to the notion of defining
feminist art at all, or accepting any "predetermined concepts of feminist
art,"[5] because we have seen the enthusiasm of those who would like to
escape feminist energy by consigning all women's art to a temporary style
or movement. In Israel, feminist art is still an oddity, and Miriam Sharon is
rare in welcoming the identification. In France, feminist art is more often
defined according to American cultural feminist notions (autobiography,
images of self, performance, traditional arts) than according to the more
universalized psychopolitical theory for which French feminism is known. In
any case, the sociological work of Croiset/Yalter does not seem typical of
either country's clichés about feminist art.

All of these confusions can be partly attributed to the fact that, as
Rowbotham has remarked in another context, the feminist tenets of organic
growth—"many-faceted and contradictory"—do not fit any current model
of the vanguard.[6] In challenging the notions of genius, of greatness, of artist
as necessary nuisance that are dear to the hearts of the institutional main-
stream and of the general public, the artists in "Issue" have also challenged
some fundamental assumptions about art. They are in a good position to do
so because feminist art has had to exist for the most part outside of the
boundaries imposed by the male-dominated art world. While these artists
exhibit in that world, they also maintain support systems outside of it and
many have established intimate connections with different audiences. Having
watched so many politicized artists reach out, only to fall by the wayside or
back onto acceptable modernism fringed with leftist rhetoric, I have the
heartiest respect for those with the courage to persist in this nobody's land
between aesthetics, political activism, and populism. The taboos against
doing so, however, bear some looking into, along with the ways such artists
have broken them.

Some are challenging the taboos against subject matter considered "unsuit-
able" for art—such as unemployment, work and domesticity, budget cut-
backs or militarism. Some are aiming at the sense of imagined superiority
that has so disastrously separated "high art" from "crafts" and "low art" and
artists from "ordinary people." Margaret Harrison, for instance, is acting on
both of these principles. Her collage paintings and documentation pieces
have long focused on the theme of women and work, but rather than picture
or objectively comment on her subject, she works from inside it with the

people it concerns. A work is finished only when it reflects and has had some effect on the selected field. Harrison has worked with isolated homeworkers and with rape groups. In "Issue," she takes on crafts and class. The visual core of the piece consists of three versions of each craftwork: the actual object, a painting of it, and a photograph of it. The items belonged to her mother-in-law. They trace the "de-skilling process" of working-class women since industrialization by moving from a handmade patchwork to a cheap doily, "made in the factory by working women and sold back to them." Like the "hookey mat"—once a shameful symbol of poverty and now enjoying the status of a desirable antique—they indicate the disappearance of crafts from the lives of working-class women to become the domain of the middle class. Harrison's theme has ramifications not only for the feminist insistence that the struggle is taking place in the home as well as in the workplace, but also as a comment on the "precious object" in current art practice.

Beverly Naidus also deals with planned obsolescence. Her title is *The Sky Is Falling, or Pre-Millennium Piece.* The audiotape talks about "selling life as it is," about unemployment and economic insecurity and the panaceas offered to cure them: consumerism and evangelical religion. She deals with issues blurred by media overkill by using cliché and collage—lists, asinine questionnaires, posters slapped up guerrilla-style over photos of people standing in lines and suffering bureaucratic banalities. This visual layering technique suggests that underneath the doomsaying is a groundswell of people power.

There is a pervasive belief, in the United States at least, that art with political subject matter is *automatically* "bad art." To some extent, of course, such taboos can be attributed to the artists' intentional divergences from conventional audiences and goals, as well as to a formalist dislike of "literary art" that is much stronger in the United States than in the United Kingdom. But social art is also *perceived* differently. An organic shape readable, say, as a mushroom cloud, is judged on a completely different scale, no matter how forcefully it may be formed, from the same shape, similarly executed, that is illegible, or abstract. Timely subjects like those listed above are not publicly acknowledged to be threatening to the status quo but are simply dismissed as "boring" or "unaesthetic." This dismissal is particularly weird coming after a decade in which the avant-garde and the bourgeoisie cheerfully validated pieces involving pissing, masturbating, match throwing, body mutilation, self-imprisonment, and so on. What, then, makes the appearance of an angry black face, a war victim, or nuclear generators so firmly unacceptable?

. . .

Adrian Piper has addressed this issue in her *Aspects of the Liberal Dilemma.* A photograph on the wall of a crowd of angry-looking black people coming down a staircase is accompanied by an audiotape that discusses the image solely in formal terms and asks, "What exactly is the aesthetic *content* of this work?" In another, similar pamphlet work, four identical photos of starving boat people are captioned as follows: "Gosh, what a tragedy.../.../ (sigh)/Is that all? Where's the art?" In a 1977 letter she suggested that "the purpose of art may transcend the development of one's aesthetic sensibilities in favor of the development of one's political sensibilities." Acknowledging the horror with which that statement would be generally received, she specu-lated: "Maybe nonpolitical messages are more acceptable because they tend to be more personal, hence less publicly accessible, hence more symbolic or mysterious, therefore more reducible to purely formalist interpretations; i.e., the more likely it is that people will understand what you're trying to convey, the less fashionable it is to try to convey it." As a black woman who can "pass" and a professor of philosophy who leads a double life as an avant-garde artist, Piper has understandably focused on self-analysis and social boundaries. Over the years her work in performance, texts, newspapers, unannounced street events, tapes, and photographs has developed an in-creasingly politicized and universalized image of what the self can mean. In the set of three *Political Self Portraits,* for example, she turns her autobio-graphical information inside out to provide devastating commentaries on American racism, sexism, and classism.

Taboo subjects inevitably include a panoply of feminist preoccupations, such as rape, violence against women, incest, prostitution, ageism, and media distortion. All of these have been confronted by Suzanne Lacy and Leslie Labowitz, working together and with other women as Ariadne: A Social Network. Like Piper, they have used "the expanding self" as "a metaphor for the process of moving the borders of one's identity outward to encompass other women and eventually all people." Their collaborative performances are unique in their grand scale and detailed planning, and in the fact that they take place exclusively in the public domain, sometimes with casts/audiences of thousands (as in the Women Take Back the Night march in San Francisco in 1978). Lacy and Labowitz have evolved a "media strategy" for their campaigns and events, which often incorporate several different approaches to reach different sectors of the population.[7] They work with a broad variety of organizations and groups, focusing on specific feminist issues. Their pieces are carefully designed so as to subvert the usual media distortion of women's issues; to attract coverage, they depend on striking visual images (such as seven-feet-tall mourning women in black, and one in

red for rage, bearing a banner reading WOMEN FIGHT BACK, in the piece *In Mourning and In Rage,* which commemorated the women murdered in Los Angeles by the Hillside Strangler). Ariadne was determined to control not only its production, but the way its images were perceived and understood. Lacy's and Labowitz's networking techniques gave them broader access to popular culture than is usual for art.

Most of the taboo subjects are, in fact, those covered (and mystified) extensively by the news media. I suspect one of the reasons they are palatable in that form of "entertainment," but not as fine art, is precisely because they are so ubiquitous in their more popular form. We are tired of them. Their focus on novelty deprives them of meaning when they are the most meaningful issues of our time, and those it is most crucial for us to see clearly. The artists in "Issue" are acutely aware of this situation and confront it in various ways. Candace Hill-Montgomery, for example, in her angry photodrawings, uses images that have survived the media blitz to remain shocking reminders of the history of racism in America. Just to be sure, she heightens their immediacy by hanging the drawings, weighted down by Plexiglas™, with unexpected and often ungainly objects that bring them still more into our own world. Thick chains support a terrifying picture of a black man chained to a tree, his back broken; a full-sized noose holds up a lynching picture; and army pants hold a piece on American military atrocities; a brass eagle holds the big, colorfully bitter *Teepee Town Is in Reserve.* By bringing relatively abstract and expressionist images into concrete space, Hill-Montgomery makes it clear that she is not talking about fictionalized history. With these almost monstrous objects mitigating the craft of her drawn surfaces, she juxtaposes the possibility of black power against the historical fact of black powerlessness, daring the viewer to enjoy her works as "just art."

Margia Kramer's *Secret* also deals with terrifying material and her use of black and white is based on a similar symbolism. Her raw material is the censored photocopies she obtained through the Freedom of Information Act on the FBI surveillance and harassment of Jean Seberg, which led eventually to the film star's suicide. In the three-hundred-page file, the FBI referred to Seberg as "the alleged promiscuous and sex-perverted white actress" and stated its desire to "cause her embarrassment and cheapen her image with the public." Seberg's persecution arose from the fact that she was a supporter of the Black Panther party. The FBI leaked to the news media the false story that Seberg was pregnant by one of the Panthers; when the baby died at birth she took it in an open coffin to her hometown in Iowa to refute these stories, but the emotional toll had been taken. Kramer's art

consists not of commentary but of strong visual presentation of the documents in video, book, and huge blown-up negative and positive photostats; with their impersonal telegraphic style and brutally censored passages, they are the ideal vehicles for this chilling tale of governmental paranoia and manipulation. Her subject is not only constitutional rights, America's race wars, the media's willingness to exploit a woman at her most vulnerable point—her sex life—but, also, paradoxically, the democratic fact of the Freedom of Information Act that permitted this ghastly story to be exposed. In addition there is a curious reversal of the feminist search for public meaning in private life in Seberg's martyrdom through public invasion of privacy.

Alexis Hunter has concentrated on gesture in what might be taken as parodies of media photos of disembodied hands capably and prettily doing women's dirty work. She is not a documentary photographer, but sets up and acts out her own ideas like a photonovelist. For several years Hunter concentrated on themes of fear and violence, rape, and domestic and sexual warfare. Despite often sensational subject matter, the work transmitted not moral outrage so much as bemused personal anger that found its outlet in highly physical or sensuous activities. There is an element of exorcism in these pieces, and at the same time there is something decidedly threatening about the elegantly female hands going about their business with such aggressive determination. Surfaces—smeared, caressed, decorated, or smashed—are dominant in Hunter's work, perhaps as a pictorial pun, since humor is rarely absent no matter how horrific the content. In *A Marxist's Wife (Still Does the Housework)*, a ringed hand wipes off a portrait labeled "Karl Marx Revolutionary Man Thinker." The second piece in "Issue" is rare for Hunter in that the protagonist is neither generalized nor disembodied. *A Young Polynesian Considers Cultural Imperialism Before She Goes to the Disco* shows a black woman trying on and then discarding a white woman's jewels (or chains). As a white New Zealander or "pakeha," the artist is implicated in this story not only as the executor of the work but as its surface. The young Polynesian becomes a mirror in which Hunter must see herself and her own race.

Marie Yates, in her phototexts *On the Way to Work,* also explores social preconception about images of women, the ways in which they are made, and their meanings. By the materialist ploy of working "in the gaps of reality," she appears to pull the viewer into the interstices between cultural understanding and misunderstanding that are left when the representational cliché is emptied of its accepted content. She does this on the levels of "real life," fiction, and politically sophisticated analysis. In her earlier work

(particularly the book *A Critical Re-Evaluation of a Proposed Publication* of 1978), Yates confronted the "display and/or consumption of landscape" by juxtaposing beautiful views of rural England with simple binary oppositions like "nature/culture, them/us." Now she applies a similar confusion of predictable romanticization and objectification devices in order to expose the codes of gender identification in this society.

Where most of the artists in "Issue" believe that art is about seeing clearly and teaching people how to see the world that surrounds them, they and others like them are sometimes attacked from the right for not sticking to formal "beauty" and from the left for having any formal preoccupations at all, as well as for being politically naive. They are caught in a classic conflict between "standards" of art taught in schools and the disillusionment that hits socially concerned artists when they begin to realize how little what they were taught can help them to get their most important ideas across. Once they have found their own ways, they may still be walking a tightrope, making art critical or neglectful of values they must accommodate to earn a living. Some such artists are eventually disarmed and assimilated into the mainstream while others are banished for uppity irrelevance to the dominant culture. Some have made a politically informed decision for this uncomfortable position, while others have moved into it organically. Either way, it is crucial for feminists to understand the ways these taboos operate and the reasons behind them, because even the least daring women's art is judged by criteria based on such antipathetic values. This situation can, in turn, lead to fear-inspired competition and factionalism and the diminution of a publicly powerful feminist art front.

 Such factionalism also can result in (or is the result of) a reverse philistinism. The kind of feminist artist who does "care about art" can find herself isolated from those who have chosen direct action rather than working with them on tasks more suited to her own needs and effectiveness. She can also find herself reacting against reactions against feminist art, and thus being controlled by the opposition. New taboos arise from rebellions against the old ones: progressive and feminist art reacts against the notion that "high standards" are to be found only where form and content are seamlessly merged, where content "disappears" into form. In the process of this reaction, a new rhetoric emerges, and artists who refuse to throw the baby out with the bathwater (to replace form entirely with subject matter) may find themselves opposing their own politics and their natural allies. This double-negation process may be inevitable if it is not analyzed and understood as highly destructive and divisive.

 At the heart of the matter is what Walter Benjamin called "the precise

nature of the relationship between quality and commitment."[8] The notion of "quality" (though I prefer the less classbound term *aesthetic integrity)* is embedded in Western culture, along with various degrees of anarchism, individualism, and pluralism. We have, ironically, seen the results of their suppression in those socialist countries where the power of art as a political force has been clearly recognized. Yet one reason why we can still not thoroughly discuss much of the work in "Issue" within a socialist framework is that the Left itself has not expanded enough to include the options art must have—just as it has had trouble incorporating feminist values. May Stevens has defined philistinism as "fear of art."[9]

It is difficult not to be confused by all these taboos against any art that might be useful or even powerful. Several complex factors are operating. The most obvious is the tenor (or tenure) of Western art education and its insistence that high art is an instrument for the pleasure and entertainment of those in power. We are told in school that if art wants to be powerful, it must separate itself from power and from all events artists are powerless to control. This is the counterpart of telling women and children to step aside, "leave it to us: this is men's work." (And it has long been clear that artists are considered "women" by the men who don't dabble in culture but do "real work" and get their hands dirty in blood and oil.) If such attitudes stem from the ruling class's conscious or unconscious fear that art may be a powerful tool of communication and organization, what are the artists themselves afraid of?

For women artists in particular, the "real world" as an arena in which to make art can appear as a fearful, incomprehensible place. We know about our fears of taking hold of unfamiliar power. And for all its dog-eat-dog competitions, the art world is relatively secure in comparison. Finally, one's art is, after all, *oneself,* and its rejection—politicized or personalized or both—has to be dealt with emotionally. One of the most popular excuses given by mainstream artists for rejecting social art is that "the masses" and the middle class *and* the corporate rich are all uneducated, insensitive, crass, vulgar, blind—leaving artists with a safe, specialized audience consisting primarily of themselves. Sometimes the frustration inherent in such limited communication leads to the international encouragement and provocation of a "fear of art." During the 1970s, much self-described political or Marxist art was watered down not only by stylistic pluralism and academic aimlessness, but by the artists' own illusions of complexity and espousal of incomprehensible jargon. So-called advanced art tries to *épater les bourgeois* just as bourgeois art tries to tempt *its* chosen audience to consume it. These games are incompatible with social-change art, where reaching and moving and educating an audience is all-important.

Yet this state of affairs is all too often only reluctantly recognized because of the pervasive taboos. And all the taboos are rooted in social expectations of art, and these in turn are rooted in class. As Piper remarked, artists concerned to communicate are often considered "bad artists" because their content is "untransformed"—that is, still comprehensible. The high-art milieu assumes that no one expects meaning from art; yet the societal cliché about "advanced art" is expressed in the question "But what does it mean?" Laypeople are inevitably disappointed when the answer is "nothing"—that is, only form and space and color and feelings, and so forth. The sophisticated assumption is that these experiences are of course open to anyone, so the audience too "dumb" to get it is not worth communicating with. One tends to forget that while the *experiences* may be open to anyone, the *meanings* are not, because we are educated to code them so they are available only to certain classes of viewer.

Even the expectations themselves can be broken down according to class. The ruling class expects "high" or fine art to be framed in gold—to be valuable, decorative, and acceptable—and preferably old, except for the bland new outdoor furniture of "public art" considered suitable for banks, offices, and lobbies. The middle class can't afford old art, so it tends to be more adventurous, preferring the new, the decorative, and the potentially valuable. Working people are resigned to expecting "beauty"—an old-fashioned, hand-me-down notion that usually has little to do with their own taste. Supposedly the working person doesn't expect meaning from art but is happy with what s/he gets from gift shops and mail-order catalogs. Yet when artist Don Celender interviewed working people in Minneapolis and Saint Paul about art, he got answers such as: "art is good training because it teaches us to look deeper into things" (a female bus driver); art is important "for appreciation of the environment" (truck driver); "art makes the world seem brighter" (housemaid); "life wouldn't be interesting if we didn't have art" (housemaid); "one of the better things in life [is] that people should be able to relate to his own type of art" (taxi driver); and "art is a way to convey and preserve a culture" (roofer).

Mary Kelly has set herself precisely this task: to preserve a culture hitherto virtually unexcavated in the first person: "the ways in which ideology functions in/by the material practices of childbirth and child-care."[10] These are among the taboo subjects, and Kelly has been exploring them for some eight years now in a multipartite work called *The Post Partum Document*. Each section consists of two forms: a series of framed collages that make refined and beautiful art objects ("fetishes" she calls them) out of stained diapers, infant clothes, her son's first marks, drawings, discoveries; and a dense

Menacé

The music is loud, too loud to talk. Sound swells and breaks, rolling over me, through me, funky, dissonant, feels good. I want to dance, smile at Ruth soliciting a partner. We push our way into the center of the room and start to move in what I think is perfect unison, except that from a certain position I can see myself in the cloakroom mirror. The image grates. I keep maneuvering back to it for a re-play, seems so out of synch with how I feel. The clothes perhaps, not tough enough, too sixties. No, the hair, too severe, should fly across my face when I turn. No, it's more insidious than that, the expression is wrong, too animated, childish even, absurd at my age. Keep the mouth closed and look cynical to compensate for the double chin. Beware of raising your arms and unleashing untidy ripples of loose flesh that linger thereon. No, the hips, definitely the hips, hardly perceptible but not quite the same, something to do with the feeling of space around the waist. Ruth has gone for a drink and someone is offering me a joint. I feel silly. Everyone I know went back to alcohol years ago. Still, everyone I know is thousands of miles away and everyone here is so Goddamn young. Mostly students. I feel like a chaperone. Aren't there any other lecturers for Chrissake. I spot a post-graduate fellow, greying at the temples, looks promising. I corner him. He says he's a fem-inist so I proceed to ramble on about the beginnings of the women's movement saying, "you remember the first meeting at Oxford, don't you?" "No," he says, "I was fourteen in 1968." I am stunned, can't speak, feel deceived. How can he know so much? Why does he look like that? Thirty-five at the very least, but twenty-seven? It's hopeless. I'm reduced to a voyeur. Besides he's with someone who looks like less than twenty-one. I hate them. He senses it, hands me another drink. For a moment, I imagine that he is Prince Gold Hand bringing the Old Crone a glass of the Water-that-Makes-Young from the Fourth Well and I croak, "Have you got it, have you got it?" "Yes," he replies and I seize it in my wizened hands, pour it over me and immediately turn into a beautiful maiden. Then, I ask him what he would like as an offering of thanks, but he says he can't think of anything because the Princess is all he desires and she is already standing with her hand in his. At this point, of course, I want to turn them both into frogs and vanish from their sight forever. But instead, I just excuse myself and go to look for Ruth.

MARY KELLY
Interim, Part I, Menacé, 1986
PHOTO LAMINATE, ACRYLIC, LATEX, SILKSCREEN ON PLEXIGLAS™
Photo: Nick Morris, London, courtesy Postmasters, New York.

Kelly's best-known early work, *Post-Partum Document,* which offered a uniquely feminist analysis of the infant and child development of her son Kelly (now in college) is extended in this multipart work to the social and psychological process of the mother's ageing. Diapers give way to chic leather jackets, but the acute weaving of diaristic personal accounts and theoretical distance is parallel.

accompanying text that includes Lacanian diagrams, charts, and a detailed analysis of "the ongoing debate of the relevance of psychoanalysis to the theory and practice of Marxism and Feminism." The section shown in "Issue" is, appropriately, the last one, in which mother and child enter the real world of writing and infant school. The "art objects" consist of chalklike inscriptions on slate, combining the mystery of the Rosetta Stone with the solemnity of the educational undertaking; the language of the alphabet books and learning stories is juxtaposed with diary entries and then in turn with the accompanying text, which dissects subjective and unconscious structures in linguistic frameworks. In one of the most complex explorations I know of—the often distorted feminist credo "the personal is political"—Kelly argues "against the supposed self-sufficiency of lived experience and *for* a theoretical elaboration of the social relations in which 'femininity' is formed." The result is a poignant attempt to understand the mother's personal sense of less (loss of the phallus is her interpretation) when a child leaves the home, and an equally moving exposition of the predicament of the working-class mother when faced with schools, bureaucracies, and all the other powers over her child that will leave her powerless again.

Fenix (Sue Richardson, Monica Ross, and Kate Walker), though dealing with similar subject matter, prides itself on a raw, comfortable ("homemade, I'm afraid") approach that offers the process of *coping* as a direct challenge to the aestheticization of high art. The three artists, who were also collaborators in the Feministo Postal Event ("Portrait of the Artist as a Housewife"), see themselves as part of the first generation in which working-class women have had access to art education. Their theme is rising from the ashes to the occasion. They want to destroy boundaries between low, hobby, and high art, motherhood and career. "It has been said many times by experts that women are not creative. They have a sentimental approach! Babies are not homemade! Flowers cannot be knitted! Reality is not a pussy cat!" They have set out to identify with and then deny the working-class suffragette Hannah Mitchell's statement "We will never be able to make a revolution between dinner time and tea!" Fenix's installations reflect the creative chaos of the home. Richardson, Ross, and Walker work on their art in public, and while the aesthetic outcome of their collaborations is risky, it is less significant than the process itself and its effect on the audience.

Martha Rosler's conceptual and book works, mail pieces, photographs, performances, and videos approach the issues of motherhood, domesticity, sex, and career in a manner that is as theoretically stringent as Kelly's and

as accessible as Fenix's. She avoids the vocabularies of the Marxism and feminism that inform all her work in favor of a "decoy"—a deadpan, easy-to-understand narrative style in which she demonstrates the most complex social contradictions and conflicts. For several years she concentrated on the uses and abuses of food—as fashion, as international political pawn, as a metaphor for a consumer society to which both culture and women seem to be just another mouthful in an endless meal. In the verbal/visual framework of her various mediums, she has examined anorexia nervosa, food adulter-ation, TV cooking lessons, the bourgeois co-optation of "foreign" cooking and starvation in those same "foreign" countries, the fate of the Mexican

MARTHA ROSLER
STILL FROM *Born to Be Sold: Martha Rosler Reads the Strange Case of Baby $M*, 1988
VIDEOTAPE PRODUCED WITH PAPER TIGER TELEVISION
Photo: Martha Rosler.

Rosler herself plays the contested baby girl in a tape that combines humor and criti-cal analysis about the surrogate mother case that raised major questions about class, women's rights, and "family values." It is part of the Paper Tiger collective's impor-tant series giving radical alternative readings of major media stories.

alien houseworkers, waitressing, and restaurant unionizing (as well as the Bowery, Chile, the PLO, and the Vietnam war). Rosler uses humor and a deadly familiarity to maintain her Brechtian distance from these subjects at the same time that she exhibits a thorough, and sometimes autobiographical, knowledge of them. Her acid intrusions into naturalism push reality up against idealism until neither has a chance. At that point, the skeleton of a demystified, but still aestheticized, truth appears.

Yet another approach to the analysis of the female role in the total society is that of Mierle Laderman Ukeles. For some ten years now she has been making "Maintenance Art," which emerged from "the real sourball...after the revolution, who's going to pick up the garbage on Monday morning?" It began in the home, when Ukeles realized that as a mother of small children she was not going to have time to make art. She decided she would have to make art out of what she spent her time doing. The work has since moved gradually out into the world—to the maintenance of art institutions, then collaborative pieces with the maintenance workers in offices and office build-ings in which the structures of their tasks were examined both as work and as art, and finally two years ago to the grand scale of the New York Sanita-tion Department—to the eight thousand garbagemen who are the pariahs of city government. The outward and visual performance aspect of *Touch Sani-tation* was a dialogue and handshaking ritual with every man on the force. Its radical aspect reflects again on taboos. Ukeles's work has been called outra-geous, trivial, and condescending by those who have not stopped to think where these accusations come from. She has also evaded Marxist assumptions about production through a prototypical feminist strategy that uses men's productive but despised support work as a means to call attention to all service work—the most significant area of which is, of course, women's reproductive work in home and workplace. The most recent result of *Touch Sanitation* is that sanitation men's wives are organizing.

Many or all these works are collages. And for a good reason. The Surrealists defined collage as the juxtaposition of two distant realities to form a new reality. Collage is born of interruption and the healing instinct to use politi-cal consciousness as a glue with which to get the pieces into some sort of new order (though not necessarily as new *whole,* since there is no single way out, nobody who's really "got it all together"; feminist art is still an art of separations). The socialist feminist identity is itself as yet a collage of disparate, not yet fully compatible parts. It is a collage experience to be a woman artist or a sociopolitical artist in a capitalist culture. "Issue" as an exhibition is itself a collage, a kind of newspaper.

. . .

The collage aesthetic is at the heart of May Stevens's moving series "Ordinary Extraordinary." It has recently culminated in an artist's book that juxtaposes the lives of Rosa Luxemburg ("German revolutionary leader and theoretician, murder victim") and Alice Dick Stevens ("Housewife, mother, washer and ironer, inmate of hospitals and nursing homes"). Like Rosler and Kelly, Stevens analyzes language, but unlike them she does it in an unashamedly affective manner. The book and the richly layered collages that led up to it are black-and-white—dark and light. They weave visual portraits and verbal self-portraits to bring out the underlying political insights. Sometimes a level of irony surfaces, which makes the roles of the intensely articulate and active Rosa and the pathologically silent and passive Alice almost seem to reverse, or overlap, offering generalized comments on class and gender. Stevens's mother became mute in middle age, "when what she wanted to say became, as she put it, much later, too big to put your tongue around." When she regained her ability to speak, "she had lost a life to speak of." Rosa, on the other hand, writes to her lover, "When I open your letters and see six sheets covered with debates about the Polish Socialist Party and not a word about...ordinary life, I feel faint."

The most ambitious collage in "Issue" is Bonnie Sherk's collaborative artwork/corporation/performance piece/site sculpture or "life frame" called *The Farm* (Crossroads Community). It consists of 5.5 acres of buildings, land, and gardens under a looming freeway, at the vortex of four different ethnic communities (and three subterranean creeks) in San Francisco. *The Farm* is a collage of functions including community center, after-school and multinutritional health and nutrition programs, experimental agriculture, appropriate technology, zoo, theater, and park; and it is a collage of living styles or social options: an old-fashioned farm kitchen, suburban white-iron lawn furniture, an International living room to show that elegance is part of the natural life, and the latest project—"Crossroads Cafe," part of a scheme for international outreach that includes the projected import of an old Japanese farmhouse. Because of *The Farm's* scope, it is virtually impossible to summarize in this context, but its most interesting aspect is its fusion of art with other functions. *The Raw Egg Animal Theatre* (TREAT), for example, could be called a stage set or an environmental installation piece as well as several other things. Sherk is concerned to integrate "the human creative process—art—with those of other life forms." She is fundamentally a visionary, albeit an earthy and practical one who managed six years ago to found and then maintain this huge-budget near-fantasy. *The Farm* emerged organically, so to speak, from Sherk's earlier art, which

involved identification with animals, study of animal behavior, and work
with growing things, such as the creation of portable parks in the inner city
and on the freeways.

Sherk's subject, like that of Ukeles and many other artists in the show,
might be said to be nurturance and its meaning in an art context that sees it
as a gender-related taboo. Yet like the notion of a female collage aesthetic,
this is also reducible to the dreaded "nature-nurture syndrome" that is taboo
within as well as outside the feminist movement. In some views, nature and
culture are incompatible and any hint of female identification with the forms
or processes of nature is greeted with jeers and even, perhaps, fears that
parallel those of the bureaucratic patriarchy when they tried to censor
Monica Sjoo's graphic depiction of *God Giving Birth* at the Swiss Cottage
Library in 1973. Some of the artists in "Issue," however, refuse to separate
their social activism and their involvement in the myths and energies of
women's distant histories and earth connections.

 It seems to me that to reject all of these aspects of women's experience
as dangerous stereotypes often means simultaneous rejection of some of the
more valuable aspects of our female identities. Though used against us now,
their final disappearance would serve the dominant culture all too well. This
is not the place to delve into the disagreements between socialist feminism
and radical or cultural feminism (I, for one, am on "Both Sides Now").
But in regard to the issues raised in "Issue," I would insist that one of the
reasons so many women artists have engaged so effectively in social-change
and/or outreach art is women's political identification with oppressed and
disenfranchised peoples. This is not to say we have to approve the historic
reasons for that identification. However, we should be questioning why we
are discouraged from thinking about them. Because such identification is
also a significant factor in the replacement of colonization and condescension
with exchange and empathy that is so deeply important to the propagation
of a feminist political consciousness in art.[11]

Sweeping Exchanges: The Contribution of Feminism to the Art of the 1970s

By now most people—not just feminist people—will acknowledge that feminism has made a contribution to the avant-garde and/or modernist arts of the 1970s.[1] What exactly that contribution is and how important it has been is not so easily established. This is a difficult subject for a feminist to tackle because it seems unavoidably entangled in the art world's linear I-did-it-firstism, which radical feminists have rejected (not to mention our own, necessarily biased inside view). If one says—and one can—that around 1970 women artists introduced an element of real emotion and autobiographical content to performance, body art, video, and artists' books; or that they have brought over into high art the use of "low" traditional art forms such as embroidery, sewing, and china-painting, or that they have changed the face of central imagery and pattern painting, of layering, fragmentation, and collage—someone will inevitably and perhaps justifiably holler the names of various male artists. But these are simply *surface* phenomena. Feminism's major contribution has been too complex, subversive, and fundamentally *political* to lend itself to such internecine, hand-to-hand stylistic combat. I am, therefore, not going to mention names, but shall try instead to make my claims sweeping enough to clear the decks.

Feminism's greatest contribution to the future of art has probably been precisely its *lack* of contribution to modernism. Feminist methods and theories have instead offered a socially concerned alternative to the increasingly mechanical "evolution" of art about art. The 1970s might not have been "pluralist" at all if women artists had not emerged during that decade to introduce the multicolored threads of female experience into the male fabric

Reprinted from *Art Journal* (fall–winter 1980).

of modern art. Or, to collage my metaphors, the feminist insistence that the personal (and thereby art itself) is political has, like a serious flood, interrupted the mainstream's flow, sending it off into hundreds of tributaries.

It is useless to try to pin down a specific formal contribution made by feminism because feminist and/or women's art is neither a style nor a movement, much as this idea may distress those who would like to see it safely ensconced in the categories and chronology of the past. It consists of many styles and individual expressions and for the most part succeeds in bypassing the star system. At its most provocative and constructive, feminism questions all the precepts of art as we know it. (It is no accident that "revisionist" art history also emerged around 1970, with feminists sharing its front line.) In this sense, then, focusing on feminism's contribution to 1970s art is a red herring. The goal of feminism is *to change the character of art.* "What has prevented women from being really great artists is the fact that we have been unable to transform our circumstances into our subject matter...to use them to reveal the whole nature of the human condition."[2] Thus, if our only contribution is to be the incorporation on a broader scale of women's traditions of crafts, autobiography, narrative, overall collage, or any other technical or stylistic innovation—then we shall have failed.

Feminism is an ideology, a value system, a revolutionary strategy, a way of life.[3] (And for me it is inseparable from socialism, although neither all Marxists nor all feminists agree on this.) Therefore, feminist *art* is, of necessity, already a hybrid. It is far from fully realized, but we envision for it the same intensity that characterizes the women's movement at its best. Here, for example, are some descriptions of feminist art: "Feminist art raises consciousness, invites dialogue, and transforms culture."[4] "If one is a feminist, then one must be a feminist artist—that is, one must make art that reflects a political consciousness of what it means to be a woman in a patriarchal culture. The visual form this consciousness takes varies from artist to artist. Thus art and feminism are not totally separate, nor are they the same thing."[5] "The problem is not with people's taste (often called 'kitsch' by superior minds) but with defining art as one thing only. Art is that which functions as aesthetic experience for you. If a certain art works that way for enough people, there is consensus; that becomes art....That which we feel is worth devoting one's life to and whose value cannot be proven, that is art."[6] Feminist art "is a political position, a set of ideas about the future of the world, which includes information about the history of women and our struggles and recognition of women as a class. It is also developing new forms and a new sense of audience."[7]

The conventional art-world response to these statements will be *what new forms?* And to hell with the rest of it. Descriptions like the above do

not sound like definitions of art precisely because they are not, and because they exist in an atmosphere of outreach virtually abandoned by modernism. For years now, we have been told that male modernist art is superior because it is "self-critical." But from such a view self-criticism is in fact a

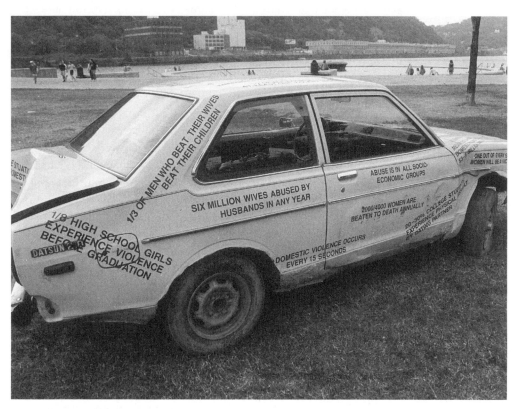

SUZANNE LACY
Auto: On the Edge of Time, 1993
INSTALLATION AND PUBLIC ART PROCESS,
AT THREE RIVERS ART FESTIVAL, PITTSBURGH
Photo: R. Hurst.

This complex piece is the latest in Lacy's collaborative explorations, begun in the seventies, of violence against women. The process of Lacy's work is always as important as the final product, which, in this case, consists of seven cars developed in groups in three different cities and situations. This car was made with sculptor Carol Kumata and women from a shelter in Pittsburgh; four others were constructed with women in the Bedford Hills Maximum Security Correctional Facility in New York State, many of whom are rape and abuse survivors. For abused and battered women, the car is an ambivalent symbol of both prison and escape (cf *Thelma and Louise*). The battered (or scarred) cars are also metaphors for women's bodies. Each car is a separate installation; this one, a bright yellow compact, covered with statistics, contains open suitcases and strewn papers, each listing what a particular woman took with her when she left an abusive situation.

narrow, highly mystified, and often egotistical *monologue*. The element of dialogue can be entirely lacking (though ironically it is *feminist* art that is accused of narcissism). Self-criticism that does not take place within or pass on out to its audience simply reinforces our culture's view of art as an absolutely isolated activity. Artists (like women) stay home (in self and studio) and pay for this "freedom" by having their products manipulated and undervalued by those who control the outside world.

A basic and painful conflict is set up when an artist wants to make art and at the same time wants to participate more broadly in the culture, even wants to integrate aesthetic and social activities. Artists who work with groups, as do so many feminists, always seem to be looking wistfully over their shoulders at the studio. "I've got to get back to my own work" is a familiar refrain, because, as it stands now, art and life always seem to be in competition. And this situation produces an unusually schizophrenic artist. One of the feminist goals is to reintegrate the aesthetic self and the social self and to make it possible for both to function without guilt or frustration. In the process, we have begun to see art as something subtly but significantly different from what it is in the dominant culture.

This is not said in a self-congratulatory tone. It remains to be seen whether different is indeed better. Success and failure in such unmapped enterprises are often blurred. Various feminists have already fallen into various traps along the way; among them: the adoption of certain clichés in images (fruit and shell, mirror and mound), materials (fabrics and papers), approaches ("nonelitist"), and emotions (nontransformative pain, rage, and mother love); a certain naïveté (also carrying with it a certain strength) that comes from the wholesale rejection of all other art, especially abstraction and painting; a dependence on "political correctness" that can lead to exclusivity and snobbism; and, at the other extreme, an unthinking acceptance of literally anything done by a woman. Beneath these pitfalls is a need for language—visual and verbal—that will express the ways our art and ideas are developing without being sappy and without denying the powers of the individual within collective dialogue.

Nevertheless, feminist values have permeated the 1970s and are ready to flower in the 1980s, if militarism and socioeconomic backlash don't overwhelm us all. Often accepted unconsciously, these values support the opening up and out of eyes, mouths, minds, and doors—and sometimes the smashing of windows. They include collaboration, dialogue, a constant questioning of aesthetic and social assumptions, and a new respect for audience. Feminism's contribution to the evolution of art reveals itself not in shapes but in structures. Only new structures bear the possibility of changing the vehicle itself, the meaning of art in society.

New? I hesitate to use the word in this context, since it, too, has been so distorted in the name of modernism: new reality, new realism, new abstraction; and similarly, all the rigid posts: postmodernism, post-Minimalism, and post-beyond-postness. Feminism is new only in the sense that it isn't post-anything. Its formal precepts are not new at all. They are simply distributed differently from those entrenched since around 1950. Much or even most of the best art by women has turned its back on the "new," preferring to go deeper into visual forms that have been "done before" (mostly by men). When I began to write extensively about women's art, I was accused by friends and enemies of becoming a "retrograde" critic. And so long as I remained attached to the conditioning of my own art education, received primarily at the Museum of Modern Art and on Tenth and Fifty-seventh Streets, I too was afraid of that stigma. However, the more women's work I saw, the more my respect grew for those artists who, having been forcibly cut off from the mainstream, persevered in exploring their own social realities, even—or especially—when such exploration did not coincide with the current fashions.

The more illuminating dialogues I had within the women's movement, the clearer it became to me that the express toward the "true nature of art" had whisked us past any number of fertile valleys, paths to elsewhere, revelations, personal and social confrontations that might forever have been missed had it not been for such stubbornly "retrograde" artists, who insisted on taking the local. During this time I was constantly being told that some woman's work was derived from some far-better-known man's work. In fact, such similarities were usually demonstrably superficial, but the experience of searching for the differences proved invaluable because it undermined and finally invalidated that notion of "progress" so dear to the heart of the art market.

In endlessly different ways, the best women artists have resisted the treadmill to progress simply by disregarding a history that was not theirs. There *is* a difference, though not always an obvious one, between the real but superficial innovations of a feminist or women's art that has dissolved into mainstream concerns and the application of these same innovations to another set of values, where they may be seen as less "original." It was suggested several years ago that feminist art offered a new "vernacular" reality opposed to the "historical" reality that has informed modern art to date.[8] Given its air of condescension, *vernacular* may not be the right word (and certainly we don't want to be "hidden from history" again), but it is the right idea. The 1970s have, I hope, seen the last of the "movements" that have traipsed, like elephants trunk-to-tail, through the last century.

The notion that art neatly progresses has been under attack from all sides

for years now; its absurdity became increasingly obvious with postmodernism in the early 1960s. By 1975, a not-always-delightful chaos of Conceptual Art, performance, photorealism, "new images," and what-have-you prevailed. The 1970s pluralism, decried for different reasons by both Left and Right, has at least produced a kind of compost heap where artists can sort out what is fertile and what is sterile. Bag ladies picking around in this heap find forms, colors, shapes, and materials that have been discarded by the folks on the hill. They take them home and recycle them, thriftily finding new uses for worn-out concepts, changing not only the buttons and the trim but the functions as well. A literal example of this metaphor is the

Chilean *arpillera,* or patchwork picture. Made by anonymous women and smuggled out into the world as images of political protest, social deprivation, crushed ideas and hopes, the *arpilleras* are the only valid indigenous Chilean art—now that the murals have been painted over, the poets and singers murdered and imprisoned.

You will have noticed by now that feminism (and by extension feminist art) is hugely ambitious.[9] A developed feminist consciousness brings with it an altered concept of reality and morality that is crucial to the art being made and to the lives lived with that art. We take for granted that making art is not simply "expressing oneself" but is a far broader and more important task:

JUDY BACA
Balance, 1991
ONE OF FOURTEEN PLANNED PANELS OF THE PROJECT
World Wall: Vision of the Future Without Fear
ACRYLIC ON CANVAS, 10′ × 30′
Photo: courtesy Social and Public Art Resource Center, Venice, California.

The World Wall is a semicircular traveling mural installation, a collaboration between Baca (seven inner panels) and artists from around the world (seven outer panels), following up on the locally based mural collaborations for which Baca has become famous. *Balance,* informed by the Hopi prophecies, represents the return to symmetry between male and female, yin and yang, moon and sun, earth and humanity.

expressing oneself as a member of a larger unity, or comm/unity, so that in speaking for oneself one is also speaking for those who cannot speak. A populist definition of quality in art might be "that element that *moves* the viewer." A man probably can't decide what that is for a woman, nor a white for a person of color, nor an educated for an uneducated person, and so forth, which is where "taste" comes in. This in turn may explain why the "experts" have never been able to agree on which artists have this elusive "quality." Only when there are real channels of communication can artist and audience both change and mutually exchange their notions of art.

Feminists are asking themselves, as certain artists and critics and historians have asked themselves for generations, "Is this particular painting, sculpture, performance, text, photograph moving to me? If so, why? If not, why not?" In this intuitive/analytical task, the social conditioning we have undergone as women, as nurturers of children, men, homes, and customs, has its advantages. We are not bolstered by the conviction that whatever we do will be accepted by those in power. The lack can be psychologically detrimental, but it also carries with it an increased sensitivity to the needs of others, which accounts to some extent for the roles that the audience, and communication, play in feminist art.

Similarly, because women's traditional arts have always been considered utilitarian, feminists are more willing than others to accept the notion that art can be aesthetically *and* socially effective at the same time. Not that it's easy. The parameters for "good art" have been set; the illusion of stretching those boundaries that prevails in the avant-garde is more exactly a restless thrashing around within the walls. Overtly feminist artists are always being accused of being "bad artists" simply by definition. That's not something I'm interested in responding to here, but it should be mentioned in the context of changing the character of art. Given the history of the avant-garde, what on earth does "bad art" mean these days? But of course if someone isn't there to say what "good art" is—then art itself gets out of institutional hand.

Perhaps the single aspect of feminist art that makes it most foreign to the mainstream notion of art is that it is impossible to discuss it without referring to the social structures that support and often inspire it. These structures are grounded in the interaction techniques adapted (and feminized) from revolutionary socialist practice—techniques on which the women's movement itself is based: consciousness raising, going around the circle with equal time for all speakers, and criticism/self-criticism. From the resulting structures have evolved the models feminism offers for art. These models, I repeat, are not new ways of handling the picture plane, or new ways of rearranging space, or new ways of making figures, objects, or landscapes live; they are inclusive structures or social collages.

The history of the male avant-garde has been one of reverse (or perverse) response to society, with the artist seen as the opposition or as out-of-touch idealist. The feminist (and socialist) value system insists upon cultural workers supporting and responding to their constituencies. The three models of such interaction are (1) group and/or public ritual; (2) public consciousness raising and interaction through visual images, environments, and performances; and (3) cooperative/collaborative/collective or anonymous artmaking. While it is true that they can more easily be applied to the mass-reproduced mediums such as posters, video, and publications, these models also appear as underlying aesthetics in paintings, sculptures, drawings, and prints. Of course, no single artist incorporates all the models I am idealizing here, and certainly individual male artists have contributed to these notions. But since male consciousness (or lack thereof) dominates the art world, and since with some exceptions male artists are slow to accept or to acknowledge the influence of women, these models are being passed into the mainstream slowly and subtly and often under masculine guise—one of the factors that makes the pinning down of feminism's contribution so difficult. Yet all these structures are in the most fundamental sense collective, like feminism itself. And these three models are all characterized by an element of outreach, a need for connections beyond process or product, an element of *inclusiveness* that also takes the form of responsiveness and responsibility for one's own ideas and images—the outward and inward facets of the same impulse.

The word *ritual* has been used in connection with art frequently and loosely in the last decade, but it has raised the important issue of the relationship of belief to the forms that convey it. The popularity of the notion of ritual indicates a nostalgia for times when art had daily significance. However, good ritual art is not a matter of wishful fantasy, of skimming a few alien cultures for an exotic set of images. Useful as they may be as talismans for self-development, these images are only containers. They become ritual in the true sense only when they are filled by a communal impulse that connects the past (the last time we performed this act) and the present (the ritual we are performing now) and the future (will we ever perform it again?). When a ritual doesn't work, it becomes a self-conscious act, an exclusive object involving only the performer. When it does work, it leaves the viewer with a need to do or to participate in this act, or in something similar, again. (Here ritual art becomes propaganda in the good sense—that of spreading the word.) Only in repetition does an isolated act become ritualized, and this is where community comes in. The feminist development of ritual art has been in response to real personal needs and also to a communal need for a new history and a broader framework within which to make art.

Public consciousness raising and interaction through visual images, envi-
ronments, and performances also insist on an inclusive and expansive struc-
ture that is inherent in these forms. This is in a sense the logical expansion
of a notion that has popped up through the history of the avant-garde: that
of working "in the gap between art and life." Aside from an outreach branch
of the Happening aesthetic in the early 1960s, this notion has remained
firmly on art's side of the gap. But by 1970, feminists, especially on the
West Coast, were closer to the edge of that gap than most artists; they were
further from the power centers, and, out of desperation, more inclined to
make the leap. Just as ritual art reaches out and gathers up archaeological,
anthropological, and religious data, the more overtly political art of public
strategies reaches out to psychology, sociology, and the life sciences. Its
makers (*planners* might be a more accurate term) work in time as well as
in images, moving closer to film, books, or mass media. Video and photog-
raphy are often used not so much to stimulate a passive audience as to wel-
come an actively participating audience, to help people discover exchanges
between art and life.

Such work can take place in schools, streets, shopping malls, prisons,
hospitals, or neighborhoods. Among its main precepts is that it does not
reject any subject, audience, or context, and that it accepts the changes
these may make in the art. To be more specific, a few examples: (1) A
group of women of mixed nationalities living in Paris who have done large
documentary pieces including drawings, texts, photographs, and video tapes
about women in prison and about Turkish and Portuguese workers at home
and in economically imposed exile. (2) An Israeli woman trying to commu-
nicate to urban workers on the Tel Aviv waterfront the plight and beliefs
of the Bedouin tribes through "desert people" costume rituals in urban
workplaces. (3) A New York woman who made her "maintenance art" first
in the home, then in office buildings, and has spent the last two years identi-
fying with the men in the city's Sanitation Department (the "women" of
the city government), recognizing their maintenance work as art by shaking
hands with every member of the department. (4) Two women in Los Ange-
les who make public pieces strategically designed to change the image and
media coverage of feminist issues such as rape and violence against women.
(5) A mixed-gender group, led by a San Francisco woman, that has built a
"life frame" which is simultaneously performance art, five acres of commu-
nity outreach, and an experimental agriculture station, making connections
between animals, plants, people, and art. (6) A group of women photo-
graphers in East London organizing child-care facilities and comparing
pictures of real life with the mass-media images of women. (7) A man in a
small economically devastated New England mill town who uses photog-

raphy as a vehicle of continuing awareness to acquaint the inhabitants with their environment, with each other, and with their possibilities. (8) Another man who mixes art and science and populism in a South Bronx storefront and calls it a "cultural concept."

All these examples overlap. Much of the work mentioned above is being executed by various combinations of artists or of artists and nonartists, often anonymously or under the rubric of a collective or network or project. Some women work cooperatively—helping an individual artist to realize her vision on a monumental scale and in the process both giving to her work and getting input for their own work. Others work collaboratively, according to their own special skills, needs, and concerns. And others work collectively in a more or less consciously structured manner aimed at equal participation and skill- and power-sharing. Each of these means helps to achieve an end result of breaking down the isolation of the artist's tradi- tional work patterns. None precludes individual work. (I find from my own experience that the dialogue or critical/self-critical method stimulates new kinds of working methods and a new flexibility. By integrating feedback into the process, and not just as final response to the product, it also changes the individual work.)

The structures or patterns I've sketched out above are laid out on a grid of dialogue that is in turn related to the favorite feminist metaphor: the web, or network, or quilt as an image of connectiveness, *inclusiveness,* and integration. The "collage aesthetic" named by the Surrealists is a kind of dialectic exposing by juxtaposition the disguises of certain words and images and forms and thus also expressing the cultural and social myths on which they are based. The notion of connections is also a metaphor for the break-down of race, class, and gender barriers, because it moves out from its center in every direction. Though men are its progenitors in high art, collage seems to me to be a particularly female medium, not only because it offers a way of knitting the fragments of our lives together but also because it potentially leaves nothing out.

It is no accident that one ritual artist calls herself Spider Woman and another group calls itself Ariadne. As I was writing this essay, I read an arti-cle about the Native American ethos of total interrelationship among all things and creatures, which says: "Thus, nothing existed in isolation. The intricately interrelated threads of the spider's web was referred to...the world....This is a profound 'symbol' when it is understood. The people obviously observed that the threads of the web were drawn out from within the spider's very being. They also recognized that the threads in concentric circles were sticky, whereas the threads leading to the center were smooth!"[10] The author remembers his mother saying that "in the Native

American experience all things are possible and therefore all things are acceptable," and he goes on to hope that "our societal structures and attitudes become bold and large enough to affirm rather than to deny, to accept rather than to reject."

I quote this not only because it expresses very clearly a conviction that lies at the heart of feminism (and should lie at the heart of all art as well), but also because it comes from another culture to which some of us fleeing the potential disasters of Western capitalism are sentimentally attracted. However, the socialist feminist model does not stop at the point of escape or rejection as did the counterculture of the 1960s. To change the character of art is not to retreat from either society or art. This is the significance of the models I've outlined above. They do not shrink from social reality no matter how painful it is, nor do they shrink from the role art must play as fantasy, dream, and imagination. They contribute most to the avant-garde by slowing it down. They locate a network of minor roads that simply covers more territory than the so-called freeways. They pass more people's houses. And are more likely to be invited in.

Rejecting Retrochic

Visual artists in this culture tread a thin line, like drivers arrested after one martini. We have this myth that artists are wild, woolly, and free—and politically radical. We have this reality that artists are isolated in studios and art-world bordellos and tend to be either unaware or downright conservative. The vectors meet in a middle ground occupied by the art audience. But the audience is invisible to most artists, and in that simple fact lies one of the great failures of modernist art. This basic alienation has, paradoxically, increased since art has entered the fringes of popular culture. These days the audience is being subjected not only to the usual indifference from the art majority, but also to a wave of hostility from an art minority that has been called *retrochic*.

Retrochic is not a style (though it is often associated with "punk art"). It is a subtle current of reactionary content filtering through various art forms. Its danger lies not so much in its direct effect on the art audience as in its acceptance by the art world itself. Too many artists and art-workers seem blissfully unaware of the social ramifications of the notion that art is so separate from life, so neutral in its impact, that "anything goes" in the galleries because it's "only art."

Retrochic offers a particularly overt example of how art is seen and manipulated in this society. In the process it becomes an unwitting tool of the very powers it seems to think it's repelling, part and parcel of the national economic backlash against reproductive rights, social welfare, and human rights. Neutrality is just what the doctor ordered for the corporate

First published as "Retrochic, Looking Back in Anger," *Village Voice,* Dec. 10, 1979.

classes controlling art (and the rest of the world). It keeps artists as safely ensconced in their small puddle as nonunionized workers are kept isolated on their assembly lines. As the product of a complex psychological current, retrochic was perfectly described by the punk rock group Devo: "The position of any artist is, in pop entertainment, really self-contempt. Hate what you like, like what you hate. It's a totally schizophrenic position, but that in itself is a principle that most people in the business and outside it don't understand."

So how did art—popularly associated with communication, enlightenment, and uplift—get into this predicament? Precisely by rejecting the "real" and distastefully "commercial" framework within which it operates and turning inward to the point where it no longer knows who its audience is, and by hating that audience it doesn't know for not knowing it.

Art has a kind of permanent innocence in this culture. We expect very little of it. We expect *nothing* of it. We expect *everything* of it. Depending on who we are. Who are we? Who is the art audience? I once called all the major museums in New York City to see if they had done audience profiles. They hadn't. But of course window-shopping—which is what art is about for most people—is not taken too seriously in the real world of big business that administers the museums and makes sure what is shown there is oriented to the right people—to the public, but not to the gum-chewing public. The art gallery audience, on the other hand, is in training to be able to swallow anything. And retrochic art is sufficiently "distanced" (or spaced out) to see racism, sexism, and fascism not as content, but as harmless outlets for a kind of disco destructiveness that feeds the art world's voracious appetite for anything consumable.

Sometimes it's the ad that's retro. What, for example, was the "Talking Legs" exhibition? I'll never know because I refused to go and see; the announcement featured a pair of high-heel-booted, garter-belted female legs cut just above the crotch and standing over a toilet seat. Sometimes it's the title that's retro, as in the now notorious "Nigger Drawings" show in which the racist title was the only provocative aspect of a group of pleasant abstract drawings. And sometimes it's the art. The item that made me maddest last season was not "punk" but its suburban cousin: photorealism. The announcement showed a lovingly executed painting of a pretty upper-middle-class living room in which a work-clothed man is stabbing the lady of the house in the neck. Beautiful little drops of blood and all. It is called *The Sewing Room,* is dedicated "to Barbara," and was described in the press release as "color-coordinating an erotically charged narrative situation." (This has to come to you from the people who have not read the extraordinary letter in the *Village Voice,* Oct. 22, 1979, which once and for all

destroys the association of sex with rape, and by extension, with murder.)
This painting, the blurb continued, was intended to "keep us cool by per-
fectly orchestrating layers of surface and narrative." It didn't keep *me* cool.
Nor did a letter from the dealer, who was surprised by my lack of cool,
denying the press release's neutral tone by insisting that this painting was a
"pro-feminist statement"!

She did, however, ask two interesting questions. First, wouldn't I go
see this kind of scene in the movies? (Absolutely not; while I don't always
know ahead of time what I'm getting in the movies, I was forewarned here,
and boycotted the show.) Second, would it be "more agreeable" to me
if it had been painted by a woman? (I thought about this one before answer-
ing no again, and also wondered what woman would be able to stand the
emotional trauma of working for three years on such an image, as the male
artist did.)

The climate is so foggy nowadays that any artist whose work incorporates
a newspaper headline, or even a photograph—especially a sleazy, grainy
one—is immediately considered "political." But what politics? Speaking to
whom and to what end? Mostly to nobody and to no end. Because it's not
politics. It's art. And art is above it all...isn't it? If it's okay to use racist
slurs and sexist violence, then why are aesthetic taboos still exerted against
"political" images taken past the artist's personalized cocoon and into arenas
such as inflation, housing, starvation, or rape? Because we all supposedly
know about all that stuff already?

That "look of concern" communicated by rough typography, banal adver-
tising images, and blurry, pseudoporn photographs is blatantly ambivalent as
well as highly ambiguous. Which is where the audience comes in—the audi-
ence as everybody not making the work in question. Since audience and
artist have no contact, no dialogue is possible, and we are left with that
familiar question: What does it mean? I happen to be personally attracted to
the nonslick "look of concern." I look more closely, I see a guy in leather
pointing a gun at me. I see black people running down a street. I see a half-
nude woman cringing in a corner. What am I seeing? Is this parody? Femi-
nist satire? Gimmicky advertising? Cinéma vérité? Is the artist a fascist or a
Marxist or nothing? Is s/he shrewdly wallowing in "politically incorrect"
imagery while claiming to be "politically correct" in some subtle (read
incomprehensible) way?

Since it's art—not photojournalism—there are usually no captions to
such images, and sometimes there are titles that sound like rock groups or
boutiques, which either neutralize or are neutralized by the image.
Compare the "Nigger Drawings" episode with the recent banning of a
photo-text work from a General Services Administration (GSA) exhibition

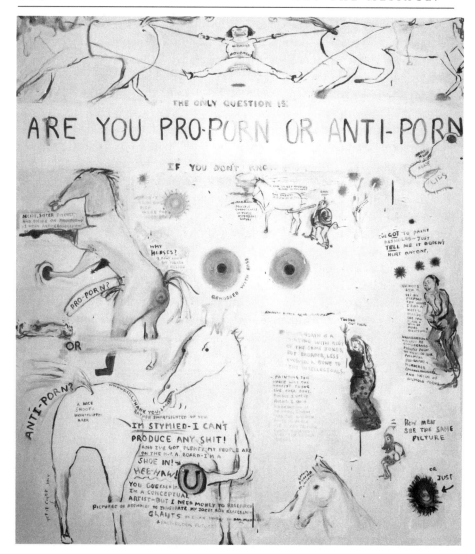

SUE WILLIAMS
Are You Pro-Porn or Anti-Porn?, 1992
ACRYLIC ON CANVAS, 72" × 62"
Photo: courtesy 303 Gallery, New York.

As a young feminist artist, Williams confronts orthodoxy—feminist and conventional—head-on, asking questions with the raw energy of a child. In cartoon imagery, she poses the debate between feminists about whether pornography incites violence against women or whether an antiporn position constitutes a dangerous threat to free speech.

in Washington, D.C. The photos were acceptable but the text ("a narrative indictment of military government, unequal distribution of wealth, violations of human rights, and U.S. business involvement in South America") was unacceptable. When it was suggested that the photos be shown without text, Isabel Letelier, widow of the murdered Chilean diplomat, protested that "without the explanation, they are just lovely colorful pieces of work that have no point. That is exactly what Latin America is for the tourists who have no explanation."

And that is exactly what art is supposed to be. When art is not seen as communication on any level, when art becomes a blunt weapon with which to beat people on the head for no reason but one's own enjoyment (as in retrochic) rather than a sharp instrument of perception, analysis, and "eye-opening" of one kind or another, then it becomes almost inevitable that art will be co-opted by the status quo and become a neutralized symbol divorced from life, work, and human need. In a period when everybody had better be thinking quick about what to do next about the world, art has been backed into a corner where artists are "allowed not to think" (as opposed to "not being allowed to think," which we condemn in other societies). This taboo effectively keeps artists out of the way and at the same time allows the present single-class buying art audience to mold it and its uses. The retrochic artist, thrashing around in the nursery like a spoiled child, is the latest version of the artist as divine idiot, neither respected nor paid, but kept docile on a daily dose of ego.

I'm enough of an old-fashioned moralist to think art should offer a critique of the society it rides on and through, that part of its responsibility is to do so in collaboration with its audience. The critique can be done in as many ways as there are individual imaginations. But it does demand that the maker think about where an artwork goes next, to whom it is meant to mean what, and for what it is to be used. If artists won't take responsibility for art, who will? (Three guesses.) If your art incorporates an exploitative photograph of a woman being murdered, can you really get away with saying "I don't know why I chose that image; it just *came* to me." (From where?) Or "I liked the diagonal her leg made. I liked the gesture. I was using the red of the blood to bring the illusionistic space up to the picture plane"? I know art speaks for itself. I know art says things you can't say in words. That's one of the things I like about art. On the other hand, I don't believe that visual language has hit such a poverty level no one is willing to admit it ever says *anything*. Even the most convinced formalist, Minimalist, or post-whatsis should know what s/he really means on some fundamental level. And if what s/he means is fundamentally fascist, I'd like to see this recognized, questioned, and rejected by the art audience.

Martha Rosler, a West Coast Marxist feminist who makes narrative photo-text pieces, videos, and performances—and is very clear about what they mean—sees them as "decoys" that "mimic some well-known cultural form so as to strip it of its mask of innocence." Ironically, this is the same aesthetic ploy used by the retrochic artists whose work comes down on the far right. Sometimes the decoy is intentionally ineffective. Sometimes the decoy is too effective; the audience is fooled and gets shot down. Rosler and a few others (mostly working on the West Coast) escape this kind of self-imposed backlash because they are aware of the crucial relationship between audience and art and of the way the audience is manipulated by the art that is available to it.

There is also a growing number of still younger artists who are concerned with this state of affairs. Some are working on the fringes of the art world, having been initially attracted to it by a notion of art they have since found to be a mirage. Others are even less visible as they try to make art in a different context altogether. They are responsible for posters like that showing the pope before a firing squad as antidote to the mass hysteria of the papal visit. They are responsible for some street pieces, store windows, artists' books, performances, actions, open studios, and scruffy artist-organized shows. And for Stefan Eins's Fashion Moda in the South Bronx, which is the only *alternate* space in town that deserves the name it rejects. They are responsible for outreach placement of relatively conventional art objects like John Ahearn's painted plaster heads of local residents in a South Bronx Con Edison office and for public works like Jenny Holzer's anonymous aphorisms, which I happen to think make good "political" art because I happen to think I get the point, though they, too, have a touch of the violence I fear. Like Nicole Gravier's very different media pieces recently shown at Franklin Furnace, Holzer's lists of slogans make me-the-audience *think*—about myths and clichés and propaganda and the slogans I use myself. What I like about this and other such work is that the irony is embedded in it. Here's the old formalist ideal of medium and message merged, rather than one tacked onto the other gratuitously to make a sensation, rather than the medium used to subvert the message.

Some of this art and some of those artists are seen as "punk," though "new wave" is a preferably woozier term. If so, punk comes in two guises: this harsh social commentary retaining an echo of Brechtian irony and of the original British music movement's working-class political force; and retrochic, which sees the audience as "parents"—authorities to be done in. The latter is most visible because it's out for power and because the social branch has for the most part (or for the time being) bowed out of that particular brawl. Retrochic, like its commercial counterpart in fashion

NICOLE EISENMAN
Father Pissing, 1994
OIL ON CANVAS, 76″ × 57½″
Photo: courtesy Jack Tilton Gallery, New York.

Another young artist, who often flaunts her lesbian feminist iconoclasm, Eisenman
delivers a blow to the facade of the nuclear family. Her scatological images, scrawled
captions, and expressive drawing style merge both meanings of the word
"cartoon"—comics and studies.

advertising, gets shown and occasionally eulogized in the trade magazines and is, I assume, bought now and then by the beleathered hordes who wander through SoHo on weekends seeking a social jolt—otherwise it wouldn't *get* shown and written about.

Because I see retrochic as feeding neatly into the right wing's fury and playing agent-provocateur to the working class some retrochic artists claim to identify with, I'd like to see this kind of art rejected. I know some will holler "censorship" (and I'll mutter "selection"—which is another whole can of worms). I know that the intention of this art is to get parents like me to scream, "Bad taste!" "Decadence!" and other flattering epithets. I did just that when I read a pseudonymous critic called Peter "Blackhawk" von Brandenburg describing the "Nigger Drawings" as "revolutionary," though I had to laugh when I read they were also "a veil between a pulp-populist catalog of nuance and a prodigal epicure's prosthetic interpretation of 'Social Lamarckianism.'" We've had this kind of language from the third-string academic Greenbergians, but it seems a bit more incongruous coming from a "movement" that is supposedly opposed to promulgating bullshit like the above. (Imagine any self-respecting punk artist claiming to employ "a symbological and epistemological lexicon"; it's lucky critics are still around to do the dirty work, to alienate the thinking audience still more effec-tively.) Probably the last laugh is offered by a Canadian punk rock group called Battered Wives, whose logo is a fist and a bleeding mouth and who sing a song of the stupidity of housewives. They surely became "high artists" when they said, "The name's symbolic. It doesn't mean anything."

It used to be only abstract art that fostered this intense disregard of or even hostility toward and from the audience. In the heyday of Minimalism, I and others used to talk approvingly of "the cult of the difficult," in reaction against the instant co-optation of new art. In a curious way the retro sensi-bility represents another, more overt, wave of this attitude toward the public. Pop art, which was once the detestably accessible art, is the idolized ancestor of unacceptable art this time around. Today's costume militarism, violent porn, pseudoterrorism, and ethnic-, racial-, and gender-based slurs are seen by some as nose-thumbing counterparts of the cereal boxes, comic strips, and washing machines of the early sixties. We've come a long way. The durable and adaptable Warhol is once again the epigone of Cool. He alone of the pop artists shared some of the Minimalist sensibility, and he alone is now whooped up by post-Conceptualists who despise the rest of sixties art. Retrochic is envisioned as a kind of red-hot risk-taking not everybody is man enough to try, "a DC current...too hot to handle," as one journalist put it.

But where are all those burned fingers? If symbols are meaningless, I

shudder to think what art is. If Warhol is the godfather of punk, the real retrochic heroine is Valerie Solanas—the uninvited guest whose *Scum Manifesto* was too hot for *anyone* to handle, or maybe Norman Mailer, who has lauded such "existential acts" as murder. Retrochic is subversive in the sense that Reagan and the oil companies are subversive. It's part of a TV culture that offers insult, assault, torture. Yawn.

New York Times IV

7 A.M.: Lie in bed for a few minutes listening to the steady breathing beside me and watching the light come through the plants and tensing up with all the things that have to be done/won't get done today. The main thing is to get down to the preface for the ARC show—"A Day in the Life." It's a good idea, but since I won't see the show and know almost none of the work, I miss the stimulation I usually get directly from the art. Of course this isn't as much about art as some shows are. It's also about life. It's about art feeding into life and life feeding into art and (the way I see it) about the positive fragmentation that structures the passion of women's arts and lives. A cup of coffee and some thinking about it. This peaceful half hour is my favorite part of the day. My son and my lover are still asleep and I'm having ideas. I mull this time, in time, on time. Decide to divide the preface into twenty-four parts.

8 A.M.: I've made Ethan's school lunch, eaten breakfast with him, sent him off. I take my next cup of coffee to my desk. The phone starts ringing. I dread looking at my list of things to do. If only I could just settle down to the ARC piece. But first I have to plan a quick supper for friends coming from Washington to see some slides, call the printer who screwed up the margins of my novel and fight about the bill again, call CAPS about the grant application, get the Printed Matter window shows scheduled, read an article for *Heresies* no. 9, make a draft of the press release for my British political artists show, call *Art in America* to see if I can review the Colorado Women in the Arts show…

One of a series of fictions and non-fictions called "New York Times" reprinted from *A Day in the Life,* A.R.C. Gallery, Chicago, 1979.

. . .

9 A.M.: Some of these things actually got done, but my lover has just gotten up and I have to stop and compare our schedules for the day. Who's going to replace the slide projector bulb and who's going to do the shopping? Phone rings. A friend who has cancer is in bad shape. I try to be sympathetic but firm. Today there isn't a minute I can get away. Torn, as usual, between being a good person, good friend, good little girl, totally human being—and all the other obligations. If I go see her I'll be angry at her because most of today's list will drag over to tomorrow and there is no time tomorrow either and the pressures building are like a monster in the corner slowly chewing through the bars of its cage. It's always about time. Who gets my time? Why do I dole it out in such chintzy doses? Lucky you. You get five of my precious minutes. When I answer the phone, people always say I sound out of breath. Time should be a medium in which we float, live comfortably. (Life as amniotic fluid?) Instead it's a commodity. Having made the insane decision to be all things to all people I have no right to complain. It's nobody's fault but my own. My friends all agree that the hardest thing for a woman to learn is how to say no.

10 A.M.: Finally beginning to write, but still distracted. I'm alone in the house now. I can sense the emptiness, the dim space that reaches beyond my desk (which is in the front corner, by the windows, by the bed) back through the chaos to the airshaft eighty feet away. Time and space coincide, temporarily. I see that my house is my diary for the last eleven years. It's a compost mound of memory, dead ideas, and those still struggling to get born. Literally tons of paper with words written and printed on it, overflowing boxes of reminders of projects undone. Old and new photographs, thousands of slides of art and places. Pebbles, stones, and rocks everywhere. I can't resist them. I could build a stone hut within these walls. Postcards, offering associations that drift me past the day's work—waterfalls, geysers, volcanos, flowers, people, dogs and fields, a golden labyrys, a button that says Failure Is Impossible and another that says Dare to Struggle Dare to Win, photos of prehistoric stones and sensuous caves, a quote from Thoreau that says "Beware of all enterprises that require new clothes." A Lucy Stone stamp, lists of lectures to give, articles to write, calls to make, letters to answer, a root coiled like a snake, a compact with tiny cows grazing in it, a sleeve ironing board made into a flower with a shell and ruffles. Atlases and maps. A matchbox containing a book made specially for me and another containing tiny bricks. An Indian shield with the moon and stars on it, a rose, a ring with an amazonite stone, a nest, a corn dolly, a little girl's drawing of flowers, fossils, recipes not yet attempted, friendships not yet

cemented, trips not yet taken, a great number of scraggly plants still grow-
ing, a card admonishing me to "forge simple words that even the children
can understand."

I love my accumulations and I wonder what they have to do with my
sense of time. I'm against consumerism and spend very little money on
things or clothes, but I'm a pack rat and live in a gigantic nest of clutter. I
build these nests around me wherever I go, thinking each time that I'll make
this a clean, clear, sparse space, an undistracting environment, and looking
around a week later to find it's disappeared. Like the time to clean it up and
start again.

11 A.M.: Not bad. A half hour's work with no interruptions, but I'm
hungry. Stop for a piece of toast, more coffee. Won't go get the mail yet;
that would mean another half hour gone opening, reading, filing away and
another psychological barrier because letters have to be answered or added
to the pile that should have been answered months ago. Another wave of
guilt. And glimpse of the deadline list makes it worse. Deadline. A dismal
term for sending out writing into the world. Writing should be live flashes
from one head to others, a way of keeping ideas alive, not burying them
in print.

12 NOON: So what does all this have to do with art and feminism? Every-
thing and nothing. The fabric of our lives is where our art comes from—a
fact that for me has consistently substantiated the claim that women make
art which is different from art by men. Because women's lives are this
fabric, woven of so many different strands and often with little sense of
what the final product will look like. How many of us are working from
subconscious patterns? How much of the art you will see in the ARC show
is marked by obsession, or by painstaking detail, or by marks themselves?
Or do the differences surface in other ways? I've come to doubt the wis-
dom of being as specific as I once was about how women's art differs from
men's, though I've in no way rejected the idea itself. At the beginning of the
feminist art movement, around 1970, there was an unavoidable flood of
conscious and unconscious imagery that was biologically or autobiographi-
cally associable with women. It was mostly unconscious until a couple of
years later, when the notion of a female imagery began to be adopted by
feminist artists searching for sources of our own. Since then there has been
the inevitable crystallization, stylization of that imagery (some would say
orthodoxy). However, it should be obvious that this does not invalidate its
contribution to an expansion of human experience. We are just beginning
to find out how the non-male half of the world experiences life.

. . .

1 P.M.: Calls start coming in from people who know I work mornings. No, we can't come to dinner. I have meetings almost every night this week and I have to see my family sometime. No, I can't meet so-and-so from Europe; I haven't got time to discuss art anymore. Yes, I'm still working on the manuscript and will bring it tomorrow. No, I can't come to your studio because I have a long list and have to go down it in order to be fair and there's never time to go to studios anyway because it's all I can do to keep up with the women showing in galleries now. (This should be cause for celebration, not paranoia.) The telephone always depresses me. I begin to drift. When I came back from England this fall, my sense of time was totally disoriented. There, for ten months, I had lived the perfect life. We were on an isolated farm. My son was in school all day. My lover was in another country. In the mornings I wrote fiction and in the afternoons I walked in the fields and moors with Gnasher, the black-and-white dog. At night I read and watched TV with the kids. I knew only a few people and the phone rarely rang. The farm family next door became my family. When I got back to New York I was still clinging to that life. I was terribly homesick, and for several months I simply lived both lives simultaneously—the one described here and my English one. As I sat at my desk around one o'clock I was also putting on my Wellington boots and setting out with Gnasher barking and leaping in excitement. As I answered the phone I was deciding which direction to walk today and as I wrote letters I could feel the earth firm and soft under my rubber feet, the damp wind blowing on my cheek, the brambles pulling at my sleeve as we scrambled through a hedge, my muscles stretching as I climbed a gate and the dog leapt gracefully through the bars. I took these walks and lived that life somewhere *underneath* my New York times, close to my body, a secret, and for a while it was realer than the life I'd returned to. This is probably as close to madness as I've gotten, but it was pleasant, and I needed it, and it only faded away when I knew I was going to be able to go back to the farm in the spring. Mad it may have been, but it was a successful if melancholy way of having *two times,* of possessing two spaces, of getting what I needed but couldn't have. I suppose writing is another way of stretching time. It takes time to do it but you are also creating another space which will be time at hand when necessary. Making time and marking time. The less people are around the less I feel time leaking away. But I like people! I like too many people! They take so much time! As I write this I notice a note in my son's lousy handwriting across a page of my phone book. It says, "If the characters are not human do they act like humans?" What does it mean?

. . .

2 P.M.: Lunch with Charles. Read the mail. Skim the paper. Try to concentrate on him but it's hard to tune out work when there's still so much to do. He resents it. I resent his obsession with *his* work, which is so much more concentrated and leisurely than mine. After seven years together we have yet to resolve all this but for some reason the relationship is still a strong one. We figure no one else could put up with either one of us. After lunch is my foggiest time of day so I go shopping, do errands, to the Grand Union which is not such a grand supermarket, to the wine store, the bread store, the post office, the Heresies office. Quick chat with the women working there, both of whom I like a lot, both of whom I'd love to know better, so I'm always about to stop and have lunch, really talk, but never do. My time is never open-ended the way other people's seems to be. But then, neither is life. Maybe all this anxiety about time is merely intimations of mortality. I dream of drifting away, bound only by delicate cords of timeless love and affection. Stones piled one on another to make a shelter, steps placed one after another to make a path, words paced across a page to make a thought, though the thoughts I like best are more like mounds— some words shooting up here, some there, like blades of grass and flowers at different seasons. Once I felt a flash of pure hatred when I saw a friend's datebook and it was almost empty. "Want to see a movie this week?" she was asking another friend. I never go to the movies. Yet she thought of herself as busy too. Degrees, as usual. Some of my friends are night people and they seem to have more time than I do, though surely that's an illusion. Back to the art show. What are the connections? This text is just another of the threads that, when woven together, make an image of woman's time. Woman's time as a blanket to crawl under.

3 P.M.: A few galleries on the way home from stores. I like one show I see but increasingly I resent the time I spend shuttling back and forth between galleries because I really don't like all that *much* of what I see and then I feel bad that I don't because I know how much work and hope has gone into each show whether or not it's my personal cup of tea. After twenty-one years, I really *have* seen a lot of it before, which is nobody's fault, but a product of the incestuous nature of the art world itself, with its lack of outreach that affects the art that is being made as much as it does the audience that sees it. I want feminist art to change this, but it's just beginning, just being nurtured, and it'll take time to mature. What I look for now in women's art is an overt concern with feminist issues and the search for visual images consonant with the importance of these issues. This seems to be happening more often in film and performance and public art than in other areas, but no medium is or should be closed off. (That's another art-

world ploy; remember "painting is dead"?) Feminism and women's art have provoked and/or expanded a number of new directions that have influenced men and women alike—among them a new interest in opening "high art" up to the decorative arts and the fiber media, politicized performance, and—especially significant in this present context—autobiographical art. Ethan comes home from school, dumps his bag, raids the icebox, and reminds me I said I'd take him to Canal Street to get some jeans. OK, OK. Just let me finish this, I mumble.

So one of the major questions confronting the feminist movement today is exactly to what extent the personal is political. When is it necessary for the personal to be enriched by a broader politics dealing with the lives of others, especially those the world is cheating? In art, as in the rest of the women's movement, it seems crucial to integrate what has been called "cultural" or "spiritual" or "radical" feminism with the Left, or socialist feminism. Socialism and feminism are in many ways the same thing. Their ideals are inseparable, though their current realities are separated by an abyss. Both presuppose a collective approach and support system, nonhierarchical leadership, joint responsibility for all aspects of the world. Because *everything* is a "woman's issue"—not just equal pay and reproductive rights. And while it's true that art may not be able to change the world singlehanded, we mustn't underestimate the power of the image as a vehicle of change. By the same token that a woman can hardly avoid making "women's work" because her social, political, and biological experience is so different from that of a man in this society, a feminist artist can hardly avoid the effect of feminism on her art.

The personal is political because if we don't know who we are and where we come from we are going to be singularly ineffective at knowing anyone else, at working together for change. On the other hand, the danger in an overemphasis on the politics of the personal is yet another wave of bourgeois narcissism—the trap into which women have already been plunged by a consumer society. Our emphasis on autobiography and self is not, hopefully, about self-indulgence, but about an expressive feminist analysis of our common lives as women. Art can reflect to a larger audience the best that feminism has to offer—not just aesthetic "quality," but caring and content too—elements without which so-called quality is "merely" aesthetic. The days in the lives of the participants in this show will be very different, but knowing our own days will help us to recognize similar threads in others' lives, and once this is recognized, it will help us to shed the sexist and classist and too often racist conditioning that has built obstacles between women. Taking responsibility for one's own images and their effect (whether those images are "abstract" or brutally realistic), deciding for

oneself whether contact is being made—these are important aspects of art-making that the feminist consciousness-raising and self-criticism techniques make more accessible.

I'm not saying that feminist art must be propaganda (although I do think that art can be propaganda and "quality" too) so much as I am arguing for a feminist sensibility as consciously and intelligently employed as any kind of formal sensibility is normally employed in making art of any kind. There is an analytic thread in even the most "expressionist" or "realist" art. Art in fact is all about choices. And choices, in turn, are all about how to use time, so that analysis of one's own life and the society in which one lives offers the means by which to know more about the connections between art and life, and by doing so, to make art a part of the lives of others.

4 P.M.: Typically, I'm running out of space. The day begins to unravel. We buy Ethan's jeans and the salesman says he is lucky because his *own* mother was very strict and I'm obviously a pushover. He gets an extra T-shirt and I get myself a turquoise vest on sale so we both go home happy and he changes into his new clothes and rushes off to Washington Square to hang out with junkies, musicians, kids, comedians, lushes, cops, child molesters, and tourists. One advantage to having no time is that I have no time to worry about dope, rape, flunking school, arrests, creeping teenagism. I make a salad of rice, green peppers, shrimp, and curry and a fancy frozen dessert. I'm wearing down. Phone call from friend who has more troubles than I do. Why am I complaining? Can I make this supper stretch to lunch tomorrow, when another friend from out of town is showing up? At least the tour of babble is over for this year. I've given at least a million lectures to recoup the money spent on "my own year" in England. But I'm a writer, not a teacher.

5 P.M.: Doorbell rings, friends are here. Charles reluctantly turns off TV. We drink, talk, see slides of prehistoric sites. I try to sew the strap back on a shoe, wonder if my company notices how filthy the house is. I've just done a fast job on it, but they probably can't even tell, because there's still grime in the corners of the bathroom and bits of food on the kitchen floor and the stove is black and greasy and the coffee table is overflowing with books so some inevitably fall to the floor if you try to put a glass there too.

6 P.M. has gone by already.

7 P.M.: We eat. We talk about traveling.

. . .

8 P.M.: I kiss everybody good-bye, nag Ethan about homework, go around the corner with Charles to a friend's first myth-telling performance. A luxury—to sit passively and listen, watch, while ancient tales of women and magic and good and evil are spun before me. No wonder oral history is a thing of the past. I don't have time to listen instead of reading, skimming, at my own mad pace. Afterwards I'm talking to another friend who says she doesn't know where the year has gone. Neither do I. We realize we don't even know where the *decade* has gone. It seems the seventies were just beginning and now they're over. What have we been doing all this time? Both of us have "made it," but was this what we wanted to make? This layered life so dense, so intense that distinctions get lost—not to mention friends and loves, books and paintings! We're overaccomplished, both of us. What then are we commiserating about? Nothing much has changed, is what we're saying.

I I P.M.: Home. Watch the news with Charles. Ethan to bed. Me to bed. Nothing left of me. I avoid looking at the phone messages lined up on the desk. Maybe tomorrow I'll be able to cope. Read five pages of a political biography of Shelley that's been my nightcap for months, and sleep.

I 2 P.M.—3 A.M.: Wake several times to tune of screeching wheels, sirens, calls on the street. The bakery workers who load pies all night holler to each other at the gleeful top of their lungs, crashing metal carts into each other. At three comes the garbage truck, louder and louder. We both wake every night at this hour, tussle with the blankets and each other's bodies, curl up tight, drift back to sleep as the noise slowly subsides down the block.

3 A.M.—7 A.M.: Dreams. I dream a lot. Dreams too expand time. I don't waste time asleep either. I dream that there's time to dream.

PART III: MORE HERESIES
1981—1993

Clash of '85

Pass or fail? Honors or ignominy? This month I'm giving a couple
of college commencement addresses, and I'm graduating at the same time.
I've been fired by the *Voice* for "bad writing…narrow subject matter…
fuzzy politics…lack of aesthetic judgment and principle…boring content…
predictability" (direct quotes from my dispatcher [Kit Rachlis], who is not
a Murdoch henchman).

I was constantly assured, however, that my politics was not the problem,
or rather that the problem lay with the form rather than the content of
my politics. After thirteen books and a few hundred articles, I don't worry
a whole lot about my writing ability. I believed the political line because
during the four and a half years at the *Voice* in which my failings escaped the
editor, no one ever interfered with what I wanted to say or how I wanted
to say it. But my friends tell me I'm not suspicious enough. Being fired is,
after all, interference on a pretty grand scale. And it's not, alas, as though
the woods were full of people writing regularly on the social and political art
being made outside (and sometimes, inside) the institutional art contexts.

I want to spend this last column not complaining (though I hope it's clear
I'm mad as hell) but examining what I've been trying to do since January
1981. I was hired with the understanding that I would not be a general art
reviewer but would cover feminist, activist, and community arts. I've liked
having a monthly networking vehicle in which to criticize, analyze, and
catalyze a developing national movement of Left culture. Introducing a great
variety of models for social art practice is part of a collage strategy that
includes political organizing with four different cultural groups, freelance

Reprinted from the *Village Voice*, June 11, 1985.

curating, and writing in books, art magazines, and catalogs; and coediting three small periodicals.

This communal base has nourished me personally and stimulated and informed my writing, which owes a great deal to collaboration, discussion, and dispute with my fellow cultural workers. I started writing "journalism" in *Seven Days* in 1976 and it has helped punch holes in my art-centered specialization as I try to be accessible to a much larger audience. I like the monthly column format because I don't have to start from scratch explaining where I stand with each article; it gives me a place to develop a sort of trialogue between writer, artist, and people working progressively in all fields—who may or may not realize how important culture could be to their own efforts.

When I graduated from college in 1958, then-senator John F. Kennedy was the speaker. He said politics wasn't a dirty word, and it was too important to leave to politicians. (After the Bay of Pigs, one had to agree with him.) The same might be said of art. It's recently occurred to me—long after it occurred to plenty of other people—that after all these years of trying to make (some would say force) connections between visual art and daily life, I was missing the link of culture itself—the ground in which both art and politics must grow. Culture in the full sense, not just the other arts, but the whole fabric, including how we eat and dress and work and make love as well as make art—a general culture in which we are all collaborators, which does not exclude so much as embrace the so-called avant-garde along with many other manifestations.

This view of culture, which has actually been expanding over the past six years or so, and has even had ramifications within the art "scene" itself, takes risks with the notion of artistic purity guarded by the academies. Artists are learning not only from other disciplines, but from the needs and experiences of their audiences. And subject matters. Maybe I'm jaded after twenty years of writing about art, but increasingly I need to know what the work I see is about, or what the artist thinks s/he is making art about. This doesn't disallow abstraction or any other generic art form except that which refuses to acknowledge its role as communication on any level.

Of course nothing's settled and we're still looking for a patch of relatively steady ground on which to build a form and language as brilliantly unbalanced as our times. Progressive art will go on dancing on the edge between action and reaction, opposition and affirmation; it will move out, then withdraw for reflection; it will mediate with aesthetic integrity between the old imposed criteria and new assumptions about what constitutes "quality." It has to be visible in the face of whiteout and co-optation and subtly subversive at the same time. As we reevaluate the relationship

between the concerned and talented individual and that broader view of culture, we've got to learn to write about it differently, to embody the critical function of art itself, which is what I'm trying to do.

I'd be the first to concede that I haven't been a proper art critic for some time now. I've never liked the antagonistic implications of the title anyway. A painter friend asked me recently if the role art plays as an agent of consciousness and change is more important to me than the other roles it plays, and I had to answer yes. I respect those "other roles" but I have become less interested in writing about the object or exhibition per se and more interested in the contradictory, mysterious ways in which artists and objects or actions enter society, in what images mean and do to people, and how contact or lack of contact with people in turn affects what artists do. So when I write about a single artist, I try to weave her or his work into the general cultural/political fabric in order to avoid further isolation. For similar reasons, I mix up high, low, and popular cultures; and when I put together a show or a series of articles, I try to incorporate as a matter of course a diversity of race, gender, age, and geography as well as style and form.

The recent history of Third World and indigenous cultures, especially in Central and Latin America, became important to me at a point when it seemed that European/North American vanguard art had come up against a wall that "postmodernism" has failed to crack. I've learned a lot from the concept of cultural democracy, in which the clamor of multicultural voices is not drowned out by a homogenized art-market version of Radio Martí. And I have been extraordinarily moved and shaken by the book *I, Rigoberta Menchú,* the story of a Guatemalan Indian woman who gained the strength to rise from the most abject poverty and powerlessness and become a political leader because of the richness and power of her thousand-year-old Mayan culture. (The book is edited by Elisabeth Burgos-Debray and distributed by Schocken.)

It seems crucial to open the windows of our own insulated and arrogant culture to these very different voices. And if the *Voice* is still a radical paper, isn't it the place where such views should be heard? (Or is it falling into the pattern set by *The Nation,* where the cultural section is far more conservative than the political coverage?) The fact that I have a political position should not be a disadvantage, although it is certainly not a prerequisite to being an art critic these days. Of all the epithets tossed at me, "predictable" is the most thought-provoking. Does it mean consistent? While I've always emphasized the role of change in my work, I hope I've also let you know what to expect—where I stand, and what I fall for. If it's "predictable" to cover art by East Village cartoonists, Australian aboriginals, feminist pornographers, Russian émigrés, rural graffitists, postmodernist photogra-

KATHY VARGAS
Missing #1, 1991–92
HAND-COLORED PHOTOGRAPH

A Guatemalan woman "whose face looked like mine," writes Vargas. "She was look-
ing for her missing husband. Since I could not help her find him, I recorded the
outline of his 'missingness.' The left panel asks if he'd brought her hearts and flow-
ers; the right panel places flowers over his possible grave, and asks if I helped make
him 'missing' simply by paying my taxes."

phers, needleworkers, Canadian propaganda analysts, demonstration artists. Nicaraguan and Irish muralists, photojournalists and SoHo abstractionists; if it's "predictable" to discuss art in regard to genocide, sexism, ethnocentrism, and imperialism...then damn right I'm predictable. Would I be less so if I astounded you monthly with one entertaining fragment of art after another, ignoring the connections to anything but other fragments of art, bestowing on lucky artists my good housebroken seal of approval?

But predictable could mean "too consistent" or it could mean "too clear." Its use in this context suggests the liberal assumption that significant questions and analyses can only be made from a so-called "neutral" and "objective" middle ground, that anything to the left of *that* particular position is unsophisticated (read uneducated, with class implications) or "rhetorical" (read a little too clear, and potentially dangerous). If that's the case, should I get paranoid and see my dismissal as a form of censorship of the cultural movement with which I'm happily identified?

It's not so bad getting all fired up. Unlike many in the class of '85, I have somewhere to go. I'll be writing monthly for *In These Times,* the socialist weekly published in Chicago, where I will predictably keep on doing more or less what I did here. Graduation, after all, is a hopeful occasion, a beginning rather than an end. Maybe that's why I can't think of a way to end this piece. I'll give the last word to Eduardo Galeano, an often-exiled Uruguayan writer who can blame some of his own troubles on the fact that he knows that culture includes "all the collective symbols of identity and memory: the testimonies of what we are, the prophesies of the imagination, the denunciation of what prevents us from being....Culture is communication, or it is nothing. In order for it not to be mute, a new culture has to begin by not being deaf."

Feminist Space:
Reclaiming Territory

The three pieces *below were originally published in* the Village Voice *as, respectively, "Biofeedback" (Mar. 22, 1983); "Feminist Space: Reclaiming Territory" (Nov. 29, 1983); and "Time Will Tell" (June 19, 1984). Rather than merge them into a single article on aspects of feminism, politics, and populism, I've kept them separate so readers can make their own connections and transitions. The women discussed come from different places, different races, and different historical moments, but they share a certain* expansiveness *that characterizes a "feminist space" in the broadest sense.*

The separation between so-called high and so-called low culture, amateur and professional, is usually employed to exclude minorities, the lower classes, and women from full creative participation in the general culture. However dissimilar, the works discussed below challenge that situation. The artists have tried, consciously and unconsciously, to combine social action, social theory, and the fine arts tradition—to be catalysts, to catch the public imagination, and to make people think for themselves about what they see around them.

The task is one of integration, of bringing together the components of lived and learned experience, seeing culture as part of the whole fabric of life. Feminist art has always been unique in the way it's integrally entwined with the social structures from which it emerges. Some of the most interesting works being made today are made in series, or else are long-term projects that may take years to complete, thereby becoming something more *than art, because they expand our notions of art. For instance, collaboration in progressive art has become a way to enrich individual work, not replace it. And storytelling—autobiographical or not—has become an aesthetic weapon against the powerful sense of alienation that pervades late capitalism, an alienation that divides and separates through specialization.*

Reprinted from *The Event Horizon*, Lorn Falk and Barbara Fischer, eds., Toronto and Banff: The Coach House Press and Walter Phillips Gallery, 1987.

"*The political is personal*" *is the neglected other side of the "personal is political"* *credo introduced by feminism in the late 1960s, which brought autobiography and* *other taboo subjects (including class, sexuality, and gender) into the art of the* *1970s. Autobiographical stories and imagery serve to put the personal into a political* *context, to understand and illuminate our social visions by way of our personal histo-* *ries. The storytelling artist with a broad consciousness can play the role of the* *griot—the historian/mythographer and conscience of a race. If that continuity is* *destroyed, culture itself is endangered. Thus the feminist "collage aesthetic"—putting* *things together without divesting them of their own identities—is a metaphor for* *cultural democracy.*

Cultural democracy assumes that culture is an active exchange, giving artists access *to audiences both like and unlike themselves, and countering the dominant culture's* *appetite for homogenized art and visual muzak. So-called pluralism is, in fact, vari-* *ations on the same theme—like the TV menu, with only the illusion of diversity: lots* *of channels, all leading to the same bay of pigs. When art is directed to communities* *other than those that own it, the dominant notions of "quality" and the supposed* *"universality" of high art are questioned. The class that art usually serves is then* *confronted with something unfamiliar—a process that usually happens the other way* *around. High art is usually doled out to the deserving "others" who have to learn to* *appreciate it—in other words, to forget their own lived experience and take on that* *of the controlling class. The "prefeminist" works of Frida Kahlo and Tina Modotti,* *the more recent "feminist" works of Lacy, Labowitz, and others, and the "nonfeminist"* *works of the elders asserting their cultural contributions all reclaim this territory.*

I .

Frida Kahlo and Tina Modotti have become cultural "sheroes" as much through their lives as through their art. This apparent imbalance is some-what justified because the sources of their art were inseparable from their histories, and from the historical times in which they lived. On the other hand, they have been dead since 1954 and 1942, respectively, and only now is the importance of their art being recognized. *This* imbalance is unavoid-ably traceable to their gender. So what better way to address its redress-ment than to celebrate International Women's Day—founded in New York in 1908—by considering the politics of biography.

The joint exhibition of Kahlo's paintings and Modotti's photographs, now [March 1983] at New York University's aptly named Grey Art Gallery, originated in England; some twenty Kahlos have been added here. It is accompanied by a model catalog by filmmakers Laura Mulvey and Peter Wollen, which provides a double historical context—concise information about revolutionary and postrevolutionary Mexico, where both artists lived,

and full awareness of recent feminist theory. There are brief, clear essays on the major issues involved—particularly those of "marginality" and "body discourse," and the ongoing dilemma of the (perhaps false) notion of a "political art."

This last dilemma has been stated so many times....I went to the Kahlo/Modotti show wondering what, if anything, it could do to illuminate or extend our understanding of the conflict. I came out wondering if perhaps the dilemma itself is not crucial to the best socially relevant art. It is the dilemma itself that often provides the tension, or dialectic, that makes these two women's work so moving; and this tension is in turn rooted in the ways they were unwilling, or unable, to separate biology from biography.

I'll try to resist the temptation to do what everyone else does—spend most of my space on their lives, especially since an excellent and exhaustive biography of Kahlo by Hayden Herrera has just appeared (*Frida,* Harper & Row); Modotti, though less well served, is the subject of briefer treatments, notably by Mildred Constantine (out of print) and Maria Caronia (the latter in a badly translated, sometimes almost illiterate, but politically detailed paperback published by Idea/Belmark, 1981). Suffice it to say, in a flash: Kahlo was born in Mexico City in 1907 of a German father and *mestiza* mother. A lifelong victim of physical infirmity, she had polio as a child, and suffered a horrendous streetcar accident at eighteen which left her spine and leg in fragments and led to miscarriages and some thirty operations; she finally died after amputation of a leg.

A self-taught painter, Kahlo married the communist muralist Diego Rivera at the age of twenty-two. This tempestuous and very "open" marriage framed her politics, which were both internationalist and steadfastly nationalist, reflecting the Mexican cultural revival movement. To mask her lameness, and a series of torturous orthopedic corsets, Kahlo wore the traditional loose-bloused and long-skirted costume of the Tehuanas (southern Mexican women renowned for their dignity and independence); to mask her emotional and physical pain, she decked out herself and her surroundings in the most colorful, exotic ornaments, just as she decked out her life in a dazzling series of lovers, ranging from Trotsky to Noguchi.

Kahlo's painting bears no resemblance to Rivera's. Though monumental in scale, it is small in size. Her own *mexicanidad* was communicated through a determined populism, deriving from the tin *retablos,* or *ex-votos,* of local folk/religious art. Herrera calls them "visual receipts, or thank-you notes, a hedge against future dangers." Kahlo similarly used her own symbolic self-portraits as talismans by which to acknowledge or ward off tragedy. She has been called both a primitive and a Surrealist. She was neither, moving in sophisticated intellectual circles on one hand and arriving at her hybrids,

fragmentation, and juxtaposition from different sources on the other. She was certainly aware of the modernist impact of her bizarre reality and in the mid-forties flirted disastrously with the artsy techniques of late Surrealism, such as the Rorschachlike "decalcomania" of Oscar Domínguez and Max Ernst.

Sometimes Kahlo chose journalistically bloodcurdling subjects in the tradition of the popular broadside, but the glowing, translucent skin tones of her best portraits recall the obsessive intensity of Northern Renaissance painting. At the same time, her figures have a weight and *groundedness* that comes from the contemporary Meso-American sculpture. Toward the end of her life, under the burden of alcohol and painkilling drugs, her touch became cruder and wilder—less rather than more "expressionist."

Modotti was born in Italy, emigrated to California with her family at seventeen, worked in textile factories, became a dressmaker, acted in movies, married a poet, modeled for photographer Edward Weston, who taught her his trade, and lived with him in Mexico from 1923 to 1926. When he left, she stayed, having become an artist in her own right and increasingly involved with Left politics. When her companion, Cuban revolutionary Julio Antonio Mella, was shot down in the street at her side (he was planning a Castro-type invasion against the Machado dictatorship), she was deported. With Vittorio Vidali, the last of her communist lovers, Modotti spent the thirties in Berlin, Moscow, and as the legendary "María" in the Spanish Civil War. Afterward they returned to Mexico, where she took up photography again and died of a heart attack at forty-five. The life of a political exile being what it is, many of her negatives and photos have been lost; the remains in this show are a tantalizing sample of a major talent.

As Weston's apprentice, Modotti was trained as "an objective aesthetic eye." With the growth of her social awareness, she came to abhor the pretentions of the "art photograph" and aspired to "the perfect snapshot," while never abandoning the geometric lucidity that made her work so striking. Maintaining a technical honesty, she added a passionate didacticism that heightened rather than diminished its effect. Modotti's photography at its best merges populism and formalism. Her bold and very modern industrial images owe something to Russian Constructivism. She could also document the poverty of Mexican *campesinos,* mothers, and babies, without sentimentality, and if for nothing else, she will be remembered for her series of workers' hands—on a shovel, scrubbing a floor, operating a street puppet show (perhaps a political message about who holds the strings).

I was particularly struck by her pictures of Indians reading the revolutionary paper *El Machete;* by her "propaganda" still lifes—an ear of corn, a bandolier of bullets, a sickle, a guitar; and by the diagonal close-up of

Mella's typewriter with a fragment of text in process ("inspiration...artistic...in a synthesis...exists between the..."), in which the silent machine becomes an articulate image. Her pictures are no less effective because they often look somewhat posed, in the best sense—as in thoroughly thought-out. (She worked with a big Graflex on a tripod.) The purity and directness of Modotti's geometries seem to demythologize her social content without banalizing it, as in two marvelous photographs—*Misery* (two peasant women outside a *pulquería,* one huddled against a wall, face hidden in her *rebozo,* the other totally exposed, passed out drunk on the sidewalk); and *Elegance and Poverty* (a tripartite composition of an ad for men's clothing with a tuxedoed and monocled dandy, over a black stone wall, over a ragged, despairing worker slumped on the curb).

"The art of both Kahlo and Modotti had a basis in their bodies," say Mulvey and Wollen, "through injury, pain, and disability in Frida Kahlo's case, through an accident of beauty in Tina Modotti's....Modotti, whose career began as a film actress and model, redirected the look which had focused on her outwards when she herself became a photographer. Kahlo's art became predominantly one of self portraiture." Modotti, who was one of the first women in Mexico to wear jeans, hated the "beauty angle" by which women were framed and measured. By the calm and modesty of her personality, she distanced herself from it.

Kahlo, on the other hand, drew attention to herself in her art as a virtual female martyr, pictured with necklaces of thorns, skeletons, hearts and uteruses, copious blood and tears, these signs of "weakness" offset by an unflinching gaze of pure strength. In her more grandiose paintings, she presented herself as a microcosmic duality that might have represented Mexico itself. She saw herself literally on the borderline—between nature and culture, between the ancient earth of pre-Columbian America and "Gringolandia"—a distastefully technological U.S.A. A synthesizer, like so many major women artists, she juxtaposed the European/Indian heritages, saw herself as loved/unloved, courageous/terrified, dying/healing, pagan/Christian, her body poised between sun and moon, the barren volcanic rock of the Pedregal and the lush leaves, vines, flowers, and fruits of rebirth.

André Breton wrote of Kahlo's art that it was "a ribbon around a bomb." Pablo Neruda wrote of Modotti, "Fire does not die." Rivera pictured the two of them in a mural handing out arms to the people. (Modotti may even have introduced Kahlo both to Rivera and to the Communist Party, though they were never close friends.) They handed out arms, all right—embraces and explosives on many levels. Both women worried that their art contributed little to the revolution. Modotti gave hers up for direct action

(though probably because her professional training was out of date in modernized Germany), after insisting that by adding to photography's documentary value "sensitivity and understanding and above all a clear idea of the position it should occupy in the unfolding of history, I believe that the result is worthy of a place in the social revolution."

Kahlo too wanted her "work to be a contribution to the struggle for peace and liberty," but added: "If I do not transmit more ideas in my painting...it is never because I think that art should be something mute." Herrera says that Frida's paintings "are hardly mute. They shriek their personal messages so passionately that there are no decibels left for propaganda." I disagree; so might Kahlo. The "propaganda" in both women's works was inherent, deep-rooted in their belief and value systems.

Some will see the politics in Kahlo's art as forced, those in Modotti's as didactic. Sometimes they are. Both representation and response are part of our aesthetic conditioning to the notion that political clarity is incompatible with successful form. Given the fantasy choice of heroines, I'd rather have been Modotti. But ironically, though Modotti was far more active in the world, Kahlo may finally have been the more effective "political artist"— certainly in terms of feminist influence, which is in large part responsible for her renewed reputation. Modotti saved lives. Kahlo influenced artists. In the forties her disciples—"Los Fridos"—made murals on a public laundry and a *pulquería,* reviving a disappearing form.

They still see her as a political as well as an artistic mentor. Her last painting bore the inscription *Viva la Vida* (Long Live Life). After thirteen days in jail, as she was being deported from Mexico, Modotti quoted Nietzsche in a letter: "What does not kill gives me strength." This could serve as an epitaph not only to these two courageous women's art, but to the continuing struggle in which they believed so wholeheartedly. Kahlo's last public appearance was in a wheelchair, at a demonstration against a CIA-sponsored fascist president of Guatemala. Sound familiar?

I I .

I was trying to think about space from a feminist perspective after seeing the "At Home" exhibition and attending the "House of Women" conference, both in Long Beach, California. A week later I went to Washington for the November 12 demonstration against U.S. Intervention in Central America and the Caribbean—an innovative action that artists and cultural workers helped to plan. The night of the 13th, a PADD forum looked at slides from the march and discussed the successes and failures of its cultural components. What emerged as a goal for the next time around was a more feminist sense of space.

Feminist art, as described by Arlene Raven, curator of "At Home," "raises consciousness, invites dialogue, and transforms culture." (So does, or so should, socialist art, but feminists said it first and have moved further to implement it.) One of the questions asked at the Long Beach conference was: What have we learned in the decade-plus of new feminist art? It's hard to answer that, because what we've learned is so deeply engrained, so pervasively part of our attitudes and actions that we barely notice it anymore. This doesn't mean that all is resolved or even perceived, nor that all is well in the house of women, but it does mean that feminist models inform or irritate much that we do. The November 12 discussion brought this home again.

Since June 12, 1982, when almost a million people flooded New York to protest the nuclear buildup, political culture has attracted more attention in the circles the Left goes around in. The European models, and the nationally circulated "We Want to Live" slide show on June 12 as a visual spectacle, sharpened interest in demo art from the artists' side. An Ad Hoc Artists group that worked on November 12 insisted on more music, theater, dance at the rallies and fewer "boring speakers"; it encouraged visual projects of all kinds, including an eighty-foot-long sculpture—*The First People's Monument,* coordinated by Aaron Roseman—on which everyone hung their own art. Ad Hoc's efforts showed. Though only forty thousand people braved the freezing winds (does everyone else think Central America is unimportant?), the demo was spirited and colorful, with more banners and puppets and portable sculptures and masks and music than any other march I've been to. Even the speeches seemed more interesting than usual, because they weren't a river of rhetoric dammed only by an occasional song, but were instead part of a varied, culturally sustained program.

I'm not going to review the demo show, but I wanted to set the stage for some ideas about space that were raised in the *post vivem* discussion. November 12 was broken into three sub-rallies that fed into the march and wound up in a big rally at the Ellipse, facing the White House (where Ronnie fiddled while we burned up). The starting sites pointed up the reasons for the march: the State Department (foreign policy); Health and Human Services (human needs neglected for militarism); and Immigration (political refugees and undocumented workers). I hung out at State, where three huge caricatures by Leslie Kuter of Jeane "Crookpatriot," Weinberger, and Kissinger presided over a Central American graveyard, Dave Dellinger emceed, and Bev Grant and the Human Condition made music that was heart-(if not foot-)warming.

The three more intimate rallies were meant to empower people to feel and assert their own creative force in the face of the numbing centralized

power of government, and to do so without being manipulative. Nurem-
berg it was not, yet the focus remained on the podiums, on the celebrities
instead of the celebration, so this was only a beginning. The theory is *begin-
ning* to be developed from the practice, and the practice will be strength-
ened by the theory.

The PADD discussion concentrated on the fact that demonstrations *are*
cultural manifestations (as theater writer Charles Frederick from Ad Hoc
Artists put it). And space—how it's used and how it's experienced—is a
crucial factor. Cultural workers are supposed to be experts in space—from
performance to sound to designed and decorated spaces. But activists and
avant-gardists have little expertise in working with thousands of people. For
instance, Dancers for Disarmament was one of the day's highlights. But
though they invited people to join them, and taught participants their jazzy
scarf-twirling movements, they remained a sideshow to the speakers.

How, then, do we create a truly participatory space and at the same time
point up the issues and control what the media sees and reports? The *New
York Times*'s offhand account of the march, with the usual distortion of
numbers, didn't even mention the visual atmosphere that was so striking
everywhere except the final rally site, where it was inexplicably invisible. If
The First People's Monument, expanded and bedecked with *all* the extraordi-
nary artifacts from the march, had surrounded the stage, it would have
formed an unavoidable image—a patchwork of everyone's rage and caring.

Those most critical of November 1 2 were the women who are participat-
ing in current women's peace events—especially the Greenham Common/
Seneca variety (and their progenitor, Women's Pentagon Action). The
participatory, egalitarian, nonhierarchal model is fiercely feminist, and most
of the art models come from the West Coast, where feminists Think Big;
viz. Judy Chicago's *Dinner Party* and *Birth Project,* the L.A. Woman's Building
(now celebrating a tenth birthday), Susanna Dakin running as "an artist for
president," Judy Baca's *Great Wall of Los Angeles*—a half-mile mural that she
calls "a reorganization of psychological, cultural, and physical elements in
space"—and, most pertinent in this context, the mass public performances
and media strategies of Suzanne Lacy. The grandeur of these conceptions
contradicts the stereotypes of "women's things" being cute and cozy. There
are also historical precedents. Lacy has been studying the mass pageantry
used by the first wave of feminism in the early part of the century.

Particularly in performance art, and particularly on the West Coast,
feminist artists today are thinking in terms of overall public and social struc-
tures that also provide intimacy and facilitate dialogue. Lacy's *Freeze Frame:
Room for Living*—visual tableaux of one hundred women in small groups
discussing survival in a San Francisco furniture showroom last year—is a

case in point. So are the Sisters for Survival (SOS), traveling across Europe performing and networking with peace groups around nuclear issues. On a smaller scale, the Waitresses, Mother Art, and the Feminist Art Workers (performing respectively in restaurants, laundromats, and at public functions) are also concerned with merging artists and audiences, reinforcing the fundamental feminist notion of art as *exchange.*

Feminism is rooted in networking, a concept that embraces both the immense and the intimate. A feminist network is the sum of innumerable one-to-one relationships expanding into the distance without being homogenized, as they are in the corporate or mystical versions. Three members of Ad Hoc Artists spent November 1 2 interviewing the crowd. Time and time again they found that people were there not only to raise their voices against the invasion of Central America but to make some human connections, to combat their own isolation and powerlessness. The woman and her daughter from West Virginia who quilted a "Self Determination" banner were not stitching for Reagan, but for us. The Left's failures and the potential strength of the many grass-roots movements can be illuminated by these needs.

Feminist art provides a model because it is so often inseparable from the social structures in which it operates. And there is also an emotional factor. From men and women alike on the Left, a groan arises when it's implied that women "care more" than men, that women have a deeper connection to earth and to life. Yet more women than men oppose Reagan, more women than men opposed the Grenada invasion, more women than men are establishing peace encampments all over the world. Not because we have more time (we have less), but maybe because we have more hope to lose. And feminism has helped women to internalize their political beliefs, to realize that "the personal is political" is a two-way street—that what goes on out there affects our lives in here far more deeply than events alone suggest.

This was a primary theme at both exhibition and conference in Long Beach, homages to the legendary *Womanhouse* project from Cal Arts' Feminist Art Program in 1972. The conference concentrated on the spaces of home in the broadest sense, interweaving anthropology, urban planning, the squatter's movement, housing, performance, and the domestic arts into a sophisticated sociopsychological exploration of embracing communal spaces as antitheses of patriarchal high rises.

Leslie Labowitz made the only outdoor piece, and it was about just the kind of spaces I'm trying to survey here. A bold jumble of hand-lettered picket signs stuck in the ground interspersed the world's most public problems with private information about Labowitz's mother's term in Auschwitz and her own birth nine months after liberation. Countering this angry bris-

tle of words and history was a green and peaceful portion of Labowitz's ongoing artwork—*Sprout Time,* also a backyard, weekly market bean sprout business—an expansive matter of sustenance, of cultural and horticultural nourishment.

Feminists talk a lot about ritual; political demonstrations are rituals. Mary Beth Edelson has clarified the relationship between private ritual (to empower and energize yourself in solitude) and public ritual (where this energy is passed on and we empower each other). The spirit of a Greenham Common, a Seneca, or a November 1 2 is contagious. It reinforces extant strengths and makes people reach out who didn't know they knew how. Collaborative art that offers people the space to believe they can be what they want to become has a similar function, and the Left in its current beleaguered state could learn a lot from its cultural workers.

III .

By the year 2020, one of every five people in the United States will be over sixty-five. This population will be predominantly female, and most of them will be single. Today women account for nearly 7 5 percent of the aged poor.

Some walked with a spring in their step, others crept by on canes. The audience cheered and wept as the procession of 1 50 white-clad women filed up cliff steps from a sunny La Jolla beach. Two weeks later, in the South Bronx, as pouring rain drenched the dismantled cars outside, another audience cheered and wept as ten women sang, danced, and flaunted their years on a stage.

Performances do elicit cheers now and then, but rarely tears. These were provoked by the dignity, courage, and high spirits of women ranging in age from sixty to one hundred. The women in white were participants in California performance artist Suzanne Lacy's *Whisper, the Waves, the Wind,* over a year in the making, which came to triumphant fruition on May 1 9 [1984]. The mostly black women in the skit *Ready for Love,* also a year-long project, were members of the Hodson Senior Center—the oldest center in the country, and perhaps in the world. It was one of three plays from different Bronx senior centers presented May 2 1 under the aegis of Elders Share the Arts (ESTA), a New York citywide program directed by Susan Perlstein.

Lacy is respected (if often misunderstood) in the high-art world, as is Perlstein in the field of social theater. Yet all the performers in their works are "amateurs," telling their own stories and feelings in their own words. This is what made both pieces so moving, but it was the "professional" frames that made it possible for the amateurs to convey their stories so

effectively. Just as performance art emerged in part as an escape from theatrical and object art conventions, so the work of ESTA and other community groups escape the conventions of Art—while still offering many of its insights. At Hodson, great moments bubbled up out of ordinary and awkward ones; in La Jolla, the surface was smoothly orchestrated, but the depths were jolting.

Whisper, the Waves, the Wind began with the white-clad women descending the cliff to become a tableau vivant when they sat at white-clothed tables on two small beaches below a natural amphitheater of cliffs. As they conversed intensely with each other, the audience above "overheard" tapes of their previous conversations on the same questions about aging, freedom, death, and the future. Rocks, surf, sea, and sky provided a backdrop that was not only scenic but symbolic. During the last half hour, the audience descended to the beaches, eavesdropped respectfully, and joined in with questions and ideas of their own. The women filed back up the cliff.

Whisper's atmosphere was at once very real and utterly dreamlike. The tableau was surrounded not only by sea and sky but by more mundane reminders of mortality. Healthy, tanned, well-dressed and undressed young bodies contrasted eerily to the voices whispering around them about death and decay: "Aging is sad, because the flesh shrivels on the wooden skeleton, and it is not so pretty." "Young people look at me and see the end of the line. This makes me angry, very angry." (An army helicopter buzzes belligerently above.) "The difference between now and when I was younger is that now I'm slower climbing mountains." "I'm not afraid of death anymore….It would be kind of nice to rest." (A Goodyear blimp lumbers by.) "I'm preparing to be content if I have to go to a nursing home." "I'd rather be dead than have to go there." "I have no family. I'm the thirteenth child and I'm here by myself. I have no alternative to a nursing home." (A formation of geese wheels above in a graceful curve.) "Your children can't face their loss so they pretend you're not going to die, and your grandchildren think you'll be around forever." "I compare myself to the rest of nature. Everything else wilts." "I feel more vocal, more politically free." "I want to live because it's so much fun to be alive, so this would be a hell of a time to *die!*"

The whole piece created an extraordinary intimacy. We saw the faces of the performers up close, one by one, as they proceeded down to the beach—women, it seemed, of *all* ages and races (more than a token number of blacks and Asians, including three Cambodian Buddhist nuns), wearing everything imaginable, from formal gowns to ethnic dress to slacks and sandals. When they settled at the tables we began to know their postures and gestures. And when we crowded around the speakers to listen to their disembodied voices, the striking visual image below almost receded into

memory because the conversations were so compelling. Each little listening group became a community in itself, smiling tearfully, giggling in recognition. Despite the noise and passersby, I was as drawn *into* this spectacle as I am in the quiet privacy of a dark theater.

The elders talked about sex, religion, self-sufficiency, families, illness, and death. Like those more often ravaged faces in the South Bronx, they were all "attractive," seen in their own context instead of isolated in ageist stereotypes. Aging women's faces—the hag, the witch, the crone—are presented as frightening (or laughed away) precisely because they show so nakedly their/our lived experience. It was awesome on both these occasions to confront the variety of ways the human body absorbs and reflects what it has undergone. The audience's tears were an admission of identification, accompanied by many emotions, among them love, guilt, pride, fear, regret, and memory. At the end, a sobbing student helper was offered comfort and he said, "It's okay. It's good for me. I never cry." A young woman rushed off to call her grandmother. The presence of absent women was almost tangible.

Lacy chose the San Diego area for *Whisper* because it is a popular retirement center. The South Bronx is not, which made the humor and high jinks of the often battered and bedraggled performers there all the more impressive. Presented along with the Hodson Center's rambunctious *Ready to Love,* directed by performance artist Sarah Safford, were the Bronx YMHA's *Excerpts from Our Lives,* a series of poignant and/or hilarious skits directed by dancer Sally Charnow, and the Bronxdale Senior Center's *The Days of the Nickel,* a loosely constructed play moving back and forth between today and the thirties, directed by Marion Stanton.

These are all life history plays. The elders (a dignified term I prefer to the blunt "old" or euphemistic "senior") concoct, write, and perform them with the support but not domination of their workshop leaders. Styles and results vary but none lacks high points. The subjects range from first job interviews (a scene that managed to be funny *and* angry about anti-Semitism), to first jobs (a riotous Edith Bunker sound-alike who thinks her plumber employer is a pervert because he makes her order screws, nipples, and ball cocks), to first babies, rush hour in a luncheonette, racism overcome at the telephone company...to sex, which the women really got off on. At one point ten performers, eight black, two white, introduced themselves, and said one way or another, "I'm ready for love," their tones ranging from hot mama to plaintive disbelief to defiant desire to a gospel-like rendition that turned the word love around.

The skit/tableau form is best suited to this kind of work (and to much performance art) in which the narrative elements come together to make a

whole, but not a linear whole. There are parallels between both Perlstein's and Lacy's work and documentary films like *The Good Fight* and *Seeing Red,* now under scrutiny (sometimes attack) for overemphasizing the "humanity" and underemphasizing the darker side of history. While I understand the issues of manipulation, whitewashing, and voyeurism, I'll risk Pollyannaism by suggesting that positive imagery and daily heroisms are in short enough supply these days. We don't need to kick every gift horse in the teeth.

The politics in all three of the Hodson plays were upfront and unself-conscious, covering racism, sexism, unemployment, poverty, and an intense dislike of the white man in the White House. The poor old days seem good in retrospect. ("We were poor then, but we didn't know it. I had a good time *having* a hard time.") Most of the performers were black (and most of the whites were Jewish); only two were men; so there was a lot of horse-play around gender-, age-, and race-switching: an elderly woman played a street kid bopping along to her ghetto-blaster; a black "man" put the make on a Jewish coquette in a turban. There was a lot of dancing and music. The singing ranged from still sweet, strong voices to husky blues to harsh but courageous tunelessness. An eccentrically dressed woman with a beatific smile played piano with such joy and finesse it was no surprise to hear she had once worked with Dizzy Gillespie, had quit under religious pressure, and rediscovered her talents at the Center. In one skit each woman gave her opinions about "Kids Today" to the delight of the teenagers in the audience. A finale by a handsome cigar-smoking West Indian woman well over six feet tall brought down the house, and was followed by reminiscences from the audience.

The real politics of these works lay in the psychological and historical connections made between past and present. Lacy and Perlstein, et al., are concerned with destroying stereotypes, altering the way elderly people perceive themselves, reducing the fear of aging, recognizing the beauty of each stage of life, while reinforcing the "resources this society shuts off in its flight from death." Perlstein's theoretical basis is Dr. Robert N. Butler's concept of "life review," as opposed to fragmented reminiscences. It combines the natural process of looking back, at the approach of death, but also involves "the resurgence of unresolved conflicts" in which visual imagery plays as large a role as verbal accounts. Along the line, life experience is transformed into symbolic material. Here indeed is a project for art. But somewhere the art has to connect to social reality. Picturesque portraits of lined faces don't contradict strongly enough the way the elderly are treated today.

Whisper and the ESTA projects differ greatly in motivation and execution. I don't want to make them sound alike except in *affect* and in the issues they

raise. Lacy's (and her assistant director Sharon Allen-Crampton's) professionalism and aesthetic vision are primarily outer-directed, as art. It's not a matter of better and worse, or art and nonart, but of context and audience. Perhaps only activist artists pledged to integrate political and aesthetic activities would see these two works in the same light. Yet both fuse subversion and empowerment; both are vehicles rather than receptacles; both processes include long-term participation, interviews, and improvisation; the politics of both evolve during collective conceptualizing that is as much part of the work as the final act. By giving people access to the creation of their own self-images, both Lacy and Perlstein integrate the functions of artist and organizer—a combination that comprises activist art. "You can't democratize the art-making process to the point where *anybody* can make high art," says Lacy, "but anybody *can* participate in the art process to the degree to which they take the risk."

Lacy is an evangelist. She wants "to enroll people in her vision." She sees performance art as "finding the form in unform, finding the shape in experience." In the course of telling their stories to each other and to other generations, the elders in *Whisper* and ESTA provide a historical overview from a rarely reported perspective, educate and entertain others, and gain respect and dignity in their "declining years." (I've always wondered exactly when these start—maybe at birth.) In *Whisper, the Waves, the Wind,* Lacy succeeds in resurrecting "an ancient communal art form, the rituals we no longer have. Women are resurrecting it because women's spirituality is in relationship." When the women in white walked toward us, it was like graduation, a ritual of passage. The light wind blew their skirts and shawls. The tide was coming in...not going out. As my mother says, old age is not for sissies.

NANCY SPERO
Bomb and Victims, 1966
GOUACHE AND INK ON PAPER, 36″ × 24″

This image is from Spero's now famous "War Series" (1966–70), made in outraged
protest against the Vietnam war. Spero has continued to combine a delicacy of
execution with brutality of content. Her scroll works often depict violence against
women, with perverse beauty and in an open, timeless space.

First Strike for Peace

It has been suggested that survival is the only modern topic, and artists seeking immortality in the nuclear age must confront the notion that there may be no posterity. In this context, art can be seen either as an escape or as a strike for peace. It is the artist's job to conceive the inconceivable, and to move us—to move us closer to realization, to empower us to imagine, even to imagine the most dreadful things. But artists are as scared as everybody else to get too close to the fires of extinction. Contemporary art is a clear reflection of how the American people fail to cope with reality. Just as images of Hiroshima or the atomic bomb rarely surfaced in the high art of the 1940s and 1950s, there is little imagery today that deals with contemporary reality—with all those issues that are integral parts of our global predicament, issues like racism, invasions in the Third World, multinational complicity in governmental corruption, the feminization of poverty, and so on and on and on.

Many women are among the artists who have found it necessary or possible to cope directly with the fear and trembling that lie beneath so much contemporary art. Whether or not you agree that survival is a "woman's issue," a glance at the last ten years of "political art" (and its subcategory, anti-nuke art) turns up more work by women than by men. Nancy Spero's protofeminist "Bomb Series" of 1966 remains a classic and courageous attempt to picture not only a potential holocaust, but its origins in imperialism, male supremacy, even religion—and to make the connections between the Vietnam war and gender issues. The "Bomb Series" consists of small works in pen and gouache and sometimes collage, on fragile rice paper, their physical delicacy belying the terrifying harshness of their imagery.

Reprinted from *Heresies,* no. 20 (1985).

Bombs, mushroom clouds, and helicopters were nightmarishly transformed into monsters, victims, lumps of shit, penises—and sometimes breasts, acknowledging women's participation in the human race and the fact that no one is absolved from responsibility. In its references to militarism and the apocalypse, the series was prophetic of the Jerry Falwell/Ronald Reagan "Armageddon" theory of the eighties in which the good guys will be "raptured out" of this world while the rest of us blow it.

Other early antiwar pieces were Lil Picard's wild Happenings about wounds and cosmetics from the late sixties (when she too was in her sixties); Carolee Schneemann's visceralized and sexualized 1967 *Division and Rubble,* with its cycles of birth and decay, creation and destruction tied into the wasteful attack on Vietnam; May Stevens's "Big Daddy" series fusing male supremacy and militarism from cops to soldiers to the KKK; and Anita Steckel's often-banned collages connecting male sexuality and brutality. But it was not until the later seventies that nuclear war in particular became a "popular" feminist subject. This came at a point in the Left/feminist art movement when self-image had given way to social image, as though a decade of self-exploration has provided the confidence to take on the world.

For some time, a major debate has raged within the Women's Liberation Movement about whether environmental, military, and all fundamental human rights are "women's issues," or whether, as Radical Feminists contend, the broadening of feminism's focus has diluted and diverted it from its primary goal—the termination of male supremacy: "If *everything* is feminist, then *nothing* is feminist."

The traditional, if romanticized, connection between women and the earth has made the environment a special concern for many women and women artists. Pacifism and antiwar work have become almost inseparable from "earthkeeping" itself (the title of *Heresies'* 1979 ecology issue), as was made supremely evident by the "Women and Life on Earth" conference on "eco-feminism" in Amherst, Mass., in March 1980. Culture was for once acknowledged as a major component of the agenda. Workshops ranged from "The Politics of Diet" to "The Ecology of Creativity" and "Art as Health and Healing." May Stevens wrote the general statement on the conference's brochure, saying in part: "Like poetry and art, women are supposed to be ineffectual in the face of the heavy stuff: governments, hardware, money, and so forth. But we helped start both the antiwar movement and the ban-the-bomb movements of the sixties....What women stand for and what art and poetry stand for are what we must preserve for any future we'd want to live in." (Stevens herself is currently embarking on a major new series on the Greenham Common Peace Camp, and the history of women in resistance.)

While women have genuinely and forcefully identified with the cause of

peace, it is still questionable whether women are *innately* more peaceful than men—a contention heavily contested within the women's movement. Cultural feminists implicitly or explicitly defend women's moral (and even biological) superiority. As Dr. Helen Caldicott puts it, "Males are particularly adept at the denial of unpleasant emotions. Perhaps it is this defense mechanism that sublimates the urge to survive and allows politicians to contemplate 'first strike capabilities' or 'limited nuclear war.'" And Dr. Lynne Jones sees hope in the "political processes emphasized by the women's movement—shared decisionmaking; non-hierarchal, leaderless groups; cooperation and non-violence"—as opposed to "the hierarchal and authoritarian systems that prevail in mixed groups."

The Radical Feminist Organizing Committee's basic position—that gender is not innate but socially constructed—disallows the premise that "women are somehow *responsible* for life on earth" because they bear children. "The equation of motherhood (nurturance) and womanhood (as part of the human species) reinforces polarization....How can women have a 'special' interest in nuclear war? A nuclear disaster would be the most equal event in the history of the world." Ellen Willis charged that the women's peace movement, by focusing on men's and women's character traits, "ignores the structural aspects of male supremacy. The claim that women are superior to men is nothing new; when men make it, it's called 'putting women on a pedestal.' Men will gladly concede our superiority so long as they get to keep their power....If the women's peace movement were seriously concerned with the imperialism of the government, it would be working to change or overthrow that government" instead of identifying with the victims of imperialism and thus escaping its inherent responsibility for it. "It amazes us," she continued, "that a woman should be asked to set aside the question of her right to control her body in favor of a campaign to preserve the human race. One's opposition to war should be based on political and personal reasons that have nothing to do with being a woman."

My own position as a socialist and cultural feminist is that women cultural workers are uniquely challenged to integrate radical social change with our concerns for women and their bodies (raped, forcibly pregnant, tortured, victimized by poverty, or on the front lines of liberation struggles). Not because we *are* women but because *as* women we bring a different experience to radical theory, conflict, and imagery—an experience that has been historically missing and/or invisible.

The women at Greenham insist that the international women's peace actions "have nothing to do with excluding men. It's got to do with, for once, *including* women." The spontaneous art woven into the barbed-wire-topped fences around the U.S. missile base continues the Women's Pentagon

Action tradition of fusing women's lives, work, arts, and politics. As such, it has been an effective participatory aesthetic. The image of 30,000 women holding hands, surrounding the nine-mile periphery of the base in 1983, is a compelling one unequaled by the strongest "high art," which of course acts in an entirely different sphere and manner. The metaphor of the web— "fragile in its parts and strong in its whole," as Marina Warner has put it— has spread as a hopeful symbol around the world, in forms as varied as a postcard chain to wish for peace; a 75,000-foot "Ribbon" around the Pentagon and other government buildings in the summer of 1985; the feminist performance group Sisters of Survival's (SOS) European tour; Donna Henes's "Chants for Peace"; Joyce Cutler Shaw's "Messages from the World" (such as "Survival" written in ice sculpture outside the UN); or Helene Aylon's "ceremonial art"—the Women's Sac Project, which collected earth near Strategic Air Command bases and put it in pictorial pillowcases ("because we don't sleep so well") displayed on clotheslines and in "dream-ins" all over the world.

Any anti-nuclear art has three basic and often contradictory mandates: to make people terrified of nuclear war, to keep people from feeling so helpless before their terror that they won't act to prevent it, and to inform—to help us all understand the roots of our terror in domestic and foreign policy, state terrorism, profiteering, and other underlying causes. There was a point in the mid-seventies when I was glad to see any picture of a mushroom cloud, but since then a developing progressive and feminist imagery has demanded more complex images. The poverty of our current symbolic vocabulary is directly linked to the fact that subject matter like nuclear war has been a taboo in the context within which aesthetic complexity is developed—i.e., the art world. In an art context, we can "like" an image without internalizing its meaning. We can take an image of war more seriously as art than as reality.

Without organizational work of some kind, and the hard-won political aesthetic analysis that comes from such work, even the most sincerely "concerned" art tends to float free of the crises that inspired it and of the audience that might be moved by it. By organizational, I don't *necessarily* mean going to a lot of meetings, but substantial aesthetic depth seems to demand at least some kind of interconnection with and mutual support among artists with similar concerns, as well as with those people organizing in the "real world"—a relationship rife with frustration as well as vitality.

Ominously, much art that purports to deplore the end of the world seems to be modeled on images of fantasy, natural disaster, or Acts of God, as though the enemies came from some occult "other world" rather than living in our own towns, our own countries. Nuclear holocaust has become a disembodied bugbear, apparently unconnected to local political issues, virtually impossible to concretize in form. It's been made abstract, and therefore

in control of those who are inaccessible to us. Like natural disaster, it is treated as something impersonal, seen by television or long distance. Artists often treat the aftermath, the day after, rather than the cause, *the day before.* The bomb comes from "above," from "heaven," producing a deadly fatalism encouraged by those who prefer to manipulate a powerless, silent populace.

There is, of course, a basic contradiction in the creation of a profound art about death. Art is a creative act; it's supposed to be committed to life. There are times when refusal to depict the wholesale death that may be awaiting us is a cowardly act; there are times when it is an act of courage, as Jonathan Schell has noted: We have to respect "all forms of refusal to accept the unnatural and horrifying prospect of a nuclear holocaust." On the other hand, with recognition comes responsibility. Just how can art be made about silence, apathy, inertia? How does a visual artist, concerned with envisioning by concrete means, confront what Schell calls "the unthinkable, but not necessarily the undoable."

Artists can't change the world alone. Neither can anybody else, alone. But art is a powerful and potentially subversive tool of consciousness. Avant-garde art is traditionally defined as oppositional, worming its way out of prescribed channels. Even the weight of the current system should not be able to extinguish totally that time-honored function. An artist's best chance to survive ethically and economically is to resist confinement to a single cultural context. Feminists have an advantage here. There is still a network (if a faltering one) or context within which feminists, like politically dissident cultural workers, can work to escape the iron fist of unstated censorship and the velvet glove of self-censorship that control the mainstream.

The mid-eighties offer a curious little pocket of air in which more or less politicized art can breathe within the art world, provided the messages are not too pointed, too angry, too close. This has facilitated an uneasy dialogue between art worlds, just as overtly feminist art was able to infiltrate the art community in the early to mid-seventies. If socially concerned art doesn't sell real well, and socially involved art doesn't sell at all, nevertheless this is a moment that should be exploited for all it's worth, not just to get more art shown, but to get more responsible and responsive artists heard and understood, and to spread the word that these taboo subjects are indeed "artworthy," so they can be taken on by a broader aesthetic and social spectrum of artists.

With Gorbachev's test ban proposal lying on Reagan's doorstep and Star Wars the most potentially disastrous art concept around, the following parable (from *The Washington Spectator*) has a moral for artists and feminists alike: A California high school class was asked by its teacher if they had hope for the future. Twenty-nine students answered "no," and one answered "yes." When asked why she had hope (I like to think it was a girl), she said, "My parents, both of them, are working hard to find an answer."

Women Confront the Bomb

On May 6 [1987], as some thirty-five hundred people gathered in Las Vegas for the Mother's Day action against nuclear testing, six young women from Boulder set out to test themselves on a more dramatic level.

Calling themselves "Pele," after a Hawaiian earth goddess of volcanoes, Donna Diamond, 22, Donna Cunningham Hickey ("Jabe"), 27, Laura Larson, 22, Naneki Scialla, 24, Trish Wilson, 28, and Paula Zoller, 25, constituted the Rocky Mountain Peace Center's first all-woman back-country team into the Nevada Test Site. Laden with forty to ninety pounds of water and gear, they were headed thirty miles into the ominously beautiful desert, to one of the many ground zeros.

Meanwhile, Clare Corcoran and Flame maintained clandestine radio contact from within the site, while Crescent (the two women go only by their first names) and Marcia Klotz handled the off-site logistics. I had been meeting with them for two weeks in Boulder, to watch them evolve from a group of like-minded activists to a closely knit team.

On Thursday, at 7 A.M., after walking for twelve hours straight toward the drill rigs of a ground zero, amid signs warning of a radiation waste dump, the six women lay down in front of a busload of workers. They displayed statements of their "affirmation of life" and their determination to do what they could to delay all nuclear tests. Their "die-in," with colorful balloons and crepe paper, stopped traffic. Nature joined in. "The sunrise lit up the flowers on the desert," Scialla recalled from a Las Vegas motel after the arrest. "Our point was to bring positive energy to the test site, and we achieved our goal."

Pele delayed what Crescent calls "this one small strand of the arms race"

Reprinted from the *Boulder [Colorado] Daily Camera*, May 17, 1987. In the late eighties I wrote features for the Boulder local paper on subjects unrelated or only peripherally related to art.

for twenty minutes before the helicopters and security forces armed with M-16s arrived to handcuff and blindfold them, taking them away to be booked on charges of trespassing. All the way, the women sang peace songs—"Down by the Riverside" and "We Who Believe in Freedom."

Pele's arrest on Thursday was the intentional climax of a long process. The decision to form a women-only team came in March. With their support group, the six trained by hiking in the mountains, orienteering, map reading, carrying heavy packs, getting used to strain and stress. They all agreed, however, that the most important part of their training was "in group process—getting to know each other, dealing with our fears and emotions."

The meetings were more or less secret. I say more or less, because their plans were announced at a Mother's Day fund raiser in Boulder on May 2, a week before they went in; and because the FBI was also privy to those plans. A week ago a polite "Mr. Contreras," who gave a local phone number, called Jim Carstensen, a former housemate of Laura Larson's, to say they had information that she might be involved in a dangerous or violent antinuclear protest. The FBI also called Larson's mother in California, who was not aware of her daughter's intentions. (Such calls are part of a pattern of FBI harassment of Central America activists, as documented by New York's Center for Constitutional Rights.)

At one of the Pele meetings, a few days before the group's departure for Nevada, the young women—all in their twenties, some still students at the University of Colorado—talked about why they had made this momentous decision, why they were willing to undertake the physical ordeal and to take their lives in their hands. They agreed that the all-woman energy was a particularly empowering factor. They all felt a fierce identification as women with "Mother Earth." They felt that they were embarking on a "healing" process, to rescue the battered earth from wounds inflicted by militarism and patriarchy.

Scialla, who is from Englewood, said, "I'm a peace walker and earth healer and I'm going to ground zero because it's time for a change. I try and work for things that are full of life. The test site is destroying Mother Earth and I think it's time to go and enlighten those folks out there and let them know they're harming themselves when they're harming Mother Earth."

Zoller, who also went on the Great Peace March, said, "I want to continue to work for peace. Doing a back-country action just fits the way I like to work. It's very direct and challenging. It's time to take a stand....It takes extremes. You need people like us—people who are willing to walk across the country or go into ground zero or spend years surrounding a missile base—for other people to feel empowered enough to write to their congressperson or the president. It's a strong and dramatic way to bear witness to what's going on."

Jabe, from Wichita, Kans., was on the Great Peace March too: "I got involved in this action because I wanted to see the test site, to see what I've been working on. One of the most powerful things we can do for follow-up is to talk to people about how it felt to be there and to see the craters made by the previous tests—the rape of the earth—and to walk the earth."

Diamond, who is from Brooklyn, New York, a senior at the University of Colorado majoring in Women's Studies with an emphasis on history, said the issues were "women, peace, environment, and freedom of the land that belongs to the Shoshone Indians." (The Shoshone have been issuing permits to the back-country infiltrators, since the land belongs to them according to an unhonored treaty; but the permits have not been legally recognized because they are not notarized.)

Larson, a CU junior majoring in anthropology and Spanish, sees the connections to her work as a Central America activist. "Our government and all the military systems of the world are waging war on people, and then on top of that to have them waging war within the earth itself is so horrific. It makes me sick to think about it. What kind of hope do we have to do anything productive if we're living with this constant threat of being annihilated at any given moment?"

And Wilson, a massage therapist, deplored the "misery and poverty on the planet caused by military economies. When I look at kids is when I really connect with how much I need to go to ground zero because I wonder if they really have a chance to live a full and happy life with the nuclear threat hanging over their heads."

Confronted by this group of nice, "average," intelligent young women in a nice, average Boulder house—their determined faces, their absurd (but on site, necessary and effective) camouflage costumes, the intimidating array of water bottles and gear, including Geiger counters and infrared goggles—I asked, "Are you scared?"

The response was a gale of laughter. "Sometimes, yeah...bombing ranges, strafing, radiation, nuclear waste, desert hiking, and Wackenhuts" (the private security forces who patrol the site). "I wasn't afraid at first," said someone else, "but the other night I had a dream about us on the site and I thought, Oh my god, this is living hell. There's all the negativity that surrounds the test site. The kind of mentality people must have to go work there day after day. It's not the radioactivity itself, but the motivation behind it...that people are so frightened of other people that they have built these things."

All of Pele nodded agreement as another woman added, "My fear of going to ground zero is no greater than the fear I live with every day, living in a world with a nuclear threat. But the fear is not paralyzing, it's a really powerful fear that's energizing, that's making us act."

All's Fair

The organizer of an exhibition is always asked how she selected the artists in it. I've put together a number of women's art and feminist art shows since 1970 and I do my best not to let them duplicate each other or overlap too much. This time around, I decided not to include *anyone* I'd ever exhibited before, as a way of opening things up for myself, as well as for others. Even so, I struggled for days over a list of some hundred artists, most of them relatively young and/or not yet broadly known. Out of the list came the theme and out of the theme came the final list.

The artists in "All's Fair" range in age from thirties to seventies; they live in Georgia, New Mexico, Minnesota, California, Kansas, Illinois, and New York; three work collaboratively; and seven are women of color. Their styles and media range from figuration to abstraction, oil paint and stone to artists' books, postcards, installation, performance, photography, neon, rope, and Xerox.

So much for the statistics. The range of style and content should make clear, yet again, the fact that feminist art is not a monolith, nor a temporary "movement" to be swept away when its market potential is exhausted, but a way of life, a state of mind, a political commitment to other women.

The feminist credo "The personal is political" has been somewhat run into the ground by now, though it remains as true as it ever was. At this time, it's also particularly important to make the point that "the political is personal." In the late 1970s a lot of progressive artists began to look more carefully at the ways in which our lives, our relationships to other people, to our work, to our dreams and nightmares, to our aesthetic and psychic developments are

Reprinted from *All's Fair: Love and War in New Feminist Art* (Columbus: Hoyt L. Sherman Gallery, Fine Art, Ohio State University, 1983).

affected by the history taking place around us. The frankly self-centered bias of early feminist autobiographical art was an absolute necessity for that stage of consciousness. Today many feminist artists are looking outwards—without forgetting their roots in self and locality. In the process (and feminist art always seems to be about process and change on one level or another), it became obvious that one of the unique elements of feminist art is the fact that it can't be severed from the social structures that engendered and maintain it, however diverse the individual's levels of activism.

The political climate affects the art world indirectly. Most artists do not think about the world in relation to their art. In fact there is something of a taboo against dealing with reality (as opposed to realism) in any direct way. Yet there is no question that love and war are prime subjects in this age of violence, fear, confused sexuality, and homogenized internationalism. Alienation and anxiety are the driving forces behind much current art-making, as behind much of life and social interaction today. The reintroduction of expressionism in this particular historical moment clearly relates to the political repression of the Reagan era. (Expressionism last flourished in the 1950s, and before that in the last depression/edge of wartime—the 1930s.) Between the malicious neglect of people's basic rights and comforts and the U.S.'s expanding militarism, desperation leads artists—even artists— to look *out,* to express that which would otherwise be repressed or suppressed, smothered under the blanket of corporate (or the misnamed "mass") culture.

For me the best feminist art is expressionist—regardless of its styles—in its need to reach out. This need can be reflected in the imagery of a painting, photograph, or sculpture in a gallery or in the structures and strategies chosen to reach broader audiences outside the art institutions. An artist's feminism can surface in her work in any number of ways, some of which may be more evident to her than to her audience. In the case of many women of color and socialists, feminism has grown within the context of racial or political work and is often inseparable from or absorbed by these contexts. Some of the artists in this show may not often call themselves feminists; some no doubt subscribe to the notion that art is genderless but acknowledge that artists are not, and fight for women artists' equality. However, most have participated consistently in feminist groups or manifestations, ranging from the full commitment of the Los Angeles Woman's Building, *Heresies* magazine, or women's collectives and co-op galleries to a more occasional support stance. It would be peculiar to find a feminist making art that admits to *no* feminist components, since both art and feminism come by definition from *inside*—from one's value system, socioeconomic background, and emotional responses.

Feminist art can only be described in general terms, as an art that concerns itself in varying degrees with combatting, extending, and transforming society's views of women and "women's issues"—among which love and war have to figure high on the list. The subjects covered in "All's Fair" include capital punishment, militarism, nuclear war, abortion and sterilization, sexual harassment, ecology, humor, racism, marriage, sex, motherhood, Third-World history, and the media. Love and war underly all these subjects, subtly in some cases, militantly among others. Perhaps the connecting thread in all this diversity, between these artists from such

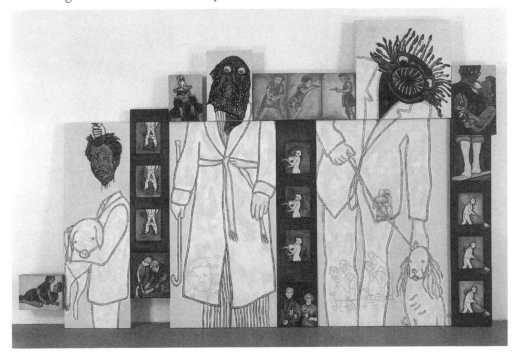

IDA APPLEBROOG
Shirley Temple Went to France, 1993
OIL ON CANVAS, 106″ × 170″
Photo: Dennis Cowley, courtesy Ronald Feldman Fine Arts Inc., New York.

Applebroog's imagery incorporates any number of feminist (and in this case, antiracist) comments, like phrases in a paragraph that each viewer will put together in different sequences and meanings. Her all too human figures perform acts that are ludicrous, embarrassing, humiliating, hilarious, horrifying, touching. They can contradict each other (a man vacuums, a woman carries a man on her back across a stream; a girl aims a gun, a naked woman plays the violin) or they can complement each other (the girl with the gun, a boy drops his pants; the woman carrying the man, a couple making love with the woman on top). Large figures are shadowed by subtexts. The three dark heads of victim, avenger, and monstrous caricature loom over the whole tale, accompanied by incongruous animal avatars.

different ages, places, and histories, is an element of passion, or a passion-
ately participatory attitude toward life and social issues.

Ida Applebroog's book/performances and the wall works that come out
of them epitomize the ambivalence of the love/war theme, the rueful, wist-
ful, ironic, often violent and would-be distanced ways we tend to live our
lives. Buried in the gentle humor of her deceptively simple vignettes are
biting critiques of the needs and greeds of capitalism and how they affect
women's personal lives. Without benefit of "refined" line or "expressive"
form, her almost clumsy, almost cartoon figures convey an amazing
poignancy. When we laugh at her *So?*, it hurts.

Irene Siegel approaches the gender gap more precipitously. In *Rome,* a
nude couple go at each other while staring out at the viewer as though
posing for a portrait in the midst of ritual battle (or is it a caress?). In *The
Green Fuse,* painted the same year, a similar division places a similar content
within the abstract frame—a line from a Dylan Thomas poem about life,
energy, generation.

Carole Fisher, a founder of WARM Gallery in Minneapolis, says her art
often comes from recognizing impulses from other women. She has long
worked in installation format. In her "Reactor Series" she uses bold red
silhouettes of active women opposed to passively outlined dolls or "little
girl" drawings, with real chairs reacting to this battle on the image field.

Barbara Kruger manipulates the blasting graphics we associate with the
mass media to ask her audience direct questions, or indirectly to tell the
world what she thinks. Actually, the bold captions slashing across enlarged
black-and-white photos are far more dynamic than conventional advertise-
ments; the conflict inherent in our public and personal interactions is
reflected by Kruger's form, which in the end also exposes the lethal bland-
ness of so-called popular culture.

Mary-Linn Hughes's series of mailing booklets about sexual harassment
in university classes and workplaces is incongruously elegant for such agita-
tional artwork. Combining stark personal stories with shiny paper, pink
photos, and headline-patterned envelopes, she raises consciousness about the
hidden problems of academic coercion and silence, about power and author-
ity relationships ranging from rape to dirty jokes. Her message: "Think
about sexual harassment not as an individual problem but as a social prob-
lem. Ask yourself how things change."

Elizabeth Layton's extraordinary color pencil drawings—begun when the
artist was around 70—stemmed from a desperation that demanded a drastic
solution; luckily, she chose a creative one—to begin making art. Her *Death
of a Son* provides an image so unfamiliar to our ageist and prurient society
that it will probably shock. Layton shows herself as an old woman nursing a

baby at her shrunken breast, while tears stream down her face and her husband's hand appears over her shoulder, offering a hankie. In other works Layton decries capital punishment, comments on the commercialization of American holidays (in a picture of herself and her granddaughter feasting on Colonel Sanders for Thanksgiving), and restores missing head and arms to the *Winged Victory* in a decidedly feminist gesture of rehabilitation. Layton's obsessively filled space and tense but tentative line reinforce the pain, anger, and compassion of her subjects.

Kazuko's string and rope installation sculptures have evolved over the years from structural abstraction to more idiosyncratic webs with interwoven objects, resembling natural nests and thickets. Sometimes doll-like figures are captured (or cuddled) in the skeins—an aspect introduced in her work around the time she had a baby. Motherhood, though not her own, is the more direct subject of Nancy Linn's photographs, made weekly at a well-baby clinic in a New York City hospital, in order to provide very young mothers with positive images of their maternity and their children. When Linn enlarges these color "snapshots," they intensify; "ordinary" people are made into extraordinary presences that combat clichés about mother-and-child pictures by women, as well as the derogatory image of teenage mothers.

Nan Becker and Carnival Knowledge both deal with the other side of the coin—reproductive rights. Their lively and informative work responds to threats by reactionary groups on the subject of abortion and the various "human life" legislations offered by the immoral minority. Becker's emblematic black-and-white wall pieces, warmed by red neon, resist eugenics and white supremacy, detailing in alternate English and Spanish the governmental, corporate, and medically sponsored programs aimed primarily at Hispanic women and women on welfare. Carnival Knowledge (originally founded by Anne Pitrone and Lyn Hughes, but now a large collective) is a whole exhibition in itself—an indoor/outdoor bazaar of booths, games, and displays. The group has performed on beaches, in schools, and (uninvited) at the Right-to-Life convention. With wit and color and below-the-belt hilarity, they expose right-wing propaganda while painlessly informing the public about birth control, sexual rights, population abuse, women's health, and the family.

Christy Rupp is known for her "City Wildlife" projects, which have included storefront exhibits in the South Bronx, on 42nd Street, and on the Lower East Side. Her interest in urban ecology and her desire "to inform the general public about the habits and behavior of our co-inhabitants" (like dogs, rats, or roaches) grew from her anxieties about environmental issues, consumerism, and commodity exchange structures. She comments on these

complex issues with sculptures and reliefs of animals in paint, papier mâché, and cardboard, which are simultaneously whimsical and critical.

Both the love and the war in Jaune Quick-to-See Smith's art emerge from her place between two cultures, her insistence not on the Native American past, but upon the primal flow of past, present, and future epitomized by passage through the Western landscapes in which she has lived. Member of nomadic tribes, daughter of a traveling horse trader, Quick-to-See Smith reconciles her double heritage of pictographic symbols and modernist space with bittersweet color and freedom from stylization.

Sabra Moore's large color-Xeroxed and painted collages and books also weave past and present into panoramas of local, class, and personal history. A recent series focuses on the lives of her grandmother and her aunt—farmwomen from Texas, where she was raised. Garish color is balanced by tenderness of detail and execution, and by Moore's deep feelings for the quilting tradition of which her work is a modern counterpart. History and landscape might be the subject too of Beverly Buchanan's sculpture—cast slabs, markers, and sculptural support systems. The personal experience and ritual component of these abstractions is somehow apparent in the rounded edges, and dented and scarred surfaces reflecting nature—used, abused, enduring.

Tomie Arai's richly colored and textured paintings on paper are also metaphors for survival. As a muralist, she pictured the histories of women from a broad variety of ethnic backgrounds who have lived on the Lower East Side of New York. In her more recent work, eschewing stereotypes, she draws masks, emblematic self-portraits, and anti-nuke images in a style that merges social and personal viewpoints, while never abandoning the decorative power of her ritual sources.

Linda Nishio, a product of Los Angeles's powerful women's community, deals in a very different way with the inaudibility and invisibility of people of color in America, especially concerning the Asian experience in the West. Working with a shifting, poetic vocabulary in various media—artists' books, phototexts, and slide-film performances—she offers a layered and sophisticated portrait of what it's like to be on the other side of the window, or the door.

Janet Henry's miniature tableaux encased in plastic may look like toys, but they are acute commentaries on how the world and the art world runs, reflecting her own "bitter" feelings of exclusion as a woman or a black woman and her own "sweet" feelings about acceptance as a woman or an artist. "My work is about my life and what I've seen and experienced," Henry says. "I'm a yenta."

Judy Baca's history of California from a Third World perspective is upfront, outfront, and visible on a grand scale. Working with Chicano,

black, and white youth, and with local artists, under the aegis of the Social and Public Art Resource Center in Venice, California, Baca is the supervisor and prime designer of the longest mural in the world—the Great Wall of Los Angeles—half a mile of boldly imaginative realism showing the injustices, outrages, triumphs, and resistance to oppression of the native population, of Mexican Americans in the zoot-suit riots, the internment of the Japanese, and other usually disregarded historical events. This summer the mural will move into the 1950s.

Ilona Granet makes her living as a sign painter and is best known as a phrenetically outspoken social performance artist. Her giant geometric cutouts of military villains are super-graphic; they loom like Cubist costumes reincarnated as deadpan punks. The Sisters of Survival are a five-woman transcontinental performance group that emerged from the Los Angeles Woman's Building: "In performance, we found an art without the tradition of painting or sculpture, without the traditions governed by men. The shoe fit and so, like Cinderella, we ran with it." They see art as an organizing tool, a way for artists and activists to collaborate—in their case, on making "an SOS to alert the citizens of the world to the nuclear threat and to urge all to join in the action towards peace." They dress as nuns in multicolored habits to symbolize sisterhood and diversity, and perform in public places with a pop flair for catching the eye and the mind.

There is only an open end to this introduction. It would be hypocritical to give it a happy ending and cynical to give it a disastrous one, as feminist art continues to evolve and to change amidst the loves and wars of everyday life....

The Politically Passionate

We North Americans are insatiable in our desire to know ourselves—all our little ups and downs. Given our national indifference to politics, we seem to experience power relationships primarily in personal/sexual terms. Carnival Knowledge's show at Franklin Furnace last month was a case in point. Carnival Knowledge (CK) is a young feminist artists' collective that began in 1981, concentrating on reproductive rights. It has organized irreverently effective street bazaars, peep shows ("See Reagan's Best Performance"), beach events, cabaret acts, and protests at right-to-life conventions. In its last project, it has taken on (and taken off on) no less than sex itself. "The Second Coming" was an exhibition and month-long performance series that included real-life porn stars, mud wrestling, artworks, and other attractions. It was intended "to confront the distortions of pornography and revitalize our erotic perspectives by creating a feminist 'porn.'"

The women's movement has drastically altered the way we look at erotic art. I just looked back at an essay on the subject I wrote in 1967 and found that I had entirely disregarded gender, interpersonal, or power relations. Yet the art itself seems to have changed little since the First Coming.

The more than a hundred objects in the "Second Coming" show depended on the same ingredients of fluffy and fuzzy, rough and smooth, bulbous and visceral rhythms, humor, parody, and just plain illustration. My few climactic moments came with some of the books and some of the performances, the art objects definitely coming in second.

An evening at the Furnace cosponsored by PADD and CK on January 8 [1984] consisted of a forum and two very different performances. The first was "Tapping and Talking Dirty" by Jane Goldberg (a warm, voluptuous sort of sexy, mature woman in red bikini underwear and see-through

Reprinted from the *Village Voice*, Feb. 21, 1984.

clothes) and Sarah Safford (a skinny, sassy "little girl" in miniskirt, unshaved legs, East Village sox, and old lady's drawers), simultaneously tap-danced and wittily ad-libbed. In an endearing borderline-embarrassing intimacy they chatted about going down and being gone down on, swallowing sperm, and their diverse sexual criteria.

Their act was followed by Diana Moonmade, a professional in the sex industry, doing her "sax dance"—"Limbic Love"—a heavy-breathing and

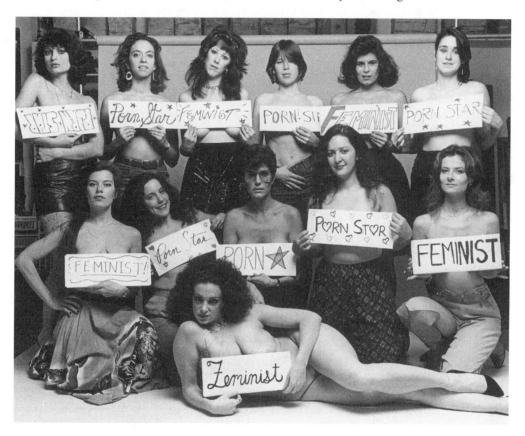

CARNIVAL KNOWLEDGE
Feminists and Porn Stars, 1984
Photo: Donna Ann McAdams.

sometimes talking duet with a decidedly phallic saxophone (which she later said she saw as "vaginal"). She started out in a satin gown and ended up in a G-string. While Goldberg and Safford were performing about sex, Moonmade was performing sex. However, she did so with such hot and cool natural confidence that the mixed audience seemed perfectly relaxed, as

though a reassuring level of dignity passed from her to the viewers, even when she was literally rubbing them the wrong/right way.

The discussion after the performances offered a frame for Carnival Knowledge's propositions. Because I can't cover this seductive subject in brief, here are some excerpts: A woman artist objected to the use of the title pornography, suggesting that it had been used to attract a male audience. Anne Pitrone of CK replied that, among other reasons, the collective had seen erotica as "classy" and preferred porn as "down and dirty." Another woman said porn has a function (arousal) while erotica is indirectly about sex. Another said porn is used to deny real erotica, as in small towns "where *Moby Dick* is banned because it has the word *dick* in it." A man said, "Porn's the right word because it's the front lines; erotic merely means exotic." Another man said the show wasn't lusty enough for him and another said it lacked the risk-taking found in *Heresies'* pioneering "Sex Issue."

The issue of violence in porn inevitably came up and the question of violence *against* porn was raised by two professionals, one female, one a gay male. A woman said that though she was aroused by some of the work, she still felt fear *for* the women in the stories. The element of danger and the ratio between vulnerability and power was approached with mixed feelings. The CK collective acknowledged that both they and Women Against Pornography (WAP) were trying to gain power over porn, but there are moral contradictions on both sides and in the discussion WAP was characterized by people in the audience as "hostile and condescending" and "misogynous," reflecting the schism that surfaced at the notorious Barnard Conference on Women's Sexuality in 1982.

Both in the show itself and in the discussion, the area of power, titillation, and passive aggression proved elusive. Nicky Lindeman's sculpture epitomized one aspect—a seesaw with a male figure asleep at one end and a woman at the other end and the word "control" spelled out in contraceptive pills between them. It offered a depressing view of gender relations in the era of sexual "liberation." There were not as many male nudes as I'd expected. (This was the major source of sexual censorship during the 1970s and is still the target of those who don't bat an eyelash at female nudity.) Men talked about the powers women hold (and withhold), reflected in the precarious "superiority" of a stripper whose audience is not allowed to touch and in the "she's-asking-for-it" element of same.

Much of the art used words and was meant to be satirical, I think. But as someone pointed out, porn is not satiric; it takes itself seriously. And too often the impoverished language reflected the dominant culture of mainstream porn, resulting in more tedium than turn-on. There was a plethora of standard "moaning and writhing, she put hers into his and felt his moving

into hers…" and lethal descriptive passages in which limbs and organs twist and bend to reach unimaginable contortions. Sometimes I felt (to my surprise) a slight twinge, so conditioned are we to accept this mechanical technology of touch as exciting. At other times there were more sympathetic variations, as in (I'm paraphrasing) "I like to be fucked by a hard cock and know I was the one who made it that way."

What was good for me too, thanks, were Sharon Jaddis's cock-and-cunt architecture and Mark Tomlinson's paper-bag goddess, Alyson Pou's chair with stones under a gauzy canopy, and Hera's giant concentric *Sweet Skirt;* Laura Foreman's silly *Ken and Barbie Entertain Friends* (guess how), a lovely oil painting of pending ecstasy in landscape by Anina Malkova, and Vernita Nemec's redressing of a feminist cliché—a messy dressing table given a history with an audiotape about Nemec's mother discovering her innocently dirty drawings when she was a teenager. It had the honesty of reality, where many works in the show, no matter how humorous and/or well-intentioned, seemed products of limited imaginations, or rather the products of our obscene but unerotic corporate culture.

What was lacking in so much of the work was precisely the element of intimacy considered a prerequisite for women's sexuality in some feminist circles. Ame Gilbert, whose narrative living room also came across, said in the forum she felt that women far more than men needed a *context* for their sexuality, needed to know the story. Who are these people? What do they *feel?* Is she happy? A lot of this has to do with personal taste. (I'm reminded of the sexist but sympathetic joke about a woman who is told that women take everything personally, and replies, "*I* don't.") Since my own taste runs to affectionate talk and passionate argument as foreplay, I found the books in the show more exciting than the objects, both aesthetically and otherwise. Artists' books as a genre are intimate, existing, like sex and performance, in time, allowing multiple views and rhythms.

The books ranged from academic to dumb to clever to lyrical (Cecilia Vicuña's poetry, presented on "Latin Night" with slides of very explicit pre-Columbian "porn"); to hilarious (Jane Dickson's *Hey, Honey, Wanna Lift?* addressed to a man, dedicated "to Mom," and Birke McGilly's *The Secret Life of the Saints)*; to earnest (Karen Gilbert's *Mama, Take My Diaper Off, There's Something Good Inside,* about a mother's confrontation with infant sexuality); to visually witty (Sandy de Sando and Sharon Demarest's velvety Xeroxes and Rebecca Michael's *The Courtship Patterns of Chairs)*; from individual confessions to many-voiced ones (Sabra Moore's anthology, *Making—Making Sex, Making Art, Making Baby)* to classics by Lynda Barry, Carolee Schneemann, Ida Applebroog.

The one book I was shocked (or at least amazed) by was Annie Sprinkle's

interminable paean to peeing. She also exhibited a wall piece, a photo collage of images from a wholesome All-American girlhood framing an inner life of S and M and other options. A similar juxtaposition was at the soft/hard core of a film that almost ingenuously cut from luscious colored porn shots to the protagonist in her pretty sunny kitchen making a big breakfast and explaining how she had to leave her small-town home "to become who she was." I didn't see the performance night—"Deep Inside Porn Stars"—but I was taken by a line describing one of the professionals in the flier: "Gloria enjoys the distinction of being infamous for not only what goes into her mouth, but what comes out as well!"

The Carnival Knowledge collective was consciously balancing what has been seen as an emphasis on lesbianism in the feminist sexuality dialogue during the seventies. Yet for all the determinedly hetero bias, the fantasies of many straight women seem to be about making love with women. Group sex was another major focus. I for one much enjoyed the puppet perfor- mance by Practical Cats (Alice Eve Cohen and Ellen Maddow), based on Anaïs Nin's erotic writings. The juxtaposition of the lifesize puppets' awkwardness and the text's elegance made for a sort of Brechtian sexiness. And parody hit a high the same night in Sarah Safford's big dummy stripper on stilts.

If this show offered a pretty good indication of what's considered sexy in our society, we're stuck with a lot of clichés not of our own making. Femi- nists and nonfeminists alike seem to be having trouble escaping from a web of unimaginative male (and maybe female) fantasies that lack the richness and depth of the sexual relationships we all think we're looking for. Maybe I'm being too hard on the CK artists (so to speak). I'm not sure porn can be reclaimed or whether feminist porn deserves or even desires the name. Still, the show was a gutsy attempt to open the closets and the dialogue. We've got a long way to go, baby. But, oooohhh, don't stop now.

Rape: Show and Tell

When a stranger followed Deanie Pass up the stairs to her apartment, she turned and, "like a good little girl," asked him, "Can I help you?" At knife-point, he forced her inside, bound, blindfolded, and raped her.

After ten years of silence (the taboos against rape victims are almost stronger than those against rapists), Pass began to make art as a way of exorcising the experience—art about rape and the dangers of being a good little girl in a society where violence against women is taken for granted. Her colorful, quasi-cute, multimedia installation—*A Piece of Cake*— is part of a traveling exhibition called simply and devastatingly "Rape," initiated by Stephanie Blackwood at Ohio State University.

In each city, the organizers work with local anti-rape groups to make the show a centerpiece for public consciousness raising. At the University of Akron art gallery, where I saw "Rape," there was a whole month of events, cosponsored by the YWCA Rape Crisis Center, including a symposium with several of the artists. It was an immensely moving day. Five artists, several rape survivors themselves, spoke about their work. They spoke with ferocity and intelligence about the most complex emotional issues, detailing the ways rape had affected their view of the world. While their presence undeniably amplified the art, most of the sixteen major works stood up well on their own, a fact confirmed by a local rape activist who said that women referred to specific works in the show as a means to discuss the issues and their own experiences.

The show embraces a great range of style and intensity, from the didactic phototext to abstract sculpture, from passionate realism to deadly irony.

Reprinted from *In These Times*, Dec. 10–16, 1986.

Amazingly few works are overtly bitter or violent, though fear, anger, and guilt clearly lie beneath their surfaces. The emotional content comes at the viewer from many unexpected angles, from the aggressive humor of Pass's plays on "piece" (a gun, a woman, an artwork) to the show's most outraged

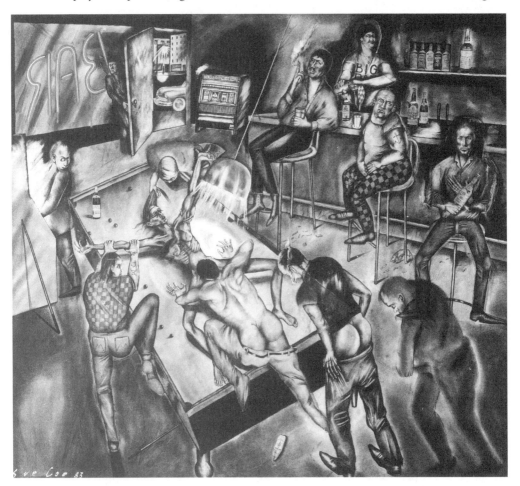

SUE COE
Bedford Rape, 1983
MIXED MEDIA ON PAPER, 40″ × 50″
Photo: courtesy Galerie St. Etienne, New York. Copyright 1983 Sue Coe.

Another painting in this series is titled with the headline: *Women Walks into Bar—Is Raped by 4 Men While 20 Watch.* That was exactly what happened in Bedford, Massachusetts. Coe's work is far more widely distributed than that of most artists, appearing in magazines and newspapers internationally because she crosses the line between "fine art" and "illustration." This is relatively amazing, since she pulls no punches and her subject matter is always on the radical front lines, from feminist and antiracist issues to animal rights and AIDS.

work, which is, stereotypically, by the one male participant—Paul Marcus's expressionistically emphatic night scene in which the black victim is sprawled on a city roof while a figure watches from a distant window and the full moon mourns.

At the opposite end of the spectrum, though no less deeply felt, is Susan Zurcher's "...*found bound*..."—a sculpture of three bound tree limbs accompanied by a photograph of two limbs bound to the body of a fully dressed standing woman seen from the back. Symposium participants felt this was particularly effective because it was open to several interpretations: woman and nature (the artist as the "third limb" of the tree), an ecological statement, or a poetic reflection of social bondage.

Sometimes the emotion simmers beneath a pragmatic realism (like Pat Ralph's beautifully executed *Incident at Snake River)* or within near-abstraction (as in Nancy Spero's delicately excruciating *Torture of Women*). The sickening brutality of Paulette Nenner's image of a woman gagged by a missile thrust deep into her throat is mitigated by a superimposed map that transforms her into an allegory for the rape of Central America. A doubly tragic image is Ana Mendieta's 1973 performance, made when she was a student at the University of Iowa protesting a campus rape. The audience, unwarned, came upon evidence of rape and/or the artist's own blood-painted body—a terrible prediction of Mendieta's death twelve years later. The exhibition and Arlene Raven's catalog text are dedicated to her memory.

"But you wouldn't want to hang this in your house!" "Art is supposed to be beautiful. Why show violence and ugliness?" These are common public responses to art that does not provide a fig leaf for society. And they are not stupid questions. Like images of nukes, South Africa, Agent Orange, or homelessness, this is *public* art. It does not belong only in people's living rooms (or in people's closets) but in people's museums, women's centers, and universities.

It has to be a public art because these works are the true "silent screams." Silence is a pervasive theme. In Ida Applebroog's *Mercy Hospital*—a two-panel painting of windows behind which a woman stares out, hugging her chest, and a woman lies in bed as a "doctor" feels her breasts—silence is the rhythmic medium as well as the subject. As Helen Mangelsdorf pointed out, "People kept interrupting me to say how upset they were by my story, but nobody, not even my parents, really wanted to hear my story."

One of the most popular works with general audiences is Anne Gerckens's grayed collage of many women's Xeroxed faces, inscribed "Shh, Don't Talk About It." It evokes the humiliation to which rape victims are subjected by a society that is still washing its hands of their blood stains. The

metaphor surfaces in Gerckens's account of the role of time and process in her art: "I started attacking the paper, then covering it up. I continued this sporadically over several years....The dyes that I used as blood on the very first layer kept bleeding through....I would paint the whole thing with gesso and for a while it would be white. Then some months later I'd take it out and there the blood would be."

When the artists were asked to talk about their work at the symposium, Lynette Molnar, from Columbus, Ohio, spoke instead about being a feminist student in the Ohio State photography department, being subjected to professors who extolled abusive and sadistic photographs by Helmut Newton and Les Krims. Sometimes, she said, as she sat in class confronting these fundamentally pornographic images, her Woman Against Rape beeper would call her away to a hospital, police station, or courtroom where she would hear the testimony of women subjected to the same atrocities pictured by such "classy," "respected" "artists"—men who publish simultaneously in the high-art and soft-core press, from *Harpers Bazaar* to *Hustler*. One of Les Krims's photographs, for instance, imitates the notorious *Hustler* cover where a woman is put through a meat grinder; his version has the model (he uses his students) putting her breast in the grinder while a dog waits expectantly.

"We're asking people to question their attitudes," says Molnar. Her own impressive series of color photos with statements by women about the way pornography affects their lives is calm and informative. Yet she has been told that this art, too, is erotic.

Such confusion about sexual violence is endemic. A couple of years ago, Barbara Jo Revelle's poster quoting street interviews with men about how they look at women was censored by the Chicago Transit Authority... because it insulted women! Jerri Allyn's piece in the "Rape" show would no doubt get a similar reception. *Raw Meet* is an audiotape performance—a rapid-fire, harrowing, and hilarious succession of real-life stories about what men say to and about women, based on Allyn's years of waitressing. ("I say, 'These peppers are hot.' They say, 'Just like you. You wanna go home and ball?'")

The collective nature of the exhibition, as it spreads its tentacles into the various communities where it is shown, is reflected in the works. Sharing the pain and rage is part of the exorcism process. Organizer Marty Schmidt collaborated long-distance with artist Leela Ramotar.

Ann Fessler's *Rape: A Crime Report* is changed in each city to reflect local conditions and statistics. Adapted from the original two-room installation in Washington, D.C., it provides "facts" that disprove "myths" about rape, interspersed with narrative fragments like "She burned the sheets." The

words are printed or projected in solemn black type on white organdy banners, arranged so that you must turn, turn again, move through this gentle maze, bombarded by grim reminders from your own "home" town.

Mangelsdorf's *Rape Group: Cheryl, Mia, Rose, Kate, Bobbie, Debby, Barbara, Helen* consists of portraits of the women in her support group. Each painting is personalized, in collaboration with the subject, by the addition of objects and images symbolizing her own rape experience: a book on feminism carried home from school, glasses smashed in the street, a knifed Tampax, a newspaper clipping, a rosary with a razor blade.

Like Deanie Pass, Mangelsdorf waited ten years before she could make art about her abduction, torture, and rape by three men in Yellow Springs, Ohio. Joining a support group finally gave her the courage and "profoundly changed" her life: "Sitting and listening to each woman's story was horrible and painfully difficult. But no matter how brutal an individual's experience, she always thought that her experience was not as terrible as someone else's....We began to experience almost euphoria in having at last found, through accepting one another's suffering, the words for our own pain."

Even as they speak, these women are taking physical as well as emotional risks. A Chicago rapist tracked down all the subjects of a magazine story on successful women. Rape is generally agreed to have little to do with sex (the "she-was-asking-for-it" syndrome) and everything to do with power and control. During the symposium in Akron, a woman turned and asked the rest of the audience, "Have you raped?" A rhetorical question, answered by a stunned silence. Someone else commented that the presence of so many men in the room was a hopeful sign. And a teacher quoted a male student who told her everyone should see the show because, "Before, I didn't understand what rape is."

Feminist art is particularly effective in this area. It often functions as an educating, healing, and empowering process for both makers and viewers. In this case, they're often the same people. One in every three women has been raped. This is why artworks like these must be made public. Blending rage, compassion, analysis, and tenderness, such art, in all its dreadful intimacy, offers not images of terror but images of strength in the face of terror.

Equal Parts

For feminists my age, the reappearance of the abortion issue as a priority is depressing, to say the least. But it has resurfaced in a context very unlike that of twenty years ago. Abortion is now part of a powerful package that includes a resurrected awareness of sexual harassment, its connection to rape, and, in the art domain, a long-standing and sometimes tedious obsession with gender representation. An extraordinary number of exhibitions in the last few years have included the word "body" in their titles—"Body Politic(s)" being an old favorite.

This too is something of a rerun (more sophisticated, less politically passionate) of the early 1970s. There are still a lot of well-meaning women artists who are convinced that the mere image of female body parts (provocative or otherwise) artfully arranged or juxtaposed with a few descriptive words (ambiguous, didactic, or epithetical) constitutes a stinging criticism of a society that takes their exposure for granted. We went through this in the early 1980s as well; there was much discussion about whether in fact the punk/new-wave use of insulting images of women to attack such insults were read that differently than when they were used by men/institutions in business as usual.

Context was—as it always is—crucial. In a feminist exhibition everybody knows that a split beaver means outrage. In street posters or even museum shows, images intended to inflame the public against the degradation of women often have the opposite effect. The would-be homeopathic method can turn against itself. Ongoing censorship by the state and by cowardly private institutions of avant-garde art about sexuality, sparked by religious

Reprinted from *Z Magazine*, Oct. 1992.

right crusades, is partly a product of avant-garde disregard for the way our efforts read outside the rarefied air of the art library. Sometimes we seem to be Asking For It. OK, so censorship is always bad, and this sounds like "blame the victim." But if victims don't analyze how they get tied to the stake they can't develop strategies for a stakeless future.

(Last year, the Public Art Fund installed a Guerrilla Girls billboard in New York that deftly killed two birds with one slogan. It showed Mona Lisa with her famous smile gagged by a fig leaf: "First they want to take away a woman's right to choose. Now they're censoring art." It appeared on a double billboard and someone with tongue in cheek chose its placement— next to a Toyota ad headlined "Not All Parts Are Equal.")

Actually some very effective activist art has been made from the point of view of the victim; for example, Suzanne Lacy's and Leslie Labowitz's classic *In Mourning and in Rage* (1977), about sensationalist media coverage of the Hillside Strangler in Los Angeles, and a number of other pieces on violence against women hatched in or near the late lamented Woman's Building. This past February, a San Diego team (Deborah Small, Elizabeth Sisco, Carla Kirkwood, Scott Kessler, and Louis Hock) mounted a bill-board/exhibition/performance/panel discussion sequence called "NHI" (police slang for "no humans involved"—an "in-house rhetorical discounting of crimes against individuals from marginalized sectors of our society") to call attention to the fact that at least forty-eight women designated as prostitutes, addicts, or transients have been sexually assaulted and brutally murdered in San Diego since 1985. Investigations have been low-priority because of the NHI status. The artists' response is "MWI—Many Women Involved."

Such works help to jolt women out of the political lethargy produced by fear and self-pity, offering the possibility of fighting back rather than simply bemoaning the fact that we are so vulnerable. As the bureaucratic hurdles mount between women and safe, legal abortion, more art like this is needed to focus in unexpected ways on the fact that half the population may be about to lose a constitutional right. Already some 20 percent of those who want abortions can't get them, according to the ACLU, especially poor women, rural women, teenagers, and women in the military.

Operation Rescue (OR) repulsively flaunts a real (dead) fetus, takes on Buffalo, and is being turned back by a militant pro-choice movement that has grown proportionately as *Roe v. Wade* gets closer to the gallows. (The wan and/or twisted faces of the women in Operation Rescue—now *there* are some victims who would gain from analysis of their situation.)

I've been wondering for a decade now why so few women artists have concentrated on the abortion issue. I remember discussions about this too

from the past. Why, we asked ourselves in the late 1970s and early 1980s, are we hung up on the coat-hanger symbol while they sport the far more dramatic, pathetic (and unethical) fetus? Since then there have been occasional group and benefit shows, and some demonstration art. (Real Art Ways in Hartford just did a big show on abortion, and RepoHistory has one coming up at Artists Space in New York.) But no new icons have emerged. The fetus still reigns. We have to get the little bugger on our side, transform its unborn bathos into the misery of the unwanted child as well as the horrors of the exploited woman's body.

(In 1989 the Chicago-based feminist collective SisterSerpents co-opted the fetus image with a shocking poster that read: "For all you folks who consider a fetus more valuable than a woman: have a fetus cook for you...clean house for you...bear your ego offspring; cry on a fetal shoulder, fuck a fetus; jerk off to pictures of naked fetuses; try to get a fetus to work for minimum wage...")

Many feminist artists have made one or a few pieces on the subject of abortion over the years. Sometimes they are powerful art, as in the work of Ida Applebroog or Nancy Spero, or Ilona Granet's flowery pseudo-billboard reading "A Womb Of My Own, Womb Sweet Womb," and featuring the "state womb"—an egg-enclosed female pregnant with the U.S. Capitol. Mostly they tend to be either very personal and/or ironic to the point of hermeticism, or expressionistically reactive. Sometimes they serve as catharsis, sometimes they are emotionally effective, but they are usually isolated artworks within a larger oeuvre. Very few artists have given over their production to imaginative, in-depth examination of this issue.

Prime among them are the collaborative team called Kerr + Malley. For three or four years now, inspired by an Operation Rescue sortie into Los Angeles, Suzi Kerr and Dianne Malley have made hard-hitting installations in which striking design and imagery carry unfamiliar facts and historical information. *Heretical Bodies* of 1989 juxtaposed Operation Rescue leader Randall Terry's writings with the fifteenth-century witch hunter's bible, the *Malleus Maleficarum*. (A year later Kerr + Malley made *O Brave New World*, which focused on women's roles in the Conquest; five hundred years of misogyny joins five hundred years of racial oppression. They point out that, like Operation Rescue, the Inquisition believed God was on their side when they murdered heretics.) Some of the photographic crosses in *Heretical Bodies* leapt the centuries to show protesters at an anti-OR demo. In fact, when the installation was shown in Grand Rapids, Michigan, OR fortuitously appeared there for the first time and a number of Kerr + Malley's viewers were moved to defend the beleaguered clinic.

Similarly impeccable historical research supported Kerr + Malley's

Faiseuse des Anges (1990), about the life of Dr. Madeleine Pelletier (1874–1939), a French martyr to the reproductive rights cause. In 1991 they made two more major works on the subject: *The Art of Deception,* showing the role of babies as future cannon fodder, and *Just Call Jane,* which responded to *Rust v. Sullivan* by juxtaposing passive and active responses to abortion: the heart-rending "Dying Declarations" forced out of victims of botched illegal abortions in the nineteenth century, and the work of an underground feminist abortion collective in Chicago in the bad old days just before *Roe v. Wade.* Kerr + Malley's commitment to this life-and-death dilemma goes beyond (while never forgetting) the current political crisis. They bring these horror stories from the past to light not merely to bemoan victimization of women in the past, but to show how our strength can redeem their sorrows.

The prize for more widely accessible public art about reproductive rights has to go to Barbara Kruger for her three life-size posters first shown in one hundred New York bus shelters by the Public Art Fund in early 1991. Separate black-and-white photo portraits of a hip African American youth, an aging white hard hat, and a young yuppie with an arm around his handsome son, are each labeled HELP! in eye-catching red labels; in the belly region, a brief narrative outlines the plight of these men, each of whom has just discovered he is pregnant and is asking, "What should I do?"

Because I have seen too much art that is inventive and ironic and incomprehensible to the general public, I have long advocated audience research for public art projects. (Before you go to the printer, find out "What do you think this means?" The respondents are often as inventive as the artists, but too often there is no meeting of the minds.) Initially I thought that Kruger's pregnancy reversal posters constituted the ideal public piece, being funny and ironic *and* highly comprehensible. However, a Public Art Fund source admitted at a panel last fall that even those works had been misinterpreted. Someone thought the black youth was a lesbian; someone else just assumed these men were talking about their wives. Nevertheless, I suspect that Kruger's message—an updated version of the 1970s poster of a pregnant Jimmy Carter that read: "If men could get pregnant, abortion would be a sacrament"—got across to enough people to warrant its prize.

Another theme that is just surfacing in feminist art is—surprise, surprise—sexual harassment. The only older piece I can recall on the subject was Mary Linn Hughes's 1980 installation at the University of California, San Diego, that bravely confronted harassment on the university campus (still rampant; here's a theme for courageous graduate students!). Linda Stein recently organized an exhibition on the subject at the Borough of Manhattan Community College to coincide with a conference keynoted by Anita Hill.

The newly formed New York feminist group WAC (Women's Action Coalition) has had unexpected media success in demo-performances with images of "the blob" (the blurred-out TV image of "alleged victims" of rape) countered by those of resistant women. Such events are important, as they spur other artists on to thought and creative action. (WAC's major cultural component, the Drum Corps, is the pulsing core of all the demos.)

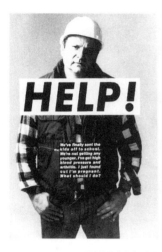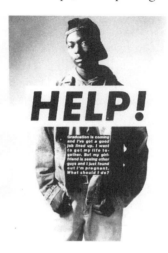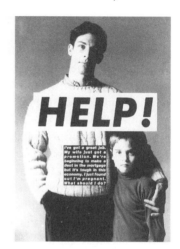

BARBARA KRUGER
Help! 1991
PHOTOMONTAGE

Kruger adapted the bus shelter images to the presidential election for the June 4, 1991, Op-Ed page of *The New York Times;* a youthful George Bush was behind the "Help!" and the text read: "I've worked hard. Business is booming and I've decided to enter politics. The campaign is going really well but I just found out I'm pregnant. What should I do?"

Two anonymous posters also hit the streets of New York last winter: One showed Susan Sarandon and Geena Davis, armed and dangerous, captioned: "William Kennedy Smith...Meet Thelma and Louise." The other was a valentine: an image of the Rape of the Sabine Women "from your ever loving Judge Clarence Thomas, Willy Kennedy Smith, Mike Tyson, the Saint John's Five, and the rest of the gang."

Maybe it's the next generation of feminist artists who will provide the much-needed, in-depth work. Lisa Link, who just got her MFA from the University of Colorado, has spent quality time for the last two years on the abortion issue, backed by exhaustive research on parallels between the erosion of women's rights in Germany in the 1930s and here in the present. In her video *Supreme Court Nightmare* and in "Warnings: 1931–1991," a series of thirty-two computer-generated posters, she links laws and statements by

leaders in a chilling history lesson. While she employs time-honored photo-montage poster devices (her model is John Heartfield) and the bright color and strong, complex design of classic Left propaganda, the images are often tipped into postmodernism by her own zany humor. Her self-portraits represent a terrified Everywoman with her body caught in the misogynist machine. Link appears on a gynecological table overseen by the patriarchy, reaching into the medicine cabinet for contraceptives suddenly personified by Randall Terry, Jerry Falwell, and Dan Quayle, or pulling the covers up to her chin as her bedroom is invaded by the seven conservative Supreme Court justices.

Other posters are more strictly historical: Hitler pins an award on the ideal mother; a German soldier shoots a Jewish mother and child; Nazi women sew swastikas. Sometimes Link uses enlarged texts printed boldly on red backgrounds to bracket her images (e.g., "Inbreeding is how we get championship horses"—a Louisiana state senator's promo for incest). On a happier note, the artist poring over books in the library is visited by a triumphal vision of Else Kienle and Friedrich Wolf—courageous pro-choice doctors from the Nazi era. The "Warnings" show can be rolled up and carried on an airplane. It has already been exhibited nationally at some pro-choice events and should be used *everywhere*.[1]

Guerrilla Girls

When women artists begin to call themselves terrorists, when they scar, deform or mutilate their images, it sounds as though the feminist art movement is running through a new cycle of rage. But this time around (postpunk), humor and irony and a certain aura of radical chic are tempering the tantrums.

Last spring, two street posters appeared everywhere in the New York art ghettos—plain, no-nonsense, black-on-white public service ads. One asked: "What do these artists have in common?" Below, forty-two male artists were listed, from Fishl and Judd to Salle and Serra, then the answer: "They allow their work to be shown in galleries that show no more than 10 percent women artists, or none at all." The second poster listed the galleries, from Boone and Castelli to Marlborough and Pace (many of them, sadly, run by and named after women). The posters were signed "The Guerrilla Girls, a Women Artists Terrorist Organization."

This fall, another Guerrilla Girls poster turned up: "On October 17 [1985], the Palladium will apologize to Women Artists." The Palladium is the hottest new downtown club, housed in the vast, semideteriorating grandeur of an old theater on Fourteenth Street, with permanent commissioned decor by five artists—all male. An invitation went out for a show that would "forever put to rest the following notions: 1) Biology is destiny; 2) There are no great women artists; 3) 'It's the men now who are emotional and intuitive'; 4) Only men can show at the Palladium." And on October 17, that show opened at the Palladium, a week-long exhibition by more than eighty women artists, sponsored by the Guerrilla Girls.

Reprinted from *In These Times,* Nov. 13–19, 1985.

The Palladium is the Guggenheim of nightclubs. Art is hard put to compete with the noisy crowds, dark and overwhelming spaces, the combination of peeling paint and trendy remodeling. However, the theatrical lighting that might have trivialized the art instead enhanced it more than conventional gallery situations.

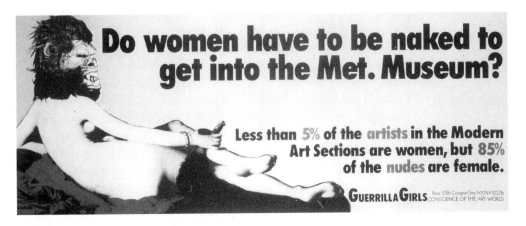

GUERRILLA GIRLS
Do Women Have to Be Naked...
STREET POSTER

For the first years of their existence, the Guerrilla Girls ("a group of women art professionals waging a war of words and images against sexism and racism in the art world") concentrated on the place of women artists in the art world, wittily castigating institutions and individuals who failed to acknowledge women's art. In the late eighties, they turned to broader issues such as homelessness, the environment, and the Gulf War.

Mary Beth Edelson's great mythic Mother/Sister greeted entrants at the door. Like Nancy Holt's visceral-industrial labyrinth of steam pipes, it should remain as a permanent part of the decor, breaking the male monopoly. Joan Semmel's eight-foot male nude hovered dramatically in the dark far overhead: Alison Saar's *Jezebel Unbound* also towered over the average clubbie. And a small, granite, almost abstract double penis by Louise Bourgeois, in her seventies the doyenne of the movement, quietly but ferociously held its own in a hallway.

The company was illustrious too. Nancy Reagan (aka Redi Story aka Martha Wilson) was in attendance, as was Bonnie Sherk's Miss Liberty, whose arm ached from waving her magic wand in vain. Spiderwoman Donna Henes appeared in a creation of plastic spiders and webs, echoed by her enticing string stairwell installation. Rap performance artist Jerri Allyn

did a fourteen-ironing-board takeoff on Wrap artist Christo (who just enveloped the Pont Neuf in Paris). Costumed appropriately, Diane Torr sold condom-wrapped data on female circumcision.

It remains to be seen what institutional effect the Guerrilla Girls have. So far, the art world masturbates in peace with little climax in sight, but the Guerrilla Girls show, token though it was, offered a strong bid for attention, and got it. Heir to the pro-choice street performers No More Nice Girls in the early eighties, Guerrilla Girls provides a link, if only a link, between the art world and the grass-roots political activism of other feminist artists across the country. They are a classic mid-eighties phenomenon—mean, but fun, avoiding or mocking rhetoric, but not necessarily less aggressive than the founding mothers of the sixties and seventies, whose 1970 guerrilla actions at the Whitney Museum raised both consciousness and the ratio of women in the museum's Annual by 400 percent. The Guerrilla Girls' bark may be worse than their bite, but they are laying out the old issues and gaining new support. For better or worse, young women who might not call themselves feminists will call themselves Guerrilla Girls. There's a button announcing "I'm a Guerrilla Girl" and the group suggests that every time you go into a gallery that ignores women's art, you sign the guest book Guerrilla Girls, to show we are ever vigilant. I wear my button and I sign the books, but I draw the line at calling myself a terrorist. It's become postpunk cute to be a terrorist; a couple of years ago the disco Danceteria invited everybody to be "cultural terrorists." The Reagan administration already calls us that, and it lets state terrorists off the hook to be coy about it.

On the other hand, there is an aspect of current art-world feminism that might be called neo-aggressionism, epitomized by the Jenny Holzer "truism" text used on the Guerrilla Girls' Palladium poster, which reads, in part: "Don't talk down to me. Don't try to make me feel nice."

[I wrote the following text to accompany the presentation of an award to the Guerrilla Girls from the women's networking organization "Art Table," in November 1991.]

ADDENDUM

I once took the Guerrilla Girls to task for calling themselves cultural terrorists, because it could provoke the righteousness of the Right, for whom *terrorist* means someone you can shoot, and it let the state terrorists off the hook. But seven years later, the Right having proved itself immune to such tact, and the Guerrilla Girls having survived with their tactics intact, I'd like to congratulate them for having kept up the level of fire. A beacon in

the obscurity of postmodernist theory, they have fulfilled their role as Conscience of the Art World, passed on to them by predecessors who also claimed that title—Ad Reinhardt and the Guerrilla Art Action Group.

The Guerrilla Girls have almost single-handedly kept women's art activism alive over one of the worst decades I hope we'll see, and they have done it with humor, wit, honesty, and anger—or rather, not anger. ("I'm a Guerrilla Girl and I'm not angry," read one poster. "Why should I be angry that only one major New York City museum had an exhibition by a woman artist last year?")

The Guerrilla Girls challenge the mass media on their own ground with a "hidden agender," as they put it. They work fast, monitoring the scene and exposing the shameful statistics, their poster brigades striking late at night. No one is safe from their toothy grins and brandished bananas. They know if we've been naughty or nice, and their targets have been known to write craven apologies as well as outraged self-justifications.

The Guerrilla Girls had the sense to realize that anonymity was a perfect weapon against art-scene/art-market greed and gossip, and they have adamantly remained in their masks, from behind which they can say the unspeakable. After a while, with a nudge from PESTS—their artists-of-color counterpart—they began to acknowledge the need for cultural as well as gender diversity in the art world. When things got really bad, around Desert Storm time, they got militant about the military, and moved into broader social criticism with almost as much éclat as they've brought to art-world machinations.

*I'm a Guerrilla Girl too....*This is what their early button proclaimed, and we were all asked to sign the gallery guest books as Guerrilla Girls, so the art world would know we were everywhere, watching. I hope everybody reading this is a Guerrilla Girl too. More power to them...and to us.

The Garbage Girls

If it had been the purpose of human activity on earth to bring the planet to
the edge of ruin, no more efficient mechanism could have been invented
than the market economy.
—JEREMY SEABROOK

In the late sixties, Conceptual artists raised the problem of the
surfeit of objects in the world, including "precious" or art objects. Various
"dematerialized" forms were developed that aimed to make art part of the
solution rather than part of the problem. Because of the overwhelming
power of the market-oriented art world, and the failure to create a new
context and new audience for a third-stream art, that particular impetus
faded; the dematerialization concept was eventually reembodied into
commodities.

With the growth of a more sophisticated art/political awareness during
the seventies and eighties, however, this urge toward the conversion of
objects into energy has persisted, especially in the environmental domain.
In the nineties, the essence of an ecological art is not the preservation
of natural beauty, nor the building of evocative site art, but the disposal of
unnatural waste. Garbage is now of greater concern to many progressive
artists than glorious vistas, although it does not make the transition from
studio to streets very easily. New Yorkers, for instance, are so inured to
garbage on the streets that it only shocks them to see it in museums.

A disproportionate number of the artists dealing with waste are women,
for obvious reasons pointed out long ago by the preeminent "garbage girl"—
Mierle Laderman Ukeles. In the early 1970s, having defined women's social
role as "unification...the perpetuation and maintenance of the species,
survival systems, equilibrium," Ukeles asked the question that continues to
resonate today: "After the revolution, who's going to take out the garbage
on Monday morning?" If by 1991 many seem to have given up on that

Reprinted from *Z Magazine,* December 1991.

particular revolution and replaced it with "paradigm shifts," the trash
remains.

Ukeles began her "maintenance art" when her children started to arrive
and she found her art time slinking out the kitchen door. To get it back, she
simply turned around and renamed her domestic duties "art," initiating an
ongoing series of explorations that have ranged from donning and doffing
snowsuits, changing diapers, and picking up toys, to scrubbing a museum
floor, to following (and praising) the workers who maintain a large city
building, and finally to becoming the "official artist in residence of the New
York City Department of Sanitation," where she found her niche. Since the
late seventies Ukeles has used the department as a base for her now inter-
national investigations of social maintenance and waste management. Her
work consists of real-life performances of workers' days, research about
environmental effectiveness, and installations constructed from the products
and tools of their labor. One of her many functions is to humanize and
beautify (even beatify) those who, like women, do the dirty work, to
endow them with grace and nobility. (Once she choreographed a "street
ballet" of garbage trucks.)

Landfills have long been among her prime concerns. In the summer of
1990, Ukeles curated an exhibition for New York's Municipal Art Society
called "Garbage Out Front: A New Era of Public Design." It focused on
imaginative documentation and a simulated cross-section of the Fresh Kills
landfill in Staten Island, where she is currently working. "Is garbage chaos,
dissolution, decay?" she asked. "Can the same inventiveness that we use for
production and accumulation of goods be applied to its disposal?" Suggesting
that the problem of citizens' unwillingness to take responsibility for the
garbage we produce reflects our inability to visualize our relationship to
society as a whole, she aims to make every part of the process of waste and
waste management visible to everyone participating in it (that is, everyone)
so that the redesign of the degraded becomes a symbol of transformation.

Christy Rupp credits Ukeles as the "mother of it all" in the garbage field,
but she has been one of its most popular exponents since the late 1970s,
when she began placing images of rats around garbage-strewn New York
neighborhoods as part of her "City Wildlife Project." She went on to call
attention to the existence of other urban animals, consumerist waste, and
city neglect with installations under the Williamsburg Bridge, in Palisades
Park, at a Forty-second Street storefront, and in the lobby of the Com-
modities Exchange. In San Francisco she constructed *Poly-Tox Park,* a simu-
lated toxic-waste site offered as "a monument to our legislators and the
people who get to determine the safe levels of toxins in our environment."
Her *Social Progress,* a giant ear of corn pulled by a snail and attacked by ants,

was installed in front of the Flatiron Building for several months and appeared on the front page of *The New York Times*.

Rupp's gallery art consists of a marvelous menagerie of cardboard and metal that comments on the destruction of family farms, the fate of rust-belt workers during the Reagan era, imports and exports, pesticides, and

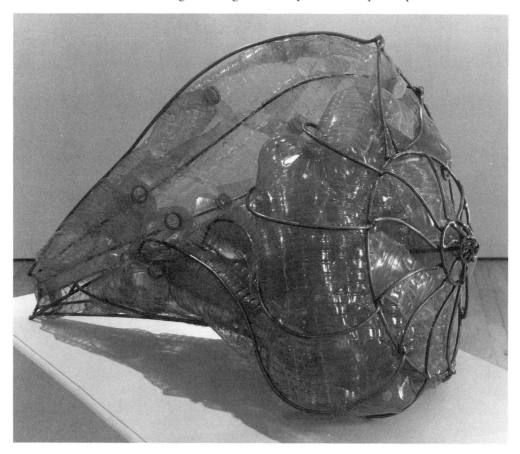

CHRISTY RUPP
Wave of the Future, 1990
WELDED STEEL, PLASTIC WATER BOTTLES, 2 5″ × 3 7″ × 2 8″
Photo: Adam Reich, courtesy PPOW, New York.

This is one of a "reverse homeopathic" series that Rupp made to comment on the process of destruction through artificialization of nature. Others included a tree stump made of newspaper and a dolphin made of cat food cans.

politics in Central America, among other issues. Most recently she has made a series of lethally graceful animal forms outlined in metal and filled with the instruments of their own destruction: a leaping dolphin form stuffed

with cat-food cans, a snail shell filled with "designer water" bottles, a tree stump stuffed with newspapers, sea turtles stuffed with Tide bottles. (She cites the increasing number of harmful products named after natural forces, as in Surf, New Dawn, Bright Water, and so on.)

Since the mid-eighties, Rupp has been particularly concerned with fish, water pollution, and wetlands. At the moment she is working on the Coney Island Water Pollution Control Plant (sewage, that is), in Sheepshead Bay, Brooklyn, where she has inspired the Department of Environmental Protection to try to re-create wetlands in a degraded creek near the neighborhood-access promenade she is building. Pursuing other public commissions dealing with water pollution around the country ("They're hiring artists to convince the public the water is potable; you'd drink this purified sewage if the art was good?"), she has discovered that with the increased awareness of water scarcity, fountains are out, so she is making images of the absence of water, such as a parched-earth pavement. For the University of Washington, Rupp is making a "rollback dam" bench ("You park your butt and feel guilty"), which comments not only on water management but points out that the endangered species act, which was made law at the same time as *Roe v. Wade,* is also endangered by rollback on its near-twentieth birthday.

Many concerned artists make paintings (such as Janet Culbertson's horrifying billboards of a blooming past set in lunar landscapes of destruction) or prefer the indirect referentialism of pretty, natural materials, such as branches, stones, shells, and woven grasses, to the ugly and virtually untransformable junk we cast off with such abandon. But the garbage girls (and occasional boys) tend to target the grander environmental horrors. Particularly valuable, therefore, if less visible, are those rare works that name names, calling specific attention to the corporations and the capitalist system on which so much planetary disaster can be blamed. The Alaskan oil spill inspired a great aesthetic spill of art decrying the desecration of nature and animal life, and the blame was so obvious that, for once, Exxon got named again and again. But too often environmental artists fudge and generalize, perhaps with an eye to making it easier to get grants and exhibit in museums often controlled by the very people who are destroying the environment.

One exception is the ecological feminist Betty Beaumont, who has made installation art on toxic wastes using government surplus materials since the 1970s. Her 1978–80 *Ocean Landmark Project* forty miles off New York Harbor was a collaboration with a team of marine scientists, material scientists, and industry to study the stabilization of waste materials in land and water environments. It transformed five hundred tons of an industrial waste product into an underwater sculpture, which has since become a thriving reef environment and fishing grounds. Beaumont's *Windows on Multinationals*

and Banned Pesticides of 1984 pointed an aesthetic finger at the First World's toxic dumping and export of banned chemicals in the Third World, citing the pesticide giants Monsanto, Ciba Geigy, Union Carbide, and FMC in a scripted audiotape. She is now working on *Fish Tales*, a flash-card set showing some twenty species of unknown fish that have evolved since atomic waste was dumped off the continental shelf.

One of the first garbage pieces that made an impression on me was a mid-1970s work called *Luxo/Lixo* (Luxury/Garbage) by the Brazilian artist Regina Vater, in which she photographically documented the trash discarded in neighborhoods occupied by different social classes. It would be interesting to see someone pursue these lines in the United States, perhaps in collaboration with the homeless people who are probably our greatest experts in the field of garbage analysis and the unacknowledged leaders of the recycling movement. In the 1980s, a number of other women around the United States have independently chosen garbage and waste as their medium. A sampling:

- Jo Hanson's *Public Disclosure: Secrets from the Street* (1980) evolved from collecting the sweepings from her San Francisco doorstep into a citywide piece about litter as cultural artifacts and the quality of the visual environment.

- Cecilia Vicuña, a Chilean living in New York, poetically comments on the scale of the solid waste problem by setting adrift in the city's gutters and rivers the tiniest, subtlest rearrangements of found rubbish. A bit of paper and a dead leaf may become a tiny raft, noticed by only an incredulous few among the used condoms and oil slicks of the Hudson River near her house. Vicuña also adds magical reminders of the power of the microcosm to wilderness landscapes and makes little sculptures and indoor installations out of social discards.

- In Santa Barbara, in 1987, Ciel Bergman and Nancy Merrill made *Sea Full of Clouds, What Can I Do?,* a room-sized installation of non-biodegradable trash they collected along the beaches. Centered on an altar, accompanied by messages from viewers about their hopes for the health of the world, the piece's "beauty" belied its humble and dangerous sources.

- Also in 1987, in Santa Fe, the French-born artist Dominique Mazeaud began *The Great Cleansing of the Rio Grande River,* organizing spiritually attuned trash brigades in an ongoing and randomly undertaken task that is primarily symbolic. Mazeaud keeps a river journal (her "riveries") and performs renewal rituals along the Sante Fe River and the Rio Grande. The one I participated in consisted of sowing corn seeds from different locales along the river banks.

- In Los Angeles, the "LA River Project" by Wilson High School teacher Susan Boyle and video artist Cheri Gaulke culminated in a 1990 student installation centered on a "river" of video monitors offering an array of

images of trash-filled water, surrounded by photographs, a chemically analyzed water sample, river artifacts, evidence of wildlife—human and otherwise—and interviews with residents, politicians, and poets. The project has now been adopted by the Smithsonian. Manuel Ortega, a student who worked on it, says, "I don't think I'll ever *not* be involved in the river. It's part of my life now."

- In Boulder, Colorado, sculptor Kristine Smock organized "The Forest for the Trees" in 1991. A citywide project with some two hundred school-children and poets, it began with collecting trash and ended with a strik-ing, community exhibition of giant sculptures made from the findings— many delightful trees, but also a wacky male figure whose shoes are made entirely of cigarette butts (eat your heart out, Red Grooms) and a huge fish stuffed with that farm-ubiquitous blue plastic. Embraced by satellite events, the project was an important community consciousness raiser, but the sculptures—made primarily by children—were among the most robustly imaginative "assemblages" (as we say in the business) I've seen in or out of the high-art context.

Since the late 1960s, a few earthworks artists, beginning with Robert Smith-son, have also tackled rehabilitation of land devastated by mining, erosion, and industrial waste; among these works are Helen and Newton Harrison's vast reconceptualizations of land use, Harriet Feigenbaum's reforestation project, and Alan Sonfist's patch of pre-Colonial "forest" in downtown New York City. As the site of some eleven thousand inactive mines, Colorado has paid special attention to the possibilities of reclamation art. In 1985 Denver sculptor Paul Kleit (now producer of the eerily innovative indepen-dent radio program *Terra Infirma*) wrote an important report for the state Council on the Arts and Humanities and the Colorado Mined Land Recla-mation Division, in which four ripe-for-reclamation sites were detailed and solutions recommended. Typically, few if any actual projects seem to have come of this. Some artists who have managed to fight the power and hang in through years of bureaucratic idiocies are:

- Nancy Holt, whose most recent work is *Sky Mound,* which will transform an entire fifty-seven-acre landfill in the so-called meadowlands of New Jersey into an astronomical observatory. The site is one hundred feet high and contains some ten million tons of garbage. As well as adding earth mounds, methane flares, spinning windforms, and steel posts that are aligned to specific lunar, solar, and stellar events, Holt is incorporating the technological specifications of landfill closure, including methane recovery wells and a water drainage system, into her sculptural landscape. Circles and rays of light will be captured by a steel ring, arches, and poles, with the most spectacular manifestation taking place at noon on the summer solstice. A flat-topped pyramid covered with grassy hills and gravel paths, *Sky Mound* will provide a wildflower and wildlife habitat (for marsh hawks,

racoons, and rabbits). It will bring another, cosmic, level to the cycles of decay within the landfill. "I'm not trying to pretend this isn't a dump," Holt has said. "I'm working with the vernacular of landfill."

- Agnes Denes, who once planted and harvested a wheatfield on an urban landfill, is now working with two landscape architects on the ninety-seven-acre North Waterfront Park in Berkeley. The accepted master plan has seventeen elements that incorporate soil engineering, methane harvesting, leachate, created wetlands and beaches, wildlife habitats, and bird rests, as well as a ghost ship (to recall that the planet is a ship), sunflower/windmills to bring water up to a field of natural sunflowers, invented "rock art," and a sculpture that changes form and sound as the tide ebbs and flows.

- Patricia Johanson has designed sculpture into nature since the sixties, and is best known for her Fair Park Lagoon in Dallas, where the sculpted jetties echo the plants and organisms that inhabit the marshes. Her most recent large-scale environmental work—now under construction—is *Endangered Garden* in Candlestick Cove in San Francisco Bay. By sinking an eyesore (a sewage holding tank for storm overload that is a third of a mile long and forty feet wide), she has created a bay walk, a series of transitions, links, and accesses, that is also a last stronghold for the butterflies, snakes, and birds that have been pushed out of the city. "They say this park won't smell," she says wryly, "but when they say that at public meetings, people who are veterans of environmental protests laugh."

- In 1990, a bicultural, bilingual group of seventeen Vermont and Quebec artists collaborated on "Deadlines/Ça presse," a two-part show on acid rain that traveled to schools and other sites in both countries. The project was partially inspired by the Canadian interdisciplinary artists' group Boréal Multi Media, from rural La Macaza in the Laurentians. There are thirty thousand dead lakes in eastern Canada, thanks in part to the aerial garbage from midwestern U.S. smokestacks. Boréal organizer Wanda Campbell says she thinks artists can make a difference by creating "cultural myths," or what might be called "Wakeup Art." However, another Vermont show makes me wonder what the audiences wake up to. A Women's Caucus exhibition about environmental distress and exploitative development called "Mowing the Mountain" at the Burlington Airport was certainly controversial. *The New York Times* quoted one of many baffled and annoyed airport employees as saying, "I guess we've learned a lot about art from this experience." Presumably, the artists would have preferred that he learn a lot about the environment.

- And, finally, a project by a token garbage boy: Yugoslavian emigré Milenko Matanovic is encouraging the rest of us to share the public burdens with a media-aimed project called "Trash-Hold"—an "eco-robic exercise to 'trim our waste.'" It opened successfully last March in Chattanooga, Tennessee, but is designed to travel and adapt to any community. The average American, Matanovic points out, discards five pounds of

garbage a day. In an attempt "to change bad habits before a crisis point is reached" (I'd argue that that point has already been reached), participants, the higher their profile the better, drag specially designed bags of their garbage around with them all week, as it accumulates, to publicize the extent of the problem. In a closing ceremony, they gather to recycle. In Chattanooga, out of 260 pounds of collected trash, only twenty pounds were not recyclable.

Powerlessness, cynicism, and greed all lead to passivity rather than change. Perhaps the greatest question for ecological artists is how do we generate hope? Recent exhibitions of art about nature in the art world have been decidedly pessimistic. Entitled "Against Nature," "The Demoralized Landscape," "The Unmaking of Nature," and "Unnatural Causes," for example, they acknowledge impending catastrophes but provide few visions for a happier future. I know real visions are hard to come by, and we've had a plethora of fake ones. But art should not just be the dark mirror of society any more than it should just be the saccharine in the cup of hemlock.

We're in trouble if all artists can do is activate our fears. As Christy Rupp said with her clipboard *Datafish* in Central Park, the emphasis on information is positive until we get fat on information for information's sake and fail to act on what we know about who's doing it to us. Individually, we can recycle until we're green in the face, but until the corporations, the government, and the ruling class get the message, not much is going to change. For all the talk about the healing power of the arts, of feminism, of the nineties—powers I too would love to believe in wholeheartedly—I see no evidence that these crucial changes are imminent. Art can never be more than a Band-Aid or a shot in the arm until it is part of the broader grass-roots movement that goes beyond private responses (individuals account for only about one-third of the world's pollutants) to fundamental social reconstruction.

Both Sides Now: A Reprise

It makes perfectly good sense that after twenty years, feminist art is a braid of multiple positions. But in fact, it's not multiple enough. Listen to Audre Lorde [in a 1987 interview I did in Boulder, Colorado]:

> I've been talking about racism in the feminist movement for how many years! I think that the extent that the white American women's movement does not take racism as an endemic, integral problem within the movement, to that extent it will fall apart....I just came back from Germany and it was so obvious that if the white German women's movement doesn't take anti-Semitism and racism as an integral part of their concerns, they will also fail. Whatever the core problems of any society are, they must also be the core problems of the women's movement, because we are *part* of society and we reflect those things for good and ill....Racism is a problem of white America and ultimately that's where it's going to have to be solved. Because more and more, as I say when I talk to Black student groups, we must move on—with or without white people, we'll have to move on. White women of good intent *must* work within their own communities first of all. It's not that we don't come together, it's not that we don't share interests, it's that basically we need to work with ourselves before we can come together as wholes, not as pieces of people.

"Both Sides Now" was the title of a show I organized a decade ago to reconcile cultural and socialist feminisms. This reprise considers two newer strategies fighting it out for a center that is not even ours to control, a center that continues to ignore the peripheries. Now we have the "essentialists" versus the "deconstructionists," or old-fashioned verus postmodern feminists, a confrontation that has too often been simplistically boiled down to practice versus theory, as in the early days of this wave of feminism. (I

Reprinted from *Heresies,* no. 24 (1989).

have an Australian poster from the seventies in which Wonder Woman swoops down on her opponents yelling, "Pure theory equals pure shit! Egghead feminists and other useless theorists, Get Fucked!" "Where do correct ideas come from?" she asks. "Do they drop from the Skies? [a brick with 'Althusser' written on it] No! Are they innate in the mind? No! They come from Social Practice!")

Today the essentialists at their most extreme dismiss all theory and unfamiliar vocabularies as obfuscatory, oppressive, and male; the deconstructionists at their most extreme dismiss both spiritual feminism and activist feminism as male-imposed, exclusively socially constructed, and just plain deluded. Each in its way ignores the best of the feminist movement, which is our ability to embrace contradiction and understand it, or at least cope with it, without collapsing all the differences into liberal wishy-washiness. As Jane Gallop says, "This problem of dealing with difference without constituting an opposition may just be what feminism is all about." So can't we analyze social formation and envision social transformation at the same time? Must we throw the body out with the bathwater?

Difference is what it's all about, but not just gender difference. We rarely apply our insights on representation and stereotypes to women outside the (global) white minority; artists of color are just beginning to be included in articles and exhibitions on "differences" and gender. Socialist feminism has long insisted on the incorporation of race and class into feminist theory, but along the way there has been a kind of competition between gender and race/class. Socialists have accused radical and cultural feminists of bourgeois romanticized elitism and of supporting all women regardless of their politics (the Margaret Thatcher/Indira Ghandi syndrome). The opposition has insisted that women's struggles are always put on the back burner in favor of (at least) lip service to race and class, that Marxism is incompatible with feminism, and that all models of women in power, no matter how abusive, must be supported. Both positions are right on various levels, but over the years the debate has rarely progressed beyond this basic argument.

A lot of differences between essentialism and deconstructionism today are found in methodology, context, and language rather than in basic belief. Nobody is arguing against the notion that woman as sign is the site of our commodification. Still, I was disturbed by a feminist panel (at the New Museum in 1987) that seemed to be digging the trenches deeper rather than producing dialogue. Its publicity pitted "the Goddess" (represented by empirical artists who have often been activists rather than by the spiritual feminists who lay most claim to Her) against "social practice" (represented by European-oriented postmodernist critics, whose idea of social practice is almost entirely based in theory). In particular, two Derridaesque statements

from the latter camp provoked me. One critic said flatly, "There *is* no experience of the body outside of representation." Another said, "It is only through images of women that female sexuality is constructed." Both writers have made important contributions to recent feminism and I have no quarrel with most of their positions; the arguments that follow are aimed at the implied narrowness and exclusivity that endanger their potential to feminism.

CARRIE MAE WEEMS
Untitled, 1990
SILVER PRINTS, ONE OF THREE PANELS, 28¼" × 28¼" EACH
Photo: courtesy PPOW, New York.

From a solo exhibition that focused on serial images of a proud single woman's struggle with love and power, and her dilemmas and supports: friendship with women, relationship with men, and mother/daughterhood as a subtle subtext.

MARINA GUTIERREZ
La isla del encanto, 1986
ACRYLIC ON PAPER, 60" × 30"
Collection El Museo del Barrio,
New York. Photo: Ken Showell.

The Enchanted Island is Puerto Rico,
its indigenous past pictured above, its
colonial present below. Gutierrez is a
Nuyorican feminist and activist who
often combines the spiritual and the
political.

In the mid-1970s, we talked a lot about the dangers of being preoccupied
and thus ruled by our opposition. This problem still seems inherent in the
fascination of much postmodernist theory, or "critical practice," with that
which is being criticized, or deconstructed—capitalism, the patriarchy, the
media, lifestyles of the rich and famous. Clearly we can't be ignorant of
what They are doing to us, or even what They are doing when they are not
apparently doing anything to us, and even when They seem to be doing
something for us (as in some overtly conservative postmodernist theories of
art that seem bent on co-opting feminism as a not-quite-political stance).
But at what point are we simply swallowing that which we can't afford to
digest, and getting a terrible bellyache in the process?

Feminists are generally agreed that language and visual representation of women mediate much of our experience, even in societies where the mass media is less ubiquitous than in our own. Analysis of the socially imposed and debilitating image of women and its effect on our lives and our sexuality has been a bulwark of feminist art since 1970. "Foregrounding" this project is one thing; isolating it is another. Too often I find a kind of fatalism—even self-hatred—in deconstructionist positions like those expressed above. If we have no experience that is not formed by the patriarchy, from what base can we even imagine our own transformations? And if language is so formative in social construction, why does most postmodern feminist theory adopt the impenetrable "discourse" of the patriarchy to overturn it? Why look at everything through the notion of a castration complex that is so clearly a male construct too? Why not duck out from under that regimenting scrutiny? *Why not concentrate on what the male gaze cannot see?*

I am convinced that there are experiences I share only with other women. My experience cannot be *fully* regulated, controlled, or interpreted by bodies and minds that do not know it. There are some aspects of femaleness (if not of femininity) that simply escape men. They provide the firm ground, the grass roots, from which women can analyze and act. Some elements of difference we have chosen for ourselves; others are the common experience of the oppressed. Experience is not dumb; it includes thought. Analysis is made on the basis of experience and, ideally, leads to action, which in turn can lead to a changed experience from which a new analysis can be born, and so forth. Analysis can *also* end up in an academic cul de sac, so distanced from experience that it no longer means anything to anyone except those specialists who live within their own self-erected domains—just as the patriarchy does. Some of us "old-fashioned feminists" are reluctant to see the whole bundle of reclamation and celebration tossed out in favor of a new line that often seems unduly harsh and narrow— downright *ungenerous,* despite its intellectual appeal.

I know other women from the first generation of this round of feminism who began their feminist art work some twenty years ago and are also feeling rather buffeted by the inevitable but often constructive changes since then. (In fact it is artists like May Stevens, Ida Applebroog, and Nancy Spero, among others, who are making work with the most to offer to both camps.) We've lived through the exhilaration and rage of the early seventies to the generalized backlash of the mid-seventies (backlash from the dominant culture, the art world, and other women), to the so-called postfeminism of the early eighties, to the present, when feminist theory is influenced by Europeans both male and female—Freud, Lacan, Cixous, Kristeva—who, incidentally, echo the main focus of British left feminists from the mid-seventies.

Significantly, these new theories emerge from media analysis, especially film criticism. Laura Mulvey, whose hugely influential "Visual Pleasure and Narrative Cinema" was written in 1974, wrote in retrospect a decade later that this essay belonged "properly to the early confrontational moments of a movement. The great problem is then to see how to move from a deconstructive mode of thought to 'something new,' from creative confrontation to creativity." Mary Kelly, an American artist who has lived in London some twenty years, and along with Mulvey has been a persuasive spokeswoman for the deconstructionist, or "critical," position, has long argued "*against* the supposed self-sufficiency of lived experience and *for* a theoretical elaboration of the social relations in which 'femininity' is formed." But Kelly's own art is important because it does not *deny* lived experience; she uses it to ground her theoretical investigations and the combination forms her art. Unlike some contemporary art, Kelly's work does not *become* the social mechanisms that it criticizes. As Jill Dolan has observed, feminists "have become so enthralled with the possibilities of the theory, we have forgotten to point out that in practice, the postmodern esthetic fails to realize anything close to a feminist agenda."

About a decade ago, I wrote that to reject all aspects of woman's experience as dangerous stereotypes often meant simultaneous rejection of some of the more valuable aspects of our female identities. Though easily used against us now, the disappearance of female identification with the earth, with nurturance, with peace (and more problematically with motherhood) would serve the dominant culture all too well. One of the many reasons so many women artists have engaged so effectively in social change and/or outreach art is our political identification with oppressed and disenfranchised people. We don't have to approve the historical reasons for that identification, but we do need to wonder why we are so often discouraged from thinking about them.

Feminist philosopher Sandra Harding, rejecting a liberal generalization of all women's experiences as complicitous with the status quo, points out that if differences between genders are crucial, aren't race and class equally so? These "other" differences are not parallel with gender, they are part of it, constituting another kind of difference within gender that is potentially a great positive resource. "We can't share each other's experiences," said Harding in a recent lecture, "but we can share the politics" that arise from different experiences. Diversity is something more complex and important than the "great Disneyland of ethnicity" preferred by liberals. Neither gender nor race should be isolated within politics, nor should race be flattened out as just another internal conflict between groups of white middle-class feminists.

As a socialist feminist (albeit an occasionally emotional, romantic one), I've

always had trouble with the notion that women are inherently better than men; as a cultural feminist (albeit a quasi-Marxist one), I have always liked the way women go about life better than men do. I can look back at the ideas we had about "female sensibility" in the early seventies and feel a certain nostalgia for the sense they made at the time. I still can't completely disavow these ideas today, because women and men still have totally different experiences in this world, biologically, socially, politically, and sexually. At the same time the deconstructive strategy (in use before it was named) is one effective way to gain our balance within the dizzying array of identities that are offered us. Although I'm personally not well enough read (and too red) to be a bona fide

YVONNE RAINER
STILL FROM *Privilege* (WITH GABRIELLA FARRAR)
16MM COLOR AND BLACK-AND-WHITE FILM DIRECTED BY
YVONNE RAINER, 1990

Privilege is a powerful feature-length film, Rainer's most accessible work to date. Filmed in New York's East Village, its effectively incongruous subjects are menopause, racism, and rape. As in her other films, it contains psychological fiction and tantalizing bits of biography and autobiography used (she has said) as "props." She walks a fine line between aesthetic distance, political engagement, and the sexual absurdity and "unalleviated intensity" of soap opera.

deconstructionist, I can work to peel away the intimidating jargon and dis-cover the valuable parts of the feminist puzzle buried in these theories.

Thalia Gouma-Peterson and Patricia Matthews, in their "Feminist Critique of Art History" *(Art Bulletin,* Sept. 1987), suggest that the first generation of recent feminists has a "fixed" notion of the female sensibility, while the second generation has an "unfixed" concept that attacks the accre-tions of patriarchal construction from all sides. This may, however, be somewhat unfair to those early days. It's true that we *fixed on* those aspects of femaleness that had been buried, that made us feel good, as principles of unity. But such rediscovered celebratory concepts weren't static; on the contrary, we could see and feel the changes happening in ourselves. A very real flux, *and* flexibility, proved to us that there was some hope of remaking ourselves, our images, and the world—even uphill against the inevitable social dominance. We acknowledged that our notion of a female sensibility was in part socially constructed, but we felt that we had also constructed it ourselves by inverting the stereotypes, by reclaiming the positive and dis-claiming the negative. An idealist approach, sure. Sometimes idealism is necessary, and works.

Today we're all more sophisticated, and resigned to a longer, deeper struggle than we'd expected in the very beginning. My own choice has been to spend my time on images of the world *by* women rather than on images *of* women by the world; I like to work in what Abigail Solomon-Godeau has called "the elusive and unknowable register of the real." So I'm grateful to those who are painstakingly dissecting the stereotypes and examining the mechanisms, even when they lose me intellectually. At the same time, a little balance, please. The total rejection of the spiritual by some decon-structionists and some socialists disturbs me. I don't happen to "believe in" a goddess any more than I believe in a god. But it's not merely a matter, as the critic at the New Museum panel disparagingly put it, of "the obsolete need to return to a simpler time." That *need* is not necessarily obsolete, no matter how unrealistic it may seem. And as another writer pointed out that same night, the goddess in eco-feminism "stands for a larger development." Sometimes it *is* a matter (so to speak) of incorporating empowering ideas from the past into current struggles, undistorted by a false nostalgia and exaggerated romanticism, or by New Age apolitical elitisms and wishful thinking (as in "Create your own reality"—a marvelous idea and impetus that is constantly abused). "Spiritual" to me means not only the "kinship among women" that Suzanne Lacy exhorts, but a sense of the ungendered possibilities of a far wider psychic field than conventional disciplines can cope with. But that's another story, even harder to integrate into global feminism than the essential and the postmodern.

Some postmodern theory challenges the frequent oversimplification of some essentialists, who verge dangerously on biological superiority built on the sand of biological determinism. But if essentialism is accused of idealism, optimism, and naïveté, surely the alternative is not to banish these not-altogether-despicable elements in favor of an apolitical defeatism. And if essentialists are accused of one kind of fetishism, deconstructionists must admit to a linguistic fetishism in which the sacred sign, signifier, and text overwhelm much of what's before our very eyes and under our very fingers.

TRINH T. MINH-HA
STILL FROM *Reassemblage*, 1982
16MM COLOR FILM (40 MINUTES)

Reassemblage is the first of three major "intertextual" films by Trinh, who was raised in Vietnam, came to the United States at seventeen, and then taught in Senegal. She wrote about it: "Some call it Documentary, i call it No Art, No Experiment, No Fiction, No Documentary. To say some thing, no thing, and allow reality to enter. Capture me. This, i feel, is no surrender, Contraries meet and mate and i work best at the limits of all categories." The film reflects the displacement of filmmaker, subjects, and viewer.

A feminist theory that does not recognize an activist wing, or at least an activist potential, is inadequate and unsatisfying. I fear the 100-percent sensuous, sentimental anti-intellectualism that is the worst of essentialism, and I fear the 100-percent academized intellectualism that is the worst of postmodernism. One lacks the distance that is necessary to see the world from different viewpoints; the other has overdone the "distancing" device we learned from Brecht. Both seem dangerously based in Eurocentrism— elegant French/Italian analyses or pragmatic British/American criticism. And both have been victims of the trickle-down conservatism of the unlamented Reagan era. For all the talk within postmodernism of a "resistant" or "transgressive" aesthetic, the overwhelming emphasis on objectification, commodity, production, and consumption finally blurs the peripheries, where I like to hang out. Objectified women are swept up with all objects (including art objects) as merely socialized signs of our unworthiness. In the process, oppositional art gets mellowed down into "critical practice"— perhaps because, as Fredric Jameson remarks, "You can't really have a cultural politics without a politics." And it's true that North American culture at its most activist still functions mainly as a consciousness raiser...and raider.

That's not so bad. On the other side of the coin, much so-called critical art is just as chewed and predigested and predictable as much art on the Left. Once life is reduced to images and spectacles for a passive audience, the image becomes the locus of evil, and one forgets that real actors are acting behind and in front of the scenes. The "homeopathic" remedy for art suggested years ago by Hans Haacke is recommended today by Jameson for the postmodern dilemma, as "the idea that you have to go all the way through this and come out on the other side." But if all our energy is spent "engaging the frame" and the "discourse" of the dominant culture, who's going to be out there experimenting with alternatives, and listening to those who are voluntarily or involuntarily hanging out on the margins?

Victor Burgin and others say that critical practices must operate from the center of the system they question, or be ineffective. Yet sometimes valuable ideas belong outside the plaza, on the rooftops where the snipers wait—feminism being a prime example—and I'm not sure they have to be domesticated to be effective. Currently, dissent is sporadically welcome in the center as a diversion. The center may be a nice place to visit, but it's not necessarily the most interesting or most educational or healthiest place for dissent to live. Oppositions too happily ensconced in the center, or in its academic suburbs, even as The Opposition, find themselves no longer in active opposition.

I am, of course, some kind of old-fashioned politico as well as an old-

fashioned feminist. I dislike the loose use of the term "political" to include anyone using quotation marks to reflect the status quo, for whatever reasons. I dislike the replacement of the word "political" with the more courteous, less threatening "critical." Solomon-Godeau is probably right when she says that few successful artists want to be called "political" because it means being "ghettoized within a (tiny) art world preserve." (But do those artists really think that their politics or lack thereof go unnoticed in the center?) She also cites the implication that "all other art is *not* political" and says that the term "tends to suggest a politics of content and to minimalize, if not efface, the politics of form." True enough, though I know plenty of "political artists" whose prime instrument is precisely the politics of form—the integration of what they have to say with how they say it. "Critical practice," on the other hand, is so broad a term as to be scattershot and meaningless if the criticism has no perceptible target or goal. To take on the mantle, or epithet, of "political" intentions may in this day and age be unwise and unpopular, but it also makes a commitment to meaning. As Gregory Lukow wrote in another context:

> It is ironic, in this age of flattened irony, that cynicism has come to permit the embrace of negation, of critique, while at the same time allowing one to ignore the implications of criticism. Via cynicism, criticism has become quotidian, yet ritualized, hollow, hip....Dissent no longer needs to be neutralized. It is part of the act of submission.

How, then, can feminists involved with art take the genuine emotions learned from lived experience and the insights gained from theory, and use them as a wedge to open feminism up to issues of race and class on a deeper, more honest level? We need to admit how little we know and to build our next theoretical rung on two supports: acknowledgment of racism as white people's problem, and at the same time acknowledgment of our own ignorance about the ways it works within the feminist community. Investigations of gender should implicitly include other entwined differences. We don't need to settle for the lowest common denominator—the generalizations about women that were important because they brought us together. It's time to get down to specifics again. I remember Barbara Ehrenreich pointing out that we all have several alliances in and out of the feminist community; we might simultaneously be a woman, a Chicana, a wage worker, a Catholic, a lesbian, a mother, and a socialist. We don't want to iron out all those honorable wrinkles, but to understand the varied ways in which we and other women experience our multiple identities, and how our priorities are constructed.

For years, I have been told by women artists of color that they do not want to be forced into being "political," or sometimes even to be identified

as "people of color" at all. I wonder about this, even though as a feminist committed to cross-cultural comprehension, I have to listen when Michele Wallace, for instance, says:

> The feminist dictum that the personal is political now becomes a kind of killjoy esthetic....Paradoxically, while black feminism might be expected to focus upon the women's movement's favorite issue—the feminization of poverty—the most compelling articulations of black feminist thought have not been political, but literary works, from Toni Morrison's *Bluest Eye* to Ntozake Shange's *Nappy Edges.* The economic difficulties of black female experience have not precluded but rather seem to demand the symbolic resolution of literary expression. Perhaps writing fiction is what Zora Neale Hurston once called, wistfully, "picking from a higher bush."

Postmodern feminism offers the possibility of presence in the place of absence, even as it wallows in that absence. But it is only a partial presence so long as it omits the absence of diverse races and classes. Hal Foster asked, "What is the Other of postmodernism?" And Michael Walsh replied, "If it has no self, it has no Other." If for women, "there is no experience of the body outside of representation," we are deprived of a center from which to venture forth to change that misrepresentation. And if the deconstructionists would deprive us of a self, the essentialists—by idealizing and over-generalizing—can deprive us of a respected female Other.

The time has come for feminist artists and writers to take the risk of trying to *re*construct, even knowing that we risk building another partially false, interim edifice of female identity; even though we, as women with such a diversity of experiences and ideas, will no doubt contradict ourselves in identifying and representing each other. This new image of woman, then, may be a setup for renewed shattering, even as it is formed. But at least we won't be stuck forever with the increasingly smaller fragments of a mirror so splintered that we can no longer see ourselves as wholes.

Double Vision: Women
of Sweetgrass, Cedar, and Sage

Sweetgrass, cedar, and sage are among the small, fragrant, and useful things Native American women send each other in letters, or bring when they come to visit. Used for ceremonies, medicines, and fiber dyes, they are redolent with the sense of place, or "home." The spirit of sweetgrass, cedar, and sage permeates this show. Many of the women in it have made special pieces for each other, as they would for their own families, in honor and celebration of showing with other Native women from across the country.

This exhibition marks the first time that has happened on such a scale.[1] It is a unique demonstration of the multicultural depths of Native America fusing in many different ways with the contradictions of contemporary Euro-American art. The women in this show come from widely varied backgrounds—not only from the geographically, historically, and culturally diverse Indian nations, but from complex interactions between those nations and various other ethnic groups. Many have parents or stepparents and siblings from other tribes or origins. Some were raised in direct contact with their traditions, while others are struggling to find their way back home in a voyage of rediscovery through the arts. "There is a particular richness to living in two cultures and finding a vision that's common to both," says Jaune Quick-to-See Smith, who is herself Flathead, French-Cree, and Shoshone. And Comanche/Métis Kay Miller talks of a "two-word world"—a unity of opposites that draws from Native spiritual traditions while acknowledging social conflicts, as reflected in her heavily painted oil images—for instance, a gun and an ear of corn.

For all their respect for their traditional sources, these artists refuse to be

Reprinted from *Women of Sweetgrass, Cedar, and Sage: Contemporary Art by Native American Women* (New York: Gallery of the American Indian Community House, June 1985).

limited by them. The curators have selected women who step across the boundaries laid down for them, who are challenging the conventions of women's art set up by Native cultures, and of Indian art set up by the dominant culture. An example: Imogene Goodshot has won many beadwork awards for traditional ceremonial buckskin dresses, but here she exhibits her funny, opulently beaded baseball cap and sneakers, commenting on adaptation and countering assimilation.

JAUNE QUICK-TO-SEE SMITH (FLATHEAD, FRENCH CREE, SALISH)
Paper Dolls for a Post-Columbian World with Ensembles Contributed by U.S. Government, 1991
WATERCOLOR AND PENCIL ON PHOTOCOPY, EIGHT PANELS, 17″ × 11″ EACH
Photo: Dick Ruddy.

Ken, Barbie, and Bruce Plenty Horses are equipped with costumes for history, such as a "maid's uniform for cleaning houses of white people after good education at Jesuit school or gov't school," or "matching smallpox suits for all Indian families after U.S. gov't sent wagonloads of smallpox-infected blankets to keep our families warm," and "Flathead headdress collected by whites to decorate homes after priests and U.S. gov't banned cultural ways such as speaking Salish and drumming, singing or dancing. Sold at Sotheby's today for thousands of dollars to white collectors seeking romance in their lives."

As cross-cultural values are weighed against the deracinations imposed by a featureless corporate culture, Indian women artists are affirming their diversity while refusing double cultural confinement. The issue is cultural self-determination, and "authentic Indianness" is its much disputed core. "Not only are we as a Native people working toward making other people aware of us as a separate cultural group," says Tuscarora Jolene Rickard, "but they have to see that we are also separate in our own groups. There is no one headband or one style of dress or one hairdo that would signify the same thing for all of us."[2]

The spirituality, or Order of Things, that informs Native American life, art, and politics, is not taught in school, but is learned over a lifetime. It is often invisible to non-Indians, and inaccessible to Indians uprooted from their own heritages:

> You get information real fast in cities, but you're not brought along spiritually, slowly, as you are on the reservation. When you leave, you make conscious decisions to leave things out, just to survive. But at what point will you bring these things back? There are Indians I know whom I can go to and talk about things not found in encyclopedias, dictionaries, universities. The understanding of the Order of Things comes in layers, like the tobacco-burning ritual, sending layers up to heaven....There is an invisible spirit for everything, but there's no place for that idea in this civilization no room in conversation, dreams, daily activity. The spirits are not separate from the creatures or plants or whatever. I'm not talking about something mystical; there's no Don Juan experiences here. (*Jolene Rickard*)

Contemporary Indian artists have to combat the romanticization of the Indian past as well as the misplaced purism of many non-Indian anthropologists, who are unable to accept innovation in Native arts. They don't seem to understand that environment changes culture and Indians too have changed in the last century. "Edward Curtis did not record a vanishing race," says Quick-to-See Smith. "Dying cultures do not make art. Cultures that do not change with the times will die."

At the same time, Indian artists who have fused traditional sources with new ideas from the dominant culture—which is where we all live, for better or worse—are sometimes suspected as "modernist" by tribal traditionalists, as "assimilationist" by tribal radicals, and as "derivative" by the white mainstream. It is particularly ironic that Indian geometric abstractionists can be chastised for being simultaneously modern and derivative, when Native Americans have a much longer history of formal abstraction than Euro-Americans do. The influence of Navajo blankets (never acknowledged by the art world as women's work) on the geometric post-painterly abstractions of the early sixties never led critics to call Frank Stella or

Kenneth Noland "derivative." As Peter Jemison, director of the Gallery of the American Indian Community House in New York said indignantly at a 1983 panel discussion, "It's OK for Picasso to take African masks, to take anything to make art, so it's OK for us too."

The widespread (and condescendingly named) "primitivism" trend in the art world of the early to mid-seventies originated in a certain nostalgia, even envy, on the part of non-Indian artists whose own ethnic backgrounds have been homogenized or melted down, who no longer have a "place." Yet despite the glorious traditional works that graced the Museum of Modern Art's recent "'Primitivism' and Modern Art" show, no contemporary Indian artist was represented.

I asked Quick-to-See Smith and Ramona Sakiestewa how they felt about the massive pillaging of international Native cultures in current white mainstream art. Ramona said, "I take anything from anywhere myself, so I can't really complain....Borrowing can be sort of good now, when everybody wants to sign their individual work in blood...so long as it's not blatant plagiarism." But she expressed disgust with "ethnic groupies" and "the generalized interest in an Indian mystique." Jaune said it made her "feel sad, because it's material we could be using, white artists can be objective about it, where Indians are subjective and not exactly sure how to draw on their backgrounds, because they are so much closer."

Maintaining spiritual contact with the past and with the meaning of their imagery, the artists in "Women of Sweetgrass, Cedar, and Sage" are trying to fuse that meaning with a contemporary form language. Living in and having to understand two or more cultures has given them particular insights into and openness to other "foreign" cultures. Karita Coffey's masks are inspired by African, Oceanic, and Australian Aboriginal traditions as well as by Native American sources. Sylvia Lark has found parallels between her Seneca background and Himalayan sherpas bound to their vast mountainous land. Her travels in Tibet inspired a series of paintings in which the dark reds and purples of cavelike spaces are lit by occasional glows, like the yak butter candles in dark temples.

Charleen Touchette, who is Blackfeet, writes movingly of her own upbringing in New England, in the French Canadian part of her family, as an affirmation of the historic alliance between French and Indians. She now lives in Arizona, in an area that has attracted people from many different nations because of its relative historical security; the Navajos, Hopis, and Pueblos, unlike most, maintain at least fractions of their homelands.

Some of these women's works appear traditionally "Indian" even when they incorporate techniques and symbols from non-American cultures, or when they mix motifs from different Native American tribes. Jody Folwell's

well-known pots retain some traditional elements, but she invents new forms and images that would be unrecognizable to non-Indians as new. Lillian Pitt's, Karita Coffey's and Edna Jackson's masks are made respectively from raku, burned and burnished clay, and handmade cedar bark paper. These techniques are either nontraditional or are not used traditionally. In some cultures, clay is not used by women. Masks are usually not made by women, and some Indian cultures have no mask tradition. Coffey's masks are made nonfunctional by their size as well as by their copper eyes and collared frames. Pitt says the raku technique adds "a special spirituality of its own" and that her masks "have no special ritual purpose but are to be consumed visually as my interpretations of ancestry." Jackson's haunting double masks are like ghosts of themselves.

Otellie Loloma's stoneware *Bird Woman* figure from 1962, with her beads and feathers, was an innovation that influenced many younger women (whom she taught at the School of the Santa Fe Institute) to create their own images. Rhonda Holy Bear makes her foot-high dolls from antique trade cloths and beads, the details reflecting intertribal trade of garments, beadwork, cloth, and jewelry. Mary Adams's baskets parody wedding cakes and create their own matriarchies, as one large basket becomes the "mother" of scores of tiny ones. Helen Hardin, whose "Woman Series" was made while she was dying of cancer, bravely stated her own identity as the daughter of Pablita Velarde, and thus the second generation of boundary-crossing women.

Silver has been a traditionally male medium, but women are crossing that gap as well. Many work with their husbands, fathers, or brothers, continuing traditional collaborative practices that diminish anxiety about authorship and connect to current feminist and activist practice. Among the most elegant and inventive silver jewelry makers in the Southwest today is the team of Gail Bird and Yazzie Johnson. They share equal credit for her design and his execution and their model is influencing other collaborating couples, as well as paving the way for more women's silver work to be recognized.

Photography as an art medium is quite new to most Native peoples—not only for economic reasons, but also because it bears a terrible stigma from postcontact days when government surveyors, priests, tourists, anthropologists, and white photographers "were all yearning for the 'noble savage' dressed in full regalia, looking stoic," in the words of Quick-to-See Smith, organizer of the first show of contemporary Native American photography. Photography for Indians, as it has been for women of all races, was just another vehicle through which they were made into objects.

Today, Indian photographers, including a number of women, are taking

the subject in hand. They are not only documenting their culture, but adapting photography to it. Carm Little Turtle's handcolored photos of male and female booted legs against an old wagon wheel, Kathleen West-cott's portraits of Indian people, and Jolene Rickard's studies of "dying" vehicles lovingly incorporated into Iroquois reservation landscapes all defiantly juxtapose old and new.

For this show, Rickard is combining for the first time her photographic work, her art director's training and technical knowledge, and her interest in the tactile, decorative beauty of the traditional arts. A large wall of light and photo transparencies is "dressed" with beadwork (commissioned from Penny Hudson) in order to redress a frustration she was beginning to feel with the simplicity and limitations of single-image photography. Combining other media seems to offer her a more effective way of conveying the beauty of different environments and the diverse peoples who live in them. Rickard would like to see her images as "icons representing for posterity Indians in the eighties and the varied ideas of the Indian heritage—like electronic storytelling, multiple cells, through the presence and power of light."

Native culture and especially landscape provide a spiritual matrix for much of the advanced art by Indian women. When a Native person is asked, "Where are you from?" says Quick-to-See Smith, it means, "What's your tribe?" "Going home" means going not where one lives or even where one was born, but to the place one's ancestors came from. The emphasis on texture and detail in so many of these women's works parallels the close observation engendered by long and loving familiarity with a specific place—and, by extension, with nature itself.

Many of these artists are concerned with what George Longfish and Joan Randall have called "landbase"—a term broader than landscape that includes "the interwoven aspects of place, history, culture, philosophy, a people and their sense of themselves and their spirituality, and how the characteristics of the place are all part of a fabric. When rituals are integrated into the setting through the use of materials and specific places and when religion includes the earth upon which one walks—that is landbase."[3]

Within this new tradition, artists give themselves permission to choose freely which older elements they will utilize for their art. For instance, nothing could be further from the crisp, linear, and decorative Tlingit tradition than Dorothy Romero's misty abstractions based on the mapping of weather patterns. Yet her choice to interpret familiar places in an unfamiliar medium makes her art no less "authentic."

The commitment to beauty, which Quick-to-See Smith writes about elsewhere in this catalog, is in itself a spiritual tradition and vehicle for strength.

In the past, Indian people subversively decorated their government ration cards and even made handsome beaded cases for them, symbolizing the enhancement of everything—even those things that might be read as negative. This is an original approach to suffering, related to the subtly political humor that has carried Native Americans through centuries of mistreatment and genocide. On close scrutiny, a current of gentle sarcasm can be perceived in much of the work in this show. Just as the artists' ancestors might have left marks on a rock to be read by those with the knowledge to interpret them, Gail Bird and Yazzie Johnson hide a pictograph under the clasp of a belt and Jolene Rickard superimposes on her black-and-white photographs tiny red painted ideograms that speak directly to her own people but are illegible to non-Indians.

Like so many feminist artists, Indian women consider process as important as final product. This view is multifaceted. Edna Jackson perceives her work as a creative process from its beginnings in the woods, where she collects bark from "old, old trees standing where women hundreds of years ago came to get their bark for weaving," to the final handmade paper relief. At the other pole, Spiderwoman Theater (Cuna Rappahanock sisters Lisa Mayo, Muriel Miguel, and Gloria Miguel) makes gloriously raucous montages of memory, outrage, and dramatic absurdity that give the erroneous impression of spontaneity, and touch a lot of raw nerves in the process.

The rituals of art-making resemble the rituals of tending to daily chores, the process of pressing and scraping animal skins or grinding corn. Kay WalkingStick makes abstractions with no recognizably "Indian" imagery, but she says that her time-consuming process of layering pebbles and wax is "ritualistic and emotive" and "implies a duality: contemporary in concept, yet primitive in application." Indian women weavers often welcome spirits with ceremonies of purification as they work. Gail Tremblay makes a ritual of constant work with her hands—"to know vision is everywhere and sensation dances beyond the edges of the skin." She parallels the reconciliation of cultural differences by using "materials with radically different textures, grains, natures."

The emphasis on detail and texture is often expressed by subtle decoration with natural materials, by "dressing" the art with feathers, buckskin, shells, bone, or glass beads. Jacquie Stevens takes traditional pottery forms and very gently, by visible *touch,* makes them both familiar and innovative, "dressing" her understated, voluptuous forms with buckskin inserts and tassels, an occasional bead or shell, and with the extraordinary matte, off-white surfaces that suggest a kind of buried pearlescence.

In Indian women's art, general cultural references tend to replace what

feminists have come to see as "personal, female imagery," although the circular awareness that underlies Indian spirituality shares elements with cultural feminist consciousness. (Non-Indian women have called upon Spiderwoman to oversee their networking and connective sensibilities, identifying with the Native American devotion to Mother Earth.) However, the traditional arts of quilting, embroidery, dolls, which many white women are now busy reviving or researching, were never lost by Indian women. Much of the work in this show is small, as is so much women's work the world over—a reflection of limited economics as well as of aesthetic conditioning and choice. So far, Indian women are not carvers, and even those who are university educated tend toward painterly images rather than to sculpture, with the obvious exception of those making pots, baskets, jewelry, and dolls.

JOLENE RICKARD (TUSCARORA)
Three Sisters, 1988
BLACK-AND-WHITE PRINTS AND COLOR XEROX, 16″ × 42″
Collection the Iroquois Museum, Howes Cave, New York

The three traditional sisters are corn, beans, and squash. Rickard lives on the Tuscarora Nation in New York State and her modernist photography is always focused on traditional and family subjects, informed by a deep understanding of the land and history where she was raised.

Another factor that has affected some of this work is Santa Fe's powerful Indian Market, which is entirely separate from the New York art world, though artists may participate in both. The Indian Market is a highly specialized network with an emphasis on "quality" traditional crafts. This imposes certain limitations, tending to discourage stylistic change, but the market also supports artists, many of whom sell literally all the work they can make.

The acculturated ambivalence about the color pink cannot be carried over

to Native women's work either. They look instead to another chromatic vocabulary that comes from their own environments—"the colors of bead-work, blankets, smoke, our own landscapes," says Quick-to-See Smith, whose oils fuse the painterly freedom of "new art" with haunting fleshed-out pictographs of horses, dogs, pots, or waterholes, and an almost tangible approach to space that reflects her own experience of place and history. "I've come across five hundred years," she says, "from being raised by a nomadic horsetrader father to being an educated woman with a master's degree." In the process, she has maintained the presence of her grand-mother, the first Quick-to-See, who "saw only inner worlds."

Women were an important part of Quick-to-See Smith's development. When she and Emmi Whitehorse were studying at the University of New Mexico, they had as teachers and friends the New York feminist painters Jane Kaufman and Harmony Hammond. Whitehorse, a Navajo, is an abstract painter whose deep-spaced, deep-colored paper works evoke a natural grandeur that recalls her homeland for anyone who has been there. The colors in the "Kin' Nah' Zin'" series come from her grandmother's weavings, the forms come from her father's branding mark and the gouges in wooden gates that record her family's sheep herds.

Whitehorse's sense of space also emerges from the Navajo traditional arts, especially the curative sand painting, or dry painting, where frequently there is no "top or bottom" to an image that exists horizontally, like the land itself, and is comprehensible from multiple viewpoints. (Her abstrac-tions extend another boundary-crossing tradition within her own nation; in 1964, Despah G. Tut Nez wove in sixteen pieces a complete Navajo Beautyway chant based on the dry sand paintings, and it has become a con-temporary classic.) Whitehorse is also paying homage to the utilitarian and wearable art objects of her people: "My hope is to put blankets back in their original place of honor, rather than on the floor."

Tapestry artist Ramona Sakiestewa sometimes wishes her own woven textiles were *used* more often, but rugs hung on the wall are more highly valued than those on the floor, "so I've been forced into a 'nonfunctional' role, though it's really up to the people who buy: the work is floor weight." She likes to leave her striking geometric hangings unsigned, as a protest against the exaggerated individualism of high art; at the same time, she does not call herself a weaver because "it sounds like hobby arts or Sunday crafts"—and Sakiestewa is unquestionably a professional.

Sakiestewa personifies many of the contradictions faced by Indian women artists today. A Hopi (whose mother is Irish), she says she never thought about being either an Indian or a woman when she was growing up, and still resents having to think about it. Yet she recently spent nine months re-

creating an Anasazi turkey-feather blanket by ancient techniques for the
Bandelier Museum, and incorporates historical petroglyphs into some of her
tapestries. An articulate, self-assured woman who has lived and studied in
New York and traveled widely internationally, she enjoys subtly destroying
the "Indian woman" stereotype in a few minutes of conversation. As a
cofounder of Atlatl, a leader of SWAIA, the only Indian president of the
Indian Market, and a member of the board of the Wheelwright Museum,
she is unarguably a role model for emerging women artists, as are all the
women in this show. Sakiestewa herself has been very influenced by older
Indian women, and she claims an "inverse snobbery" about being a woman,
because Hopi women run their families: "There is a spiritual strength about
Indian women."

This is abundantly clear in "Women of Sweetgrass, Cedar, and Sage."
These artists have struggled against difficult economic and domestic situa-
tions, against race and gender discrimination. Armed with humor and
beauty, they have overcome the obstacles, educated themselves in both the
old ways and the new, and have developed an art that maintains spiritual
contact with the past while opening new doors for the future. Beyond indi-
vidual creation, these artists are empowering their own sisters and teaching
others about the realities of Native life. They are providing a significant
meeting ground for cross-cultural interaction, helping non-Indians make the
leap into an art that in its many-layered language recalls values the rest of
the United States seems to be in the process of forgetting.

Out of Turn

According to Michele Wallace, the only "tradition" available to the black female critical voice is that of "speaking out of turn." Out of turn, outside the dizzying circle of white and male discourse. It says something about the one-dimensionality of this country's view of African American culture that such a salient facet of feminism—itself central to social change—is so little known, that to speak of it is still to speak, and to write, out of turn, out of history. Wallace has been on the cover of *Ms.*, on the Donahue show, in *The New York Times,* and so forth. Yet her second book is justifiably called *Invisibility Blues.*

It is a selection of essays from 1975 to the present, and, logically, visibility is its focus. Wallace is preoccupied with the cultural representation—negative and positive—of the seen-but-not-heard-from black woman, whose dilemmas she makes tangible. As she explains it:

> We are always trying to speak simultaneously of the experience inside the
> wrong race and the wrong gender in a culture that persists in seeing the
> problem of each as mutually exclusive....The problem with feminist
> theory, in general, is its failure to be concerned with palpable alternatives
> to conventional living arrangements because of its fondness for generaliza-
> tions that will encompass us all. The problem with black feminists is the
> tight space they are forced to occupy as the "other" of both black men and
> white women, who are "Other" themselves....

Rejecting the notion that cultural production can simply reverse racist assumptions (thereby subjecting itself to racism's rule), she raises complex

Reprinted from *Transition,* no. 52 (1991). This essay is a review of Michele Wallace, *Invisibility Blues: From Pop to Theory* (London/New York: Verso, 1990).

questions of internal colonization, the internalization of racism, and, especially, issues of visual representation in mass and popular culture (but rarely in high culture). Wallace cites the high visibility of black women (as models, singers, and so on in mainstream culture) compared to "their almost total lack of voice." ("The more famous and successful Alice Walker becomes, the less we seem to hear from her directly.")

As granddaughter to Zora Neale Hurston's "specifying," sister to bell hooks's "talking back," Wallace has been speaking out of turn for over a decade now. In 1979, as the youthful author of the iconoclastic *Black Macho and the Myth of the Superwoman,* she was gawked at by the mass media, attacked by June Jordan, lauded by Julius Lester, and became the catalyst for public controversy over black sexism and the disillusion of the post-Civil Rights Movement generation. The resulting furor in the black community wounded her, and the healing process took several years of frustration and failure. Since the mid-eighties, however, Wallace has become a well-known cultural critic, and one of black feminism's major spokeswomen, seeking "new and unoccupied spaces for subversive literary and cultural production." She retains the outspoken honesty that made *Black Macho* such a sensation while adding to it a new level of maturity and scholarly seriousness that has not subdued her wit.

I remember Michele Wallace in 1969–70, when she was a quiet, pretty teenager, a member of the Art Workers' Coalition and WSABAL (Women Students and Artists for Black Art Liberation). The group was led by her mother, the fearless feminist artist Faith Ringgold, and affiliated with Ad Hoc Women Artists. We were protesting the Whitney Museum of American Art for its pathetic showing of women artists and artists of color. All of us were feeling pretty bold and feisty, but few if any of us understood how much braver the black women on that picket line had to be. Ringgold, Wallace, her sister Barbara, and a few others were not only bucking the white high-culture system, but as avowed black feminists collaborating with white women they were also going up against the psychological grain of black power and most of the black community.

This is the story Wallace tells in the first section of her book, "Black Feminism/Autobiography." "I've always been my own favorite case study for considering the systematic obstacles to black feminist articulation," she says. Her early writings are high-spirited, colloquial, and (like the later ones) courageous. Wallace says she writes consciously to

> challenge, tease, entertain, educate and enlighten the woman I think of myself as having been when I wrote *Black Macho and the Myth of the Super-woman.* I see that woman as being at the intersection of "white" and "black" culture and "high" and "low" culture, virtually blinded by white liberal

humanist and black nationalist discourses to other ways of seeing the world
and other ways of reading texts.

While the blindness has been replaced by a lucid enchantment with critics
like Hortense Spillers, Henry Louis Gates, and Fredric Jameson, Wallace
still oversees that crossroads. As a black feminist, she knows several sides of
the color line—from black nationalism to white feminism to the Left to
a potential multiculturalism. As a middle-class university professor, she has
to cope with the bafflement of her (often working-class) students when
confronted with the intricacies of cultural criticism. As a self-described
"black Socialist intellectual," Wallace has come down in different places at
different times of her life, but she is always burdened with the knowledge of
how another sector thinks. *Invisibility Blues* is both confined (she never really
addresses the pressing question of cultural communication with the so-called
underclass) and enlightened by her ambivalence. Her position at the cross-
roads is finally to her advantage. Too many white feminists have never even
crossed one street.

Autobiography is not confined to the book's first section. Snatches of
life continue to shine through "Pop" and "Culture/History" until the final
"Theory" section, and it too is clearly informed by lived experience.
Wallace's background is important for both personal and political reasons.
She is a northern urban woman, third generation of her family in Harlem,
uninfluenced, as she puts it, by the "roots (geographic or medicinal)" that
inform the work of so many black women writers who were raised in, or
are close to family in, the South. Her mother was not a poor woman strug-
gling to retain dignity, but an outspoken student, teacher, then artist and
activist.

Wallace's mythology lies in Harlem. She constructs her own identity in
terms of her impressive matrilineal family. Throughout Wallace's writings,
one senses a complex—though loving—relationship and a difficult weaning
process from her talented, strong-willed mother. "My childhood evenings
were often spent in a circle of women, drawing, cutting, sewing—making
things," she recalls about her middle-class upbringing in the apartment
Dinah Washington had lived in. (Middle-class, but not so middle-class as she
once thought, says Wallace in an aside.) From seventh grade she attended
the mostly white and private New Lincoln School.

Faith Ringgold was familiar with Kenneth and Mamie Clark's black and
white doll tests, and when in 1961 she led her female family (two daughters
and her mother) on a grand tour of Europe's art treasures, she bought a
black doll at the Galeries Lafayette in Paris. At home the girls were even
given a brown crayon to take to school so they could color faces properly.
Wallace's grandmother—Willi Posey—worked in a garment factory down-

LORNA SIMPSON
Counting, 1991
PHOTOGRAVURE WITH
SILKSCREEN, 73″ × 38″
Photo: Ellen Page Wilson,
courtesy Josh Baer Gallery
and Brooke Alexander
Editions, New York.

Simpson juxtaposes
numbers—time
("9 A.M.–1 P.M." "310
years ago"), materials
(1,575 bricks), and
activities ("25 twists,
70 braids, 50 locks")—
with a woman's partial
and shadowed bust, a
round brick building that
suggests the slave trade,
and a spiraled braid.
Labor, patience, mourn-
ing, and anger subtly
confront the viewer
head-on.

town, but at home in Harlem she was fashion arbiter and dress designer; until her death she collaborated on Faith Ringgold's "soft art" and story quilts. Wallace's 1984 essay, "The Dah Principle," is a lyrical praisesong to her family's female creativity, inspired by the (then) newest member, her sister's daughter, Baby Faith.

"Memories of a '60s Girlhood: The Harlem I Love" and "Anger in Isolation: A Black Feminist's Search for Sisterhood" are filled with poignant glimpses into a Harlem coming-of-age, though hardly a typical one. Wallace writes about the hair ethic/aesthetic and how "being feminine *meant* white to us" (thanks to the pervasive media image of beauty); she writes about reclaiming her life as a sixteen-year-old in 1968 under the rubric of black consciousness, about an abortive stint at Howard, and being "in the front row" at City College's first women's studies course. But she was also being informed "of the awful ways in which black women, she included, had tried to destroy the black man's masculinity....The new blackness was fast becoming the new slavery for sisters. I discovered my voice, and when brothers talked to me, I talked back."

So the seeds of *Black Macho* were sown. Wallace relates the painful tale of attempts to organize a black feminist movement, and her early (later reconsidered) concerns with sexism, with "the quality of our psychological and emotional lives in interaction with black men" to the exclusion of racism and political/economic injustices. Her development is illuminated by a later discussion with Ntozake Shange about the terrible lack of role models for black girls, and the "affliction of specialness" in the black middle class: "Middleclass black women are slow to identify with each other's problems. We're all so special."

From where Wallace sat in the sixties and seventies, there was a power struggle between the feminist movement and the male-dominated Black Power movement and she was caught in the middle. It was not a struggle that affected most of us in the women's movement; in fact, we white socialist feminists tended to see ourselves as black men's allies, unconsciously leaving black feminists in the lurch. Wallace was also warned that white feminists were using black women, and it was only later that she was forced to concede the truth of those claims. These are problems that have still not been worked out between black and white feminists, and if ever there were a time to tackle them, it is now, when the abused but crucial concept of multiculturalism is getting a hearing. In 1975, Wallace wrote wistfully, "Perhaps a multicultural women's movement is somewhere in the future." But in a recent interview, she warned against the shallow multiculturalism that conflates different cultural groups and does not acknowledge class, gender, generation, immigration history, and so on.

Wallace does not waste her fire on rhetorical clay pigeons, but aims straight at the sacred cow (or bull). She takes on Spike Lee's (negligent and negligible) treatment of women in his films; she opposes the beatification of a few black women novelists, and she is not afraid to criticize Alice Walker or Toni Morrison even as she admires them. Grateful but ambivalent about Henry Louis Gates's benevolent monopoly on black cultural criticism, she calls him the "phallic mother of a newly depoliticized, mainstreamed, and commodified black feminist literary criticism," citing his "academic feminist ventriloquism."

The "Pop" section of *Invisibility Blues* is sassy, sarcastic, and, while more distant or externalized than the other sections, it builds natural bridges between pop, literature, and life. Wallace tackles the movie version of *The Color Purple* from her seat in a theater in Oklahoma (where she taught for two years), "surrounded by white people in baseball caps and cowboy boots." She nails music videos as hybrids that "not only sell us what we expect to be free, namely our own private and unfulfillable desires," but make it "impossible to distinguish between the genuine mass appeal of an artist and the music industry's simulation of that appeal." Michael Jackson is viewed from the vantage points of black modernist angst and black post-modernist apathy, "in which the critique of racism is effaced by the autism of aesthetic demonstration." She perceives *Do the Right Thing* as "a symbolic substitute for a riot this summer," and chides the director of *Mississippi Burning* for swallowing "white left-liberal conceptualizations in which economics is privileged over racism." She observes ironically that "the most sympathetic and interesting black male character I've ever seen in a movie"—John Sayles's *Brother from Another Planet*—"was entirely unable to speak in any language." Analyzing Jesse Jackson's 1988 convention speech (and his use of the female figure therein) as an example of ruptures with the dominant culture that can be created by a dynamic popular culture (as opposed to mass culture), she writes, "It was representation, not substantive political change, that scored the victory here." I wish her recent writing on women's rap music and sexism in the hiphop scene could also have been included.

Although I think it was very wise of Wallace not to become an art critic, her homegrown ability to decode visual images has been useful to her media criticism and would also be invaluable if applied to contemporary art by her generation of black women artists. If she knows the trials of black writers, she is also aware of the still more excruciating tortures reserved for the black artist in the world of white art and precious objects. I wish she would join more often Judith Wilson, Lowery Sims, Leslie King Hammond, and Kellie Jones in writing about black women's art, especially the postmodernist (or whatever) strains—not to mention the white artists on whom her skills could equally importantly be brought to bear.

Art critic or no, one of the best essays in this book was written for a cata-
log of Tim Rollins and KOS. It is also one of the best essays written about
this much-written-about group, precisely because it comes from a skillful
cultural critic. Wallace deals thoroughly with all the social and ethical
aspects of the extraordinary process by which a young white artist came to
enter into long-term collaboration with black and Latino youths labeled as
"learning disabled," and how they found six-figure success in the art world.

It is the "Culture/History" section that fleshes out the skeleton Wallace
repeatedly (and sometimes repetitively) constructs with her biographical
references. The major theme, with which the book begins and ends, is
"negative/positive images" of African Americans—especially women. She
considers the lack of women of color in positions of power in the media and
academia a "cultural crisis of the first order." Made aware of the taboo on
internal criticism when Ntozake Shange's *For Colored Girls Who Have Consid-
ered Suicide* was attacked for "attacking" black men in 1976, she is also able
to confront the fact that "so-called 'negative images' will probably be neces-
sary" to the "restructuring of prevailing images of 'race' and 'ethnicity.'"
The issues get increasingly complicated: "Black and white, male and female
exist in asymmetrical relation to one another; they are not neat little oppo-
sites to be drawn and quartered. We recognize the persistence of such
measures in our narratives in order to dismantle them in our lives."

Wallace dissects Ishmael Reed's "female troubles" firmly but surprisingly
kindly (noting his competition with white feminists, who in turn overcon-
demn him):

> In the "real" world, the black male has obviously had a hard time politi-
> cally and economically, but he has repeatedly portrayed his difficulty as a
> ritual of castration....For the upwardly mobile black male intellectual,
> role reversal is neither tenable nor entertaining....Reed attempts to
> displace only the color of the center (like trying to peel the white off
> snow!).

Having "read her life in feminist terms," Wallace wrote in 1987 that
every day she was less certain of any definition of feminism: "Surely it is
process, ethos, movement, archive and article of faith all at once." I have
harped on autobiography here not only because Wallace does, but because
there is a hunger among white progressive feminists to "know" our black
counterparts better, even when we must acknowledge that they have proba-
bly been wise to withhold their secrets from us. I hope this book—and bell
hooks's *Yearning*—is read by all those white feminists who wonder why
black women won't identify with us against a generalized patriarchal world.

Wallace quotes Ntozake Shange as saying that black feminist creativity is
like "half-notes scattered/without rhythm/no tune." But that was years ago;

today we are beginning to hear the beat, the tune, and the words of the Queen's "Ladies First." Yet the burden of development is still on the shoulders of black feminists. Most white feminists criticize black women's writing gingerly, if at all, since all but the wisest attempts tend to be seen as either offensive or defensive. Wallace says that "when race is addressed by feminists in cultural studies, it is usually subsumed by class. As a result, feminist academia, as well as the feminist intellectual left, reinscribes the same racist exclusionary criteria as do white, male-dominated academics and left intellectuals."

Yet for all of its cantankerousness (most of it practical, some of it scathing, none of it didactic or unfair), *Invisibility Blues* is a warm book, even a hopeful one. Simultaneously confident and vulnerable, full of hard-earned insights into American culture and un-starry-eyed evaluations of the available role models, it is the unfinished saga of a proud outsider trying to make a place for herself and her sisters. Writing about Sherley Anne Williams's novel *Dessa Rose,* Wallace says that what excited her about it was "its definition of friendship [between a black woman and a white woman] as the collective struggle that ultimately transcends the stumbling blocks of race and class. If the creative writer can't dream these dreams, who can?"

Art in a Multicultural America: An Interview with Lucy R. Lippard by Neery Melkonian

This interview was facilitated by Ms. Lippard's visit to Santa Fe on May 4, 1990, where she was invited by the Institute of American Indian Arts to give a talk on contemporary multicultural art, the topic of her forthcoming book [Mixed Blessings (New York: Pantheon, 1990)]. Later that evening she delivered a public lecture, "Toward a Post-Columbian World," at the Museum of Fine Arts. The questions below, particularly those related to making multicultural issues and representation integral to the agendas of the dominant art world, incorporate concerns that were expressed during the discussion sessions at both lectures. Recent developments in world events reveal that decision makers can no longer carry on by ignoring peoples whose voices history conveniently tends to neglect. This interview is an attempt to encourage dialogue toward the creation of a more balanced worldview.—N.M.

Neery Melkonian: In the context of your forthcoming book, who do you define as a Third World artist, who is the subject of your study?

Lucy Lippard: The subject of my book—*Mixed Blessings: New Art in a Multicultural America*—is not contemporary Third World art per se, but rather the cross-cultural process, illuminated within a series of themes and circumstances by artists from the major communities of people of color in the U.S.—African, Asian, Latino, and Native American. Some Native Canadians are also included, since national boundaries are irrelevant to Native peoples.

NM: Could you talk about how the previous work you had done on women artists and on spirituality in art has helped you to write Mixed Blessings?

Reprinted from *Artspace*, Sept.–Oct., 1990.

LL: The work I've done on and with women artists (some of them women of color) since 1970 was helpful politically and emotionally; the experiences and the resulting analyses helped us understand the way we live in a dominant culture that disenfranchises so many of us. Racism and sexism (and we could add homophobia) are in some senses, as the old slogan goes, "same

VALERIE SOE
STILL FROM *All Orientals Look the Same,* 1986
BLACK-AND-WHITE VIDEOTAPE
(90 SECONDS)

As a panoply of men's and women's faces flash by, the stereotypes implied by the title phrase are literally turned on their heads. The viewer is provoked to confront the contradictions inherent in his or her own prejudices and misconceptions about Asian Pacific Americans.

game, different name." But they aren't really the same, so while there are a lot of parallels between the social conditions surrounding feminist art and art by conscious, militant gays and artists of color, as well as between art by white women and artists of color in general, the differences are as important as the similarities. I've been able to use feminist activism as a framework, but have always had to keep in mind the shifting relationships between race, class, and gender.

My 1983 book, *Overlay: Contemporary Art and the Art of Prehistory,* wasn't on

spirituality as such, but it turned out to be a spiritually important project for me personally, and apparently for some readers too, since it involved the origins of art, religion, language, and concepts of nature. Its relation to *Mixed Blessings* is more educational, since it broadened my view of the world, of culture and history, and of the role of public or communal art. I've said elsewhere, and often, that for me the political and the spiritual are both acts of faith. Like art, they move people, sometimes quite literally.

TOMIE ARAI
Framing an American Identity (DETAIL), 1992
SITE-SPECIFIC INSTALLATION, MIXED MEDIA, DIMENSIONS VARIABLE
Photo: D. James Dee; courtesy The Alternative Museum, New York.

The installation consists of luminescent Asian portraits framed by bamboo, chopsticks, fans, silk cords. Some of the images are the dominant culture's stereotypes, others are historical or from family albums. As a third-generation Japanese American, Arai is still conscious of being an "other" in North America, and her often public art challenges the imposed identities.

NM: Why this particular title? How did you choose it?

LL: The title just came, very early on, and I knew it was right for the book I hadn't even written yet. It took longer to figure out the structure and actual

content, and the title was a factor in getting them together. The book incorporates, as do all interesting subjects, a lot of contradictions. In this case, given the double-edged past of rape and colonization, and the double-edged future of a new and freely mixed world of "parallel cultures," there is a certain ambivalence about the advantages and disadvantages of difference. There are the possibilities of a richer culture with changing demographics, and the fearful racism that seems inevitably to accompany them. Then in the art world there's also the tension between cultural pride and the desire for recognition as artists like everyone else, the conflict between money and aesthetic integrity, and the individual dilemmas about where to draw the lines between acculturation and transculturation, isolation, and separatism and cultural apartheid. What all this provides is a liminal space in which all hell can break loose. The writings of the Mexican American performance artist Guillermo Gómez-Peña are the most powerful statements of these "border" states of mind.

And then of course there's the mixed blessing of a white woman taking the familiar colonial role of putting all this material together. I still find myself, paradoxically, speaking for others whose voices I am hoping to make heard. To introduce some polyphony, there are a lot of sidebars in the book—quotations from artists and writers of color—which sometimes contradict each other and me. In the introduction I say I am writing in what James Clifford has called "that moment in which the possibility of comparison exists in unmediated tension with sheer incongruity...a permanent ironic play of similarity and difference, the familiar and the strange, the here and the elsewhere."

After a year or so of holding the title in my mind, I found Rachel and Paul Cowan's book called *Mixed Blessings,* which is about Jewish/Gentile intermarriage. Despite some pressure to change my title, I couldn't. It was already too imbedded in the book and changing it would have meant changing the book itself. The subtitle, on the other hand, changed endlessly; I was finally persuaded to use the word "multicultural" instead of "cross-cultural" so more people would get it. "New Art in a Multicultural America" also makes a probably too-subtle point since "America" in most people's minds still refers hegemonically to the U.S. alone instead of to the whole hemisphere, as it should. I meant the singular "America" to show that this is only one of the "Americas." While the art in the book was made in the U.S.A., it is distinctly "American" in its broader sources and references.

NM: Within the diversity of expression among artists of color, are there any common threads?

LL: Yes. That's why I chose to organize the book in themes, so there wouldn't be such a separation of cultures, and to get it off the survey track.

On the other hand, similarities and dissimilarities are part of what the book's about; they are equally important. Another built-in conflict is between cultural references and stereotypes—where one stops and the other starts. And of course try as I might to avoid it, I may be guilty at times of stereotyping, or of overemphasizing the cultural attributes and backgrounds cited by the artists, and underemphasizing the common ground.

NM: You pointed out that art centers continue to be sources of racism, despite the fact that here and there the mainstream is including Third World artists/artists of color. What is the basis for such imbalanced representation and how do you explain the occasional inclusions?

LL: The basis for unequal representation is purely and simply institutional and cultural racism. Most institutions—public, nonprofit, and commercial—simply don't know about the breadth and depth of art being made by people of color, although the current multicultural boom is taking care of some of that. It's a conspiracy of ignorance as much as anything, but that ignorance is inexcusable in this day and age. The increasing visibility of so-called minority artists is due primarily to the long-term hard work of grass-roots cultural groups with specific cultural or multicultural constituencies—community centers, alternate spaces, and direct political protests like the one taking place in Santa Fe. Those in power won't be motivated to change until they are forced to confront issues that they think don't affect them.

There's also been a push from the theoretical end by a new generation of articulate and angry writers and artists in the last decade, often looking to models in the revolutionary Third World like Frantz Fanon, Amilcar Cabral, C. L. R. James, or Eduardo Galeano. (No accident that they're all men; Rigoberta Menchú seems to be in a different though certainly not less important place.) In the last few years we've seen a number of large and small, national and local exhibitions recognizing the contributions of Latino, Native, and African American artists, with Asian Americans less clearly perceived as a group so far, though that work too is being done now. As with the women's movement, this is the way into the mainstream, for better or worse. Once the institutions have a larger pool to choose from, even without going to the communities themselves, then things start to move. One of my pet peeves is those curators and critics who say they just don't *know* any artists of color; I and a number of other people get called constantly for lists of artists of color who do this or that kind of work. The same thing went on for years with women artists. I wish the institutions would get out there and do their own work firsthand. There's a lot of leg-work to be done before the head work will be satisfactory.

For the most part, however, it is still white people doing the selecting,

from our own cultural viewpoints, and that's got to change. Every group show, every issue of a magazine, every panel and lecture series should include artists of color as a matter of course, and they should be asked to talk about all kinds of issues, and not just those related to culture and "race." One hopeful event was this summer's "Decade Show" in New York, jointly organized and selected by the Museum of Contemporary Hispanic Art, the Studio Museum in Harlem, and the New Museum of Contemporary Art. Nilda Peraza, MoCHA's director, says in the catalog that we really need to work toward "the creation of a very generous and open art environment in this country, one that will allow and accept artists from all backgrounds, without stereotyping and pigeonholing."

NM: The mainstream often uses notions such as "quality" to explain their exclusionary practices. This in turn furthers the marginalization and ghettoization of what is different. What are the disadvantages and advantages of artists of color who produce within such boundaries?

LL: The whole notion of "quality" is class-bound. It has come to mean simply what the ruling class has decided they like. They have claimed this turf; they have become the only people who can identify this elusive "quality." And since we were all educated in that mode, the conditioning is hard to shake off. But in fact, "quality" varies drastically among classes, cultures, even genders. To paraphrase that old New Yorker joke, "One man's fish is another woman's poison." Yet cultural differences, when they are perceived at all, are recognized only in a hierarchal sense, on a kind of sliding scale. That's when people come to be grudgingly called "one of the best women artists," "one of the best black artists," and so on. Again, to a limited extent, this works in favor of the ambitious artist of color, but the "glass ceiling" exists here as in the non-art world. The Great Artists are still white males.

NM: How does the ethnicity you have come to understand differ from the predominant definitions?

LL: I don't claim to have redefined ethnicity. What I've learned is the infinite variety and constant flux within this country and within each of the cultural groups in the book, each of which is made of different nationalities, language bases, immigrational generations, religions, politics and so forth, not to mention the obvious individual aesthetic diversity. The generally monolithic cultural view of people of color is the counterpart of "they all look alike." They're all supposed to make art that's alike too. I'd like *Mixed Blessings* to help expand the view of what these artists are doing inside and outside their own definitions of ethnicity. I keep stressing the fact that this book is not a survey. There are reproductions of work by only two hundred

artists, and they had to be chosen with a certain amount of anguish from
about a thousand artists I've seen and/or know about. I chose them for the
usual thicket of reasons, including fairly even distribution between groups,
genders, geographies, but primarily relating to the themes I discuss.

The chapter headings are "Mapping" (the introduction), "Naming,"
"Telling," "Landing," "Mixing," "Turning Around," and "Dreaming" (a post-
face). The five central chapters respectively deal with: self-representation
and stereotypes; family, history, religion, storytelling; place and displace-
ment; intercultural connections and *meztizaje;* irony, humor, and subver-
sion. There are a lot of terrific artists I couldn't fit into these chapters, and
others I found out about too late, but it's a beginning, and we can hope this
is not the last such book.

*NM: What motivated you to write this book? When did you begin to be interested in
this subject?*

LL: Well, originally in the sixties, then of course continuing through the
feminist movement and work with the Heresies Collective, especially,
"Racism Is the Issue." I've known Howardena Pindell, Adrian Piper,
and Faith Ringgold since the sixties, and their work really made a lot of
feminists think about ethnocentrism in the women's movement. The
"Nigger Drawings" show in 1979 and the protests and organization of Art
Against Racism that ensued were also eye-openers and a personal water-
shed in which I began to move still further away form the liberal art
world. In 1978–79 there was a brief and very dynamic coming together of
young black, Latino, and white artists from the Lower East Side and the
South Bronx that preceded and merged with the much-hyped East Village
art scene.

At the same time I was working with PADD (Political Art Documenta-
tion Distribution), and we were doing some multicultural work with our
shows, our magazine, actions, and Second Sunday forums. In 1982, I got
involved with the Alliance for Cultural Democracy, a national liaison group.
ACD really opened my eyes to what was happening in progressive theater
and art outside of New York. Through my working partner Jerry Kearns,
who had worked with Amiri Baraka's Anti-Imperialist Cultural Union, the
Black United Front, and CAFA (The Committee Against *Fort Apache*—the
racist Paul Newman movie), I learned a lot about grass-roots organizing.

Around the same time—the early eighties—I got involved in the North
American solidarity movement with Central America and learned a lot
about intercultural organizing by collaborating with the Salvadoran artist
Daniel Flores Ascencio on various projects, including Artists Call Against
U.S. Intervention in Central America, which, with Art Against Apartheid,

introduced me to a lot of strong artists of color. I mention all of this in detail because I was really disturbed to see the short view of history rolled out in the "Decade Show" catalog. Even within the categories of "activist art" and "socially conscious" art, these activities and others of equal vitality in the early eighties have already been forgotten.

HUNG LIU
The Raft of the Medusa, 1992
OIL ON CANVAS, LACQUERED WOOD, MIXED MEDIA, 61″ × 96″ × 8½″
Collection Barbara and Eric Dobkin. Photo: courtesy Steinbaum Krauss Gallery, New York.

The punning title on the great Géricault painting of shipwreck survivors is applied here to colonialism. The image is taken from a historical photograph. These melancholy Chinese women have been cast adrift in Western-style clothes, vessel, and art. Liu herself left China only some ten years ago, and in her work she wittily scrutinizes the differences between her two worlds.

Anyway, I'd been interested in Latin America for a long time and decided to focus on this hemisphere—the intercultural mixings and the indigenous influences and movements. I'd recently been in Cuba, Nicaragua, and El

Salvador, and I was intrigued by ways the modern, traditional, and indigenous were being combined in the new art there. At that point I wanted to do a book on Central American culture and the ways the very different history and politics of each country had affected the arts. André Schiffrin, my publisher, suggested that the themes I was into related to the Caribbean and even to all of Latin America and that I shouldn't limit myself geographically. While I was pondering that (and my lousy Spanish), life interfered, and for family reasons I wasn't able to travel as much, so over the next few years the book wobbled all over the place and came to rest in the U.S., which was plenty big enough. I had collected a massive amount of material by then, and had worked in tentative political coalitions with cultural workers of color. I knew I wanted to deal with racism and ethnocentrism and religion and land and political art, but I couldn't find a structure for this bizarre amalgam. For about two years I struggled with that—a new experience, since usually my books almost form themselves. Finally, with the help of dreams and the *I Ching,* I found the armature and wrote the thing.

But the real "motive" was the fact that over the last thirteen years I've become increasingly interested in the fusion of politics and the spirit. When I looked around for the artists who best expressed that vision they were overwhelmingly often people of color.

NM: Certain artists of color who have been away (sometimes for centuries) from their Third World origins reject categorization. They feel constraints of identities offered to them both by their original and host communities. They identify with other postcolonial cultures scattered in exile or in diasporas. As a result a "Fourth World" culture is in formation, one that crosses national boundaries and expresses concerns for the global community. Do you view this development as an alternative, or is it too utopian in ideology?

LL: I don't think it's too utopian. Very little is "too utopian" for me, so long as the ideas are backed up by actions. The larger the vision of a "Post-Columbian World," the better. The troubles are vast so the visions might as well be too.

The "Fourth World" usually refers to nations within nations, indigenous peoples who are surrounded by a more dominating culture of invaders. But there is certainly a global community of postcolonial exiles, and their perspectives tend to be broader than those of monocultural people who've stayed in one place. The British magazine *Third Text,* edited by Pakistani-British artist Rasheed Araeen, is doing a great job of getting some of those ideas out. I think a lot of people are trying to conceive a syncretic view of the world, and a new syncretic art for which the Caribbean is a model.

New ideas and images are genuinely disturbing to the dug-in mainstream, which prefers to control its "borrowings" from the Third World rather than see the birth of a new and powerful hybrid whole. Writers and artists of color are breaking out of (and into) the dominant structures by critiquing them. White intellectuals are having to do a lot of homework, learning to step back and let Third World thinkers call the shots on things they know best. Finally there are an increasing number of symposiums and magazines in which that dialogue is heating up *among* the various communities of color and progressive whites, and not just *between* "us" and "them." The Euro-American West has to learn to see itself as simply Another instead of The Other.

THINGS I NEVER TOLD MY SON ABOUT BEING A MEXICAN

YOLANDA LOPEZ
Things I Never Told My Son About Being a Mexican, 1984–94
MIXED MEDIA INSTALLATION, 9′ × 12′
Photo: courtesy the Museum of Contemporary Art, San Diego

Lopez, who has long been an integral and activist member of the Chicano art community in San Francisco, has made a video tape and an installation on the subject of stereotypes and denigrating images of Mexican Americans, collecting them from North American popular culture.

NM: In recent years Western critical thought has opened up new arenas of dialogue for Third World cultures, particularly related to issues of identity and difference. Are there areas where these discourses fail?

LL: Obviously Western critical thought fails insofar as it fails to listen to and interact with the people it theorizes about. It fails when it lays its own intellectual "crises" on other areas where they are irrelevant. It fails when it gets tangled up in academic language and territory that limits its audience, obscuring the issues instead of clarifying them. It fails when it is apolitical. No matter how intelligent the ideas are, it fails—and I see this in the art world around activist art as well—when those concocting the ideas are out of touch with the actual practice. I'm horrified when someone whose writing I respect turns out never to have *heard* of major artists of color who have been showing in New York for years.

NM: As an Anglo art writer and curator you have played a significant role in introducing the marginal to the mainstream. What remains absent is the Third World artists having negotiating powers within the institutional spaces where culture is validated. Do you think we will witness a change in this situation in the nineties? What will bring it about?

LL: Aesthetic developments are a lot less predictable than the market manipulations. Until the 1992 celebrations and anticelebrations of Columbus's accidental invasion of the Americas are over with, I think there will be a certain momentum. A lot of us are following the lead of the Submuloc Society, begun by Native American artists in Montana, to reverse and rename the existing Columbuses, in the real and metaphoric senses.

These shows and actions will be particularly important in the Southwest, which is always bragging about its "tricultural" base. It's a good moment to rewrite history from more varied perspectives and envision a very different five hundred years to come. After that, it will, as usual, be a matter of hanging in, keeping up the pressure, and fighting the inevitable backlash when those who feel they own the center would like to see usurpers go back to the margins.

There's always a tendency in the art market to make "movements" out of newly visible work, followed by a kind of planned obsolescence when interest in the novelty peaks and then diminishes. If the pattern set by women's art is followed, it will depend in part on how responsibly the survivors who "make it" act in relation to those who are still outside the folds. There has to be continuing support for those coming along by those with power in and out of the community. Enduring coalition-building is also going to be important. The art world is a political entity, for all its general dislike of politics in art.

The desirable alternative, of course, is that real understanding and acknowledgment of depth and variety develop during the period of fresh interest, so that art by people of color is finally accepted as just plain art. This is already in process, as you suggested in your question about the diaspora. There are already plenty of artists of color who are trying to transcend (and sometimes to reject) their specific cultural ground, along with others who never acknowledged it at all.

This is a delicate situation for a conscious artist who doesn't want to denigrate or abandon her or his heritage but is feeling constricted by its public image, who wants to expand it into the larger culture, without losing its positive elements. There's a debate going on now about "Post-Chicano Art," for instance. Although I think the term "post" is a mistake (as in "post-feminism," which implies that political consciousness is no longer necessary), the debate is important to ensure that the art of any group isn't kept imprisoned in the past or in an implied *sub*culture. Cherokee artist Jimmie Durham has written about such dilemmas: "The story about us [Native peoples] is so complete and closed that any attempt at intervention is seen as minor entertainment....There is an ocean between showing and being included in the discourse....Postmodern pluralism can be a new kind of lookout."

NM: Most art writing does not reflect the multicultural nature of our society; can you suggest ways that the progressive publisher, editor, and art critic might go about altering this situation?

LL: We need to hear the voices of those who are living multiculturalism, whether they are in or between cultures, including the dominant culture. And that includes all of us. The more we know about ourselves the better equipped we are to comprehend other angles. Although listening and looking are the bottom lines, editors, publishers, critics, curators, and universities have got to practice affirmative action. The notion of even self-imposed quotas is much resisted in the art world, where "freedom" (for some) is taken for granted. And tokenism is always a danger. But the fact remains that there is a lot of good art being made and little effort to seek it out and consider it within the institutional frameworks. For years, I've always made sure my shows and articles represented white women and artists of color as well as white men. Contrary to popular opinion, this process doesn't bring things "down to the lowest common denominator." The work is good and it's out there. Sometimes its inclusion does complicate matters and change my initial idea, usually for the better, because when more people are heard from, the issues become more complex.

Although it's always best to begin locally, it's also important to bring in

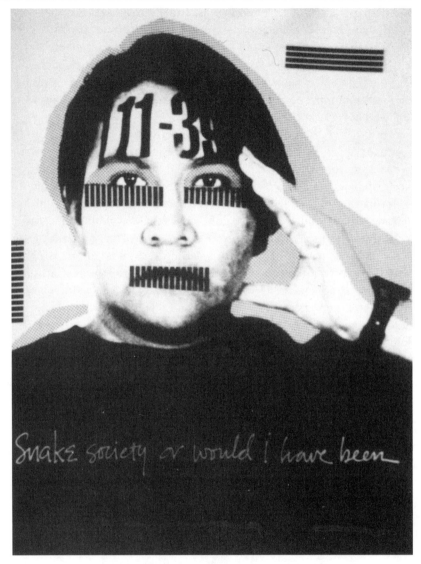

HULLEAH TSINHNAHJINNIE (CREEK, SEMINOLE, NAVAJO)
CENTRAL IMAGE OF TRIPTYCH *Would I have been a member of the Nighthawk,
Snake Society, or would I have been a half-breed leading the whites to the fullbloods?*, 1991
PHOTOGRAPH, 40″ × 30″

The number on her forehead is Tsinhnahjinnie's tribal registration number, a
comment on the Indian Arts and Crafts Board Act of 1990 (to which she is opposed)
that forces Native artists to be officially identified as such or give up their public
identity. She is also drawing parallels between these numbers, which ignore the
complexity of Native identity, and those given Jews in the concentration camps
during the Holocaust.

visiting artists, lecturers, traveling shows, so the models get broader, stronger, and more diverse. Again, the next couple of years, because of the Quincentennial, is going to be a good time to push for these things. In the long run, it's up to artists to work for changes both inside and outside of their art, because nobody else cares as much about what happens to artists as artists do.

NM: As a writer within the establishment, what kinds of issues confront you in dealing with both worlds?

LL: All of the above. Since the late sixties I've seen myself as a "sniper" (I write a column in *Z Magazine* called "The Sniper's Nest") in relation to the establishment. I'm not an art world insider anymore, but I had a few years of acceptance in the mainstream before I got more interested in the tributaries, so I'm still able to get my shots in here and there. Hilton Kramer once paid me the compliment of saying that I once was a pretty good writer until I "fell prey to the radical whirlwind" and lost it. (Of course, *I* think I *found* it.)

I only live four months a year in New York now, so my experience of the art world is decentralized, different on yet another level when seen from Colorado or isolated in Maine. My concerns have become a good deal more national than they were for the twenty-eight years I was a provincial New Yorker, although I was always interested in so-called regional art. I'm increasingly drawn to the complicated issues and images within contemporary Native American art (in the hemispheric sense) because of its "political spirituality," humor, irony, fusion of so-called high and low cultures, and alternative views of the natural. But I don't wannabe a wannabe, so I have to figure out—or *we* have to figure out—if there is a place for me to work in that context that won't interfere with the fiercely guarded sovereignty that has given Native peoples the strength to survive. So I'm not dealing with "both" worlds, but with a fragmented perspective from—but not in—several worlds. Which is in fact where a lot of artists of color find themselves too.

Undertones:
Nine Cultural Landscapes

Although there is a long history of women artists who have—
for better and worse—identified with and been identified with nature and
land forms, there are very few female photographers included on the rolls
of old or "new topographers." Men have dominated the field of landscape
photography just as men have dominated the land itself. Thus "shooting" a
"virgin" landscape has been man's work—hunting, not gardening. It is as
though "the outdoors," especially in the western United States, is the only
remaining male sanctuary among the domesticated interiors of both home
and workplace. While large numbers of women photographers have gath-
ered outdoor images, their failure to impress the art and journalism markets
suggests that landscapes are still perceived as trophies from the battle of
culture with nature.

Perhaps the calmer, more intimate approach to "nature" (whatever that
is) offered by many women artists is not exciting enough to appeal to a
public taste formed by the dramatic spectacles of the BLM (Boys' Landscape
Movement), by the banal beauties of *National Geographic* and the glamorous
oranges and blues featured in *Arizona Highways,* all of which constitute an
aftertaste of frontier heroics in which the bigger the land looked, the bigger
the men who conquered it were reflected. If Laura Gilpin's loving portraits
of the West,[1] Marilyn Bridges's aerial views of ancient civilizations and
sacred places, Joan Myers's images of southwestern landmarks, Lyn Davis's
monumental interpretations of landscape and ruin, and Linda Connor's
formal evocations of time and place have received a certain acclaim, they
have not been permitted even to play Eve to the two generations of Adams
(Ansel and Robert).

This article will appear in *Reframing Photography* (ed. Diane Neumaier), forthcoming
from Temple University Press, Philadelphia.

Only recently have women photographers in North America been cutting their own paths into the land-mined "wilderness" of landscape photography, and they have not done so as an influential group but as isolated individuals—unnamed, perhaps in their diversity unnameable—responding to and critiquing their own cultural circumstances as echoed in the environment. Although most of these artists are feminists, their work is not necessarily "feminist landscape."

What would it be, anyway, a "feminist landscape"? Something intimate and comfortable—either the opposite of the Marlboro man's domain or a subtle intervention therein? A landscape seen as the body of a woman? A critique of the landscape photography made by men? A critique of landscape art or "landscape" altogether? The creation of or the dismissal of the notion of gendered landscapes? Postcolonial vignettes? Analyses of the politics of space? Or just the stuff that men aren't doing?

Or perhaps the "feminist landscape" is an acculturated landscape. Landscape is where culture and nature meet, though both terms are problematic. Photographers dealing with the whole rather than the parts will turn to the landscape of culture, which defines place and its meaning to people rather than *viewing* everything from the outside. People (and their ideologies) are often left out of art and criticism about land, the landscape, and place.[2] Landscape must include the results of the ways that land is formed by social relations and the ways social relations are formed by the land.[3] (The scape, or scope, is broad indeed, ranging from archaism to futurology.)

Few of the women whose work I discuss below are even landscape photographers in the conventional sense. They are doing something else. First and foremost, the not-quite-yet-extant feminist landscape tends to include people, although people may or may not be included in the pictures. The focus is the seen from the inside, from the viewpoint of people familiar with it rather than recording its otherness. At the risk of being accused (yet again) of dread "essentialism," I'd say many women photographers, like many women public artists, tend to be more interested in the local/personal/political aspects of landscape than in the godlike big picture, and more attuned to the reciprocity inherent in the process of looking into places.[4] Their approach might be called vernacular.

Most of these artists have been led into the political from personal concerns. They are more likely to picture the ways in which landscape is a collective and interactive production—the land affecting those who land on it, and vice versa, offering clues to the cultures that have formed it. This does not exclude acute social criticism, and it most certainly includes an awareness of power relations as the agent of spatial production. In almost all of their work there is a dialectic between compassion, memory, continuity,

connectedness on one hand, and, on the other, the looming shadow of an ominous future imposed by forces uncontrollable or uncontrolled (acts of god being secondary to acts of greed). But even when the message comes through loud and clear, the undertones are often as important as the overview.

The intercultural contributions that have opened up a certain cross-ventilation in the arts over the last decade have also shed new light on the incredibly complex politics of nature and place. A major part of the cultural ecology is our relationships to each other, as well our mutual relationships to place. These are linked by social privilege and spatial distribution; to be ignorant of one is to misunderstand the other. If only Euro-American history is studied, the place remains hidden. A culturally inclusive (or a culturally specific) landscape aesthetic is only beginning to be revealed. Until there is increased access to education, equipment, and distribution for a broader economic spectrum of women, the picture will be partial.

Because the ground for this subject is still in a rough state, and generalizations are dangerous in such an early stage of discussion, I am going to pursue these ideas through specific images by specific artists. One of my own first inklings of these issues occurred in the early eighties, when I heard Jolene Rickard speak about some photographs she had taken on the Tuscarora Nation, where she was raised. They depicted old cars and trucks rusting away amid weeds and shrubs, and what she said about them completely reversed the Euro-view of such remnants as a "blight on the landscape." On the reservation, she said (I'm paraphrasing from memory), these old trucks were honored reminders of their function, returning slowly to "nature" (with less self-consciousness, I'd add, than the old boats and bathtubs used as planters in white people's yards). Their parts having migrated to other vehicles, they were there for the same reasons an old horse, no longer useful, might be pastured until its death.[5]

Another Native American image that has influenced my thinking is a photograph by Hulleah Tsinhnahjinnie (Navajo/Creek/Seminole) from her *Metropolitan Indian* series of the late eighties. A handsome Native woman dressed in traditional Plains buckskins is mounted on a horse on a rounded California hill overlooking a freeway. Although she is of course *there*—a point being made by the image—the effect is that of a collage: the "vanished" Indian superimposed on the "modern" landscape that has replaced the decidedly vanished Native landscape. The emphasis is less on beauty and nobility (although they too play a part) than on survival and, in other pictures in the series, on the near-invisibility of the urban Indian population within the spaces created from their own lands.

While conventional landscape is rare in modernist Indian art,[6] the land on

which Native people live or once lived remains primary; its presence, spirit, and beauty—often presented with humor or irony—is ubiquitous. (Tsin-hnahjinnie herself only shoots "pure landscape" of Navajoland in slides, for home consumption rather than as art.) The role of the landscape in this image might be assumed to be peripheral, a mere background. Yet place is a consistent subtext, as important as the handsome figure; a displaced person proudly re-placing herself is a central theme of the whole series.

Patricia Deadman's "Beyond Saddleback" is a series of portraits of nature blurred in movement. They contain some of the mystery of a bush moving in a sudden breeze, subtly conveying the fact that the movement is internal, taking place within the landscape, within the glowing trees and shadowy mountain or thicket, rather than externally imposed by a modern time sense, a hurried photographer, an uninterested passerby.

In fact, Deadman does not move her lens but manipulates the photograph while printing, shifting it four times to achieve a curious combination of focus and lack of focus. She prints her black-and-white images on color paper, causing an additional imbalance or loss of equilibrium, as Theresa Harlan has pointed out, and challenging "the notion of the familiar a step further by reminding us that if we stray from the path or underestimate our environment, we can easily become lost and confused, and thus vulnerable."[7] The process permits relatively ordinary images to take on an extraordinary emotional intensity, drawing the viewer into the pulsating scene. Deadman says she intends "to monumentalize these ambiguous qualities, in order to recognize the sublime and the elusive in the experience of landscape."[8]

Deadman (who is Tuscarora, raised on the Six Nations Reserve in Canada) made her earlier work at powwows, where motion and energy were also her subjects. Painting over small photos of dancers, she stirred up hidden rhythms with flurries of paint, sucking the figures into colorful abstract whirlwinds that transcended physical movement to reach for the spirit and meaning of Indian people dancing. Although landscape per se is absent from these images, and photography itself is only the point of departure, they presage the "Saddleback" series by suggesting connections between the human heartbeats and those of the terrain being activated by the dance. Dancers and landscape are made indistinguishable, which is also the philosophical point, as time and place are blurred into a timeless and placeless energy zone.[9] In some of these works, Deadman is also "commenting on the women participants and their role in dance and in traditional Native society," representing "a positive link with the past…the stability that holds cultures together."[10]

Family history and culture is at the heart of Marlene Creates's recent work about place as repository of memory. Her early work involved peopleless places, slightly altered prehistoric sites. In 1982 she made *Sleeping Places, Newfoundland*—twenty-five black-and-white photographs depicting the matted grass where Creates bedded down in her sleeping bag while traveling alone. She saw them as "one more layer, a mark, laid upon the thousands of other layers of human and geographic history on the surface of the land."[11]

During a sojourn on Baffin Island in 1985, Creates solicited directions from local people and was taken by two strikingly different maps of the open tundra, made by a white man and an Inuit man. The former depended on labels and the latter on contours and topographic features. This was the beginning of a piece called *The Distance Between Two Points Is Measured in Memories,* in which Creates worked with elderly country people displaced into towns or cities, setting up a counterpoint between lived space, recalled space, and "natural" space.[12] One of her intentions was to resurrect human history, to dispel prevailing images of Labrador as "a pristine untouched wilderness where there is no one and where no one has lived."[13] There is another layer to the piece as well. The nostalgic coziness of place gives way not only to the melancholy of lost pasts but to the threat of more drastic change. In the 1940s, an air force base was established in Labrador, and since a NATO agreement around 1981, militarization has increased with vast bombing ranges and low-level flying of which few Canadians are aware. This is the ominous, untold background theme of the apparently intimate stories recounted.

People, and the ways their narratives are told and remembered, become the mediums through which place is perceived and are also the subject of Creates's ongoing series called "Places of Presence: Newfoundland Kin and Ancestral Land." It is focused on "three precise bits of 'landscape'" where her grandmother, grandfather, and great-grandmother were born. Aside from the personal aspects of this "poetic inheritance," Creates's photographs also reveal "a pattern of land use in rural Newfoundland where land has been passed down from generation to generation, divided into smaller and smaller pieces among sons and nephews and, with some interesting exceptions, inherited by daughters."[14]

She compares these stories and photographs to "a net that was set up at one point in the flow of people, events, and natural changes that make up the history of these three places." They are palimpsests, impressed with lost or barely recalled histories. The images themselves are most evocative when a trace remains, such as the flowers her grandmother planted in a garden long since gone "back to nature."

. . .

Carrie Mae Weems "went looking for Africa" in the "Geechee," or Gullah (from Gola, Angola), community off the Georgia coast. In her 1992 installation *Sea Islands,* the landscapes might be seen as incidental to her postmodern folklore, but that would be missing the point where the two come together. As the daughter of Mississippi share croppers who migrated to Portland, Oregon, in the fifties, and as a trained ethnographer long involved with African American folklife and inspired by Zora Neale Hurston, Weems pictures places that are entirely acculturated. It is not the history of their colonization that concerns her, but the maintenance of culture, and of a powerfully different sense of place and nature beneath colonization. Weems has frequently used family history as a lever into general black American experience, which has often been land-based even when land-deprived. Like Rickard's and Tsinhnahjinnie's art, hers is also about survival, integrated with the land on which the process "takes place." In a way, the culture *is* the landscape in these photographs, even when the landscape itself is a very real presence, an integral part of the whole enterprise. Recognizably "southern" (live oaks and Spanish moss), the land and the buildings are the containers of imported knowledge—ancient, elusive meanings that incorporate the terrible oppression of displacement. One of the most evocative images is that of huge old palm trees at Ebo Landing, where a cargo of Ibo men declined to be slaves and walked back into the sea to their deaths, saying, "The water brought us, the water will take us away." Some of the trees stand solid and straight, others sway and are about to fall.

People occasionally appear and disappear like the phantom child in Julie Dash's film *Daughters of the Dust.* Even without them, the landscape is clearly a lived one, a place filled rather than emptied of meaning. The cool, matter-of-factly documentary format of the images does not bely this undertonal layer but offsets it, as do the cryptic texts, which are less captions than parallel poetry, sharing the lucid understatement of the images:

> "I went looking for Africa" and found "A bowl of butter beans / on a grave / newspapered walls /for the spirits to read / rice in the corners / a pan / of vinegar water / up under the / bed."

Weems elevates "superstition" to spirituality—"the opening up of yourself." "How do you get closer?" she asks. "How do you spin in and unravel?"[15] By going to the local source, her "Sea Islands" show provides new ground for contemporary black artists' scrutiny of their historical and spiritual roots—from "picturesque" brick slave houses to hubcaps on the lawn (providing a "flash of the spirit" to repel evil spirits), to a bedspring in a tree, literally imbedding culture in the landscape. At the same time, there is a political task yet to be done. Weems feels she needs to add something

that might help fend off the impending threat of suburban golf courses to this ancient culturated landscape.

In the late eighties, Masumi Hayashi made panoramic photocollages of Superfund sites in the postindustrial midwestern landscape. Her recent work concerns similarly infamous locations, but now they are particularly pertinent to Asian Americans, and to her family—Angel Island, where her grandmother came as a "picture bride" and her own birthplace, the Gila River Relocation Camp. "Having been born in a concentration camp, this series has ties to my birthplace and the struggles my family members have passed through."[16]

Beginning with the personal—Gila River—Hayashi moved into a series of works on nine other internment camps, marking a historical moment when, as she says, "racism and nationalism outweighed moral judgment, civil liberties and logic." She has heard the testimony of those who experienced these places, including in her installations audio interviews with survivors, friends, and relatives.

"All of these buildings are abandoned; some evoke the feeling of archaeological ruins."[17] In an amnesiac late-twentieth-century society, works like Hayashi's constitute social archaeology. There is, as J. B. Jackson suggests, a "necessity for ruins."[18] Hayashi's photographs convey a relationship between the metal, concrete, wooden ruins and the desert landscape that differs from an external perception of the scene as simply picturesque, melancholy, historical. Perhaps because of her personal involvement, Hayashi has downplayed the eerie beauty of the place, while creating desolate sculptural parallels. The dramatic skies also evoke the site's ominous history. She is not picturing the power of "nature" to transcend that history so much as insisting on the remains to tell or cue in the stories that Asian Americans know but not enough other people have heard or remember. Her griddedphotocollage technique, which sometimes includes double images of one form through slight overlapping, and may allude to scientific mapping techniques that filter our views, also suggests the multiple viewpoint of traditional Asian landscape aesthetics, or the double-exposure quality of memory itself. You the viewer are not quite "there"; your vantage point is disturbed, in transition, potentially catastrophic. Beauty is used to draw the viewer into a politically contested space.

Landscapes often appear in Caroline Hinkley's gridded works about "the authority problem" as terrains of psychic terror, but only as equal elements within a hermetic whole. A longtime scholar of landscape and photography who has taught environmental design, Hinkley's interests lie in exposing the

dominance of the masculine gaze and its corollary: the exclusion of women from representation as subject. She quotes Michele Montrelay's notion that women are "the ruin of representation" because they have nothing to lose and their exteriority to Western representation exposes its limits.[19]

Hinkley lists her devices for the dismantling of cultural and ethnographic authority (what she calls "visual swipes" at men in suits, uniforms, robes): repetition of symbolic gestures and objects, appropriation, seriality, truncation, amplification, and reduction. Her usual format is six or nine horizontal photographs, most of them appropriated, apparently unrelated, connected by details or closeups that totally revise their meanings. The landscapes, although reduced to the scale of "everything else," tend to determine the (usually dark) mood. As a lesbian, Hinkley also slyly confuses gender and gender references as subtle (almost invisible) digs at the dominant culture and its scenic overlook.

There are three landscapes in *Death of the Master Narrative* (1991): clouds almost hiding a bare slope, mountains with dramatic sky, and a volcano. Each one is a striking image in itself, but here they are subordinated to the whole with its political allusions. All the pictures in this piece are appropriated from *National Geographic,* the epitome of imperialist pictorialism, the master narrative. (Having played god to the extent of moving pyramids and rearranging sunsets on a cover, *National Geographic* is fair game for feminist appropriation.) Three decontexualized landscapes (one a different view of another) are triangulated with three views of the Catholic priesthood. In the lower right, several priests (one with a particularly sinister face; one with a gap-toothed smile, a minor reference to the stereotypical lasciviousness usually applied to women, as in Les Blank's film) sit around an altar featuring the Madonna, whose force lines lead up into the steaming volcano above. At lower left, two young monks stare up at a stuffed dog (mascot of the St. Bernard hospice monastery) who might be awaiting his master's voice or might represent the moribund rigidity of the master narrative. Above, a closeup of the dog's feet from this picture locates the gaze and two ominous shadows. Aside from the formal power of these juxtapositions, they communicate an equally forceful message: man's thwarted desire for control over nature and spirituality. The distant clouds, rugged mountain landscape, and angry volcano imply its defeat.

The feminist photographer who has thought and written most about, as well as practiced, a postmodern landscape photography in relation to local political histories is Deborah Bright. In an attempt to move the ailing documentary photography tradition into a more precarious and layered place, she has worked primarily with installation and "textual landscapes," beginning in

1981 with the "Battlefield Panorama" series, in which history was recalled through texts that made the vicious events of the past rise from bland images of the now domesticated grounds on which they were fought.

Bright's turf is the apparently innocuous landscape charged by its history. In *How the West Was Won (Caution—Do Not Dig)* (1987), ordinary color photographs are made subversive by texts that explain the political contexts and reveal the ideologies underlying what happened there. The story begins with General Groves of atomic bomb fame reminiscing about having been brought up in the West early in this century and worrying that there was nothing left for *him* to conquer. The cowboy gods were to offer up a reward for such faith in manifest destiny and he became top administrator of the U.S. nuclear program, managing the world's first nuclear reactor, which was installed in 1943 some twenty miles from Chicago; around 1950 it was bulldozed under what is now "parkland."

Bright's piece is bracketed by two "rustic" stone monuments, one commemorating the landmark and the other admonishing CAUTION—DO NOT DIG, while insisting in smaller print that "there is no danger to visitors." In between are the Groves texts and the landscapes. Nancy Gonchar writes that "what is most compelling about this piece is the spareness of the information displayed, in contrast to the enormity of the project and its implications for the future." She points out, however, that "the visual image becomes the backdrop for the unfolding text."[20] There is a certain, deliberate, bloodlessness about the overall installation that stems, perhaps, from the fact that form, text, and substance are in reaction to the dominant culture and therefore mirror its emphasis on objectivity at all costs.

In Bright's brilliant writings on the history of the arranged marriage between photography and nature, she interrogates her own and other photographers' work by questioning the ideologies perpetuated by all photographs and by asking "in whose interest they were conceived; why we still desire to make and consume them; and why the art of landscape photography remains so singularly identified with a masculine eye."[21]

In "Elements of a New Landscape," Rebecca Solnit, the other major feminist writer on the subject, writes that "as an analysis of entrenched structures of belief, feminism reached far deeper to disrupt the binary relationship around which the culture organized itself"; and "the explosion of the bomb is the moment when two traditions of thought collided: the world of dead fragments of Descartes and Bacon and the world of interconnected systems of quantum physics, of ecology, and later of postmodern theory" (to which I would add feminism).[22]

Feminist landscape and the bomb do seem deeply connected, not just on

a theoretical level, but also on an emotional one. From an eco-feminist viewpoint, the brutality with which the new weaponry treated "Mother Earth" has been viscerally felt by women (already culturally charged with "horticulture," maintenance, nurture), whose bodies had so long been identified with the hills and valleys under siege. (Neil Smith has coined the composite "M/Other Nature."[23]) Power, but not necessarily the balance of

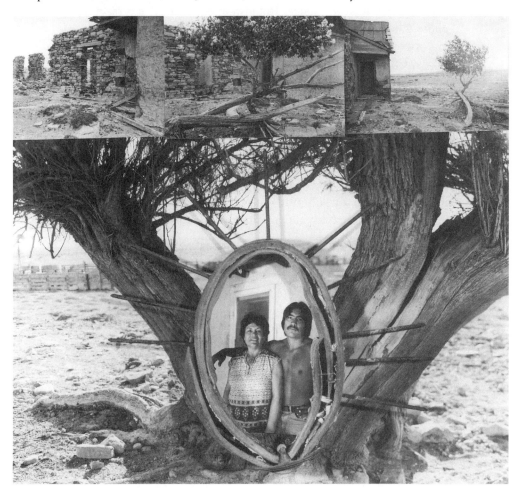

MERIDEL RUBINSTEIN
Delpha Graham and Son, Progresso, N.M.
FOUR EKTACOLOR PRINTS WITH OBJECT IN SHADOW BOX, 1982–83

For the New Mexico Photographic Survey, Rubinstein chose three sites (a Native American pueblo, an Anglo ranch cluster, and a rural Hispanic village) through which to examine the marks of time on people and structures. "These remarkable places," she wrote, "seemed to exist at once in the past, present, and future, each with its own fiction as well as its own reality."

power, is the key to looking at almost every "natural" landscape, and power is always a feminist issue.

For several years now, Meridel Rubinstein (in collaboration with performance artist Ellen Zweig and videographers Steina and Woody Vasulka) has been working on *Critical Mass,* a multimedia installation about the cultural intersection around Los Alamos of the terrains and territories of Native America and nuclear science. Rubinstein comes to this project after years of photographing northern New Mexico and its inhabitants. Her "world-shaking" narrative is centered on the story of Edith Warner, the "Woman at Otowi Crossing," a refugee from the East who in the twenties moved to a cottage near the Rio Grande and became close both to the Pueblos at San Ildefonso and to the top-secret-ridden inmates of Los Alamos. A number of crossings are the subject of this work, and the Rio Grande runs through it. A vortex is established between two ways of experiencing land—nothing so simple as the past versus the future.

Rubinstein's landscapes reflect two conflicting belief systems entangled in power, doubt, fear, and beauty on a cosmic scale. Her work is usually multipartite, layered, offering multiple viewpoints on a subject or place, interweaving disparate realities. The *Critical Mass* images combine portraits, still lifes, and landscapes. As Rebecca Solnit has observed, Rubinstein's photography

> postulates a kind of subjective nonfiction that dissolves the distinctions between the personal and the documentary, the made and the found....Photographs—and by extension, witnessing and vision—are revealed as far more complex phenomena, shaped by the artist and viewer as invested participants....All of Rubinstein's work of the past decade can be said to describe a world that shapes its inhabitants as they construct it, and to explore the resonance between place, action and belief.[24]

Broken Landscape (1990) includes not people but cultural artifacts. It is a panoramic view of bare hills in the Pajarito plateau interrupted by a picture of an old jail cell, the horizon line moving from exterior and back out again; below these three rectangles is a long, low, horizontal (but still suggestively phallic) missile, serpentlike and needle-nosed, lurking in the underworld, a virtual subtext. This is a landscape "broken" in several senses. Its lunar appearance (not a tree in sight) suggests that the land might have been subjected to nuclear testing. The prison suggests the fate of the land—cordoned off from its own past and from ordinary life—as well as the fate of those protesting the nuclear enterprise and those who would suffer from a disaster.

. . .

The paradox buried in the late-twentieth-century landscape is that earlier ruminations on the sublime and cosmic natural beauty have given way to a discourse about poisons. The beauty is still there in many cases, but it has been (often literally) undermined. Carole Gallagher's book *American Ground Zero: The Secret Nuclear War* and Sharon Stewart's *Toxic Tour of Texas* take on the future.[25] These two projects witness the parallel destruction of people's lives and the land they live on. Devastating indictments of the willful disregard for both by the powers that be—public and private, governmental and corporate—neither project can be done justice in this short space, since the information behind the pictures is as significant as the images. The voices of victims, witnesses, and activists (sometimes the same people), as heard in interviews, echo through the vast spaces surrounding them: downwind (mostly in Utah) from the Nevada Nuclear Test Site in Gallagher's work, which also includes atomic veterans and test site workers; waste disposal sites all over Texas in Stewart's.

Texas, Stewart points out, is indeed biggest and best in some distressing categories: its industries discharge "the highest level of toxic air in the country"; it has "the largest concentration of oil refineries and chemical plants in the nation...[and] ranks first in the amount of known or suspected carcinogens in the number of hazardous waste disposal sites, seventy percent of which leak and threaten groundwater."[26] The guides on her "tour" are "farmers, priests, mothers, ranchers, engineers, nurses and teachers intent on protecting their land, their children, their homes and their communities." Each photograph, some of them of apparently bucolic vistas, others of people, is accompanied by grisly testimony. For example, in the haunting image unpoetically titled *Chevron's 160 Acre Uranium Mill Tailings Pond. Contents: Six Million Tons of Radio Active Waste and Chemical Solvent,* a branch fence, partly submerged, leads symbolically from a foreground littered with empty drums into the lethal waters, toward the far shore of this contemporary Styx.

Gallagher's book (also an exhibition) was begun in 1981, when she dropped out of her life as a SoHo artist and rented a basement room in St. George, Utah. She remained in the area for most of eight years. This monumental decision to embark on a private antinuclear humanitarian crusade was inspired by her discovery of some declassified Atomic Energy Commission documents from the 1950s and a quote from Francis Bacon cherished by Dorothea Lange, a documentary photographer's credo:

> The contemplation of things as they are, without error or confusion, without substitution or imposture, is in itself a nobler thing than a whole harvest of invention.

In the documents, Gallagher found the people living downwind of the

Nevada nuclear testing site described as "a low-use segment of the popula-
tion." Mormon Utah was apparently chosen as a sacrifice area because its
religious/patriotic (and extraordinarily naive) population wouldn't question
the government that planned to kill them, their livestock, and their land.
(Eisenhower is alleged to have said, "We can afford to sacrifice a few thou-
sand people out there in the interest of national security.") Until recently,
the perpetrators' calculations were, tragically, correct.

It is the rural Mormon culture that emerges from the faces, surrounding
landscapes, and texts. Gallagher's photos primarily document and take
testimony from the people dying and dead from unheard-of types and rates
of cancer, some of whom still can't or won't believe that their government
would do such things to them. As a feminist, Gallagher makes sure that
women get equal time, citing, for instance, the ways women with all the
symptoms of severe radiation sickness were diagnosed as neurotic or having
"housewife syndrome."

The last section of the book includes the images of some heartrendingly
beautiful landscapes, all profoundly contaminated. These include the animal
cages near ground zero at Frenchman's Flat (atomic veterans have testified
they saw both animals *and humans* chained in cages on this site of twenty-
seven detonations), an abandoned schoolyard, condemned sheep ranches,
downwind grain elevators and fruit orchards, still functioning, still in our
lives, still "out there" in the silent West, described in a 1950s magazine,
Armed Forces Talk, as "a damned good place to dump used razorblades"; this
scorned land has become a vortex of crucial issues, since much of it is still
legally owned by the Western Shoshone, who feel differently about it.[27]

"Death by geography," comments Gallagher. Her book, like Stewart's
tour, is a call to action. She details the despicable history of court cases
against the government ("the fox guarding the chicken coop"), but *American
Ground Zero* should help blow the door off the closet in which these scandals
have been kept. Although the landscapes she pictures are in the West, she
also quotes an air force colonel who told her "there isn't anyone in the
United States who isn't a downwinder."

The loss of paradise has been a constant theme in American art at least since
the end of the nineteenth century. And the farther we get from "paradise,"
the less we are connected to the land we live on and the less we understand
how it came to be as it is. Geographers have argued that to "explain why
something occurs is to explain why it occurs where it does."[28] Landscape
itself might be defined as place at a distance, framed with some objectivity,
whereas the concept of place leans to the subjective, the intimate, the
marked, the recalled, and by implication, the female. Annette Kolodny has

written that American women have inhabited a metaphorical landscape that they had no part in creating and "to escape the psychology of captivity, women set about making their own mark on the landscape, reserving to themselves the language of gardening."[29] Judith Fryer writes poignantly about the "felicitous spaces" created by Willa Cather and Edith Wharton—intimacy centered in vastness, defined by a sensuous expansion from visual perceptions to information learned from touch, smell, sound, the better to perceive "a world in flux, of connectedness."[30]

However, outside of literary criticism, analyses of contemporary gendered space have usually focused on home and workplace, urban and suburban experience.[31] While intimacy has been women's (socially constructed but not entirely evil) terrain, less attention has been paid to women's perception of "open" space and place outdoors—in the public domain or in less circumscribed locations defined by an artist's eye. Temporal and spatial distance within photographic images is a crucial element in this new arena. The psychological ambiguities of spatial interpretation have further confused research into landed desire.

Do women photographers still reserve "the language of gardening"? If interior divisions have to do with labor and childbearing/caring, does landscape invoke freedom and is freedom still by definition a masculine reward? Are women psychologically excluded from the Great Outdoors by constructed (sexual) fears? How do acculturated spaces perceived from the inside differ from the views from the outside?

The forms society makes and takes when overlaid on what's left of nature are preeminently artistic turf. The challenge now is to translate segregation and exclusion from interior to exterior through the eyes/lenses of women. Through the work of the women discussed above, among others, a different set of lived experiences of land and place is edging its way into contemporary aesthetics, exposing the deeper layers of life that form a cultural landscape.

> A whole history remains to be written of spaces—which would at the
> same time be the history of powers...from the great strategies of geo-poli-
> tics to the little tactics of the habitat.[32]

Endnotes

Changing Since *Changing*

1. Most of this book was written from 1966 to 1968; proofs were completed early in 1970.

2. In fact, I did write two short pieces on individual women (aside, of course, from many reviews of women's shows in *Art International* in 1965 and 1966), both in 1968. They were on Irene Siegel and June Leaf.

3. "Excerpts," from "After a Fashion—The Group Show," *The Hudson Review* (winter 1966–1967), in *Changing*, pp. 205–206.

4. The Bowery Boys (my term; we all lived on or around it in the early 1960s) were Robert Ryman, Sol LeWitt, Robert Mangold, Frank Lincoln Viner, Tom Doyle, Ray Donarski—and Eva Hesse, Sylvia Plimack Mangold, and me. They differed not only in aesthetic but also in political attitudes from the Greenberg artists and their mentors, some of whom, for instance, were in favor of the war in Vietnam.

5. Judy Chicago, *Strait* (Buffalo, Feb. 1973).

6. In conversation with the author about this introduction.

7. Judith Stein, "For a Truly Feminist Art," *The Big News* (California Institute of the Arts) 1, no. 9 (May 22, 1972), p. 5.

8. Shulamith Firestone, *The Dialectic of Sex* (New York: Bantam, 1971), p. 157.

9. See Carol Duncan, "When Greatness Is a Box of Wheaties," *Artforum* 14, no. 2 (Oct. 1975), pp. 60–64.

Sexual Politics: Art Style

1. An optimistic statement, given the vicissitudes of this course. After two more years of administrative hanky-panky, the women's course was finally set up, thanks to continuing protests from students and teachers. [In 1994, it still exists; May Stevens has taught it for years.]

2. *Art News* (Jan. 1971); this so-called woman's issue was also blown up into a book that, incidentally, took its name, unacknowledged (like this article, titled by the editors), from Kate Millett. No other American art magazine has done a special issue on women since.

3. The Guggenheim Foundation has changed little since this was written, maintaining for years, despite complaints from the outside, an apparent "rule" of one female painter or sculptor a year; recently it has gone up to two or three. The National Endowment, on the other hand, has improved a good deal. [From a 1994 vantage point, so has the Guggenheim Foundation.]

Prefaces to Catalogs of Three Women's Exhibitions

1. Women critics have taken their lumps, too; for example, Clement Greenberg once wrote: "What did in all the lady art critics with the triple names was the collapse of Abstract Expressionism....The delusion persists you can talk about art as you can about matters of fact or scientific situations. You can't and that's why there's so much crap talked and written about art and why someone like Miss Lippard can be taken seriously..." (quoted from an interview in *The Montreal Star*, Nov. 29, 1969).

2. Hardly the result, however, in the first women's show I did, at the request of Larry Aldrich, who later told *The New York Times* (May 30, 1971) that "he didn't see anything in it he wanted to buy." This was untrue, for he had attempted to purchase one difficult-to-transport piece at such a cut rate that the artist preferred to destroy it rather than let him have it. He also refused to have slides made of the show, as he customarily did of all other shows in his museum, and claimed a "first-time incidence of money-back requests from the public." Although this was the first women's art show since the resurgence of the women's movement, it was never reviewed in the art press.

3. The Women's Art Registry, founded by the Ad Hoc Women Artists' Committee in the winter of 1970–71, now occupies a space of its own at the nonprofit gallery Artists' Space in New York City. It provided the model for other WEB registries in other cities, and more recently, for mixed-gender artists' registries all over the country.

4. WEB now has groups in twenty-two states and eleven foreign countries. It was originally founded to keep the early groups in Los Angeles and New York in touch with each other—thus the title.

5. The Rip-Off File, a publication of statements of exploitation by art-world women, published by an independent group of women artists with the help of the Ad Hoc Women Artists' Committee; it was also made into an exhibition.

6. I have been suggesting, unsuccessfully, for several years, that women students not only assure their own futures by demanding more women teachers, more direct role models, but also implement this demand with a boycott on payment of tuition, which should cripple schools with largely female student bodies.

7. The series began at the suggestion of and with the encouragement and inspiration of Joan Snyder; it has been organized each year by Lynn Miller and Naomi Kuchinsky. The library was chosen as an alternate exhibition space when the regular school art galleries refused to show women. [1994: The Women's Art Registry is now housed in the Douglas/ Rutgers library.]

Fragments

1. This increase was largely due to the pressure from women's groups, as the museum's director admitted in *The New York Times;* curators contacted women artists out of the blue at the last minute to boost the percentages. For further information, see *A Documentary Herstory of Women Artists in Revolution* (New York: Women's Interart Center, 1973).

2. Georgia O'Keeffe, quoted in Dorothy Seiberling, "The Female View of Erotica," *New York Magazine* (Feb. 11, 1974).

3. Faith Wilding, "After Consciousness-Raising, What?", *Everywoman,* 2, no. 7 (May 1971).

4. Louise Bourgeois, quoted in Seiberling, *op. cit.*

5. Lynda Benglis, contribution to "Un-skirting the Issue," *Art-Rite,* no. 5 (spring 1974).

6. Paul Shepard, *Man* [sic] *in the Landscape* (New York: Ballantine, 1972), p. 96.

7. From Cindy Nemser, "Conversation with Barbara Hepworth," *The Feminist Art Journal* 2, no. 2 (spring 1973).

8. Sherry B. Ortner, "Is Female to Male as Nature Is to Culture?", *Feminist Studies* 1, no. 2 (fall 1972).

9. Barbara Rose, "Vaginal Iconology," *New York Magazine* (Feb. 11, 1974).

The Women Artists' Movement— What Next?

1. Now, some eight months after writing this text, I feel a good deal more optimistic about the health of the New York feminist community. The fall of 1975 saw a renewed surge of energy directed at specific projects, among them three new periodicals, a school, and reactivated political activity.

The L.A. Woman's Building

1. In December 1975 the Woman's Building reopened at 1727 North Spring Street, Los Angeles, having been forced to move when the old building was sold. [The Woman's Building closed in 1991, although some of its structures and programs survive.]

The Pains and Pleasures of Rebirth: European and American Women's Body Art

1. The Gutai Group in Japan also made similar events in the late 1950s and Carolee Schneemann's *Eye-Body* (Nude in Environment) dates from 1963.

2. This continues. Max Kozloff's "Pygmalion Reversed" in *Artforum* (Nov. 1975) is the latest example. A few women body artists are mentioned and no women are reproduced in twelve illustrations. He also seems unaware of the existence of a large selection of such art by women and complains that there are "very few artists exploiting dress, ornament and headgear...."

3. In the course of my research in European art magazines I found: a woman with her blouse open, a woman's body signed as art, a woman with a gallery announcement written on her two large bare breasts, a provocative 1940s pinup captioned "Subscribe to me—I'm Extra" to advertise an "artists' magazine" of that name.

4. The 1968 quotations are taken from Schneemann's book *Cézanne She Was a Great Painter* (1975); the 1975 quotation was from another self-published book, *Up To and Including Her Limits* (1975).

5. Benglis's wax totems are acknowledged labial imagery; her sparkle-covered knot pieces are named after strippers and all the knot pieces have sexual connotations.

6. Susan Mogul, in Los Angeles, has made a delightful feminist parody of Acconci's masturbatory activities in her vibrator video piece.

7. This is a quotation from gnostic mysticism in "The Myth of the Androgyne" by Robert Knott (*Artforum,* Nov. 1975). The subject is also treated in the same issue by Whitney Chadwick, who notes that throughout the nineteenth century "the myth of 'the man/woman'... emblemized the perfect *man* of the future" (my italics), thus absorbing the female altogether, which seems to be the point of most male androgynous art.

8. I have written on costume, autobiographical, and role-playing art by women in "Transformation Art," in *From the Center,* pp. 101–108.

9. Nitsch, quoted in Max Kozloff (*op. cit.*). The Knott article (*op. cit.*) cites the relationship of androgyny and "countless fertility myths" that employ violent dismemberment. Chadwick (*op. cit.*) sees debasement of women and androgyny as ways male artists have used to "desexualize the female...as a defense against a severe castration anxiety," responsible for "violent attacks on the female's natural procreative functions"—from sadism to the making of art as competition with the mother and her ability to create the artist himself.

10. Leslie Labowitz and Friederike Pezold in Germany have also made menstruation pieces, as have Judith Stein, Jacki Apple in a terrifying autobiographical text, and Carolee Schneemann in her important orgiastic Happening, *Meat Joy* (1964).

The Pink Glass Swan: Upward and Downward Mobility in the Art World

1. Charlotte Bunch and Nancy Myron, eds., *Class and Feminism* (Baltimore: Diana, 1974). This book contains some excruciating insights for the middle-class feminist; it raised my consciousness and inspired this essay (along with other recent experiences and conversations).

2. Actually nothing new; the history of modern art demonstrates a constant longing for the primitive, the simple, the clear, the "poor," the noble naif, and the like.

3. Michele Russell, "Women and the Third World," in *New American Movement* (Oakland, Calif., June 1973).

4. Don Celender, ed., *Opinions of Working People Concerning the Arts* (St. Paul, Minn.: Macalester College, 1975).

5. Baruch Kirchenbaum, in correspondence. Celender, *Opinions of Working People,* offers proof of this need and of the huge (and amazing) interest in art expressed by the working class, though it should be said that much of what is called art in his book would not be called art by the taste dictators.

6. Bunch and Myron, *Class and Feminism.*

7. This despite their publication of and apparent endorsement of Carolee Schneemann's "The Pronoun Tyranny," in *The Fox* 3 (New York, 1976).

8. Sheila Rowbotham, *Women, Resistance and Revolution* (London: Allen Lane, 1972; New York: Pantheon, 1972).

Making Something from Nothing

1. Rubye Mae Griffith and Frank B. Griffith, *How to Make Something from Nothing* (New York: Castle, 1968).

2. Dot Aldrich, *Creating with Cattails, Cones and Pods* (Great Neck, N.Y.: Hearthside).

3. Hazel Pearson Williams, *Feather Flowers and Arrangements* (Temple City, Calif.: Craft Course).

4. Deena Metzger, "In Her Image," *Heresies,* no. 2 (June 1977). This essay is an important contribution to the feminist dialogue on "high" and "low" art.

5. Harmony Hammond, "Feminist Abstract Art: A Political Viewpoint," *Heresies,* no. 1 (Jan. 1977). See also Hammond's "Class Notes," *Heresies,* no. 3 (Sept. 1977).

6. The British Postal Event, or "Portrait of the Artist as a House-wife," is a "visual conversation" between amateur and professional women artists isolated in different cities. They send each other art objects derived from "nonprestigious folk traditions," art that is "cooked and eaten, washed and worn" in an attempt to "sew a cloth of identity that other women may recognize." It is documented in *MAMA!* (a booklet published by a Birmingham collective and reprinted in *Heresies,* no. 9 (1980).

Some Propaganda for Propaganda

1. Jacques Ellul, *Propaganda* (New York: Alfred A. Knopf, 1965).

2. Batya Weinbaum and Amy Bridges, "The Other Side of the Paycheck," *Monthly Review* (July–Aug. 1976).

3. *Canto Libre* 3, no. 1 (1979).

Issue and Taboo

1. Griselda Pollock, "Feminism, Femininity and the Hayward Annual Exhibition 1978," *Feminist Review,* no. 2 (1979), p. 54.

2. Another omission that will be obvious to British viewers is that of the Hackney Flashers; I should have loved to have them in the show but they had just stopped making new work when I asked, and I had decided not to exhibit anything previously shown in England. The German artist Mariane Wex was also invited, but she was in between homes and did not receive the letter in time.

3. A "Social Work" show was held at the Los Angeles Institute of Contemporary Art in 1979, but that was still an "alternate space." I organized "Some British Art from the Left" at Artists' Space in New York City in 1979, as well as "Both Sides Now" at Artemisia in Chicago; in 1980 "Vigilance"—a show of artists' books about social change, organized by Mike Glier and me—was at Franklin Furnace, and there have also been small "political" shows at institutions outside of New York as well as a number of artist-organized events over the years. [By the late eighties this picture had changed drastically and "political art" had expanded to the banks of the mainstream.]

4. Roszika Parker, talking to Susan Hiller, though the view expressed was a prevailing one rather than that of either participant; *Spare Rib,* no. 72 (1978), p. 30.

5. Harmony Hammond covered this in her "Horseblinders," *Heresies,* no. 9 (1980).

6. Rowbotham, Segal, and Wain-right, *Beyond the Fragments: Feminism and the Making of Socialism* (London: Merlin, 1979), p. 109.

7. See *Heresies,* no. 9 (1980), for Leslie Labowitz's "Developing a Feminist Media Strategy."

8. Walter Benjamin, "The Author as Producer," in *Understanding Brecht* (London: New Left, 1977), p. 86.

9. May Stevens, "Taking Art to the Revolution," *Heresies,* no. 9 (1980).

10. Mary Kelly, in the notes for and around *Post Partum Document*—the sources for all quotations here.

11. Adrian Piper raised the crucial distinction between condescension and empathy at a symposium on social-change art at the Cincinnati Contemporary Art Center in June 1980.

Sweeping Exchanges: The Contribution of Feminism to the Art of the 1970s

1. Even Hilton Kramer, though he fears it is "lowering the artistic standards."

2. Judy Chicago, *Artforum* (Sept. 1974).

3. Surrealism was also self-described along these broad lines, and with Dada has proved that it, too, was never a movement or a style, since it has continued to pervade all movements and styles ever since.

4. Ruth Iskin, quoting Arlene Raven at the panel on feminist art and social change accompanying the opening of *The Dinner Party,* March 1979.

5. Harmony Hammond, "Horse-blinders," *Heresies,* no. 9 (1980).

6. May Stevens, "Taking Art to the Revolution," *Heresies,* no. 9 (1980). Many of the ideas in my article emerged in discussions with the collective that edited this issue and with Hammond and Stevens in particular.

7. Suzanne Lacy at the panel accompanying *The Dinner Party.* See note 4.

8. Jack Burnham in the *New Art Examiner* (summer 1977).

9. The distinction between ambition (doing one's best and taking one's art and ideas as far as possible without abandoning the feminist support system) and competition (walking all over everybody to accomplish this) is a much discussed topic in the women's movement.

10. Jamake Highwater, quoting Joseph Epes Brown, is an unpublished manuscript.

Equal Parts

1. Two other major works on abortion around the time this article was written were RepoHistory's *Choice Histories: Framing Abortion,* an exhibition at Artists Space in New York, 1992, which was also presented in the form of an artist's book; and "Wake Up Little Susie," a traveling show based on the book of the same name by Rickie Solinger—in a collaborative installment by Kathy Hutton, Cathleen Meadows, Kay Obering, and Solinger.

Double Vision: Women of Sweetgrass, Cedar, and Sage

1. However, the Gallery of the American Indian Community House did present a smaller exhibition, "Native Women Artists," in 1982.

2. Jolene Rickard, *Upfront,* nos. 6–7 (1983), p. 20. The artists' statements included in this essay come from conversations, from statements written for this catalog, or from those in the catalog *Contemporary Native American Art* for the exhibition at Oklahoma State University in Stillwater, October 1983. The three women I was able to interview at length—Jaune Quick-to-See Smith, Ramona Sakiestewa, and Jolene Rickard—represent a variety in geography (from the Plains, Southwest, and Northeast), age, and medium; coincidentally, they all come from nations in which women traditionally have leadership positions.

3. George Longfish and Joan Randall, "Contradictions in Indian Territory," in *Contemporary Native American Art* (see note 2).

Undertones: Nine Cultural Landscapes

1. Martha Sandweiss writes about Gilpin's interest in "the cultural significance of the landscape," and "in the land as an environment that shaped human activity," and J. B. Jackson said Gilpin's book on the Rio Grande "established Gilpin as a cultural geographer." ("Laura Gilpin and American Landscape Photography," in Vera Norwood and Janice Monk, eds., *The Desert Is No Lady* [New Haven: Yale University Press, 1987], pp. 62–73.)

2. Jeff Kelley has distinguished the notion of place from that of site, made popular in the late 1960s by the term *site-specific sculpture.* A site, says Kelley, "represents the constituent physical properties of a place, while places are the reservoirs of human content." *(Headlands Journal, 1980–84* [San Francisco: Headlands Art Center, 1991], pp. 34–38.)

3. Daphne Spain offers a variation on this common idea: "Although space is constructed by social behavior at a particular point in time, its legacy may persist (seemingly as an absolute) to shape the behavior of future generations." *(Gendered Spaces* [Chapel Hill: University of North Carolina Press, 1992], p. 6.)

4. This is borne out by the massive amount of material I have been compiling for a book on land, history, culture, and place. There are more women working in site and photography in this area, as in "real" public art; that is, art that takes into account, involves, and responds to the place it is put and to the people who are there.

5. Jolene Rickard, speaking at a PADD Second Sunday, Franklin Furnace, New York City, winter 1982–83. Rickard is currently working on a series on land use/landscape from the Native viewpoint.

6. See the exhibition catalog *Our Land, Ourselves* (Albany: SUNY Albany, University Art Gallery, 1991).

7. Theresa Harlan, "Message Carriers: Native Photographic Messages," *Views* (winter 1993), p. 7.

8. Patricia Deadman in *Fringe Momentum* (Thunder Bay: Thunder Bay Art Gallery, 1990), p. 14.

9. See, for example, Vincent Scully, *Pueblo: Mountain, Village, Dance* (New York: Viking, 1975). Scully relates southwestern topography to pueblo architecture and dance.

10. Janet Clark, in *Fringe Momentum,* p. 9.

11. Marlene Creates, *The Distance Between Two Points Is Measured in Memories* (St. John, Can.: Memorial University of Newfoundland, Sir Wilfred Grenfell College Art Gallery, 1989), n.p. This piece recalls Susan Hiller's 1974 *Dream Mapping,* in which parallel dreams were recorded after several people slept overnight in "fairy circles" in England.

12. In a 1988 installation/artist's book, Creates interviewed the former inhabitants (Naskapi Innu, Inuit, and Euro-Canadian settlers) of an isolated area in Labrador; they told stories and penciled tentative maps from memory. These maps were then installed with a portrait of the storyteller in her or his living room, a brief reminiscence, a photograph of the mapped place today, and a natural object, such as a bundle of grass, a rock, or dried flowers.

13. Marlene Creates, "Statement" (unpublished), Dec. 1990.

14. Marlene Creates, artist's statement (unpublished), 1991.

15. Carrie Mae Weems, "Conversation with Carrie Mae Weems," by Susan Benner, *Artweek,* May 7, 1992, p. 12.

16. Masumi Hayashi, in *Centered Margins: Contemporary Art of the Americas* (Bowling Green, Ohio: Dorothy Uber Byron Gallery, 1992), n.p.

17. Ibid., n.p.

18. J. B. Jackson, *The Necessity for Ruins* (Amherst: University of Massachusetts Press, 1979), pp. 89–102.

19. Michele Montrelay, quoted in Caroline Hinkley, "Work in Progress" (unpublished), 1990.

20. Nancy Gonchar in *Deborah Bright: Textual Landscapes* (Binghampton, N.Y.: University Art Gallery, 1988), n.p.

21. Deborah Bright, "Of Mother Nature and Marlboro Men: An Inquiry into the Cultural Meanings of Landscape Photography," *Exposure,* winter 1985. This is a key text on the subjects discussed here.

22. Rebecca Solnit, "Elements of a New Landscape" (manuscript), pp. 4 and 5.

23. Neil Smith, "Making M/Other Nature," *Artforum,* Dec. 1989, pp. 17–19.

24. Rebecca Solnit, "Meridel Rubinstein: Critical Mass," *Artspace,* July–Aug. 1992, p. 47.

25. Carole Gallagher, *American Ground Zero: The Secret Nuclear War* (Cambridge: MIT Press, 1993); Sharon Stewart, *Toxic Tour of Texas* (Houston: self-published, 1992).

26. Stewart, *Toxic Tour.*

27. The U.S. government contends that it has legally bought the lands deeded to the Shoshone by the 1863 Treaty of Ruby Valley. The Shoshone contend that they were never for sale and that they wanted not money but the return of their land.

28. Robert David Sack, *Conceptions of Space in Social Thought* (Minneapolis: University of Minnesota Press, 1980), p. 70.

29. Annette Kolodny, *The Land Before Her* (Chapel Hill: University of North Carolina Press, 1984), pp. 6–7.

30. Judith Fryer, *Felicitous Space: The Imaginative Structures of Edith Wharton and Willa Cather* (Chapel Hill: University of North Carolina Press, 1986), p. 290.

31. See, for instance, Daphne Spain, *Gendered Spaces, and* Peter Jackson, *Maps of Meaning* (London: Unwin Hyman, 1989), chap. 5; and Alexander Wilson, *The Culture of Nature* (Cambridge: Blackwell, 1992) on the women/gardens and men/lawns syndrome, p. 99; and the work of Dolores Hayden. The exception is the Sandweiss article referred to in note 1 above.

32. Michel Foucault, *Power/Knowledge* (New York: Pantheon, 1980), p. 37.